FADS AND FANCIES

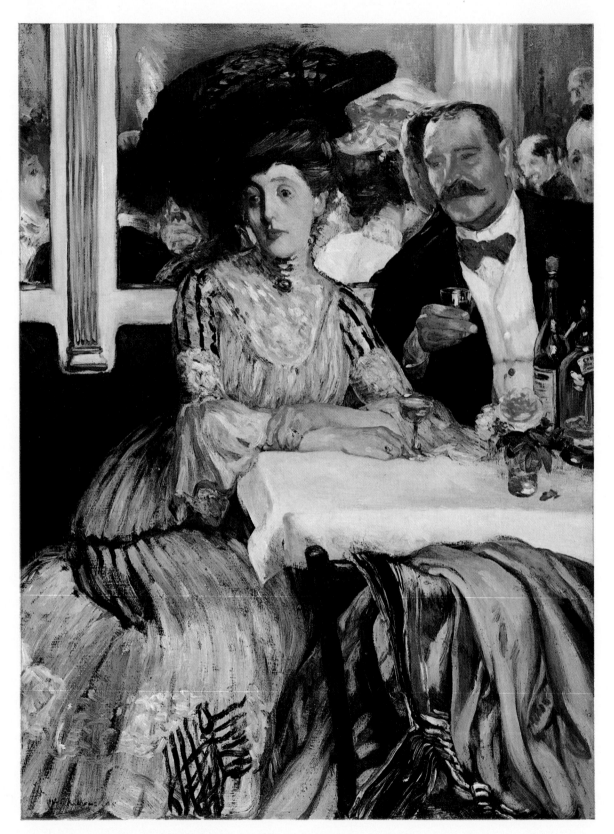

Chez Mouquin by William J. Glackens (1870–1938). 1905. Oil on canvas. 122 × 92 cm.
Gift Friends of the American Art Collection. The Art Institute of Chicago.

FADS AND FANCIES

DENYS SUTTON

with an introduction by Kenneth Clark

Wittenborn & Company
New York

In memory of my mother

The title of this book is taken from a revue in which my mother danced. Thanks are due to Lord Gibson for permission to reprint these editorials, to David Grey who did the original layout, and to my wife for her encouragement and patience. D.S.

The relevant issues of *Apollo* from which this collection is drawn are as follows: pp. 9–17, August 1969; pp. 18–27, June 1973; pp. 28–41, September 1974; pp. 42–57, June 1974; pp. 58–71, November 1973; pp. 72–85, April 1973; pp. 86–97, November 1972; pp. 98–109, October 1972; pp. 110–129, September 1972; pp. 130–143, July 1977; pp. 144–151 February 1973; pp. 152–158, November 1975; pp. 159–171, January 1970; pp. 172–185, November 1971; pp. 186–207, December 1973; pp. 208–217, December 1977; pp. 218–226, January 1976; pp. 227–240, May 1973.

First published in the United States 1979
by Wittenborn and Company,
1018 Madison Avenue, New York, N.Y. 10021

© The Financial Times Ltd. and Denys Sutton 1979

Library of Congress Catalog Card Number: 79–64887

Printed and bound in Great Britain

ISBN 0–8150–0903–8

CONTENTS

Introduction by Kenneth Clark 7

Le Bon Ton and *Le Roast Beef* 9
Does an English Rococo exist?

'The Faire Majestic Paradise of Stowe' 18
The historical and artistic background of a famous house

The Final Flowering of the Medici 28
A little-known aspect of Italian patronage

'Magick Land' 42
Artists and travellers in eighteenth-century Rome

Realms of Enjoyment 58
The culture of eighteenth-century Bath

The Black Swan of Bom Jesus 72
English travellers in eighteenth-century Portugal

A Silver Age in Dutch Art 86
The discovery of eighteenth-century Dutch art

The Paradoxes of Neo-Classicism 98
A reappraisal of a major artistic movement

Il Cavaliere Alberto 110
The life and times of Thorvaldsen, the Danish sculptor

The Incomparable Josephine 130
The Empress Josephine and her taste

The Prisoner 144
An assessment of Dante Gabriel Rossetti

Celtic and Classical Dreams 152
Burne-Jones and his world

A Long Affair 159
The Bostonians and French art

Munich: City of the Arts 172
The major artistic role of Munich from 1800 to 1914

Wanderers and Aesthetes 186
Russian art from the Symbolists to the Revolution

'A Rose's Place Among Our Memories' 208
Paris in the 1890s

The Sharp Eye of Edith Wharton 218
The American novelist and her taste

The Singularity of Gino Severini 227
Italy's most original painter of the twentieth century

INTRODUCTION

For many years *Apollo* has been one of the most entertaining, one of the most instructive and one of the best produced of art periodicals, and it owes this preeminence to the wide-ranging intelligence of its editor, Denys Sutton. The numbers devoted to a single subject, a gallery like the Hermitage or a private collection such as that of Frits Lugt in Paris, are a revelation even to those who believe themselves fairly well acquainted with the gallery in question. Anyone who has experienced the frustrations and delays of putting such compilations together will know how long and patiently Denys Sutton must have worked. But in addition he has preluded each number with an essay, sometimes vaguely connected with the matter that followed, sometimes concerned with current art topics, but usually reflections on subjects that interested him. A choice of these editorial overtures forms the contents of this book, and it could have been twice as long with no loss of quality.

The essays show a really extraordinary command of information on some very recondite subjects. Denys Sutton has a particular sympathy with half-forgotten periods, and brings them back to life with the help of details which an excellent memory has retained from a mass of reading. But I hope he will not quarrel with me if I say that his favourite period is the French nineteenth century, especially the second half, when the literary sources, journals and memoirs, are more revealing and amusing than at any period before or since. It is in France, from the de Goncourts to Paul Bourget, that he seems to feel most at home. Being myself old enough to have sat in the background when the last survivors of this happy period were enjoying their only competitive sport, conversation, I can vouch for the accuracy of his assessments. I do not know what Paul Bourget and Edith Wharton can have had to do with an art magazine, but I am glad to be reminded of them now.

KENNETH CLARK

Le Bon Ton and *Le Roast Beef*

One question which requires to be examined, and with an eye cocked at the Continent, is the extent to which the Rococo flourished in this country. At first sight, this style might seem to have had few affinities with English art (Chippendale and his rivals excepted, of course, and even they with a notable difference); and it is generally and rightly associated with the brilliant monuments and works of art of France, Bavaria, Austria and Venice. There are, it must be admitted, no grand Rococo buildings in England, and, interestingly, Sir John Summerson devoted no section to the Rococo in his admirable Pelican history of English architecture. On the other hand, Christopher Hussey has written with customary delicacy about the Rococo features in certain country houses and Sir Sacheverell Sitwell once claimed[1] that James Gibbs, who employed such Italian stuccoers as Artari and Bagutti, was a Rococo architect, and that his Senate House at Cambridge foreshadowed the buildings of Héré and Gabriel. A case has even been advanced for hailing Pope as the master poet of the Rococo.[2]

Awareness of the Rococo strain in English art is of recent date. How little was known about this style, as far as concerns our national School, may be gleaned from the late John Steegman's *The Rule of Taste* (1936). He was something of a pioneer, for at that date few writers bothered to show much concern with the finer points of eighteenth-century English art. Yet he was writing at a time when interest in this particular subject was growing and when such discerning amateurs as the Sitwells were exploring the territory and when collectors such as Sir Philip Sassoon and his cousin, Mrs. David Gubbay, were buying examples of English Rococo. It attests to the spell which the century as a whole concurrently started to exert on a group of formidable scholars that the groundwork was then being done which permits us to approach the arts of this period with greater assurance, and tribute deserves to be paid to the fundamental studies on furniture, architecture, painting and sculpture which have been published by Margaret Jourdain, Margaret Whinney, Ralph Edwards, Christopher Hussey and E. K. Waterhouse.

The endeavour of the 'founders' has not been in vain. A younger generation of writers on the decorative arts of the period has also tackled the fascinating problem of the English Rococo. In their writings the complexities of the question are made so evident that it is hardly surprising that no general account of the English Rococo has been written. Indeed agreement is by no means general on

1. *Allegorical Tomb of the Duke of Devonshire*
by Sebastiano (1659–1734) and Marco (1676–1730) Ricci, *c.* 1720.

Oil on canvas, 217 × 137 cm.
Barber Institute of Fine Arts, Birmingham.

the definition of the term Rococo (although the sequence of events which led up to its emergence and marked its evolution is more or less common ground), thus indicating the difficulty of finding appropriate words to describe such a whimsical and paradoxical style. The debate as to its range in England—and the battle has been strong over such points as the alleged Rococo character of Pope's garden at Twickenham—has been revealed, from time to

2. *The Rotunda at Ranelagh Gardens.* Engraving, 23·5 × 36·2 cm. The London Museum. The scene shows a Jubilee ball held on the occasion of the birthday of George, Prince of Wales, on 24 May, 1759

time in the correspondence columns of *The Times Literary Supplement.*[3]

The problem would be thrown into sharp relief by an exhibition, and an obvious and sympathetic place for such a display would be the Victoria and Albert Museum. The last time that a show provided some representation of the English Rococo was in 1955-56, when a Rococo section (as well as others devoted to chinoiserie and the Gothic) was included in the splendid Royal Academy exhibition 'English Taste in the Eighteenth Century'; the preface contributed to the catalogue by Ralph Edwards remains the most succinct and penetrating summary of this style as it was manifested in England. An exhibition along the lines advocated here would have to include photographs of buildings and decorations and contain some comparative material; and it would be attractive to offer such delicacies as a model reconstruction of Vauxhall Gardens, that enchanting pleasure-ground which held a role in London life analogous to that now enjoyed by Tivoli in Copenhagen. It could prove a most enthralling exhibition, one moreover which would afford a real contribution to scholarship.

An exhibition would not prove enough, however; it should serve as the backcloth to a symposium, along the lines of the Colloques Poussin held in Paris, or the Guardi debate held in Venice. The opportunity to exchange ideas about a subject which still remains rather nebulous would be exhilarating, and theories could be sustained or rejected, as the case may be, by reference to precise examples. This colloquy should not be narrow in its terms of reference. Room should be found to include spokesmen to champion their views about the Rococo elements (if such exist) in literature, music, the stage and even philosophy. The years from about 1700 to 1760 produced

such a strange interplay of forces in this country that the debate should be most rewarding, and it would diminish the temptation to propound over-simple solutions.

A glance deserves to be spared for the literature of the period. The French Rococo had its genesis during the last years of Louis XIV's reign between 1695 and 1715, but it is not easy to find English contemporaries to such French ornamentalists as Audran, Berain and Gillot who paved the way for the emergence of the Rococo. As yet, indeed, the impact of Daniel Marot on English design or the influence of the Huguenot craftsmen who came to this country has not been studied in depth, so that many problems remain unresolved. But is it possible to find a Rococo element in the comedy of manners so brilliantly represented by Congreve and does his wit contain a Rococo touch? He lived until 1729, although his last comedy was composed in 1700. Then, what about Vanbrugh? Although there is nothing Rococo about his architecture, this playwright-architect, who died in 1726 and wrote his final play in 1705, was associated with some of the trends that were to produce the Rococo. It is surely relevant for the spread of this style in England that he built a theatre for the Italian opera (a convenient reproduction is found in Hugh Phillips's *Mid-Georgian London,* 1964, Fig.110) and that two of his comedies were based on plays by Dancourt, the very playwright who inspired Watteau.

The fact that Vanbrugh was fascinated by this dramatist raises one of the central questions of the Rococo—namely, the way in which English artists and designers derived their material from French sources, and the extent to which, in many cases, they endowed them with an English twist. Charles Whibley (rather unfairly treated, incidentally, in John Gross's recent *The Rise and Fall of*

the Man of Letters) wrote of the *Confederacy* which Vanbrugh derived from Dancourt's *Bourgeoises à la Mode* that 'Closely as it follows the original, it is as racy as our soil. As you read it, you think not of the French original but of Middleton and Dekker. It was as though Vanbrugh had breathed an English soul into a French body'.[4] These words may be recalled when studying those English painters, such as Hogarth and Hayman, who owed something to French prototypes. The difference, for instance, between the 'conversations' of De Troy and Hogarth are immense, in tone no less than mood. The famous pendants, *Indiscretions: Before and After,* by Hogarth certainly treat of the sort of libertine theme likely to appeal to a French artist, but the interpretation is very different from that found in a Boucher or a Baudouin; and surely Valmont would have turned up his nose at this 'country-style' adventure.

The 'Rococo-problem' in this country can only be studied when some analysis of the political and social background is attempted. Obviously in this context Anglo-French relations are of prime importance; the fact that between 1713 and 1744 and between 1748 and 1756 peace reigned between the two countries and that in 1716 the Pretender was compelled to leave the Court of St. Germain for Rome is relevant; the artistic implications of this move have been analyzed by Professor E. K. Waterhouse.[5] When the Seven Years War broke out in 1756 the interruption of relations with France had small effect on the spread of the Rococo, for this style was then in full bloom and in both countries the trend was increasingly towards neo-Classicism. The domestic situation must always be taken into account too. Is it possible to find a parallel to the conflict between the Palladian establishment architects and the younger proto-Rococo men in that which was obtained between the Whig 'authoritarianism' of Sir Robert Walpole and the opposition of the 'Boy Patriots', who included Lord Bolingbroke and Lord Chesterfield, the latter a staunch supporter of the French style?

The emergence of the Rococo in England was accompanied by the appearance of several concomitant factors which influenced its evolution, although they did not necessarily constitute Rococo elements. One of these was the considerable patronage extended towards the Venetian School, which had been admired in this country ever since the time of James I, when various collectors had acquired important sixteenth-century Venetian pictures. The consequence of the interest in Venetian art shown in the first half of the eighteenth century was not only that Englishmen bought Venetian works but that Venetian painters, such as Sebastiano and Marco Ricci, Bellucci, Antonio Pellegrini, Amigoni and Canaletto, came to England in search of patronage. It was significant of the complexities of the day that the champion of Palladianism, Lord Burlington, employed Ricci and Pellegrini to execute decorations for Burlington House. Sebastiano Ricci was defeated in his aim to decorate the dome of St. Paul's—a commission that went to Sir James Thornhill.[6] This was a portent, moreover, of the nationalist current that was partly responsible for the ultimate failure of the Rococo to become fully integrated with English art.

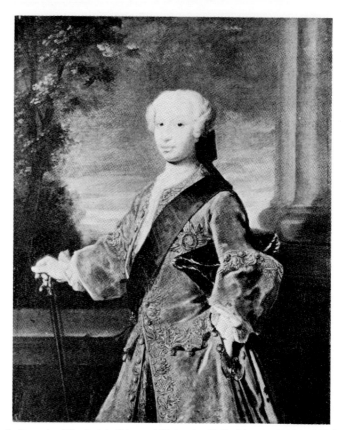

3. *Portrait of Frederick, Prince of Wales,* by Philip Mercier (1689–1760), *c.* 1735–40. Oil on canvas, 122×96·5 cm. National Portrait Gallery, London. The Prince was a great admirer of the Rococo style

Venetian painting accustomed English eyes to a more vivid apprehension of colour and to a sketchy handling of paint. These qualities are well shown in the decorations on canvas set into the walls which Pellegrini painted for Kimbolton Castle, the seat of the Earl of Manchester, who had brought back this artist and Marco Ricci from Venice in 1708 when returning from his second embassy to that city. The figures in *Musicians,* as Michael Levey has observed,[7] 'already announce the eighteenth century's love of the exotic; real Negro boys to serve chocolate or carry torches, and oriental clothes to lounge in and wear at fancy dress routs'. An undoubted Rococo spirit may be detected, too, in the famous series of twenty-four tombs of Whig statesmen (Fig. 1), which was planned in about 1720 by the bankrupt impresario Owen McSwiny. This intriguing figure had worked for Vanbrugh and had sought refuge in Italy to escape his creditors; for the fulfilment of this project he pressed into service a number of Venetian and Bolognese artists, including Ricci, Canaletto and Piazzetta. English patrons were also purchasing such undoubted Rococo pictures as Canaletto's *Portico of a Palace. Capriccio* (Collection the Duke of Norfolk), which F. J. B. Watson[8] has dated to 1740, that is to say, at the very time when the Rococo was spreading its wings in England.

French art, however, was the main channel by which knowledge of the Rococo was introduced into England. Ever since the Revocation of the Edict of Nantes in 1685, French craftsmen had been coming to this country; for instance, Paul de Lamerie was a second generation Huguenot. Men of fashion and writers were increasingly aware of the avant-garde movement on the other side of the Channel. It was typical of this growing admiration for French taste that, during the 1680s and '90s, the Duke

11

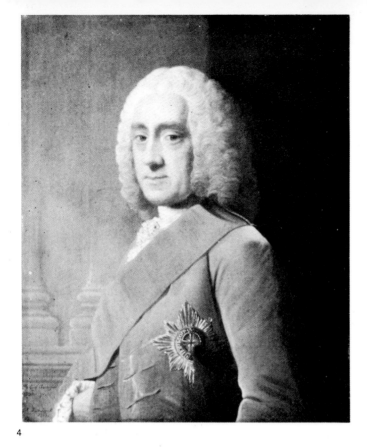

4

of Montague, who had served as Ambassador in Paris, employed a group of French artists to undertake decorations at Bloomsbury House and Boughton. One of these, Louis Cheron, remained here and played 'an important part in the foundation of the first two Academies of painting in 1711 and 1720'.[9]

If the influence of this circle was relatively restricted, it was not the case with the various engravers who started to settle in London. The lead was given in 1711 when Nicolas Dorigny was the first of the French engravers to be entrusted with the commission to make prints after the famous Raphael cartoons. Among those who arrived was Bernard Baron, who became well known as an engraver after Watteau's work and found a place in Rouquet's book on English art. It was by means of the engraving that English artists and craftsmen grew aware of the 'modern' style.

It stood to reason that a number of rich clients were anxious to employ artists who were aware of the up-to-date trends in interior decoration and furniture and that such artists were eager to find solutions to the problem of designing for the smaller rooms that were replacing the larger Baroque saloons. It has to be remembered that the eighteenth century was to witness the emergence in England of a wealthy middle class, as well as a considerable number of tycoons. Ability to plan small rooms with elegant and comfortable dimensions naturally won adherents in this country; but in nearly all cases, the formulae adopted took into account local peculiarities.

The tendency of replacing large-scale 'heroic' compositions by smaller and more intimate works of art was a feature of the time, and it is admirably shown in the tapestries woven by Joshua Morris for the Soho Tapestry Works in 1720. He is known to have produced arabesques in 1723 and Edward Croft-Murray suggests[10] that the designs for these may have been due to the French artist

Andien de Clermont. This artist, who specialized in *Singeries,* was active in this country from 1716 to 1756 and was engaged on various decorative schemes for the ninth Earl of Pembroke, the fourth Earl of Radnor and the sixth Lord Baltimore. Morris's small and harmonious woven panel in the Victoria and Albert Museum shows how the elegant scrollwork of the arabesque had been adjusted to suit the English taste. The presence in the composition of a bouquet of flowers and a macaw suggests, too, some connexion with the paintings of J.-B. Monnoyer, which were so much admired in the seventeenth century and which decorated many country houses.

One of the finest English tapestry suites of the eighteenth century was a set of four (at Ham House) based on pictures by Watteau and woven by William Bradshaw at the Soho Works.[11] They provide valuable evidence of the way in which the genius of Watteau was appreciated not only by such German monarchs as Frederick the Great but by English art lovers. In the same year, 1720, that Nattier and Raoux crossed to London, Watteau arrived to consult the famous physician, Dr. Mead. This distinguished collector acquired two pictures from the artist. Other paintings by Watteau were owned by English collectors, including Horace Walpole, and his style was familiarized by engravings.

Watteau's reliance on the theatre for his subject-matter would have also been appreciated in England. The influence of stage design on the development of painting is a subject that is never quite sufficiently studied and it would be well worth finding out more about the sets which were presumably designed by the Ricci for Vanbrugh's Opera House in the Haymarket. Opportunities were likewise available for becoming familiar with the ever fascinating imagery of the *Commedia dell' Arte,* for various pieces connected with it were performed by the French comedians at the Little Theatre in the Haymarket, on and off between 1718 and 1735. Dr. Robert Raines, for instance, has drawn attention in a recent book to the way in which Marcellus Laroon, the artist of French extraction once compared by Osbert Sitwell to Sickert, found some of his subject-matter in this quarter.

The relationship between the stage and ornamental design is suggested by the intriguing career of William De La Cour, which was ably sketched by John Fleming in an informative article 'Enigma of a Rococo Artist' in *Country Life* (24 May, 1962) and about whom further information was provided by Eileen Harris in a letter to *Country Life* (5 July, 1962). It appears that De La Cour was employed from 1740 to at least 1743 as a stage designer for the Italian operas presented at the King's Theatre under the aegis of Lord Middlesex, the Earl of Holderness and the Duke of Rutland, and that in 1741, 1742 and 1743 he published *Eight Books of Ornament* which were dedicated to these three noblemen. His decorative designs undoubtedly formed one of the ways by which the Rococo infiltrated into this country.

It is tempting to cast the net too wide in pursuing the Rococo thread in English life and art during the first half of the eighteenth century. Yet there can be little doubt that the entertainment world did offer one way in which Rococo decoration could be employed. When James

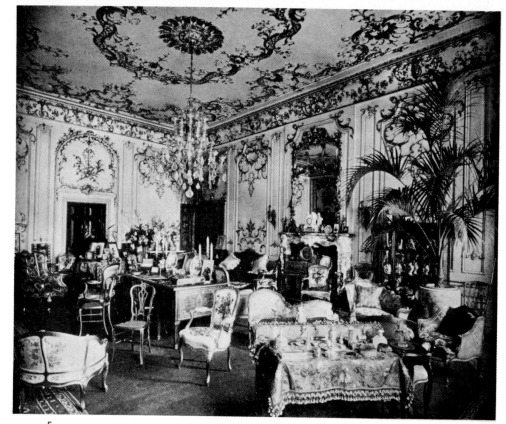

4. Opposite: *Portrait of Philip Stanhope, Fourth Earl of Chesterfield,* by Allan Ramsay (1713–84), 1765. Oil on canvas, 72·4 × 59·7 cm. National Portrait Gallery, London. This statesman and man of letters was a devotee of French civilization

5. The drawing-room of Chesterfield House, London. This photograph was taken in 1894. This house, which was demolished in 1934, was one of the rare examples of the Rococo style in England

6. Design for the ceiling of the Music Room of Chesterfield House, Plate 81 in *Complete Body of Architecture,* 1756, by Isaac Ware (died 1766)

5

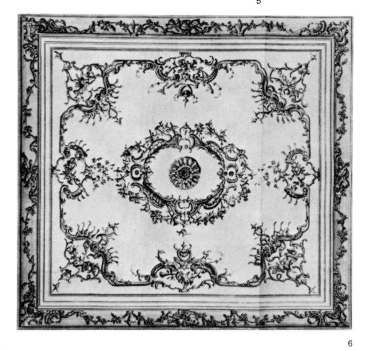

6

Heidegger took over the management of the Haymarket Opera House, he organized subscription balls and masquerades, and the latter resembled the Venetian *ridotti.* The description which Horace Walpole supplied of the Jubilee masquerade held at Ranelagh in 1749 on the occasion of the Peace of Aix-la-Chapelle refers to a maypole, harlequins and scaramouches, and the Little Pavilion contained a statue of Pan—a figure intimately associated with the Régence style as later with the Rococo in France. The other notable pleasure resort in London, Vauxhall Gardens, which was opened by Jonathan Tyers, had supper-boxes decorated by artists such as Hogarth and Hayman and contained a Chinese pavilion and afforded another example of the Rococo style.

At this point, the question must be asked if we are justified in claiming that the Rococo manifested itself in two ways in England: firstly, in the narrow sense of an ornamental style derived from the *rocaille,* and as such admirably analyzed by J. V. G. Mallet in his article in this issue, and, secondly, in terms of a new subject-matter, largely based on the example of Watteau and his followers. In essence the themes of the painters were imbued with the licentiousness and libertine spirit of the Régence, the expression of the reaction against the austerity and grandeur of Louis XIV and Lebrun. It is reasonably evident that much of the most Rococo-like painting in England—the pictures of Hayman and Hogarth, for instance—is tinged with the eroticism of the Régence; in terms of English art, therefore, a sophisticated paganism became intermingled with the traditional maypole. Thus the poetical *fête galante* of the French was given a more popular character in English painting; the actors were not gallants playing at shepherds and shepherdesses but farm folk dressed up for the occasion. The extent to which the Régence and the Rococo (with their overlappings) produced a special pictorial technique, in terms both of the creation of an illusion of space and of the technical application of paint, is a difficult question. What is not in dispute is that a sketchiness of paint and a linear application of ornament —i.e. colour in the case of painting—as much as the famous serpentine line are characteristics of the Rococo.

Nevertheless, some caution is advisable in seeking to relate too closely, for instance, the painting of Hogarth with that of the French. In his valuable book *Early Conversation Pictures* (1954) Ralph Edwards reminded us that in such pictures as *The Cholmondeley Family* and *The Conquest of Mexico* 'the sitters are endowed with the "graciousness" and air of breeding appropriate to their station, but they could never be taken for members of the French *noblesse*. The design in the "family piece" is most happily invented, and the exuberant

13

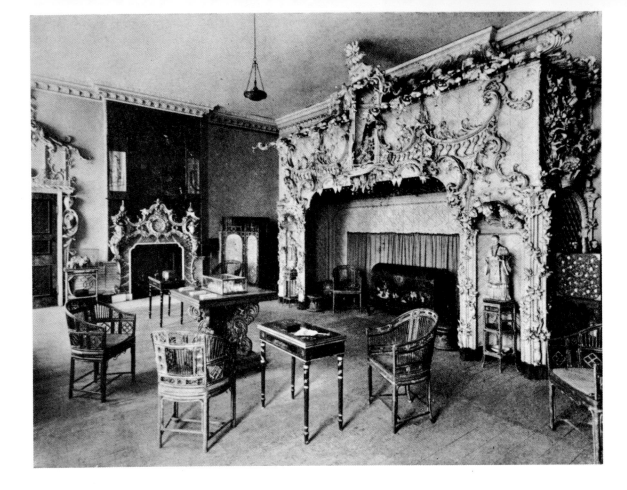

7. The Chinese Room at Claydon House, designed by Lightfoot, 1768–71. Photograph *Country Life*

8. Opposite: The Gallery at Strawberry Hill, Horace Walpole's famous house, Twickenham, decorated by Thomas Pitt (1737–93) and completed in 1763. Photograph *Country Life*

rhythm that derives from the romping boys, to whom the pose of Lord Cholmondeley is so happily related, may pass the "rococo" only because the term is so vaguely defined'.

By the 1730s and '40s a new spirit was in the air. Various factors—the influence of the Italians, the presence of the French immigrants and the possibilities of visiting Paris—were encouraging an awareness of the Rococo. The silversmiths headed by Paul de Lamerie had taken over designs from the French, although this master's precise sources are not known. And local craftsmen could grow more conscious of the new style by looking at Gaetano Brunetti's *Sixty Different Sorts of Ornament* (1736), Matthew Lock's *A New Drawing Book of Ornament* (1740) and Lightoler's designs in Money and Halfpenny's *Modern Builders Assistant* (1742). The furniture-makers such as Langlois (who rendered his accounts in French) and *entrepreneurs* such as Nicholas Sprimont all contributed to making the London art world aware of the new fashion, and it was a trend that received its imprimatur in the publication of Thomas Chippendale's *The Gentleman and Cabinet Maker's Director* in 1754. It can now be seen that the twenty years between 1730 and 1750 form a distinct period—one with features as distinctive as those of the '90s, when, as with this era, the wind blew from France.

Too often it is tempting to think of artists working in isolation and to forget that, especially in this clubbable epoch, they were in frequent touch and in fact lived in the same district. It is one of the merits of three stimulating articles which Mark Girouard contributed to *Country Life* (13 January, 27 January, 3 February, 1966) that he made us aware of the extent to which a group of artists, writers and collectors forgathered at Old Slaughter's Coffee-house in St. Martin's Lane, 'The Grub Street of the Arts', as Austin Dobson once called it. This café, which was later immortalized by Thackeray in *Vanity Fair*, acted as a sort of clearing-house for the dissemination of the French style, and many of the artists who visited it were connected with the St. Martin's Lane Academy, founded by Hogarth in 1735. This coffee-house attracted some of the leading spirits of the time—men who included such Frenchmen, 'fasting Monsieurs' to use Dr. Johnson's words, as Gravelot, Clermont and Roubiliac. Other habitués were Moser, Hayman, Cheere, Dr. Martin Folkes, the antiquary, James Paine, Garrick and Gainsborough. Not all these men were necessarily supporters of the Rococo, but they did share one thing in common: an openness to new ideas and a high intelligence.

It is now known that one of the most seminal figures of the Old Slaughter set was Hubert Gravelot, who arrived in England in 1732 and quickly made his mark as an energetic and talented engraver and book illustrator, and some 100 works are known to have been illustrated by him. His charming drawings suggest, too, one way in which Gainsborough was introduced to a knowledge of French art; not that this accomplished and elegant painter required much persuasion to paint in a charming and debonair manner. In this issue Desmond Fitz-Gerald shows the way in which Gravelot's influence made itself felt on furniture design and persuasively argues that Lock, Chippendale and Johnson 'must have received their Rococo education from Gravelot, or, at any rate, from persons who were immediately connected with this talented French draughtsman'. The infiltration of the French was so powerful that the reaction was all the more understandable.

One aspect of the Rococo in England that demands investigation is the state of contemporary patronage and the identification of those men (and women?) who supported the new style. This subject requires the same sort of patient detective work as Sir Lewis Namier adopted for a study of the political structure. What is obvious is that the spread of the Rococo would not have gone far without the existence of patrons who appreciated its virtues. One of the most fascinating of those who did so was Frederick, Prince of Wales (Fig. 3). He has often been sharply treated by historians, for instance by F. Homes Dudden in his standard biography of Henry Fielding. Shortly after arriving in England in 1727, however, he showed himself to be an accomplished dilettante, playing the cello and sitting to a number of artists. Besides Mercier, who was attached to his household, these included Amigoni, Van Loo, Barthélemy du Pan and Hogarth. He extended his patronage to such silversmiths as Nicholas Sprimont and was a connoisseur of seventeenth-century painting, adding fine examples of Rubens and Van Dyck to the Royal Collection.

It would be interesting to know more about his friendship with Frederick the Great and the reasons for his admiration for the duc d'Orléans, the Regent of France. There was certainly a frivolous cast to his mind. When the news of the Duke of Cumberland's defeat at Fontenoy in 1745 reached him he was deep in the preparations for a performance at Leicester House of Congreve's masque *The Judgment of Paris,* in which he took the role of Paris. He wrote a French song for the part, which includes the words:

> Que n'importe que l'Europe
> Ait un ou plusieurs tyrans
> Prions seulement Calliope
> Qu'elle inspire nos chants . . .
> Passons ainsi notre vie
> Sans rêver à ce que fut
> Avec ma chère Sylvie
> Le temps trop vite me fuit!

This is an undoubted example of the Régence-Rococo spirit and it would not be difficult to imagine these words appearing under an engraving after Watteau; and the last line quoted here recalls Madame de Verrue's famous epitaph.

The Prince lived in Leicester House, in close proximity to the artists' quarter. However, when this residence was redecorated by him it does not seem to have been done in the Rococo style. Indeed, when he commissioned William Kent to build Kew Palace,[12] which was probably begun in 1729, this was in the Palladian taste and one of the first buildings in this style to have been designed by this architect; however, subsequently the Prince abandoned Palladianism for the chinoiserie that was so entertainingly represented by the House of Confucius. This was designed by Sir William Chambers and erected in 1750 and was one of the earliest chinoiserie buildings in Europe. The Prince's liking for this taste was also shown in the Chinese pavilion at Vauxhall Gardens, which was built in 1751.

Several of the Prince's household or political associates were devotees of the French taste, or knew France well, figures such as Lord Bolingbroke, who was married to

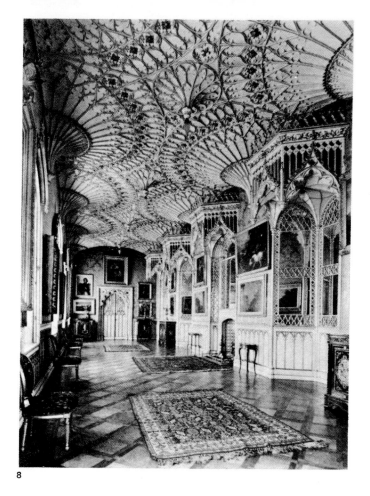

8

a Frenchwoman and had been a Jacobite, Lord Chesterfield, Lord Baltimore, who had visited Frederick the Great in the company of Algarotti, and Lord Lyttleton, a friend of Pope. The two last-mentioned acted as his treasurer and his secretary. Although Lord Chesterfield, that cynical man of the world, in one of his early essays in *Common Sense* (11 November, 1738), had shown himself to be critical of 'the absurd and ridiculous imitation of the French, which is now become the epidemical distemper of this kingdom', he was a true lover of French civilization. His mistress, Madame du Bouchot, was French and the mother of the ham-fisted recipient of his celebrated letters. The clue to his attitude lies in the advice that he gave to this young man when in Paris that he should endeavour to meet those people *'qui donnent le ton'*. 'Paris', were his words, 'is the place where, if you please, you may best unite the *utile* and the *dulce*.' This statement explains the reason why Paris had become the centre of taste in the eighteenth century; it was the city where the visitor armed with the proper credentials could mix in a society renowned for its elegance and intelligence and where the salons of Madame du Deffand and others were centres of wit and deportment. In Paris marvellous objects of art and porcelain were available to the discerning buyer, such as Horace Walpole.[13] Rome certainly offered an immense range of monuments and works of art for the young man on the Grand Tour, but socially this city was restricted, as Horace Walpole pointed out in a well-known letter to Richard West.

It was hardly surprising that when, in 1747, Chesterfield decided to build Chesterfield House—in one letter he headed his paper 'Hôtel Chesterfield'—he should have commissioned Isaac Ware to design it in the French style. In July 1748 he told his confidante, Madame de

Monconseil: *'J'ai accommodé la plûpart de mes chambres entièrement à la Françoise'*.[14] Shortly afterwards he wrote:

> *La boisure et le platfond sont d'un beau bleu, avec beaucoup de sculptures et de dorures; les tapisseries et les chaises sont d'un ouvrage à fleurs au petit-point, d'un dessein magnifique sur un fond blanc; par dessus la cheminée, qui est de Giallo di Sienna, force glaces, sculptures, dorures, et au milieu le portrait d'une très belle femme par la Rosalba.*[15]

Whether or no Ware was distressed at having to work in this style is not clear, and although he is generally considered to have been inimical to the Rococo, John Harris has pointed out[16] that one of the ceilings (Fig. 6) at Chesterfield House was included in his *Complete Body of Architecture*, 1756. Unfortunately it is not now possible to ascertain whether the additions made by Chesterfield to his house at Blackheath, the present-day Ranger's House, were Rococo in style, and the building as it now stands is Palladian, but it was typical of his francophilia that he christened it Babiole as a compliment to Madame de Monconseil and later spoke of it as *mon petit Chartreux*.

This Editorial is not the place to attempt any detailed account of those buildings which were decorated in the Rococo taste in England during the 1740s and 1750s. However, reference must be made to Woodcote Park, which has been carefully analyzed by John Harris.[17] His account of the house (the salon is now in the Boston Museum of Fine Arts) indicates that the design of the rooms was more Rococo than at Chesterfield House, whose rooms retained their Palladian shape, despite the Rococo decoration. It is not certain when the Rococo decorations were executed at Woodcote Park. The original house was pulled down in 1725 during the time of the fifth Lord Baltimore, who later became treasurer to Prince Frederick, and the rebuilding might have started during his ownership, or, which seems more likely, during that of the sixth Lord Baltimore. He was known as one of the most licentious men of his time, and was even charged with rape in 1763. Another friend of the Prince, Lord Lyttelton, was responsible for the Rococo decorations at Hagley, subsequent to his succeeding to the title in 1751.

The 1750s witnessed the high-water mark of the Rococo style in England. It is significant that in his introduction to *The Director* Chippendale alluded to three different forms of furniture—'in the *Gothic, Chinese* and *Modern* taste'. It is at this point that certain complications arise in any study of the Rococo, for, although chinoiserie and the Gothic intersect with this style, they were not tributaries of the Rococo; indeed, as Ralph Edwards points out, 'both were flowing strongly long before they poured into the main flood. The vogue for chinoiseries represents the latest and most intense expression of an old enthusiasm, a curiosity long since awakened in the art of a remote and mysterious land'. Since the publication of Hugh Honour's scintillating volume, *Chinoiserie. The Vision of Cathay*, 1961, it would be futile to attempt to describe in any detail the way in which, to quote this author, chinoiserie 'reached a height of popularity in England in the 1750s, which it attained at no other time in no other country'. It was a taste which is recalled by the Chinese room (Fig.

7) at Claydon, Buckinghamshire, dating from the 1760s, which is a masterpiece of robust native Rococo, and by the furniture of Chippendale and Linnell; however by no means all chinoiserie pieces are necessarily Rococo. Chinoiserie also not only reminds us of what England took from the Continent but recalls that the design of the Anglo-Chinese garden, which itself could possess Rococo elements, was influential in France and Italy, a theme which has been explored with great skill by Hugh Honour.

The rise of the Gothic taste is a familiar story, and not without its peculiarities; for instance, 'it was William Kent, the high priest of Palladianism who "evolved the flimsy decorative equivalent for Gothic which was to persist throughout the eighteenth century", and far beyond'.[18] When the Gothic revival of this age is seen in perspective, it is hard to resist Christopher Hussey's contention[19] that it was a native form of Rococo—and this argument is borne out by such interiors as those at Lacock Abbey, designed by the Warwickshire squire, Sanderson Miller, and at Strawberry Hill (Fig. 8), where Horace Walpole called on the services of Clermont. The pervasive character of this taste is brought home by the fact that, although Fielding, in *Tom Jones*, modelled Mr. Allworthy's house on Ralph Allen's Palladian Prior Park, he actually made it a Gothic mansion, perhaps on account of his friendship with Sanderson Miller.

The Régence-Rococo combination achieved much of note in England, but many problems remain to be solved. For instance, there is the position of Roubiliac and the question whether or not he can be classified as a Rococo artist. But there are various reasons which help to explain why the expression of this movement was limited. One was surely the premature death of Prince Frederick. But there were more profound ones than this event. It is here that the position of Hogarth is highly important. He owed much to French art; he advocated the serpentine principle in his famous *The Analysis of Beauty*; he employed a Rococo flicker in such paintings as *Wanstead Assembly*; but in the final analysis he remains a very national artist, owing his allegiance to a different philosophy from that of the Continental Rococo painter. His aim was analogous to that of Fielding, who declared in the preface to *Tom Jones*: 'I have endeavoured to laugh mankind out of their favourite follies and vices'. Fielding and Hogarth owed much to the tradition of the 'humours' as exemplified in the plays of Ben Jonson and in doing so they side-stepped the tradition of wit shown in the plays of Congreve and the whimsical linearism of the Rococo.

The Rococo reached this country at an important period in our history when many different ideas and theories were being formulated, when artists and craftsmen were intrigued by such a variety of possibilities, and when patrons enjoyed the means to follow their fancy. Thus it is not possible to restrict the study of its impact to the visual arts alone. Or rather, it is tempting to wonder if the explanations for its acceptance and then rejection are to be found in the main intellectual arguments that then circulated. It may be asked, for instance, if it was possible for the Rococo to flourish at a time when a belief in naturalness at all costs was held by so many of the most

influential figures. For instance, when Garrick went to Paris in 1764 and gave various private performances, on one occasion appearing with Mademoiselle Clairon, he was admired for the naturalness of his performance. Marmontel, who translated 'The Rape of the Lock' into French, wrote to the actor: 'If we had acted like you, our scenes would not be so diffuse; we should let their silence speak, and it would say more than our verse'. Then from the point of view of the history of art, significance can be attached to Hume's theory that naturalness was the opposite of Reason, and consequently, it may be argued, of the Cartesian doctrine which influenced so much French art.

English art would surely have been more richly tinged with the spirit of the Rococo if our painters had been as devoted to Venus as their French counterparts. This was not the case and there was no consistent tradition of painting the female nude in this country; no Boucher, for instance. The only real exception was Gainsborough, whose *Diana and Actaeon* in the Royal Collection has the grace of movement and elegance of colour that are so typical of the Rococo. This is not to suggest that Englishmen lacked enthusiasm for the opposite sex, for this was an age when the man of sensibility or the rake could find plenty of game either in Society or in the dubious bagnios of Leicester Fields. However, the harlots of Hogarth lack, we may feel, the elegance of the hetæræ of Paris. In addition, there were no English equivalents to Madame de Pompadour or Madame Du Barry, women with a sense of quality, to set the tone; we had our blue-stockings but there were few, if any, salons where the man of taste and fashion would have found the same *'esprit'* as in Paris.

One of the chief explanations for the failure of the Rococo to achieve a strong position in this country must lie in the very differences between France and England. The artists of the Régence and the Rococo had reacted against the absolutism of Louis XIV and Lebrun. But in this country there was no establishment in this sense, except that of Burlingtonian Palladianism, which demanded a sharp reaction. Thus the Rococo when it appeared in England was not inspired by the same sort of force which activated the French.

In any event, the English artist and man of letters had no reason to blush for their achievements. It was the English novel and philosophy that set the tone for much of the Continent; it was the liberalism of the Whigs which inspired hopes of a new régime in France. There was, in fact, no need for any lack of confidence on the part of the English at this time, and fortunately they were spared the self-denigration that is now only too popular.

The Rococo suffered from another disadvantage in this country. There were no two ways about it—the Rococo was a foreign style and thus there was every reason for the Anti-Gallican Association to combat it, even though, paradoxically, in 1758 Thomas Johnson was to dedicate his book of designs, which contains many in the Rococo taste, to Lord Blakeney, the President of this chauvinistic body. And France was the enemy. It was a situation which was dramatically summed up when at Drury Lane in November 1755 Garrick staged Noverre's ballet *Les Fêtes Chinoises,* for which Boquet did the elegant

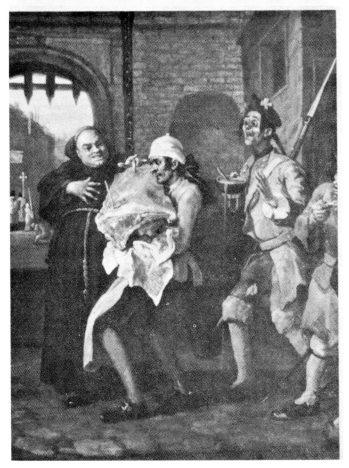

9. Detail of *The Roast Beef of Old England: Calais Gate* by William Hogarth (1697–1764), 1748. Oil on canvas, The Tate Gallery, London

costumes. Although the King and many of the nobility appreciated the piece, it did not appeal to the groundlings. What was to prove the last performance took place on 18 November. By three o'clock the house was packed; to while away three long hours the audience whistled and sang songs and called on the band to play national airs, *'surtout le roast beef'.*[20] It was the partisans of *Le Roast Beef* (immortalized by Hogarth in a celebrated picture—Fig. 9) who won; in the end the operation of national spirit ensured that the Rococo did not gain the ascendancy.

[1] *British Architects and Craftsmen* (1948 edition), pp. 109–10.
[2] cf. Wyllie Sypher, *Rococo to Cubism in Art and Literature*, 1960.
[3] Ralph Edwards, 'Baroque and Rococo', 18 August, 1945; Leader, 'Rococo to Romanticism', 23 March, 1946; Fiske Kimball, 'Art Terms', 8 June, 1946: Ralph Edwards, 'Hogarth's Baroque and Rococo', 27 January, 1956; and Reviewer and Peter Fleetwood-Hesketh, 'Hogarth's Baroque and Rococo', 3 February, 1956.
[4] Quoted by Bonamy Dobrée, *Restoration Comedy 1660–1720*, 1924, p. 48.
[5] 'English Painting and France in the Eighteenth Century', *Journal of the Warburg and Courtauld Institutes*, 1952, 15, pp. 122–36.
[6] cf. Edward Croft-Murray, 'Decorative Paintings for Lord Burlington and the Royal Academy,' in APOLLO, January 1969, LXXXIX, pp. 11–21.
[7] *Painting in XVIII Century Venice*, 1959, pp. 27–28.
[8] See F. J. B. Watson, 'Venetian Paintings at the Royal Academy, 1954–55,' in *Arte Veneta*, 1955, IX, pp. 253–64.
[9] Elizabeth Einberg in the introduction to the catalogue of *The French Taste in English Painting during the first half of the Eighteenth Century*, 1968.
[10] See 'The Soho Tapestry Makers', Appendix I to *Survey of London*, XXXIV, 1966, p. 516.
[11] These are illustrated in H. C. Marillier, *English Tapestries of the Eighteenth Century*, 1930, pl. 46.
[12] See John Harris, 'Exoticism at Kew', APOLLO, August 1963, LXXVIII, pp. 103–8.
[13] 'Walpole and the Taste for French Porcelain in Eighteenth Century England' in *Horace Walpole, Writer, Politician and Connoisseur*, ed. Warren Hunting Smith, 1967, pp. 184–94.
[14] *The Letters of Philip Dormer Stanhope Earl of Chesterfield*, ed. Lord Mahon, 1892, III, p. 294.
[15] *The Letters*, op. cit., p. 302.
[16] 'Clues to the "Frenchness of Woodcote Park"' in *The Connoisseur*, April 1961, pp. 241–50.
[17] *The Connoisseur*, ibid.
[18] Ralph Edwards in his preface to catalogue of Royal Academy Exhibition, *English Taste in the Eighteenth Century*, 1955/56, p. XV.
[19] *English Country Houses: Early Georgian 1715–1760*, 1955, p. 24.
[20] Quoted by Frank A. Hedgcock, *A Cosmopolitan Actor David Garrick and his French Friends*, n.d., pp. 133–34.

'The faire majestic paradise of Stowe'

It might prove an amusing and rewarding task to interpret English history in terms of its clubs, along the lines of the fascinating volumes on the eighteenth-century Members of the House of Commons which were inspired and edited by Sir Lewis Namier. The significance of groups of men linked by common interests and meeting in congenial circumstances is especially relevant during the eighteenth century, when the Beefsteak Club, the Kit-cat Club, the Society of Dilettanti and Brooks's played a memorable role in creating specific artistic, social and political conditions.

In many respects the way of life that emerged at Stowe during the eighteenth century can be best understood by recalling Kneller's famous Kit-cat Club portraits which now hang in the National Portrait Gallery. The club was largely organized by Jacob Tonson and used to meet at a London tavern famous for its mutton pies, known as 'kit-cats', and then at a house taken by this active publisher at Putney. Its members forgathered in the evening, according to David Piper, 'to discuss politics, literature or the news of the day over a bottle of wine'. They shared common interests: they were Whigs who favoured religious toleration, subscribed to the principles of the Revolution of 1688 and supported the Hanoverian Succession. Staunch patriots opposed to French aggression (the Pretender lived in France), they firmly believed in their right to guide the destinies of the country.

The fluidity of the social system in England in the early-eighteenth century is shown by a glance at the membership of the club. The majority were nobles (some of recent creation), but others were men of letters, painters and architects—Addison, Congreve, Steele, Sir Godfrey Kneller and Sir John Vanbrugh. Many were keen lovers of art and collectors, for instance the second Duke of Devonshire, Lord Somers and Lord Burlington. It was a club, in fact, that allied the worlds of wit and fashion, and its ethos helped to produce the cultivated society happily evoked by James Lees-Milne in his book, *The Earls of Creation* (1962).

One member was Sir Richard Temple, later first Viscount Cobham. This engaging and powerful character, who won the friendship of many of the leading men of his time, has not yet received the attention of a biographer. This is hardly surprising, for an account of Cobham and his circle requires the exploration of the vast archives from his family home, Stowe House, which are now in the

Huntington Library, San Marino, California. He richly deserves to be written about, for he enjoyed a long and rewarding life in which public service, both in the field and in politics, was combined with an appreciation of architecture and literature. He stands out as a pioneer in the art of the garden.

Born in 1675, he was the eldest son of Sir Richard Temple, the third baronet, who did much to restore the somewhat dilapidated family fortunes and built a charming house at Stowe which remains the core of the present building. The younger Temple was up at Christ's, Cambridge, in 1694 and may possibly have spent some time reading law at one of the Inns of Court. Possibly at this time he came across William Congreve (Fig. 3), for the dramatist was at the Middle Temple in the 1690s and he, Temple and a mutual friend, Delaval, would drink together in their youth 'six nights in seven'. Congreve became an intimate friend of Cobham and in his verse *Letter to Viscount Cobham* (1729) spoke of him as the 'Sincerest Critick of my Prose, or Rhime'. He bequeathed his old friend £20 in his will and Cobham invited William Kent to design an amusing monument in his memory which survives at Stowe (Fig. 10).

Temple was an ambitious man possessed of a strong sense of family pride which was shown in his dealings with his relations. He entered the House of Commons for Buckingham, his father's old seat, although he lost it at one election. He clearly had an adventurous nature and when very young may have seen service as a 'gentleman volunteer' in Flanders. He came into his own in 1702, when war broke out with France and William III appointed him Colonel of a Regiment of Foot, an event later commemorated at Stowe House (Fig. 12). He distinguished himself at the Siege of Venlo (1702) and, although not present at Blenheim, he took part in several of the major engagements of Marlborough's campaigns—Lille, Malplaquet, where his regiment suffered severe losses, and Bouchain. He ended up as a Lieutenant-General and was appointed to command a Regiment of Dragoons.

Mr. Secretary Craggs once said of Temple that he was a man who 'does not hate a difficulty'. He spoke his mind and held such strong political views that Swift noted that he was known as 'the greatest Whig in the Army'. This being so, it was hardly surprising that he was cashiered by the Tory Government in 1713. However, the accession

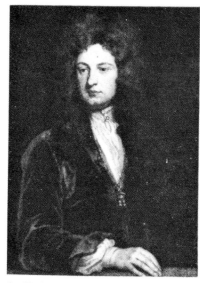

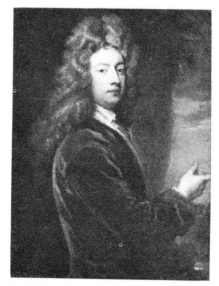

1. *Richard Temple, first Viscount Cobham* (1675–1749) by Sir Godfrey Kneller (1646–1723), *c.* 1710. Oil on canvas, 91·4×71·1 cm. National Portrait Gallery. The Kit-cat portrait

2. *Sir John Vanbrugh* (1664–1726) by Sir Godfrey Kneller, *c.* 1704–10. Oil on canvas, 91·4×71·1 cm. National Portrait Gallery. The Kit-cat portrait. Vanbrugh, a close friend of Lord Cobham, played a major role in the redesigning of Stowe House and gardens

3. *William Congreve* (1670–1729) by Sir Godfrey Kneller, 1703. Oil on canvas, 91·4×71·1 cm. National Portrait Gallery. The Kit-cat portrait. The dramatist and Lord Cobham met in their youth and cracked many a bottle of wine together

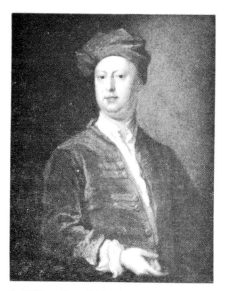

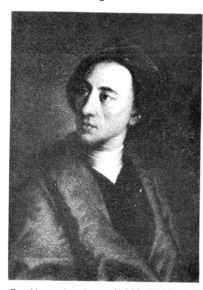

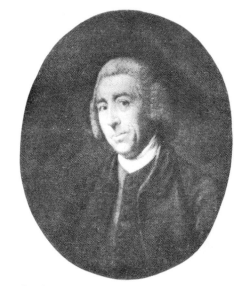

4. *William Kent* (1684–1748) by Bartholomew Dandridge (active 1711–51), *c.* 1750. Oil on canvas, 89×68·5 cm. National Portrait Gallery. Kent worked for Lord Cobham at Stowe, both inside the house and in the gardens

5. *Alexander Pope* (1688–1744) by William Hoare (1707–99), *c.* 1739. Pastel, 72·5×44·5 cm. National Portrait Gallery. Pope dedicated his first *Moral Essay* to Lord Cobham and was a frequent visitor to Stowe

6. *Lancelot Brown* (1715–83) by Sir Nathaniel Dance (1735–1811). Oil on canvas, 73·7×61 cm. National Portrait Gallery. 'Capability' Brown started his career at Stowe as head gardener and he later became clerk of the works

of George I (whose statue by John Nost stands outside the north front of Stowe House, Fig. 7) brought about an improvement in his fortunes. He was appointed Colonel of the Royal Dragoons, created Baron Cobham and sent as Ambassador Extraordinary to the Emperor Charles VI in Vienna with the mission of announcing the new King's accession.

He saw military service again in 1719 after England and France declared war on Spain. Lord Cobham (who had been given a viscounty in 1718) was appointed commander of a punitive expedition designed to land on the Spanish coast. He acquitted himself well, capturing Vigo, where he picked up a 'Japan chest, beautifully inlaid with mother-o'-pearl'. He sent General George Wade to Pontevedra, where the arsenal was burnt and eighty-six guns were spiked. The expedition was so successful that

the Spanish Government sued for peace before the year was out.

Many years later, in 1727, he was appointed to head the expeditionary force intended to be sent to Holland owing to the Austrian threat to attack the Dutch frontier towns by way of 'diverting the attention of the British Government from Gibraltar', then invested by the Spaniards. However, the expedition was cancelled when Spain made peace with England. This was the end of Cobham's active military career, although he held various commissions and was made a Field-Marshal in 1742. He was also Governor of Jersey, but never seems to have visited the island.

Memories of old campaigns fade away, and Cobham's main claim on modern attention lies in his achievement in enlarging his family home into 'the finest Seat in

England', as Lord Perceval called it in 1724. His fortunate marriage to Anne Halsey, the co-heiress of a wealthy brewer, gave him the means to carry out his ambition. It says much for Cobham's innate taste and organizational ability (apparent in his military career) that he employed capable architects to work at either enlarging the house or laying out the gardens. The lead was given by his old friend and fellow member of the Kit-cat club, Vanbrugh (Fig. 2); others who assisted him were James Gibbs, William Kent (Fig. 4), Henry Flitcroft and the Venetian Giacomo Leoni. Their contribution is summarized by Michael Gibbon in this issue.

Little documentary evidence is available about Cobham's relations with his architects and designers, but more may be discovered when the Stowe papers are investigated in depth. But there is no reason to believe he was visually inexperienced; indeed Vanbrugh, when writing to Lord Carlisle, a great friend of Cobham, about his proposals for Castle Howard, pointed out that Cobham agreed with his use of an indirect approach in architectural design because he had 'seen the very thing done to a great Palace in Germany'. His taste in literary matters was acknowledged by Congreve and Pope.

Cobham had inherited a picture collection, mainly of family portraits, with the estate and he seems to have found a few things abroad, such as four genre scenes by Cipper and possibly the painting by, or attributed to, Tintoretto which hung in the chapel. Most of the wall space in the main rooms was taken up by tapestries, and he owned a set of the famous series woven to commemorate Marlborough's campaigns.

He was more interested in painting when it came to the decoration of the house or the garden pavilions. He employed the Venetian Francesco Sleter on many jobs both inside and outside the house. This painter decorated the Temple of Venus with scenes from *The Faerie Queene* (an early instance of romantic history painting!); he also painted the outside of the Chinese Pavilion, which had within 'the Image of a Chinese Lady asleep'. This charming building, which now is said to stand in Co. Kildare, was located in the wider part of the Alder river and approached by means of a little Chinese bridge. Its existence at Stowe reveals that the bluff and extrovert soldier was not averse to flights of Rococo fancy.

The delightful conversation painter Francis Nollekens, father of the celebrated sculptor Joseph Nollekens, who made a bust of Frederick Prince of Wales (once at Stowe), also worked for Cobham, painting the interiors of the lake pavilions with scenes from Guarini's *Pastor Fidor*. Local talent was also called upon and the inside of the Witch House, which dates from the 1720s, was painted by one of Cobham's servants. Thomas Ferrand, with 'odd representations of witches' taken from engravings by 'the famous Gillot, call'd his Dreams'.

Lord Cobham naturally required sculpture for the gardens and some of the leading men of the day were pressed into service: John Nost, J. M. Rysbrack and Peter Gaspar Scheemakers. The last-mentioned also made a lively bust of his patron (Fig. 13), now in the Victoria and Albert Museum. It is interesting to compare this with the early Kit-cat portrait by Kneller (Fig. 1) and the shrewdly observed portrait of the experienced soldier

and man of the world done by the French artist Van Loo (Fig. 9). This hangs at Hagley, the former home of his close friend and nephew George Lyttelton.

Stowe House and its gardens present a variety of visual experiences. They do not constitute a complex done for one man at one period; rather they reflect the changing and evolving tastes of several personalities over almost a century and, as such, their importance for the history of architecture and, above all, for the art of the garden is considerable. One impulse radiates the whole, however: the desire of the owners and of the men who worked for them to create what the poet James Thomson termed a 'faire majestic paradise'.

In the first instance, the gardens were given an individual stamp (though formality remained the chief note) by the collaboration of Lord Cobham with Vanbrugh and Charles Bridgeman, later principal gardener to George II. Their efforts were to some extent assisted by the 'Genius of the Place' which, as George Clarke observes in his article, necessitated the working out of novel solutions, thereby providing an example of the way in which the accidental can assist in the creation of a work of art. Mr. Clarke's two articles in this issue, as well as others in *The Stoic* (the house magazine of Stowe School) and *Country Life,* and the writings of the late Christopher Hussey (to which all enthusiasts of English civilization are indebted), Michael Gibbon and Laurence Whistler have helped to clear up many of the problems necessarily attendant upon the history of gardens as extensive and as complex in design as those at Stowe.

Many minds were directed to their arrangement. Besides the professional designers, there were men such as 'Capability' Brown (Fig. 6), who started as head gardener and then became clerk of the works, before going on to an independent career, Alexander Pope (Fig. 5), one of the great favourers of this art form, and William Pitt (Fig. 14), who visited Stowe when young. The Great Commoner discovered in garden design the solace from political cares that Mr. Edward Heath finds in music. Yet in the end the final responsibility for the gardens must have rested with Lord Cobham. His activity was akin to an impresario's, and as George Clarke says, 'It is not fanciful to suggest that by the mid-1740s he was the most experienced gardener in the Kingdom'.

The originality of the gardens is beyond dispute and the Grecian Temple of *c.* 1748 is one of the earliest examples of neo-classical architecture in England. This Roman-type building of Greek intention is partly derived from the Maison Carrée at Nîmes. Mr. Gibbon feels that it was put up not by Cobham but by his nephew, Richard Grenville, the future master of Stowe and a founder member of the Society of Dilettanti. This opinion is shared by Dr. Michael McCarthy in the April 1973 issue of the *Burlington Magazine.*

Stowe's gardens have a magical quality, with their surprises, vistas that recall Claude's Arcadia and associative qualities of all sorts. The setting evokes a way of life, as Austin Dobson pointed out in a charming and informative essay published in *At Prior's Park and other papers* (1914). In the eighteenth century, Horace Walpole, no friend to Cobham and his clan, had succumbed to the appeal of the place, as he acknowledged in a bravura

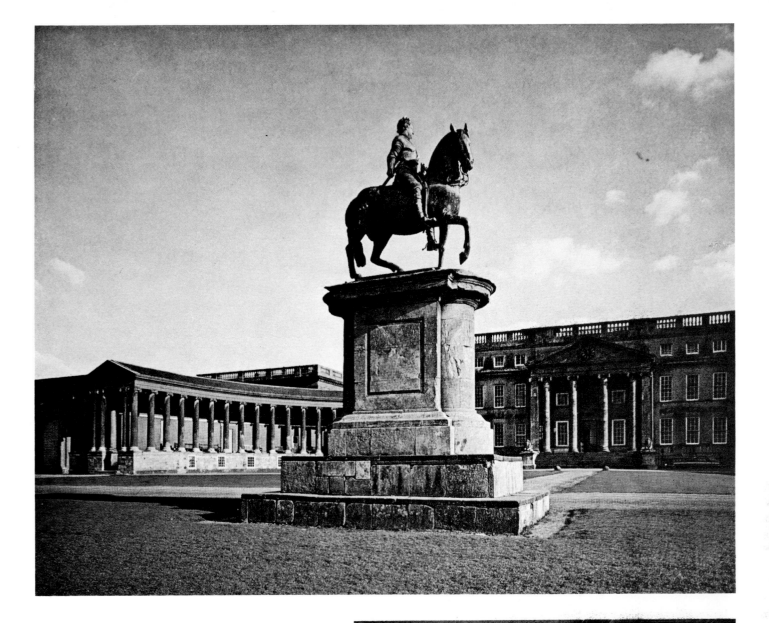

7. The north front of Stowe House. The statue of George I is by John Nost the elder (1686–1729)

8. The south front of Stowe House
From colour photographs by John Bethell

letter of July 1770 to his crony George Montagu. The scene enchanted Pope naturally, and in 1739 he described the comfortable days spent by a house party there to Martha Blount:

All the mornings we breakfast and dispute; after dinner, and at night, music and harmony; in the garden, fishing; no politics and no cards, not much reading. This agrees exactly with me; for the want of cards sends us early to bed.

Pope, always a welcome guest in the houses of grandees on account of his wit, social gifts and political dexterity, used the example of Stowe as an illustration of a perfect garden in his celebrated *Epistle to Lord Burlington* (1731).

Yet by mid-century Stowe was more than a retreat for men of letters. It had become a centre of intense political activity, so that we can imagine couriers and post-chaises arriving with letters, newspapers (of which

21

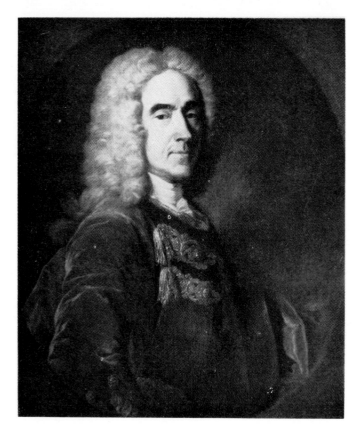

9. *Lord Cobham* by Jean-Baptiste van Loo (1684–1745), *c.* 1740. Oil on canvas, 75·6×62·9 cm. Lord Cobham, Hagley Hall, Stourbridge

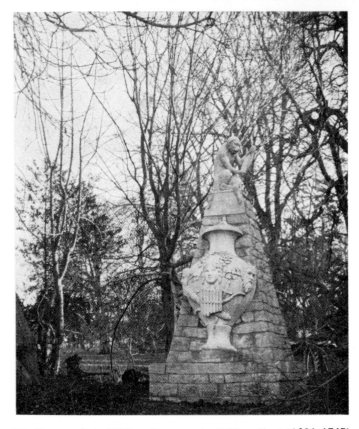

10. *Monument to William Congreve* by William Kent (1684–1745), 1736. Stowe gardens

there were plenty) and guests. During the next fifty years or so Stowe was to be the scene for much political plotting. The target of Cobham's hostility was Sir Robert Walpole. This statesman made a great contribution to national life, but, with time, power made him increasingly over-bearing and to quote his biographer, Professor J. H. Plumb,

> Not only was his power resented; and his royal favour loathed; his whole manner of life bred detestation wherever he went. He paraded his wealth with ever greater ostentation . . . And he gloried in his power, spoke roughly if not ungenerously of others, and let the whole world know he was master.

Cobham began to grow increasingly impatient of Walpole's policies and, like other Whigs, felt he had encouraged corruption, supported Hanover to the detriment of the national interest and paid insufficient attention to French and Spanish interference with British trade. He took particular exception to the Government's support of the directors of the South Sea Company.

The break came over Walpole's introduction of the Excise Bill of 1733. This was an extension of the scheme by which duties were paid on goods only when taken out of bond and Walpole calculated that, by including wine and tobacco, its enactment would enlarge the revenue by some £200,000-£300,000 on tobacco alone. Basil Williams points out in *The Whig Supremacy 1714-1760* (1939):

> It was put about that the new scheme was only the beginning of a plot to impose an excise tax on every article of consumption by means of an army of excise men scouring the country-side and prying into every shop, nay every home; even the land-owners who were to profit by the scheme, looked askance at the project as they preferred the existing small rate on their under-valued lands to unknown evils.

Besides Cobham, the opponents of the Bill included Lords Bathurst, Burlington and Chesterfield, sophisticated men of taste.

Mr. Lewis M. Wiggin in his valuable *The Faction of Cousins* (1958) has observed that at the start Cobham was not experienced in political opposition. He learnt fast. The buttons were off the foils between him and Walpole, for the latter had taken revenge on him by depriving him of command of his regiment, an unheard of procedure in those days when a regiment was considered as its colonel's private property.

What now emerged was a secessionist party within the Whigs which derived support from Cobham's Grenville and West nephews, and his many friends and connexions, including George Lord Lyttelton. Lyttelton was a delightful if dull fellow. He was a secretary to Frederick Prince of Wales and held office at one point as Chancellor of the Exchequer. A minor poet and historian, he won a place in Dr. Johnson's *Lives of the Poets* and his charming personality partly served Fielding for 'Mr. Allworthy'.

One card played by Cobham and his friends was support for the Prince of Wales, who was at logger-heads with his parents. The Prince with his love of music and the arts was just the man to fit into the Stowe world and he paid several visits there. From the point of view of Cobham and his friends, it was obviously good politics to be on the side of the heir apparent. Thus the Patriots, as they were termed, supported the Prince's pleas for a larger allowance. William Pitt joined in the fray and lost his cornetcy as a result.

If it is a touch naive to be too idealistic about the eighteenth century when jobbery was rife, there is no

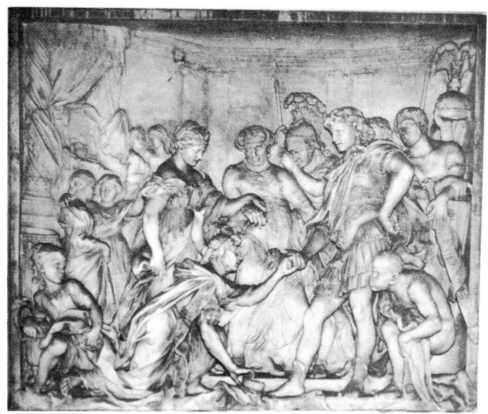

11. *The Family of Darius before Alexander* by Christophe Veyrier (1637–89), *c.* 1680–82. Marble, 1·13×1·37 m. Stowe House

12. *Lord Cobham* (*when Sir Richard Temple*) *receiving a sword from Mars* by Kent, *c.* 1731. Monochrome on a gold mosaic ground. Stowe House. This commemorates Temple's appointment to the command of a Regiment of Foot, 1702

denying that Lord Cobham believed firmly in principle; in the 1740s he resigned his commission on the issue that troops were being employed in defence of Hanover. In 1744 he joined Pelham's coalition administration only after receiving an express undertaking from the Duke of Newcastle that national interests should predominate over Hanover's.

One of the most fascinating and unusual aspects of the gardens at Stowe is their reflection of some of Cobham's political views, as George Clarke explains in an analysis of the true meaning of the Temple of British Worthies, the Temple of Ancient Virtue and the Gothic Temple. Although Mr. Lewis M. Wiggin is a shade sceptical about Stowe's reflection of Whiggism, Mr. Clarke's account of the iconography of these buildings is convincing. They

have not lost their pertinence at a time, like the present, when many national traditions are under sharp attack. And it is entertaining to speculate about who would now be included in the Temple of British Worthies. In presenting his views in this form Cobham showed how much he deserved the words with which Pope concluded his *Epistle to Lord Cobham*:

> And you, brave Cobham, to the latest breath
> Shall feel your ruling passion strong in death:
> Such in those moments as in all the past
> 'Oh save my country!', heav'n shall be your last.

Pope's spirit hovers over Stowe. His polished and easy couplets not only evoke the charm and significance of the gardens but remind us—such is the sense of sting that lurks behind their elegance—of his satirical power, his

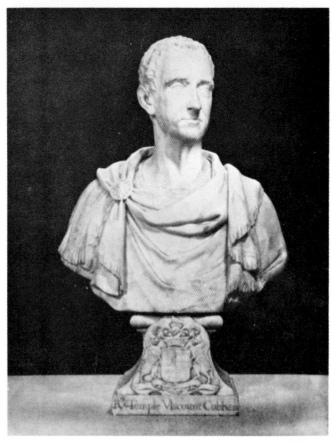

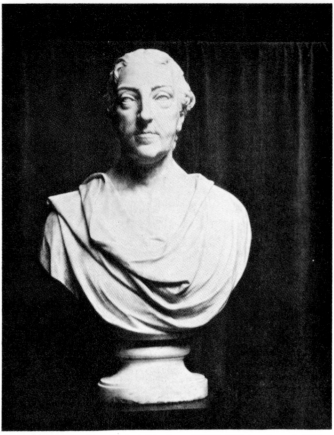

13. *Viscount Cobham* by Peter Gaspar Scheemakers (1691–1781), *c.* 1740. Marble, height with socle 84·5 cm. Victoria and Albert Museum. Formerly in the Temple of Friendship at Stowe

14. *William Pitt, first Earl of Chatham* (1708–78) by Joseph Wilton (1722–1803), 1759. Marble, height 76·2 cm. National Portrait Gallery of Scotland, Edinburgh. Pitt was Earl Temple's brother-in-law

ability to scourge follies and foibles and to score points off his enemies. A walk round the gardens should make us return home and take down his poems; it will make us regret that no modern successor is available to lash the absurdities of our own age and the place-seekers, sycophants and double-talkers who too often parade as cultural leaders.

When Lord Cobham was granted his viscounty in 1718, he had been given a special remainder whereby, if he were to die childless, his honours were to pass to his sister, Hester, Mrs. Grenville, and her heirs male. Cobham died in 1749 and was survived by his wife; she remains a somewhat shadowy figure but, although some found her *'maussade . . . gronde . . . absurde'*, according to Mr. Wiggin 'she was the best of souls and the kindliest of hostesses . . .' Mrs. Grenville became Viscountess Cobham in her own right. Her eldest son, Richard, was quick off the mark in demanding for her an elevation in the peerage, and this was granted to her with the title of Temple. She died in 1752 and her son succeeded to the title; he had been running the estate meanwhile.

Richard, who was born in 1711 and whose father died young, had been brought up by his uncle and aunt at Stowe and groomed for the great position he was destined to hold in the world. He spent four years on the Grand Tour and became fluent in French and knew some German and Italian. Richard acquired such typical Italian views as those by Canaletto, Joli, Orrizonte and Panini that once graced the walls of Stowe and when in Venice sat to Rosalba Carriera.

Temple has received something of a mixed press. He was energetic and humorous and could arouse affection. He was deeply attached to his wife, Anna Chamber, an heiress, and what began as a marriage of convenience turned into one of love. He had many good sides; Wraxall, an experienced man of the world, found 'his conversation animated, brilliant and full of entertainment'. But he was vain and proud, as may be seen from Allan Ramsay's portrait, and he had a strong streak of caprice in his nature. In later years, his peppery character may well have been exacerbated by pain, for 'Squire Gawkey', as he was called, was almost bent double and was forced to hobble along on a crutch. Perhaps he was a martyr to arthritis or suffered from a slipped disc.

Immediately on the death of his uncle, Temple became the nominal head and actual paymaster of the Cobham squadron, henceforth more discreetly known as the Grenville Connection. George II detested him, telling Lord Waldegrave that Temple was 'so disagreeable a Fellow, that there was no bearing him'. However, the King was forced to swallow his dislike and accept Temple as a minister when, with the outbreak of the Seven Years War in 1756 and the loss of Minorca, William Pitt took office. Pitt rightly placed a good deal of reliance on Temple, his brother-in-law: he was an able administrator, holding the office of Privy Seal, and when Pitt was prostrate with gout, as was often the case, Temple directed affairs. He and Pitt gave General Wolfe command of the British army in Canada and, after his death, Temple erected a monument to the memory of this

unusual soldier in the gardens at Stowe which survives.

Temple had nothing of a trimmer in his nature. When Pitt's ministry was replaced by one headed by Lord Bute, he would have nothing to do with it and fell out with his gifted brother, George Grenville, when the last-mentioned joined Bute. He quarrelled with him as he did with Pitt when the Great Commoner accepted a peerage as Earl of Chatham. This is not to say that Temple had failed to show kindness to Pitt; he helped him financially and made up with him at a later date. Yet with a wilful capriciousness he refused to cooperate with him in 1766 when Pitt had the chance of forming a new administration. He made matters worse and revealed his spleen 'in a bitter pamphlet compiled by two docile hacks' which was written against his old friend and colleague. Happily, they were reconciled in 1769 and it is appropriate that Copley included his portrait in his famous *The Collapse of the Earl of Chatham* in the Tate Gallery (Fig. 15).

Despite his faults, Temple is on the side of the angels. He believed in principle (admitting that he could afford to do so); he spoke out for freedom of the Press in the House of Lords; and he supported John Wilkes in his battle against the Establishment. Wilkes, it should be remembered, was a local man who represented a Buckinghamshire constituency and became High Sheriff of the county in 1754. Together with Temple and Pitt, he organized the local militia.

When Wilkes was arrested for the publication of an alleged seditious libel on George III in the *North Briton* in 1762, Temple rallied to his defence, entering a plea of habeas corpus on his behalf. It was due to Temple and to him alone, observed Almon in his edition of Wilkes's correspondence (1805), 'that the nation owes the condemnation of general warrants and the arbitrary seizure of persons and papers'. His involvement in this affair earned his dismissal from the post of Lord Lieutenant of Buckinghamshire; his brother, George, by the way, was a member of the Government. However, Temple was no firebrand and he counselled Wilkes to withdraw an inflammatory piece against the King in his paper. All in all, Temple was a true upholder of the Whig ideal and his determination to stand up for his beliefs echoes down the centuries.

He followed in his uncle's footsteps by spending much time and money on the beautification of Stowe House and the gardens. He probably felt that he knew much more than his uncle would have claimed to have done about architecture and gardens; and he mixed in a circle which included such skilful amateurs as Sanderson Miller, his cousin Thomas Pitt, Lord Camelford, and his fellow members of the Society of Dilettanti. But a difference in the nature of his patronage may be noticed. Whereas Lord Cobham had mainly employed English architects (Leoni being an exception), Lord Temple mainly went in for foreigners whom he could demonstrably patronize: two Italians, Borra and Valdrè, and the Frenchman G. B. Blondel, whose role at Stowe was first illuminated by John Harris.

Temple was as capricious a patron of art as he was a politician. Things did not work out well between him and Blondel, for he rejected this architect's design for the south front of the house and the Frenchman was com-

15. *The Collapse of the Earl of Chatham* (detail) by John Singleton Copley (1737–1815), *c.* 1779/80. Earl Temple is shown leaning over Lord Chatham. Tate Gallery

pelled to solicit the intervention of Sir William Chambers to secure the settlement of his outstanding account. He complained of the unpleasantness of working for a man *'qui me paye que d'ingratitude'*. Some coldness may have arisen between Temple and Robert Adam when the latter was asked to design a façade for the south front in 1771. Although his drawing was the basis for the south front, Temple was not content to leave it alone and seems to have collaborated in establishing the final design with his cousin Thomas Pitt, Lord Camelford, an amateur architect of taste and competence.

Life at Stowe during the 1770s can hardly have been comfortable with so many alterations going on. However, Temple had the satisfaction of sitting out under his new south portico. There must have been much to brood on: his political dogfights and his quarrels with his brother and Pitt. His last years were saddened by the death of his beloved wife. His state of mind was revealed when he told his nephew and heir, George Grenville (1753-1813), and his charming Irish wife, Mary Nugent, when they offered to come and look after him, that it would not be fair to expect young people to put up with him.

Desmond Fitz-Gerald has suggested that George Grenville almost certainly introduced his uncle to Valdrè and engaged him to work at Stowe, where he decorated the music-room charmingly in the Pompeian taste. Grenville was one of those young men who were fired by enthusiasm when they saw Pompeii, which he did on his Grand Tour of 1774. During his stay in Italy, he bought some of the antiquities once at Stowe, among them a bust of Nero, a

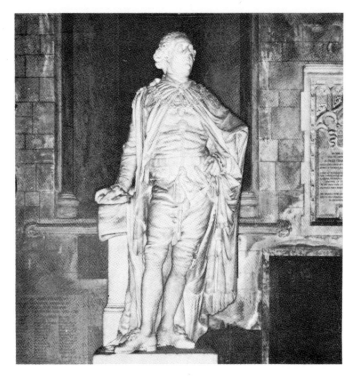

16. *George Grenville, first Marquess of Buckingham* (1753–1813) by Edward Smyth (1749–1812), 1783. St. Patrick's Cathedral, Dublin. This is not a funerary monument. Buckingham, who was Viceroy of Ireland, is shown as Grand Master of the Order of St. Patrick, which he instituted

17. *St. Thomas touching Christ's Wound,* Maiolica, Deruta, early sixteenth century. Yellow lustre, diameter 43·2 cm. Courtauld Institute Galleries. Acquired by Thomas Gambier-Parry at the Stowe Sale, 1848

sarcophagus found on the road to Tivoli and a statue of Paris holding the Apple of Discord. He acquired this work from Gavin Hamilton, who had excavated it near the ruins of the ancient Lanuvium between Albano and Velettri in 1771. While in Rome, Pope Clement XIV had a portrait painted of himself specially for presentation to the young milord. According to a titbit reported by Joseph Farington (1804), Grenville was in Italy with Lord Bulkeley and when he returned to Stowe 'just before supper' he gave Lord Thomond the impression of being for a young man 'remarkably stiff & dry'. This fragment of gossip recorded that 'He was at that [time] full of admiration of the Princess of Stolborgh, wife of the Pretender'.

In Rome Grenville commissioned from Thomas Banks a marble alto relievo, *Caractacus pleading before the Emperor Claudius in Rome,* exhibited at the Royal Academy in 1780 (Fig. 18). The sculpture remains at Stowe. Poor Banks had considerable difficulty in securing payment for his work. However, Grenville was not a notable patron of modern art, although both he and his wife sat to various portrait-painters. He made efforts to expand the collection of Old Masters, buying partly with the help of Reynolds, and his trophies include works by Rembrandt, Rubens and Teniers. He was also keen on books and manuscripts and commissioned Sir John Soane to design a Gothic Library which remains one of the most individual features of the house. His final addition to Stowe was the 'winter entrance for the house' under the steps of the north-front portico which was done up in Egyptian taste and modelled on the 'small temple of Tintyra' reproduced in Baron Vivant-Denon's celebrated volume on Egypt.

Just as did other members of the family, Grenville, who was stout and stuttered, played a considerable role in political life. In 1782-83, during Lord Shelburne's ministry, he served as Viceroy of Ireland, but his efforts to secure an improvement in Anglo-Irish relations came at an unfortunate period, for his chief was too occupied with the conclusion of the American war to pay attention to them. During this period in Ireland he founded the Order of St. Patrick, of which he was the first Grand Prior, as he is so designated on the statue of him by Edward Smyth (Fig. 16) in St. Patrick's Cathedral, Dublin, which was commissioned by Lord Tyrawley.

On his return to London Grenville was soon involved in political intrigue and took a leading part in the manoeuvres which helped William Pitt the Younger to defeat the Fox-North coalition. He was also active in killing the India Bill in the House of Lords. Pitt invited him to become Secretary of State in the House of Lords. However, with characteristic petulance, after having accepted, he changed his mind and resigned within two days, probably, it was believed at the time, out of pique at not being given a dukedom. However, he was created a marquess.

In 1787 he undertook a second term of duty as Viceroy in Dublin, where he had to face considerable difficulties, as Irish opinion was strongly against England. It was an indication of the complexities of the situation that in 1789 he refused to transmit the address of the Irish Parliament to the Prince of Wales during a period in which George III was off his head and when no Regency had been declared. When a national revolution broke out in Ireland in 1798, he returned at the head of a militia regiment. He seems to have made a nuisance of himself and adopted an extremely hard line, complaining to his brother, Lord Grenville, Foreign Secretary, about General Cornwallis's leniency.

On his death in 1813, he was succeeded by his son, later first Duke of Buckingham and Chandos, who brought many works of art to Stowe through his marriage to Anna Eliza Brydges, daughter of the last Duke of Chandos.

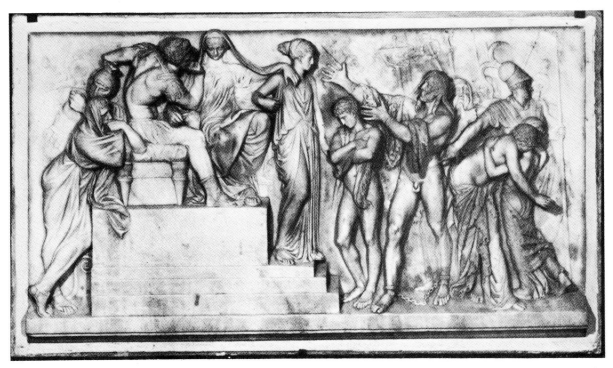

18. *Caractacus pleading before the Emperor Claudius in Rome* by Thomas Banks (1735–1805), 1777. Marble, 91·5×192·4 cm. Stowe House. Commissioned by the Marquess of Buckingham and exhibited at the Royal Academy, 1780. Buckingham refused to pay more than half the 200 gns. asked for this modern work

Although mainly interested in 'Natural Science', as was shown by the museum once at Stowe, he was a discerning collector, as Colin Anson emphasizes, acquiring pictures by Albani, Cuyp, Domenichino, Francia, Poussin, Rosa and Rembrandt and an important group of prints which were dispersed in a thirty-day sale in 1834.

However, all was not well at Stowe. Already in 1804, under the Marquess of Buckingham, Farington reported that, although the Marquess's income was large, it took from a year and a half to two years for accounts to be settled. It was the worsening of this financial situation that obliged the first Duke to leave Stowe. He did so in some style, taking a yacht the 'Anna Eliza' on a three-year cruise (1827-29) in the Mediterranean. During his time abroad he acquired many geological specimens and classical antiquities. He also paid for excavations in Rome in 1828, near the tomb of Cecilia Metella. One of his prize possessions was a marble sarcophagus which was bought by Lord Lonsdale at the Stowe Sale of 1848 and had stood in the gardens. In it 'were deposited the remains of the late Duke's favourite dog'. Buckingham had bought Harlequin, a red-nosed pug, in Bologna, where he 'was a chief actor in a travelling showman's company'.

It was an indication of the Duke's keenness on classical art as on geology that he commissioned John Martin to paint *The Destruction of Pompeii*, a picture which met its fate when the Thames flooded the basement of the Tate Gallery. Buckingham was also attracted by Italian maiolica and purchased an extensive collection in Florence, of which many pieces came from the Colonnas. At the 1848 sale several were bought by the discerning collector Thomas Gambier-Parry, one of which is illustrated here (Fig. 17).

The Duke adhered to family tradition by going into politics and he served as joint Paymaster-General and deputy-President of the Board of Trade in 1806-7. During the Hundred Days, he took a militia regiment across the Channel and served under Wellington.

The great days of Stowe were nearing an end and in 1848 financial hardships necessitated a large sale at Stowe, of which some account is contained in this issue. This took place in the time of Richard, second Duke of Buckingham (1797-1861), who, when a young man in Rome in 1817, conducted excavations and was clearly keen on classical antiquities. He visited Lucien Bonaparte, who presented him with some Etruscan vases (called Greek in the 1848 sale catalogue) and later on bought a Greek bronze of Mars. He was in Parliament from 1819 until his succession to the dukedom in 1839 and took part in the debate on the Reform Bill, introducing into this the tenant-at-will clause. He spent much of his time writing historical books. The family still retained Stowe House, which was let in 1892 to the comte de Paris, pretender to the French throne; photographs of the interior taken before the final sale in 1921 show that it was not as sparsely furnished as might be thought. The third Duke (1823-89), a true Victorian, carried on the family tradition of public service and spent five years (1875-80) as Governor of Madras.

Nearly all the treasures that once graced this grand house have gone, but the building and gardens remain as a monument to the taste and enterprise of Lord Cobham and his successors. No other country place of the period evokes the spiritual and intellectual aspirations of the Whigs so well as does Stowe. Some may even feel that a message for our own time is presented by the Temple of British Worthies. Above the bust of John Locke in this building may be read these stirring words:

Who, best of all Philosophers,
understood the powers of the human mind:
the nature, end, and bounds of civil government;
and with equal courage and sagacity, refused
the slavish systems of usurped authority
over the rights, the consciences, or the reason of mankind.

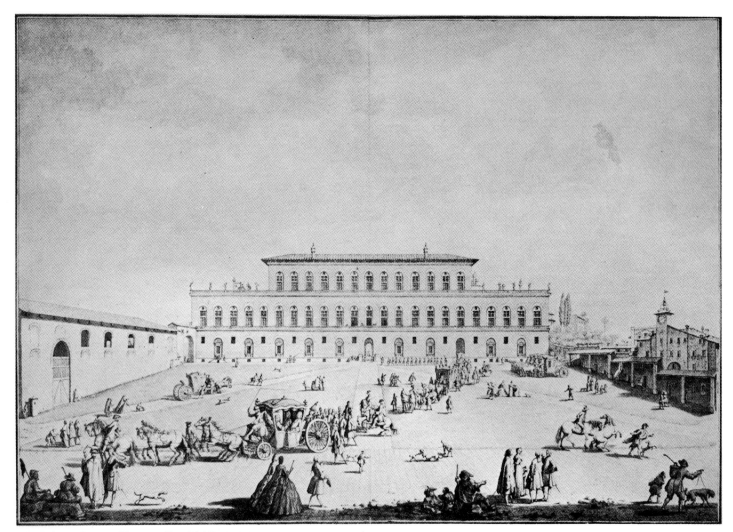

1. *Palazzo Pitti* by Giuseppe Zocchi (1711–67) *c.* 1744. Pen and black ink and grey wash, 46·4 × 67 cm. Pierpont Morgan Library, New York. Henry Wotton found it 'the most magnificent and regular pile within the Christian world'. The palace was built under the direction of the architect Luca Fancelli. The annexes to the front wings were added in *c.* 1765

Except for Figures 1 and 20–24, the works illustrating this article were in the exhibition 'The Twilight of the Medici' at Palazzo Pitti, Florence, and at the Detroit Institute of Arts, 1974

The Final Flowering of the Medici

Few who came across Vernon Lee when she was living with her parents at No. 12 Via Solferino, Florence, in the 1870s would have realized that she was engaged on research that helped to bring about a new and indeed revolutionary interest in an almost forgotten period in Italian history—that of the eighteenth century. Her book on the subject, which came out in 1880, was something of a *tour de force*; one of its chief merits was to make better known eighteenth-century Italian music, which had won admirers in England in its own time, but since then had been neglected.

She was a pioneer, for hers was the period of Bode and Berenson. Yet her liking for the eighteenth century did not exclude appreciation of the then fashionable Renaissance and—an amusing gobbet of information to be fitted into the glittering mosaic of Anglo-Florentine cultural relations—she gave in 1892 a lecture on Italian Renaissance sculpture, as part of a series held in the Palazzo Ginori, only a stone's throw from San Lorenzo.

Admiration for Settecento Italy grew during her lifetime and even such a hardened supporter of the Renais-

2. *Grand Duke Cosimo III de' Medici* by Giovanni Battista Foggini (1652–1725), *c.* 1685. Marble, height 80 cm. Donaueschingen, Fürstlich Fürstenbergisches Schloss. Cosimo III (1642–1743) was the father of Grand Prince Ferdinando, Gian Gastone, the last Grand Duke, and Anna Maria Luisa, Electress Palatine. He did much to foster sculpture

3. *Grand Prince Ferdinando de' Medici* by Giovacchino Fortini (1673–1736), *c.* 1700. Marble, height 1·9 m. The Lady Lever Art Gallery, Port Sunlight. Ferdinando (1663–1713) had a highly individual taste with a special love of Venetian painting, oil sketches and *modelli* for sculpture

sance as J. A. Symonds appreciated Tiepolo. A sign of this trend was that Arthur Acton, a keen connoisseur of the Primitives, did not hesitate to acquire splendid examples of eighteenth-century Italian furniture and decorative painting for his villa, La Pietra, Florence, and notable seventeenth- and eighteenth-century sculpture from the Veneto for the gardens which he started to lay out in 1904.

How appropriate that his son, Sir Harold Acton, should be the author of a volume on the last Medici (1932), as well as one on Tuscan Villas (1974), and that in the year of his seventieth birthday an important and intriguing exhibition, 'The Twilight of the Medici', is being held at the Palazzo Pitti. It marks a date in studies of the period and its organizers—Frederick J. Cummings, Director of the Detroit Institute of Arts (where it was first shown) and Marco Chiarini, Director of the Palazzo Pitti—deserve congratulations on their efforts: so do the scholars responsible for the erudite catalogue, of which there exists both an English and an Italian edition.

Their aim is not to present the political and social life of the period but its art; and, understandably, emphasis is placed on the patronage exercised by the Medici. The moralist might be tempted to argue that the decline of the House of Medici—the result of disastrous marriages—was paralleled by some kind of artistic collapse. But this was by no means the case, and, although the artistic achievement in Florence of the years 1670–1743 is not comparable to that of the Renaissance (no major architects or painters were active), it was more considerable and varied than was long believed and the sculpture was excellent.

The appeal of the exhibition is heightened by its being held in the Palazzo Pitti with its menacing façade (Fig. 1); this must have reminded Dostoevsky, who lived at No. 22 Piazza di Pitti in 1868–69 when writing *The Idiot*, of the authoritarian atmosphere of his homeland. The Pitti is rich in memories of the last Grand Dukes, with their intrigues and dramas; those who treasure their Acton will recall his vivid sketches of life there and his portrayal of the final Medici ruler, Gian Gastone, heavy with drink and

obesity, immured in his apartment—a pitiful end for a youth who had seemed full of promise, to no less a person than Leibniz.

Nor will they easily forget Anna Maria Luisa de' Medici, the widowed Electress Palatine (the story of her jewels is recounted elsewhere in this issue of APOLLO), spending her last sad days in the Palace, 'redeemed from despair by a deep inward faith which removed her from the existing order, and farther from the spirit of the age'. This *grande dame* with her parchment face and passion for charity bequeathed the magnificent collections of the Medici to the new Grand Duke and his successors—a fitting gesture from the last of a dynasty that had done much for the arts and helped to make the name Florence synonymous with Humanism.

By a happy coincidence the exhibition is taking place at a time when interest is growing not only in this period of Florentine art, but in its history. Much germane to the study of baroque Florence is to be found in Eric Cochrane's enjoyable *Florence in the Forgotten Centuries 1527–1800* (University of Chicago Press, 1973, $12·50, or £5·65), which is studded with out-of-the-way information and skilfully blends political and intellectual history.

Professor Cochrane is a follower of Sainte-Beuve and Sir Lewis Namier; he believes that the key to the complex changes in the mood and outlook of society may be found in a study of those individuals who break new ground and his penetrating analysis of men such as Galileo, Lorenzo Magalotti, Giovanni Lami and Francesco Maria Gianni makes Florence of these shadowy years more comprehensible than hitherto.

How fascinating it is to find his tracing the founding of modern Etruscology back to the treatise written by Thomas Dempster, a Scottish Catholic 'made for war and contention', who taught at Pisa in Galileo's day. Dempster's manuscript was later given by Anton Maria Salvini to Thomas Coke, later first Earl of Leicester, who often crosses the path of the student of the eighteenth century, and not the least of Coke's claims to remembrance is that he provided a subsidy for its publication by the distin-

4. *Allegorical Fantasy* by Niccolò Lapi (1661–1732). Oil on canvas, 1·16 × 1·78 m. Collection M. Guidi, Florence. Its pendant is also on view. Both are satires on female guile

5. *Harlequin and Glutton* by Giovanni Domenico Ferretti (1692–1768), *c.* 1740. Oil on canvas, 97×127 cm. The John and Mable Ringling Museum of Art, Sarasota. Opera and theatre flourished in eighteenth-century Florence

guished and learned antiquarian Filippo Buonarotti.

Professor Cochrane is enlightening on cultural matters and his interpretation of the effects of the Galilean revolution on the visual arts illuminates a relatively obscure subject; he points out that the delight in new techniques, disregard for 'authority' and dedication to 'nature' observable in Carlo Dolci, Lorenzo Lippi and Pietro Tacca—to take three different artists—were due to this movement. The last-named kept a wild boar in a cage while working on his celebrated bronze *Porcellino*, which was set up in the Mercato Nuovo in 1640!

Any exhibition which ranges from one specific date in history to another inevitably offers only an arbitrary view of the artistic activity of two distinct periods and some men and movements are necessarily shown in a foreshortened manner. However, the convert to Florentine culture of the period on view—some seventy-five years—will soon gain familiarity with the art of the preceding era. In the Palazzo Pitti itself the great airy ceilings which Pietro da

Cortona, with the help of Ciro Ferri, executed for Ferdinando II de' Medici in the 1640s remind us that the Roman Baroque swept all before it; in the same decade, the mysterious and exotic paintings of Salvator Rosa, offspring of Neapolitan *terribilità* (not fully discussed by Professor Cochrane), introduced a new style into Florence, one corresponding to the preoccupations of the cream of a highly cerebral society. On the other hand, the artistic situation in the second half of the century is still obscure.

The exhibition has a paradoxical quality; the closing years of Medici rule might be expected to have produced an art that was neurotic in mood, but this is not altogether the case, and earlier baroque painters, such as Cecco Bravo, Furini and Carlo Dolci (the last-named is included because he lived during the time of Cosimo III, who greatly appreciated his art) were more in tune with the *fin de siècle* mentality than were those of the concluding days of the Grand Dukes. Nothing on view, moreover, is as fevered as the painting of Filippino Lippi or Botticelli; their art

6. *Hunting scene* by Alessandro Magnasco (1667–1749), *c.* 1706. Oil on canvas, 85 × 111 cm. Wadsworth Atheneum, Hartford, Connecticut, The Ella Gallup Sumner and Mary Catlin Sumner Collection. Prince Ferdinando is shown pointing his gun at his buffoon, while his wife, Princess Violante of Bavaria, lowers the barrel

7. *Sketch for a vase* by Giovanni Antonio Fumiani (1643–1710), *c.* 1699–1702. Oil on canvas, 73 × 59 cm. Uffizi. Commissioned by Prince Ferdinando from a Venetian painter whom he much admired. It bears the Medici coat of arms

reflects a note of true spiritual crisis.

The character of Medicean patronage emerges in the contrast of taste between Cosimo III and Prince Ferdinando; the father was a Roman by allegiance, the son a Venetian. But generalizations are difficult, for both men were admirers of the charming painter Bartolomeo del Bimbo, called Il Bimbo, who is represented by two amusing pictures of figs and cherries that have the added attraction of listing no fewer than fifty-one varieties of figs and thirty-four varieties of cherries. Cosimo III commissioned this engaging *petit maître* to paint rare flowers and fruits for La Topaia, his summer house above the Villa di Castello, and for L'Ambrogiana. He was a painter of curiosities, which corresponded to the scientific temper of his age, and Dr. Gerhard Ewald observes in the catalogue that the Medici gave him commissions to paint 'such things as a ferocious wolf killed in the Mugello, a strange bird sent as a gift to the Grand Duke, a giant cucumber, and a truffle of exceptional size'.

A liking for still life was no novelty in Medicean circles, for mid-seventeenth-century Florence witnessed the arrival of Otto Marseus van Schriek, painter of almost surrealistic pictures of butterflies, plants and snakes, who had something of the vision of an obsessed Victorian botanist about him, and Willem van Aelst, a more conventional artist. Prince Ferdinando and, above all, Cardinal Francesco Maria de' Medici were captivated by the still life pictures (Fig. 8) of Cristoforo Munari, who painted decorations for the Cardinal's residence, the Villa Lappeggi. Although no rival to his master Baschenis, he had a pleasing talent, and the presence of only one picture by him is short commons.

A strain of whimsicality may be noticed in some painters active in Florence during the late-seventeenth and eighteenth centuries. This emerges, for instance, in two fantasies by the obscure Niccolò Lapi in which the wiles of the '*éternel féminin*' are pictured with wit (Fig. 4). How surprising that—as far as is known—works of this sort were not collected by the fellow countrymen of Swift and Pope; in any event, they may be allied to those squibs which enlivened eighteenth-century England.

One painter with a sarcastic touch and a penchant for the macabre, Magnasco, who worked for the Medici has won admiration in England—from the Sitwells and Sickert, for instance. His name was used as the title for the amusing society which staged exhibitions in London during the '20s and '30s and held dinners at the Savoy with music by Rossini and others providing an attractive and festive background to claret and port. Harold Acton was the youngest member of this entertaining coterie; and let us hope that the health of Prince Ferdinando was proposed!

The Prince admired Magnasco; so did Gian Gastone, and Sir Harold rightly regrets that he never painted 'his snuff besmeared patron, recumbent with night-cap or tattered periwig...' Another subject suitable for Magnasco would have been the astonishing spectacle presented when a donkey laden with peaches—the annual tribute from Settignano—was led into the bedroom of this eccentric ruler.

One of the most delightful pictures on view (though

8. *Fruit, Pots, Books and Flute* by Cristoforo Munari (1667–1700). Oil on canvas, 42 × 67 cm. Uffizi. This charming *petit mâitre*, who came from Parma, worked for Cardinal Francesco Maria de' Medici at the Villa Lappeggi

it is on the dark side) is Magnasco's *Hunting scene* (Fig. 6), which depicts Prince Ferdinando, as much a lover of the chase as Charles III, pointing his gun at his buffoon, while his wife, the wistful Princess Violante of Bavaria, lowers the barrel. Marco Chiarini suggests in the catalogue that this may have been commissioned by a Florentine noble 'to record a scene worth remembering in much the same way as one would take a photograph today'.

A further sign of Ferdinando's nose for the unusual was the delight he took in the work of the Bolognese artist G. M. Crespi, whose rustic scenes often have mysterious undertones and whose *Self-portrait* is not without an equivocal touch. The exhibition also includes his *La Fiera del Poggio a Caiano,* which was painted for the Prince at Pratolino in 1709, where three years earlier Handel had composed *Rodrigo* at his invitation. Crespi's picture does not quite live up to its reputation, owing to its darkened colours.

The most important local painter of the eighteenth century—belonging to a later generation than Magnasco, Lapi, Bimbo and Crespi—was Giovanni Domenico Ferretti (1692–1768). He was much patronized by the Florentine aristocracy, for which he painted frescoes, though he did little for the Medici, apparently being elbowed out by his jealous colleagues. A vein of humour marks his four bucolic pictures—*poesie boschereccie,* as they were then termed—and four Commedia dell'Arte scenes (Fig. 5). Dr. Ewald tells us that the artist was a friend of the Florentine poet Giovanni Battista Fagiuoli (1660–1742), who enlarged the repertory of the Commedia by introducing contemporary figures into his plays, and in his time no fewer than twenty playhouses were open in Florence.

At the close of the seventeenth century, Venetian painting conquered Florence, and Prince Ferdinando, who twice visited Venice, appreciated the sketchy handling and fluent colour of her artists as well as her fleshpots. One of the pleasures afforded by the Pitti show is that sketches by local men such as Bonechi (Fig. 11), Ferretti, Gabbiani

and Sagrestani (Fig. 12) illustrate the way in which Florentine decorators were captivated by Venetian exuberance.

The main impetus for the development in Florence of a freer and more colourful style was supplied by the ubiquitous Luca Giordano, who first came to the city in the 1650s and returned there in the middle of the next decade, when he received commissions from the Court. At this stage, however, his natural ease of manner had not been enriched by contact with Venetian painting, above all that of Veronese. The decoration he did for the Corsini family chapel in the Carmine in 1682 embodies the results of his Venetian experience; but it was only in the same year, when the Marchese Riccardi asked him to decorate the ceiling in the palace he had bought from the Medici, that Giordano came into his own; the ebullience of his approach may be seen in the celebrated sketches from the Mahon Collection which—ornaments of the exhibition—reveal his mastery of colour and composition (Fig. 10). Like some Neapolitan Harlequin, Giordano bounded on to the Florentine scene, blending his native brio with Venetian colour.

A vivid sequel to his innovations was provided by Sebastiano Ricci, who was much admired by Prince Ferdinando. Ricci's role as a herald of the Rococo is underlined by the presence of a decoration for the Palazzo Marucelli-Fensi, and the exquisite sketch (from Orléans) for the ceiling of the ante-room of the Prince's summer apartment in Palazzo Pitti, a delicious confection foreshadowing Tiepolo and Boucher.

Another Venetian who appealed to the Prince was G. A. Fumiani, best known for his decoration of the church of S. Pantaleone, Venice, and he commissioned him to execute sketches for candelabra and a vase (Fig. 7), which amusingly express the liking for fantasy admired by this patron. These enchanting sketches have a rococo-like quality and illustrate the type of preciosity beloved by a capricious man of taste.

The wealth of decorative painting done in Florence during the late-seventeenth and eighteenth centuries may come as something of a surprise; it helps to dispose of the

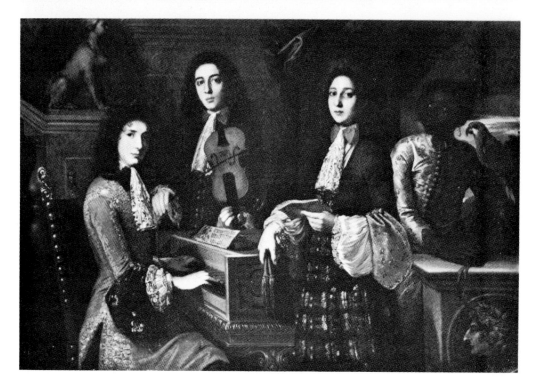

9. *Group of Court Musicians* by Antonio Domiani Gabbiani (1652–1726), *c.* 1681. Oil on canvas, 1·41 × 2·08 m. Palazzo Pitti. Prince Ferdinando was a passionate music lover and commissioned Alessandro Scarlatti to compose operas for him. Probably painted for the Prince's villa at Pratolino

legend that the Florentine aristocracy and patriciate were ruined. Had this been the case, they would not have employed artists to enrich their palaces. Further evidence about Florentine decorative art is supplied by Marchese Leonardo Ginori Lisci in his remarkable two-volume book on the Florentine palaces (1972), which contains illustrations of many unusual and unfamiliar items, including a small rococo boudoir with mirrors, paintings and elegant decoration in the Palazzo Rinuccini in the Via S. Spirito.

The many English visitors to Florence during the period might be expected to have taken an interest in modern Florentine painting. Dolci's paintings found their way into English hands; however, few contemporary artists are mentioned in the letters to Horace Walpole from Sir Horace Mann, who lived in the city for over forty years and was keen on art. When their mutual friend, John Chute (whose life has been sympathetically sketched by Warren Hunting Smith in his attractive volume *Originals Abroad*, 1952), commissioned a painting from Ferretti for the chapel in his house, The Vyne, in Hampshire, this was not an original composition, but a copy after a Santi di Tito, thus suggesting the domination which the early Baroque exerted over English connoisseurs, enamoured as they were of Domenichino and Guercino. Moreover, Mr. Mahon's sketches for the Giordano ceilings were acquired by Lord Shrewsbury, not in the eighteenth century, but in the early part of the succeeding one.

The situation with regard to Florentine baroque sculpture, which has been brought to the fore by Klaus Lankheit in his fundamental book of 1962, presents a rather different picture. Professor Lankheit and Jennifer Montagu point out in the exhibition catalogue that Foggini was commissioned to cast the statue of Queen Anne to be set up in the Strand and that he won a commission for bronze statues for Lord Stafford. Foggini and Soldani were rivals; the latter secured a major award when asked to make four bronze casts for the Duke of Marlborough in 1711: two—*The Medici Venus* and *Dancing Faun*—are on view. A summary of the documents relating to their transaction, in which the British Minister, Sir

Henry Newton, received permission from Cosimo III for the work to be done, is supplied in the catalogue entry.

The cultural traffic between England and Florence was by no means one way, as Anna Maria Crinò pointed out in a useful summary in the catalogue of the exhibition, 'Firenze e L'Inghilterra' (Palazzo Pitti, 1971). Cosimo III visited England, where a miniature portrait of him was painted by Samuel Cooper, and, anticipatory of the fascination exerted by English female beauty on Italian sensibility, he ordered miniatures of a number of 'stunners', Lady Castlemaine, Lady Cavendish, the Countess of Northumberland and Mrs. Cheke, and from Sir Peter Lely pictures of a bevy of handsome women— portraits now hanging in the Italian Embassy in London. On a more humdrum level, the productions of the Royal Mint so impressed him that he commissioned the young Soldani to improve Florentine coinage and medals.

Foggini's bust of Cosimo presents the salient points in his character; intractability, love of pomp and a melancholic streak (Fig. 2). He was also a man of sense and sensibility and his patronage gave an impetus to local sculpture; his awareness that this branch of art was less flourishing than it had been in the past led him to establish an academy for young artists in Rome. He well understood that the Baroque provided a new source of inspiration; he himself preferred Algardi to Bernini, elegant linearism to ebullient plasticity.

The exhibition, in fact, offers an admirable opportunity to gain some idea not only of Florentine sculpture but—as many busts are included—of the personalities of the Medici and of such leading intellectuals as Giovanni Alfonso Borelli and Marcello Malpighi. However, it is a trifle sad that neither the bust of Gian Gastone (Uffizi) nor the imposing statue of Cardinal Leopoldo by Foggini (Uffizi) is on view, although fortunately the show contains the brilliant *bozzetto*, from Berlin, for the latter work. The cardinal was a far-sighted amateur whose collection of drawings forms the basis of the Uffizi's Gabinetto dei Disegni; he also founded the Gallery of Self-portraits, which offers an extraordinary opportunity for the psycholo-

10

11

12

10. *Allegory of Agriculture* by Luca Giordano (1634–1705), 1682. Oil on canvas, 1·21 × 1·92 m. Collection Denis Mahon. *Modello* for the ceiling in the Palazzo Medici-Riccardi, Florence, which exerted an immense influence on the local School

11. *Allegorical scene* by Matteo Bonechi (*c.* 1672—after 1754). Oil on canvas, 1·9 × 1·2 m. Private collection, Venice. Probably a *bozzetto* related to the decoration of the Palazzo Tempi (now Bargagli-Petrucci), Florence, which was destroyed during the 1939 War

12. *Glorification of the House of Tempi* by Giovanni Camillo Sagrestani (1660–1731). Oil on canvas, 1·9 × 1·2 m. Private collection, Venice. *Bozzetto* for the oval ceiling in the Palazzo Tempi (now Bargagli-Petrucci), Florence

gist, amateur or otherwise, to study the features (often astonishingly revealing) of men whose pictures are usually more familiar than their faces.

A fine item by a less familiar sculptor is Giovacchino Fortini's striking bust of Prince Ferdinando de' Medici (Fig. 3), which bears an interesting relationship to French portrait sculpture. The Prince, who had a touch of Hamlet in his nature, was not only an amateur of painting with a sophisticated taste, but also a keen lover of music, like Ludwig of Bavaria; he greatly admired Alessandro Scarlatti, who wrote operas for him, and appropriately the show includes Gabbiani's delightful picture of some of his musicians (Fig. 9). Ferdinando inherited his father's fondness for sculpture, but his own penchant was for *modelli,* thus complementing his taste for oil sketches. When at his behest Soldani executed a series of the Four Seasons in bronze for his brother-in-law, the Elector Johann Wilhelm, Ferdinando had the terracotta *modelli*

framed behind glass and hung in his private apartments. Both *modelli* and the finished works are on view, though they are not quite as well displayed as they deserve to be. The terracottas are most elegant and, like other works from this phase in Florentine art, suggest a connexion with French art; for instance, the modelling in *Spring* looks ahead to the technique of Clodion.

From now on there will be no excuse for failing to recognize the quality of sculptors such as Foggini, or Soldani, or Cornacchini (Fig. 15): the same is true of the medals which are a feature of the show and provide a valuable iconographic adjunct to it. The exhibition underlines, in fact, that Florentine sculpture was far superior to Florentine painting during the baroque period.

The special appeal of the finest Florentine bronzes of the Baroque lies in a subtle blending of refinement and sensibility. Often the works of Soldani or Foggini achieve a lighter effect than those of Roman baroque artists,

34

possess their own spicy charm, which is also evident in Soldani's remarkable *Lamentation over the Dead Christ* (Fig. 13), in which refinement does not hamper the expression of religious sentiment.

Foggini is a hero of the exhibition, and Cosimo III showed good sense in appointing him not only 'Primo Scultore della Casa Serenissima' but 'Architetto Primario'. His position in Florentine art life underlines, too, the absolutist character of the Medici and the control they exerted over the arts. Foggini was a brilliant all-rounder. Besides portrait busts and bronzes, he made designs for high altars, such as those in SS. Annunziata and the Chiesa Collegiata di S. Maria, Impruneta and the stuccoes that heighten the allure of the Giordano gallery in the Palazzo Medici-Riccardi. The most extraordinary piece of furniture shown—the Elector's Cabinet (Fig. 17)—was designed by him; the documents relating to the commission specifically state his responsibility for the statue of the Elector and the other figures. No less exuberant—although on a smaller scale—is the *prie-dieu* for which he cast the bronze ornaments; it shows, too, the continuity

13. *Lamentation over the Dead Christ* by Massimiliano Soldani-Benzi (1656–1740), *c.* 1715. Bronze, height 74·9 cm. Seattle Art Museum, Gift of Samuel H. Kress Foundation

14. *Hercules and Iole* by Foggini. Bronze, height 38 cm. Victoria and Albert Museum. The subject is derived from Boccaccio

15. *Sleeping Endymion* by Agostino Cornacchini (1686–1754), 1716. Terracotta, height 33·6 cm. Museum of Fine Arts, Boston. This model and the bronze cast from it may well have been made for the sculptor's first patron, Francesco Maria Niccolò Gaburri, who wrote 'Lives of Florentine artists'

14 15

though of course they are indebted to Rome. Their quivering, almost windswept, quality echoes the fluttering draperies of Renaissance sculpture and has a touch of the theatricality found in the graphic work of Jacques Callot and Stefano della Bella (who painted the youthful Cosimo III) and the stage designs of Buontalenti and Parigi.

Hercules and Iole (as modelled by Foggini and derived from Boccaccio, Fig. 14) could appear in an elaborate Florentine festival, all the more so as this sculptor made designs for such affairs. This piece has considerable chic. But is there a hint in it—as indeed in other bronzes of the period—of that decline in form that fussed Berenson in old age? Decline is perhaps too harsh a word; should we talk rather of the triumph of femininity over virility? Such works do not have the force and concentration evident in Renaissance bronzes, so that a reaction towards the discipline of neo-Classicism became almost inevitable. But Florentine baroque bronzes

of Florentine craftsmanship: the cherubs are descendants of those found in Renaissance sculpture.

Effective use is made in both pieces of *pietre dure* (hardstone), which was greatly favoured in Florence, where the Opificio di Pietre Dure was exceedingly active, and the use of this material displays the sort of opulence associated with Court art which had its swansong in the works produced by Fabergé for the Tsars and the Russian aristocracy. But the hot-house atmosphere of the Medici Court is not without an icy note; an intimation of mortality that would have appealed to John Donne is the wax *The Triumph of Time* by Gaetano Zumbo, a self-taught Sicilian sculptor who invented a special recipe for coloured wax and made use of painted backgrounds. In this gruesome work—a forerunner of Madame Tussauds waxes and much modern art—various stages of death and decay are represented. It belonged to Prince Ferdinando, who also owned a wax *The Plague*; works of

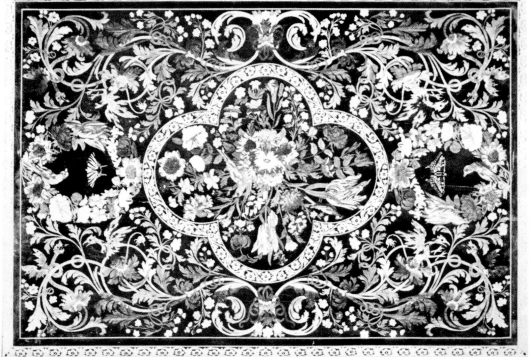

16. *Table top*, ascribed to Leonardo van der Vinne, (active last part of the seventeenth century). Ebony fruit wood, ivory inlay, diameter 1·16 m. height of table, 78 cm. The Detroit Institute of Arts, Walter and Josephine Ford Fund Donation. Van der Vinne, whose origins were presumably Dutch, executed a number of musical instruments and fire-arms for Prince Ferdinando. The style of the table is Flemish

17. Opposite: *The Elector's Cabinet*, 1707–9. Height, 2·8 m. Museo degli Argenti, Florence. This richly decorated cabinet, which contains superb *pietre dure* inlays, was sent by Cosimo III to his daughter Anna Maria Luisa, when she was married to the Elector Palatine

a similar macabre nature were done for his father.

The emphasis on the decorative arts in the exhibition is welcome and the introduction to this section of the catalogue by Kirsten Aschengreen-Piacenti and Alvar Gonzáles-Palacios is rich in information on this topic. They describe the composition of the grand-ducal workshops and note that Cosimo III owned some very large Mexican terracotta vases from Guadalajara; that Prince Ferdinando had a passion for blue-and-white Chinese porcelain; and that Gian Gastone owned Meissen. He was, they say, 'a much more discerning collector than has previously been assumed. The number of snuff boxes in his collection, all lost and known only from the inventories, was considerable and shows him entirely up-to-date in his tastes'.

The splendour of the Medicean decorative arts is a revelation and objects now scattered in various parts of the world assume a special flavour when shown, as is here the case, in an appropriate princely setting. They remind us that Florence enjoyed a high level of craftsmanship and that many of its practitioners were cosmopolitan; for instance, Leonardo van der Vinne, who did superb floral decoration in marquetry (Fig.16), was of Dutch origin, and Holzman, the Court silversmith, and Sengher, who worked in ivory, came from Germany.

The connexions between Florence and France in particular were more extensive than is often realized and an instance of these are the beautiful tapestries. *The Four Parts of the World* (Fig. 18), which were woven after designs by Sagrestani; their subtle design and ravishing colours raise the question as to the extent to which Florentine tapestries, which then, as now, were much admired abroad (as is the case with the splendid piece now hanging in the Italian Embassy in London), influenced the Gobelins. The French *garde-meuble*, Dr Aschengreen-Piacenti and Alvar Gonzáles-Palacios note, derived inspiration from Italian organizations such as the Guardaroba, 'and the genesis of the various manufactories created by Colbert and Le Brun at the Gobelins cannot be

properly understood without the Florentine Grand Ducal workshops in mind'. Recently, too, Françoise Viatte in her impeccable catalogue of the Stefano della Bella drawings in the Louvre has examined this vivacious artist's relations with French print dealers such as Langlois and Mariette the Elder, and her findings will prove of value to anyone interested in the absorbing question of the international character of decoration.

Obviously the exhibition will stimulate research into the intricate and fascinating question of artistic relations between France and Florence which were of considerable significance for artistic matters in France and the family relations that linked the Courts of France and Florence must be borne in mind; Catherine de Medici hardly requires mention to those raised on Dumas, but what is not always remembered is that Ferdinando had a French mother. No doubt students will now pursue the problem of the connexions between Florentine and French sculpture; and it is hard to doubt that brilliant portrait busts of Foggini or the charming bronzes by this artist and Soldani, for instance, failed to attract French amateurs of taste. Surely the painter Rigaud must have been delighted when Cosimo III sent him the pair of mythological bronzes by Foggini, now in the Victoria and Albert Museum.

The exhibition enhances the stature of Giacinto Maria Marmi, about whom little is known, except that he was *guardarobiere* to the Grand Duke from at least 1658, and he was still active in 1697 and that he finally became a *gentiluomo di corte*. Certain of his works, such as a pair of beautiful mirror frames and his pretty presentation drawings for a carriage, are proto-rococo in style. However, except for the porcelain made at the Doccia factory (Fig. 19), the Rococo rarely flourished in Florence, and even then somewhat gingerly.

In his stimulating contribution to the catalogue, Giuseppe Chigotti argues that 'the only total expression of Rococo architecture in Tuscany' was the Palazzo Mancini in Cortona; this region, 'steeped in its traditions, could not be receptive to a concept as foreign to its nature

18

19

as the Rococo'. He draws attention to the few buildings of importance put up in Florence during the seventeenth and eighteenth centuries. The show includes Pier Francesco Silvani's model for the Corsini Chapel in the Carmine and drawings by Antonio Ferri and Girolamo Ticciati for Palazzo Corsini, which was enlarged by Marchese Filippo Corsini, the eldest brother of the future Pope Clement XII and a childhood friend of Cosimo III. The façade, to quote Giuseppe Chigotti, 'breaks away from the rules both of symmetry and of an unbroken front, creating a double play between the palace and the Arno: the river appears like a scenic background to viewers in the palace, and the palace appears like a stage set to those observing it from the river' (Fig. 20). The interior is an example of Florentine Baroque at its most grandiose, with decorations by Gherardini, Gabbiani and Ulivelli (Fig. 20).

Much architectural effort was expended on building temporary structures as settings for festivals, which had been greatly favoured by Lorenzo the Magnificent in the fifteenth century. Such ephemeral decorations are difficult to reconstruct in the mind's eye, but the drawings and prints shown help us to do so. Many important festivities were held in honour of marriages and these jollifications also included theatrical performances, such as that of Matteo Noris's play *Il Greco in Troia,* which was presented at the Teatro della Pergola on the occasion of Prince Ferdinando's wedding to Princess Violante. The theatre was modernized by the architect Filippo Sengher and the stage, built by Ferdinando Tacca, was also transformed by Venetian engineers brought in for the occasion by Prince Ferdinando. This famous theatre has enjoyed a distinguished history and, happily, survives. Gordon Craig, who published his intriguing review *The Masque* in Florence, presented a notable production of *Rosmersholm* at La Pergola in December 1905.

The opera was a centre of Florentine life; and Horace Mann supplied vivid details about the goings-on there: the Pretender being sick in a corridor; Chute being

carried to the opera in a chair; and a singer continuing to sing even though her husband, the impresario, had died in the theatre. Mann had been in Florence since 1737, when he was assistant to Fane, the British Minister whom he succeeded in 1740. He was *en poste* at a complicated period; after the death of Gian Gastone, Francis Stephen had succeeded to the Grand Duchy of Tuscany, the rights to which he had obtained in exchange for the Duchy of Lorraine. The Duke stayed in Vienna and Florence was ruled by his regent, the Prince de Craon, who had been the Duke's tutor and had married one of the mistresses of his father. She had attracted the old Duke's notice, R. W. Ketton-Cremer wrote, 'when driving turkeys in a field'. Mann had to flatter the new régime and, at the same time, keep a wary eye on the Jacobites, for the Pretender's sons were then growing up; the '45 rising was in the offing. He had also to receive endless visits from his compatriots, Walpole among them.

During Mann's early years in Florence Giuseppe Zocchi was preparing for publication the two sets of views, *Scelta di XXIV vedute delle principali contrade, piazze, chiese, e palazzi della città di Firenze* and *Vedute delle ville e d'altri luoghi della Toscana* (issued in 1744), that provide an appealing record of Florentine architecture and street life and of villas in the city vicinity during the eighteenth century. They show the Arno full of craft with a *traghetto* ferrying animals, as well as human beings, from one bank to the other and such events as the Procession of Corpus Domini outside the Cathedral, a chariot race in the Piazza of Santa Maria Novella, the football (*calcio*) game in the Piazza of Santa Croce and the Festival of Homage in the Piazza della Signoria, records which vividly present the pleasures of Florence.

Zocchi has an additional claim to fame for, although no painters comparable to Longhi, Hogarth and François de Troy held the mirror up to the world of fashion in Florence, he evoked the 'bon ton' in the series *Times of the Day* executed in *pietre dure*, with other decorative works relating to Tuscany, for the Vienna residence of Francis

Veduta di una parte di Lung' Arno dalla parte opposta al Palazzo del Sig.r P. Corsini

20

18. Opposite: *Europe*. Tapestry, 4·42 × 5·80 m. Museo Bardini, Florence (on loan from the Florentine Galleries). One of a series *The Four Parts of the World* woven in 1720–30 by Vittorio Demignot, Leonardo Bernini and Gaetano Bruschiera to designs by Sagrestani. One of the most famous productions of the Arazzeria Medicea

19. Opposite: *Double-walled coffee-pot, c.* 1750. Doccia. Porcelain, height 25·1 cm. Collection Paolo Venturi-Ginori, Florence

20. *View of the section of the Arno from the bank opposite the Palazzo Corsini* by Zocchi, *c.* 1744. Pen and black ink and grey wash, 47 × 67·8 cm. Pierpont Morgan Library, New York

21. *Interior of the Palazzo Corsini.* This splendid palace was enlarged by Marchese Filippo Corsini, the eldest brother of the future Pope Clement XII and a childhood friend of Cosimo III. It contains decorations by Gherardini, Gabbiani and Ulivelli

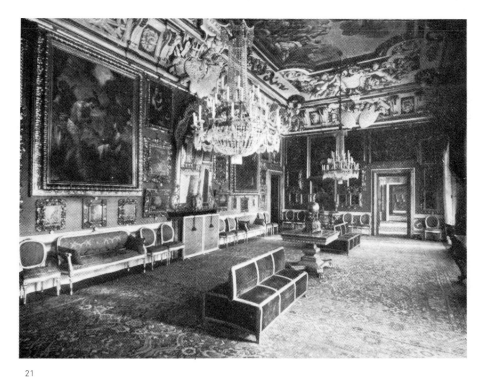

21

Stephen. One, *Le Lever*, as Edward A. Maser rightly said, ought to have provided the inspiration for the first act of *Der Rosenkavalier*, not Hogarth's engraving *Marriage à la Mode*. Oil sketches in the Opificio della Pietre Dure, as well as drawings in the Uffizi, exist for this set and related ones (Figs. 23 and 24).

Zocchi's depiction of polite society makes it understandable that tourists began to pour into the city; the English, then on the crest of the wave, were probably the most numerous. What a pleasing exercise it would prove to while away the hours reading the often amusing accounts of Florentine life given by Mann, Lord Herbert and Arthur Young. Life there was also evoked by Thomas Patch, a close friend of Mann, in such well-known pictures as *The Punch Party, A Gathering at Sir Horace Mann's, The Music Lesson* and *A Gathering of Dilettanti round the*

Medici Venus (Fig. 22). Zoffany's famous *The Tribuna*, now on view at the Queen's Gallery, which forms the subject of a special study by Sir Oliver Millar, is another admirable record of English grand tourists.

Florentine life was a hive of social activity. The Florentines entertained a good deal and, unlike the Venetians, mixed with foreigners and young Englishmen sometimes acted as *cicisbeos* to Florentine ladies! How amusing to find Mann writing to Walpole in 1751:

Then, for the common transactions of the town, they are all confined to the knowledge of what cicisbeos have been displaced, and what new establishments have been made. The great news of this kind is that Madame Acciajuoli, who immediately after her joined cicisbeos Mr. Pelham and Milbanke, took to Jacky Langlois, whom the town thought an unworthy successor, has now turned him off for a young Marquis Pucci, who succeeded Lord Rockingham with the Siristori, whom that Pucci has abandoned abruptly without a just cause, conse-

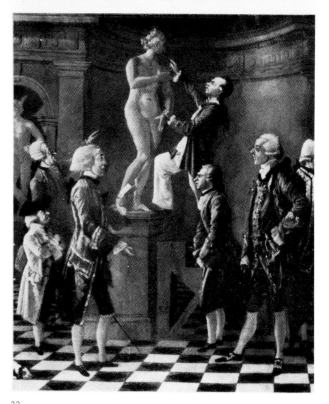

22

quently has offended against *le legge d'amicizia*, as Madame Acciajuoli has done likewise with regard to her friend the young and handsome Siristori, in debauching her *cavaliere servente* from her. These are the attentions that employ the attentions of the gay Florentine world.

But, adds Mann: 'An English traveller frequently deranges the whole harmony of "cicisbe-ship".' Was this a sign of our once famed empiricism?

One young milord who succumbed to the charms (or wiles) of an Italian was Lord Fordwich, later third Earl Cowper, who fell in love with the Marchesa Corsi, on whom he lavished presents, thereby arousing the indignation of Mann. Cowper, who refused to obey his dying father and return home, spent thirty years in Florence, away from what he called 'the dull melancholy of England'. He lived in the sumptuous Villa Palmieri (Fig. 25) and the Villa Cipresso, and, being immensely rich, entertained in style.

He was devoted to music and science and exchanged many letters with the well-known scientist Alessandro Volta. His delight in music made him a friend of Charles

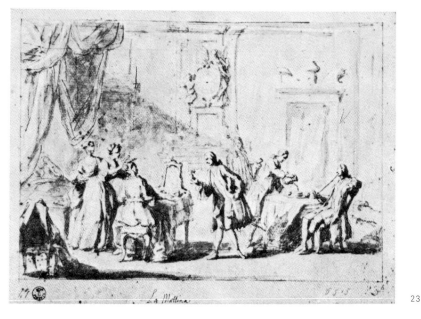

23

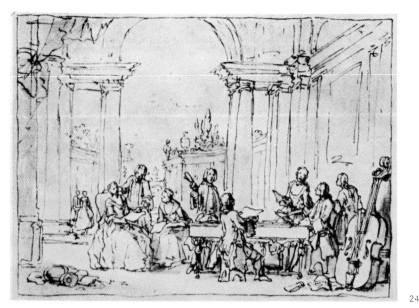

24

22. *Detail from 'A Gathering of Dilettanti round the Medici Venus'* by Thomas Patch (1725–82), *c.* 1760–68. Oil on canvas. Collection Brinsley Ford. Sir Horace Mann, on the left, is pointing to the Medici Venus, while Patch, mounted on a pair of steps, is measuring the proportions of this famous statue. Some of the most celebrated statues from the Tribuna are placed here in an imaginary setting

23. *Nine O'clock in the Morning, or Le Lever (Series of the Times of Day)* by Zocchi, Pen and ink, 18·1×24·3 cm. Uffizi (Santarelli Collection). Sketch for a *pietre dure* series decorating the Vienna residence of Grand Duke Francis Stephen

24. *Music (Series of the Arts)* by Zocchi. Pen and ink, 15·2×20·8 cm. Uffizi (Santarelli Collection)

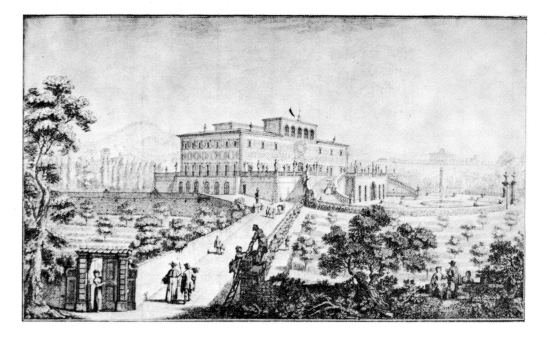

25. *Villa Palmieri* by Zocchi. Pen and black ink, 27·8×47 cm. Pierpont Morgan Library. The home of the third Earl Cowper, who lived in Florence for many years and played an active role in local society. The Earl of Crawford and Balcarres bought the Villa in 1874 and laid out the gardens in both Italian and English styles

Gore, the original of the travelled Englishman in Goethe's *Wilhelm Meister,* who was an amateur cellist and watercolourist. Gore's daughter, the lovely Anna, married Cowper and seems to have become the first acknowledged mistress of the Grand Duke Pietro Leopoldo. Cowper, who shared the Grand Duke's love of music and science, became *persona grata* at Court and was granted the rank of a Prince of the Holy Roman Empire, much to the waspish amusement of Mann and Walpole.

Cowper also bought pictures—works by Rosa, Andrea del Sarto and Raphael—and patronized his English contemporaries, Hugh Dean and James Macpherson; however, in 1776 Thomas Jones sadly noted that the Earl declined to take him up for 'he had no more room for pictures'.

Less exalted Englishmen lived in Florence, too. Among them were Don Enrico Hugford and his younger brother Ignazio, who were Catholic *émigrés.* The elder brother became clock-maker to Cosimo III and then entered the Benedictine Order and was Abbot of Vallambrosa in 1743, spending much time on perfecting the scagliola technique. Ignazio, a minor painter, who dealt in pictures, produced the sixth edition of Vasari's *Vite* (1767–72) and formed a collection of Primitives which later entered the Uffizi. Patch was also interested in the early Italians, issuing in 1770 and 1773 respectively his series of engravings after the frescoes by Masaccio and 'Giotto' (now destroyed) in the Carmine and publishing in the following year the accounts for the work on the construction of Ghiberti's two doors for the Baptistry. Ignazio Hugford and Patch may be hailed as the forerunners of a man such as Herbert P. Horne, a fervent collector and historian of early Italian art whose memory is enshrined in the Horne Museum.

The exhibition will arouse curiosity about what happened in the art world of Florence after the death of Gian Gastone, when authority was exercised from Vienna. The situation merits investigation and, as usual, titbits can be found in Mann's letters. Writing to Walpole in December 1761 he reported that it was now expected that Pietro Leopoldo would become Grand Duke (which he did in 1765):

They are new furnishing all that part of Palace Pitti painted by

Pietro da Cortona, whose ceilings are cleaning. Marshal Botta has got models of chairs from France, one of the Duke of Richelieu's, the frame of which cost 700 *livres.* Glasses and all other furniture is to be in that taste. The Marshal is very tawdry, but piques himself upon his *goût* in those things. He has made great alterations in Princess Craon's house, and much for the better though they are very faulty.

The Marshal's recourse to French models was not an intimation of a sharp awareness of the new neoclassical style, for Svend Eriksen's valuable book reveals that Richelieu only employed Victor Louis, an exponent of this style, in the late 1760s. The chair was presumably one of those in rococo taste that were to be found in the Pavillon d'Hanovre (1757), which was famed for its splendid appointments.

When Pietro Leopoldo arrived, he made important acquisitions for the Florentine collections, buying Etruscan works for the Uffizi and establishing the Archivio and the Library. However, much was lost to the Medici collections, for sales were regularly held of works from the Guardaroba, much to Mann's surprise. The ageing minister felt that times were not what they were, for in 1780 he told Walpole: 'Here is neither painter, engraver, or sculptor above the most common sort'. In his view, the best sculptor was 'a drunken Englishman whose whole employment is to make chimney-pieces for the palace and some for Russia, whose Empress buys everything good and bad that her emissaries can find in Italy'. This inebriate was apparently Francis Harwood, whose studio was near the 'Convento della SS. Nunziata'.

On balance, Mann was right about the decline of creative power in Tuscany during the latter part of his long sojourn in Florence and this pleasurable exhibition demonstrably underlines the way in which art in Florence was increasingly out of step with modern trends elsewhere. Death in beauty is a phrase used by Klaus Lankheit in his general introduction—echoes of Aschenbach no less—and it is not far off the mark. Would the situation have been different if Ferdinando had lived?

By the closing years of the eighteenth century new trends began to emerge, and with the rise of neo-Classicism a fresh chapter opened in the long history of artistic life in Florence, which has been well served by this absorbing exhibition.

'Magick Land'

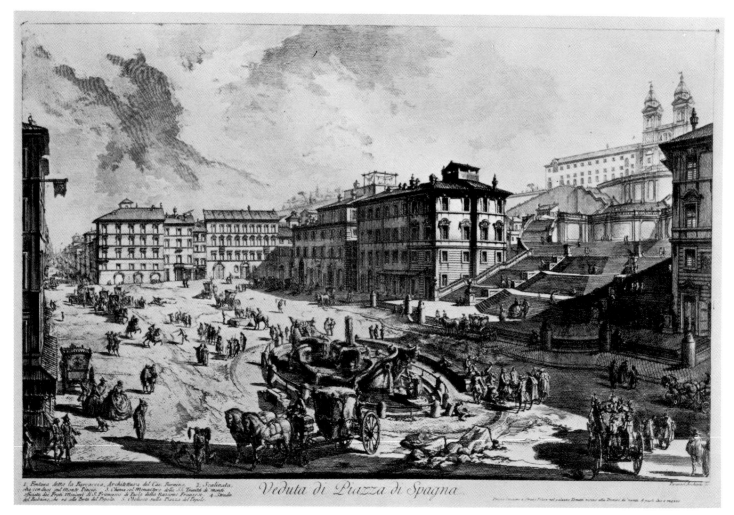

1. *The Piazza di Spagna, Rome* by Giovanni Battista Piranesi (1720–78). Etching. From *Le Vedute di Roma, c.* 1751, Courtesy Thos. Agnew & Sons. Piranesi first visited Rome in 1740

Just over a decade ago Rudolf and Margot Wittkower published an intriguing book[1] about the character and conduct of artists from Antiquity to the French Revolution, many of whom were presented in an unexpected way. Agostino Tassi is a case in point. He is a small fish indeed, mainly of interest to the student of Claude, but in the Wittkowers' volume he appears in a most unexpected and lurid guise. He was a monster. His escapades included rape, incest, sodomy, lechery and possibly homicide; he even served a term on a Florentine galley.

He was brought before the courts on a charge of raping Artemesia Gentileschi, a sexy and precocious girl. But all ended well, for her father, Orazio Gentileschi, forgave the culprit and their old friendship was renewed. It is a tale that reminds us that the *données* of the Jacobean dramatists were drawn from life.

This book also described the emergence of artistic Bohemia, a subject which demands further investigation, although some useful work in connexion with nineteenth-century Paris has been undertaken by Malcolm Easton.

In the seventeenth and eighteenth centuries it was Rome, not Paris, that appealed to the itinerant artist with raffish tastes. Bohemia was situated there in the attractive area between the Piazza di Spagna (Fig. 1) and the Piazza del Popolo, which includes such streets as the Via Bagutta and the Via Margutta.

The recent exhibition in Rome and Paris of the French followers of Caravaggio, which was briefly noticed in the April 1974 APOLLO, was a reminder of how Northerners flocked to Rome, where they were even able to find local patrons. The French were not the only foreigners to head for Rome and an ever-growing contingent of Dutch and Flemish artists—the *fiamminghi*—succumbed to the lure of the city.

A sufficient number of Dutch painters had settled in the city by 1623 to ensure the foundation of an association that had as its aim the protection of their rights and interests. These men won considerable notoriety on account of their loose living, and when an artist joined the Bentvogels the initiation ceremony was the excuse for a wild orgy. Their behaviour on such occasions—Italian wine seems to have proved lethal—brought them into bad odour with the authorities and matters came to a head in 1720 when a Papal decree dissolved the Brotherhood.

French artists, as Catholics, were in the running for religious commissions. Not so the Dutch, who were obliged to make a living by painting small cabinet pictures of local scenes. They opened a window on to the crowded and colourful street life, which now, as then, attracts lovers of the picturesque. This genre achieved success in their time, both in Rome and back home, and it returned to favour about twenty years ago, perhaps because its mood accorded with that of the neo-realistic Italian cinema.

Such painting also reflected the upsurge of landscape art which is a feature of the seventeenth century in Italy and in the Low Countries. The two most distinguished Roman masters, Claude and Gaspard Dughet, have long been admired in England.

Recent research has established the extent to which the idea of the *veduta* as an identifiable artistic category had its followers in Rome. Dr. An Zwolle in an important study[2] has shown how, during the period 1675–1725, men such as Gaspar van Wittel, Jacob de Heusch, Theodor Wilkens and Hendrik Fransz. van Lint worked in this attractive style. They produced charming and evocative pictures of Rome and her surroundings and, not surprisingly, on his visit to the Continent in 1712–18 Thomas Coke, first Earl of Leicester, acquired a series of Van Wittel's Roman views. These are still at Holkham.[3]

Thomas Coke was in Rome at a fortunate period, for he came across Lord Burlington. This taste-maker[4] bought a number of pictures by Domenichino and the modern master, Carlo Maratti, for the Red Room at Chiswick. Coke also met William Kent, who had the honour of designing a ceiling for S. Giuliano dei Fiamminghi (Fig. 3). Kent sent copies of pictures by Dughet done by Orrizonte to his patron, Massingberd, and, while there, imbibed ideas which were later reflected in the gardens he designed in England. He and Lord Burlington assisted Coke in the early stages of the build-

.ing of Holkham, thus providing an illustration of the way in which Italian influence acted as a catalyst on English taste.

Coke not only bought classical sculpture and Old Masters, but also went in for the moderns, sitting to Trevisani (Fig. 2). He was one of the numerous milords attracted by the last flickers of the Roman Baroque.

Rome was not only a city with grand masterpieces of architecture, painting and sculpture, but one with seductive views and limpid and lucid light. The environs presented a variegated scene—mountains, waterfalls, lakes—that had much to offer painters and where the antique echoes had a special meaning for a generation steeped in classical learning. It was scenery that appealed to numer-

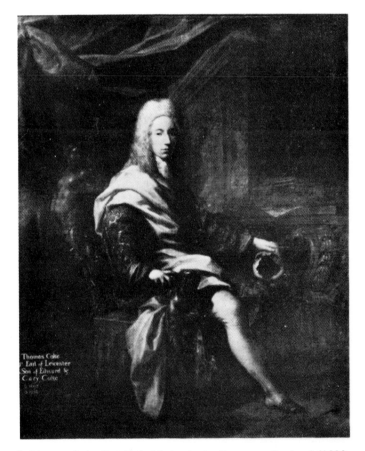

2. *Thomas Coke, first Earl of Leicester* by Francesco Trevisani (1696–1746), 1717. Oil on canvas, 1·78 m. × 1·53 m. Collection the Earl of Leicester, Holkham. While in Rome, Coke met William Kent and Lord Burlington

ous painters during the period, and, significantly, a horse-painter, John Wootton, who visited Rome in the 1720s, was inspired by Dughet's paintings of the Campagna.

The first English artist to discover the Roman scene was really Alexander Cozens, who was in the city in 1746 and made several charming drawings of congenial places (Fig. 4). He worked under C.-J. Vernet. This gifted painter had arrived in Rome in 1733 and became a student of Manglard and Locatelli; he remained until 1753, when, at the invitation of the Marquis de Marigny,

3

4

5

French 'Minister of Art', he returned to Paris.

Rome released Vernet's talent and his many views—some of contemporary events such as *A sporting contest on the Tiber* (Fig. 5) in the National Gallery, London—and his *capricci* appealed to English patrons. They found their way to his apartment in the Palazzo Zuccari (at the top of the Spanish Steps), a building which became an artists' nest, comparable to la Ruche in Paris of the 1910s. The English would have faced no problem in buying pictures from him, for he had an Irish wife, Virginia Parker, the daughter of the commander of the Papal fleet. It may well have been the quick-witted Frenchman who spotted where Richard Wilson's true talents lay, for he is said to have persuaded him to take up landscape painting.

Whether English artists living in Rome during the 1750s and 1760s were influenced by the many Dutch *vedute* pictures which must have been available is an interesting question. An artist such as Wilson painted in a different style from Van Wittel, or, for that matter, Locatelli and Busiri, who were favoured by English Grand Tourists (William Windham of Felbrigg had a Busiri room), but his work may be related to the Dutch *vedute* tradition, even though he conjured up a more lyrical atmosphere in his paintings and drawings.

Wilson was lucky, too, in finding English patrons such as the Earl of Wicklow and Lord Dartmouth prepared to buy his landscapes, a genre then in its infancy in England, as well as those of such stars as Vernet. Thomas Hollis even commissioned him to paint his portrait (now at Harvard), which is, however, rather a journeyman affair.

Hollis, a fervent Republican, was one of the many unusual Englishmen who fell in love with Rome during the eighteenth century; he was so enamoured that he commissioned Canaletto, when this artist was in London, to paint a sparkling view of the Campidoglio (Fig. 13). Hollis got to know many Italian scholars, writers and artists and was responsible for inspiring Ridolfino Venuti to write dissertations on liberty and archaeology. Franco Venturi in his exciting book, *Italy and the Enlightenment* (1972), points out that Venuti, who had a large English circle, was not only an admirer of Piranesi and an illustrator of the excavations at Herculaneum, but also a supporter of free trade and a partisan of agrarian reform, being eager to compel landowners 'to adopt a wider variety of more modern agricultural methods'. Can we doubt that his views would have interested some of the English visitors, owners of, or heirs to, broad acres?

English visitors to Italy were not only bent on pleasure. Lord Herbert was barely twenty on his Grand Tour, but he called on the Abbé Galiani, one of the foremost intellectuals of the day, at the request of his tutor, the Rev. William Coxe. It is as if a scion of a Texan billionaire family were to find his way to Sir Isaiah Berlin! Even someone such as the Earl-Bishop, whom we are apt to think of almost exclusively as an epicurean aesthete and eccentric, took considerable interest in local conditions, collaborating with Thomas Denham in his thorough inquiry, *The Temporal Government of the Pope's State* (1788), which, to quote Venturi, 'gave a detailed description of the corruption, incompetence and unwieldiness of the machinery of the Pope's economic administration'.

From the 1750s onwards an increasing number of English artists found congenial subject-matter in Rome and the Campagna. Besides Wilson, there were Thomas Jones, William Pars, John 'Warwick' Smith, Francis Towne and J. R. Cozens; even men such as Robert Adam and Allan Ramsay, who were not landscapists, did not hesitate to pull out pencil and pad and sketch some favourite site.

How deeply the scene touched the imagination of the visiting Englishman may be seen from the enthusiastic letter written by Jonathan Skelton (11 January, 1758) to his friend William Herring, in which he spoke of painting

3. Opposite: *Sketch for the ceiling of S. Giuliano dei Fiamminghi, Rome* by William Kent (1685–1748), 1717. Red chalk heightened with white on paper, 30·5 × 41·9 cm. Collection Professor and Mrs. Peter Murray. Kent, who was in Italy during 1709–19, agreed to paint the ceiling of S. Giuliano in fresco without any fee, but he was given a small honorarium

4. Opposite: *View near a town on a river* by Alexander Cozens (1717–86). Pen, ink, grey wash on paper, 12 × 18·4 cm. British Museum. Cozens was in Rome in 1746 and was one of the first of the English landscapists to go there

5. Opposite: *A sporting contest on the Tiber at Rome* by Claude-Joseph Vernet (1714–89). Oil on canvas, 99 × 136 cm. National Gallery, London. Vernet, who was in Rome in 1733–53 had an Irish wife and was much admired by English collectors

6. *Still life with a flask* by Richard Wilson (1713/14–82). Black chalk and stump on white paper, 21·6 × 17·8 cm. British Museum. This unusual experiment in drawing by candlelight once belonged to Herbert P. Horne, the author of a *magnum opus* on Botticelli. Wilson was in Rome in 1752–57

7. *An Egyptian decoration. Design for the Caffé degli Inglesi* by Piranesi. Etching. *c.* 1769. Private collection. This famous café was in the Piazza di Spagna

6

7

pictures that were partly 'Studies from Nature' and reported that as the weather was no longer cold he could draw in the fields. Skelton was not without a touch of vanity and claimed that he was the best landscape painter in the city. He informed Herring:

I have taken a very handsome Lodging on the Trinita del Monte on one of ye Finest Situations about Rome . . . I shall have the finest opportunity of painting Evening Skies from my Painting-Room that I could almost wish, – surely I shall be inspired as I am going to live in the Palace of a

45

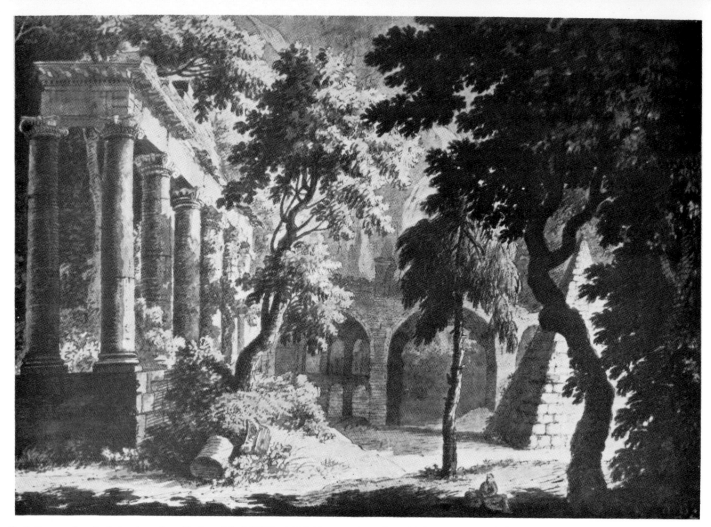

8. *A Roman Capriccio* by Jonathan Skelton (died 1759), 1758. Water-colour, 26 × 36·6 cm. **City Art Gallery, Leeds.** The artist, who was in Rome in 1758–59, wrote, 7 June, 1758: 'One may draw many pleasing reflections from these venerable Relicts of ancient Roman Grandeur. They show how Time erases everything . . .'

9. *Ariccia* by Francis Towne (1739/40–1816). Pen and water-colour. 32·5 × 47 cm. British Museum. Towne, who was in Rome in 1780–81, had a gift for making harmonious patterns of colour and shape. The cupola is that of Bernini's S. Maria dell' Assunzione

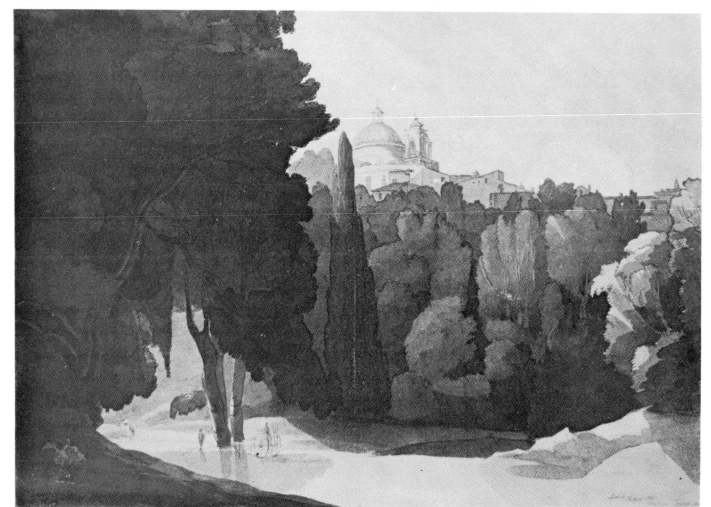

10. *The Church of La Trinità dei Monti* by John 'Warwick' Smith (1749–1831). Water-colour with pen and ink, 34·2 × 54·2 cm. British Museum. Thomas Jones noted in his diary (15 July, 1779) that Smith, who was in Italy in 1776–81, had taken rooms in a house just below the Trinità dei Monti

11. *An Excavation* by Thomas Jones (1742–1803), *c.* 1777. Oil on paper, 42 × 56 cm. Collection J. H. Adams. Jones records in his diary a visit to an excavation at the Villa Negroni in July 1777. He was in Rome, in 1776–83

12

late Queen and in the same apartment that Vernet had (when he was here), and within 80 or 100 yards of ye House where those Celebrated Painters Nicolo and Gaspar Poussin lived.

Some of Skelton's water-colours are on the dry side, but in others (Fig. 8) he sounded a romantic and dramatic note. Who knows how he would have developed if he had not died prematurely in Rome? He was escorted to his grave by his fellow artists. It makes for sad reading to run through the inventory of his effects, which included a tea-pot. The sketches of Thomas Jones (Fig. 11), who has found a warm partisan in Ralph Edwards, possess an attractive freshness. It has been suggested that Jones, a friend and follower of Wilson, was in touch with Valenciennes, that delicate French *petit maître* who, together with Bidauld, produced pictures that anticipated Corot's.

The role of English artists in Rome is an appealing theme and an excellent conspectus of the work they did in this city is provided in the exhibition at the Iveagh Bequest, Kenwood (8 June–27 August), which has been admirably organized by Miss Lindsay Stainton. Her excellent catalogue, which is rich in information, will take its place beside the publications of Andrea Busiri-Vici, Brinsley Ford, Hugh Honour, John Fleming, Basil Skinner, Anthony M. Clark and other lovers of the Roman scene during the eighteenth century.

As much as anything else, the works on view illustrate the way in which the Roman experience was a vital influence on the English School; it was a solvent that certainly acted on the development of national landscape painting, as Luke Herrmann made clear in a recent publication. This being so, it was rather a shame that no

place for even a token showing of the English Romanists was found in the exhibition of English landscape painting held earlier this year at the Tate Gallery. Rome was also a strong force in the development of English neo-Classicism and Romanticism.

English artists were at some disadvantage compared with the French, for they did not enjoy the advantage of having a headquarters. The French Academy was then situated in the Palazzo Mancini in the Corso. Nevertheless, English artists were allowed to attend its life class, and one who did so was Allan Ramsay. They could also work in the Accademia del Nudo, which was opened in the Capitoline in 1754 and where instruction was given by the members of the Academy of St. Luke. The competitions organized by this Academy were open to foreigners and a number of Englishmen carried off prizes, James Byres among them. Foreign students could also work at private schools in Rome and gain access to the studios of leading masters such as Batoni, Mengs and Imperiali. Boswell recorded how he looked in at Batoni's and watched him making drawings for his dashing portrait of Colonel William Gordon of Fyfie in Highland costume.

The handicap of there being no English art academy in Rome was for a short time overcome when one was founded in 1748 with the active support of Lord Charlemont, the 'Volunteer Earl' (Fig. 15), and run by Parker. However, the students, especially Thomas Patch, were dissipated and unruly and it closed in 1752.

One of the chief differences between the French and English artists in Rome during the eighteenth century was that the latter could count on no official support. England was not diplomatically represented at the Holy See and

12. Opposite: *Gardens of the Villa d'Este at Tivoli* by Charles-Joseph Natoire (1700–77), 1760. Pen and brown ink, watercolour heightened with white over black and a little red chalk, 31·3× 47·5 cm. The Metropolitan Museum. Natoire produced many landscapes during his time as Director of the French Academy in Rome and encouraged the students to do likewise; they included Fragonard and Hubert Robert

13. *A View of the Piazza del Campidoglio and the Cordonata at Rome* by G. A. Canaletto (1697–1768), 1755. Oil on canvas, 50·91× 61·27 cm. Courtesy the Leger Galleries. Painted for Thomas Hollis (1720– 72), a keen patron of Canaletto

the unofficial representative, Thomas Jenkins, was obviously not in a position to rival the future duc de Choiseul. This Ambassador brought Hubert Robert with him to Rome and during his stay in 1754–57 commissioned Pannini to paint the famous *Roma antica* and *Roma moderna*. Nor was there anyone quite so much in the swim as the agreeable Cardinal de Bernis, who made the Palazzo de Carolis in the Corso an elegant centre of hospitality. Often the visiting Englishman had somewhat gingerly to solicit the help of the Jacobites to gain entrance to collections.

Only during the last two decades or so has the scope of Roman painting in the eighteenth century been seen in the round. Now the contribution of men such as Maratti, Batoni, Mengs and Giaquinto can be assessed and their position was clarified at the time of the notable exhibition 'Il Settecento a Roma' held in Rome in 1959. It was a sign of the success of the Roman School that some of its luminaries were called abroad—Mengs and Giaquinto worked in Madrid and the latter's influence on Goya is by no means negligible.[5] Besides the better-known painters active in Rome, there are lesser figures, such as Sebastiano Ceccarini, whose portrait of five children of a Roman patrician in the role of the Senses combines charm and sophistication (Fig. 14).

The 'Settecento a Roma' exhibition and a recent small but stimulating show at the William Benton Museum drew attention to the range of Roman patronage of the arts. Support for the arts may not have been as magnificent as it was in the sixteenth and seventeenth centuries, but it produced rich results. This was true of the architecture sponsored by the Popes, and Christian

Elling in his book *Jardin i Rom* (1943)[6] pointed out that Rome in the 1730s and 1740s was a lively and modern city where much of architectural merit had been built, such as the Spanish Steps, the Fontana di Trevi, the new façade by Alessandro Galilei for S. Giovanni in Laterano and Fuga's Palazzo della Consulta. The Trevi fountain and the Lateran façade were paid for out of the proceeds of the lottery that was instituted by Clement XII (Corsini) in 1731, and Frederick den Broeder notes in his valuable introduction to the Benton show that this Pope used his own funds to add the opulent Corsini Chapel to the Lateran.

Another Pope, the learned and delightful Benedict XIV (Lambertini), restored and added to the façades of S. Croce in Gerusalemme and S. Maria Maggiore in preparation for Holy Year in 1750 and built the charming coffee house in the Quirinal. This building, which was painted by Pannini, was decorated by this artist, Masucci, Batoni and Van Bloemen.

Men such as Cardinal Clement XIV (Ganganelli) and Cardinal Alessandro Albani did much for the study of archaeology,[7] the former founding the Museo Pio-Clementino and the latter housing his famous collection in the Villa Albani—built by Carlo Marchionni in 1743–63 —and employing Winckelmann as his librarian. Cardinal Ottoboni was a patron of the theatre and formed a magnificent library, which, after his death, was bought in 1748 for the Vatican by Benedict XIV. Moreover, various important foreign patrons such as Charles III of Spain, Catherine of Russia, Victor Amadeus of Piedmont, João V of Portugal and Lothar Franz von Schönborn, Bishop-Elector of Mainz, were eager to buy works by living artists and the products of Roman craftsmanship.

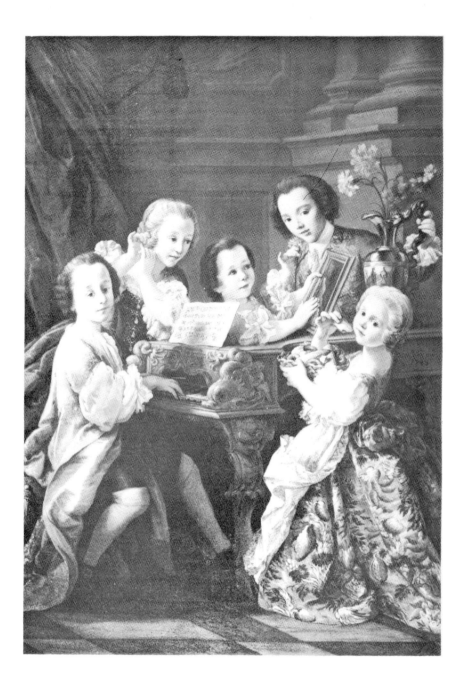

14. *Allegory of the Five Senses* by Sebastiano Ceccarini (1703–83), 1748. Oil on canvas, 17·4×12·3 cm. Courtesy Galerie Pardo, Paris

It was understandable that João V turned to such modern Roman sculptors as Foggini and Ludovisi for the figures in the basilica at Mafra. Although the Roman minor arts were not of the same calibre as those produced in Paris, their quality was high, as may be seen from the wonderful church furniture by Arrighi and Galiardi for the Chapel of St. John the Baptist in the Church of San Roque, Lisbon.

Nevertheless, the Roman patriciate was in decline. There is a tell-tale passage in Thomas Jones's memoirs in which he describes the house of an old count in the Corso where he lodged as a successor to Henry Tresham. The count lived in penury and his son, who was a cardinal's servant, made his living by gambling and pimping. His daughter was a 'Professed Courtesan', who remained pretty, 'but a little batter'd' and 'plaistered with Paint'. However, her charms were still sufficient to 'flux many of our new unfledged English cavaliers who had not resolution enough to withstand her fascinating Artifice'.

Rome offered pickings for dealers and collectors.

They were able to secure treasures from the great Roman families such as the Albani, Chigi, Ludovisi, Mattei, Guistiniani who were compelled to dispose of their possessions. In his introduction to his catalogue of the pictures at Houghton, Horace Walpole describes how most of the major works from the Pallavicini Collection were then in his father's house. How ironic that he should have seen them sold to the Empress Catherine! One major Roman collection to have been broken up was that of Cardinal Valenti, of which Pannini painted as a record a picture now in the Wadsworth Atheneum, Hartford.

The art trade attracted different types of men and two of the main dealers in Rome, James Byres and Thomas Jenkins, were failed artists; the latter was also a banker and a political agent. Their deep involvement in local life is brought out by Brinsley Ford, who has done much to make better known this intriguing phase in cultural history, in his studies that appear in this issue of APOLLO. Another well-known artist-dealer, Gavin Hamilton, was a man of considerable talent and wide interests. He exported such

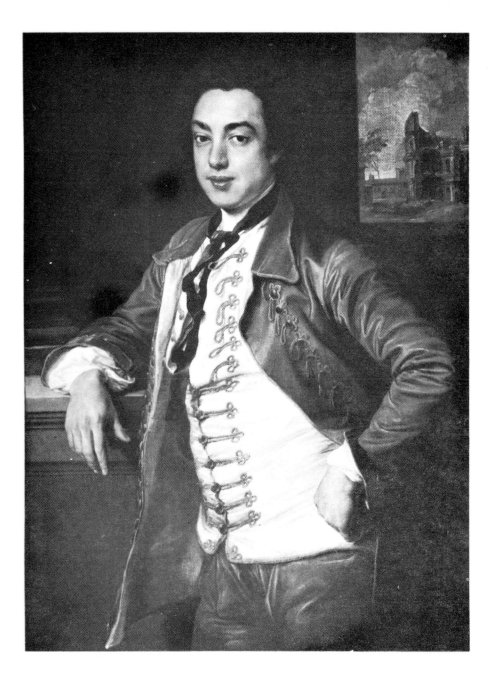

15. *Portrait of James, first Earl of Charlemont* by Pompeo Batoni (1708–87), 1751–53. Oil on canvas, 72·39×73·66 cm. Collection Mr. and Mrs. Paul Mellon. This portrait is one of two painted for Charlemont in Rome in 1751–53: the other is a full-length so far untraced

masterpieces as Raphael's *Ansidei Madonna* and Leonardo da Vinci's *Virgin of the Rocks* (both in the National Gallery, London) and presented the orthodox view of art of his generation in his book of engravings, *Schola Italica Pictura*. He was a keen archaeologist, excavating at Hadrian's Villa and elsewhere and supplying English collectors with their treasures. One client was Lord Lansdowne and his letters to his patron are fascinating. Basil Skinner in his delightful booklet, *The Scots in Italy in the 18th Century* (1966), has drawn attention to Hamilton's advice to his good client Charles Towneley that he should 'never forget that the most valuable acquisition a man of refined taste can name is a piece of fine Greek sculpture'. Towneley bought from him a splendid second century A.D. vase (Fig. 17). Not all his patrons were English, for Prince Borghese commissioned him to paint frescoes, *The Story of Paris and Helen*, for the Villa Borghese.

Now that neo-Classicism is in vogue, Hamilton the painter gets a better press than at any other time since his own day, and the credit for his revival must go to Ellis

Waterhouse, who in his notable lecture on the British contribution to the neo-classical style in painting (1954) drew attention to his position 'in the chain between David and Poussin'. The Kenwood exhibition provides an opportunity of seeing Hamilton's *The Oath of Brutus* (Fig. 19), which antedates David's famous picture *The Oath of the Horatii* by twenty years.

The way in which foreign artists were influenced by what they saw in Rome is a complex and considerable question and it can hardly be treated of in this Editorial. First and foremost, they were keen on the Antique, as may be seen from Richard Wilson's Italian sketch-book, now in the Mellon Collection. Collectors in England were eager, too, to have copies of famous works, and many English painters made money by producing them for their patrons.

It is perhaps as well to emphasize that this was the only period in the history of English taste when collectors and patrons were in step with the modern Continental School. It was almost a matter of course for a visiting

16

17

18

House with copies after the most admired masterpieces in Rome painted by such leading artists as Pompeo Batoni, Agostino Masucci, Placido Costanzi and Mengs.

However, there is sparse evidence to suggest that the Baroque of a Maratti, or the Rococo of a Masucci, or a Giaquinto exerted any decisive influence on English painting. It was only with the emergence of the neo-classical current that a close relationship may be observed between English and Roman painting. The same situation was no less evident with sculpture, and one of the

achievements of modern research has been to point to the contribution of Hewetson, who undertook work for Roman churches (Fig. 16), Thomas Banks (Fig. 18) and John Flaxman. How appropriate that later Thomas Hope should have been the *deus ex machina* who saved Thorvaldsen from having to return to Copenhagen. But the activity of English sculptors in Rome was much less important than that of such French sculptors as Clodion, Houdon and Slodtz.

The most exciting artist in Rome during the period was G. B. Piranesi, who arrived in the city in 1740.[8] He is an astonishing personality, brilliantly imaginative and a master etcher. His numerous views of Rome not only present scenes familiar to the Grand Tourist and to his more humble modern successor but show the way in which this nostalgic city could provide him with themes that

grandee to sit to Batoni—the Sargent of his age—or to Maron, or, to a lesser extent, to Mengs, for this artist was away much of the time in Madrid. But English patrons did more than sit for their portraits. In the 1750s the Duke of Northumberland employed Mengs to paint a copy of Raphael's *School of Athens*. This art-loving nobleman was decorating his great gallery at Northumberland

16. Opposite: *Monument to Cardinal Giambattista Rezzonico* (died 1783) by Christopher Hewetson (1739–98). Inscribed: CHRISTOPHER HEWETSON FECIT. S. Nicola in Carcere, Rome. This Irish sculptor was in Rome by 1765 and he stayed until his death

17. Opposite: *The Towneley Vase,* Marble, second century A.D. height 92·40 cm British Museum. Found by Gavin Hamilton at Monte Cagnolo, on the supposed site of the villa of Antonius Pius, in 1773–74, and sold by him to Charles Towneley. It partly inspired Keats's famous Ode

18. Opposite: *Achilles arming* by Thomas Banks (1735–1805). Height 47·8 cm. Victoria and Albert Museum. The sculptor's daughter, Lavinia Forster, said that all her father's terracottas were made in Rome, where he was during 1772–79

19. *The Oath of Brutus* by Gavin Hamilton (1723–98). Oil on canvas, sight size 2 × 2·7 m. Collection Theatre Royal, London. Although this picture, engraved by Cunego in 1768, was never publicly exhibited in the artist's lifetime, it is his major work; its influence on other artists was considerable. Hamilton was in Rome from the 1740s until his death

20. *Self-portrait* by Gavin Hamilton. Chalk on paper, 53·34×43·18 cm. National Portrait Gallery, Edinburgh

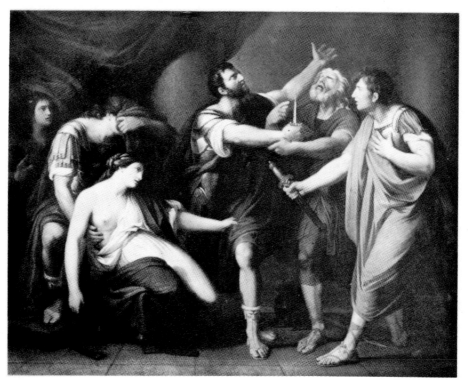

19

20

opened up new vistas, evident in his blending of classical and Egyptian themes. Many Roman artists did not reveal discoveries for the future. But Piranesi's *Carceri* with their sense of doom and fate (Fig. 25) foreshadow the world of Beethoven's *Fidelio* and Dostoevsky's *Letters from the Underworld.* In his own time he had a strong influence on French artists in Rome such as Le Geay and, through him, on William Chambers.[9]

Piranesi's contacts with the English were considerable and his work was familiar to them from his decorations for the Caffé degli Inglesi in the Piazza di Spagna (Fig. 7). He knew Lord Charlemont, who around 1751 agreed to finance the publication of *Le Antichità Romane,* but the Irish peer backed out, thus provoking the artist's open letter to him, *Lettere de Giustificazione scritte a Lord Charlemont e a di lui Agenti di Rome.*

Rome intoxicated Piranesi and the publication of Allan Ramsay's pamphlet *The Investigator,* which denigrated Roman architectural achievements and praised those of the Greeks, enraged him. His indignation was vented in the famous polemic *Della Magnificenza ed architettura de Romani,* 1761. The Marquis de Marigny, who had bought Piranesi's prints in Rome, minuted a letter from the artist (1762) sending him a list of his works; he stated his disagreement with Piranesi's thesis about the primacy of Roman architecture.[10]

Piranesi's example meant much to Hubert Robert, whose mingling of classical and Egyptian motifs reflects his influence; Piranesi's *Carceri* lie behind such pictures as *Le Pont Ancien* at Yale (Fig. 24). Robert may be seen as a precursor of the historicist vision associated with Gustave Moreau and the artists of the 1890s, just as his 'pure' landscapes look ahead to Corot's vision of Italy. He was by no means the only French artist to derive inspiration from the Roman scene: others who did so included Blanchet, Fragonard and Natoire (Fig. 12).

One fruitful field of research would be a study of the relations between foreign artists in Rome at this time. For instance, Robert Adam, who was in Italy during 1755–57, met Clérisseau in Florence and they were together

21

21. *William Drake with Dr. Townson and Mr. Holdsworth* by James Russel (died 1763), 1744. Oil on canvas, 45·7×61 cm. Collection F. Tyrwhitt-Drake. The earliest known conversation piece by an English artist to have been executed in Rome. Russel, who lived in the city 'upwards of twenty years', was the author of *Letters of a Young Painter Abroad to his Friends in England*, 1748

22. *Interior of a Roman Coffee-house* by David Allan (1744–96), *c.* 1774. Pen and ink and water-colour, 26×18·7 cm. National Gallery of Scotland, Edinburgh

23. *In the gardens of the Villa Pamphili, Rome* by John Robert Cozens (1752–97), *c.* 1782–83. Water-colour, 25·4×44·4 cm. Victoria and Albert Museum. Cozens was first in Italy in 1776–79 and again in 1782–83, and on the second occasion he was employed by William Beckford to whom this drawing may have belonged

in Rome, spending much of their time in the company of Allan Ramsay. Obviously such residents as Byres, Jenkins and Hamilton had the chance of coming across the many foreign artists who turned up in the city.

Opportunities, in fact, were plentiful for artists of different nationalities to get to know one another. Jones, for instance, provides a delightful account of a group of artists—Danes, Swedes, Russians, Poles, Germans and English—turning up for a Christmas Eve party given in 1779 by a Mr. D'Argent, a young Dane. When Jones

arrived, he found them all puffing away at their pipes. The dinner was of traditional Danish fare, consisting of 'a large Bowl of Rice Milk a fricassed Kid and Pancakes', a repast which was washed down with the best Roman wine. How well the good-natured Welshman conjured up the atmosphere:

We sallied forth to hear a Band of Music at the Appollinare – from thence we went to S'a M'a Maggiore to *see the procession of the cradle etc* – Where we dispersed and I returned home about 6 o'clock in the Morning in order to prepare for entertaining a few friends (Messrs Pars,

22

23

24. *Le Pont Ancien* by Hubert Robert (1733–1808). Oil on canvas, 76·2×100·3 cm. Yale University Art Gallery. Although this picture, which reflects Piranesi's influence, may date from 1760, it could have been painted after Robert's return to Paris in 1765. Robert spent almost a decade in Rome

25. Plate V from the *Carceri* by Piranesi. Etching

24

Day, Durno, Mitchel and Smith) who were to dine with me – being CHRISTMAS DAY, & spend the Evening.

This cosmopolitan background helped in the genesis of the neo-classical and romantic movements, in so far as they emerged in Rome. Stylistic relations may be observed, indeed, between the work of Abildgaard, John Brown (Fig. 28), David, Flaxman, Fuseli and Hamilton. The complex interplay of forces and ideas then existing has understandably intrigued art historians, and the researches of Gérard Hubert, Hugh Honour and Robert Rosenblum permit the situation to be seen much more clearly than was possible even seven years ago, when (May 1967) we published a special issue of APOLLO devoted to eighteenth-century Rome. Art heralded the immense political and social changes that took place at the close of the century.

Eighteenth-century Rome may be seen through many different eyes by means of the journals and letters of the visitors from different countries who had their first sight of the city when entering the Piazza del Popolo. There were monarchs and princes and, above all, English Grand Tourists, equipped with cash and curiosity, being bear-led by their tutors and taken round the sites by such antiquarians and ciceroni as 'Old' Nulty, Morison, Byres and the Abbé Grant. There were the artists, 'little' Cozens, setting off on a mule for a sketching expedition in the Campagna, or Ruby falling for a local girl.

There were eccentrics such as Mr. Walsh, a former London magistrate who would regale anyone who listened at the Caffè degli Inglesi with stories of London crime and whose daughter became a Catholic. Much about the Roman world is revealed in the Memoirs of Thomas Jones, who reported the death of poor Mrs. 'Pars', whose funeral was attended by the English colony. She had 'a taste for Poetry and elegant Amusements' and had been picked up in a Covent Garden bagnio by John Smart. Once he had finished with her, she ran off with Pars. It is a tale that could have inspired Hogarth or Fielding. Jones's writing has the directness of observation found in Boswell's account of his stay in Rome, where he came across John Wilkes and his tiresome Florentine mistress, Gertrude

Corradini; Wilkes was piloted by Winckelmann. Willison's delightful portrait of Boswell (Fig. 26) has an owl in the background—a proper symbol for a young man who was a night bird, a notorious womanizer and a frequenter of Casenove's brothel when in Rome. He caught the pox, which was diagnosed by Dr. James Murray, the Old Pretender's physician. Boswell's insatiable curiosity led him to strike up a friendship with Andrew Lumisden, the Old Pretender's secretary, who had looked after him with great devotion for so many years.

25

26

not the vivacity of that in London or Paris, music and plays were performed. For many it was a visit to Rome that was their first experience of the great world.

What pleasure is afforded by the group portraits of young Englishmen in Rome—that by James Russel (Fig. 21) and those by Nathaniel Dance, for instance—and how, despite the problems of travel in those days, can we see them without a touch of envy? Our country was then on the crest of the wave; now... ! What memories they must have enjoyed when, with gouty legs, they looked back on their youthful escapades in Rome. When casting an eye on a water-colour by Ducros or a portrait by Batoni, they must have recalled their exhausting outings with Byres or Morison or even 'Old' Nulty.

The lucky visitors would have seen the horse race in the Corso or watched one of the festivals—the Chinea perhaps—for which French artists are known to have done designs. No doubt, the more frisky milords, heated by Roman wine, would make their way to Casenove's.

How understandable that the foreigners provided rich fare for the caricaturist or the observer of human quirks. Reynolds is shown in an unexpected guise with his parody of the School of Athens and his caricatures of young sprigs in Rome. In thinking of the Roman scene, we may often recall David Allan's amusing drawings (Fig. 22), or Ghezzi's sharp caricatures of French artists.

Gibbon and Goethe were two of the creative spirits who gained inspiration in Rome. It was one of Rome's special qualities, in fact, to have nourished a constantly changing parade of talent, as artists of one generation succeeded those of another. There a painter could happily put down roots. One who did so was Angelica Kauffmann, who had attracted Boswell and outlived the century. How agreeable to think that this charming woman, whose urbane style matched the cosmopolitan upper class world of her day, was able, like the Abbé Sièyes, to survive disaster.

The eighteenth century ends on a melancholy note, with the disruption of the *ancien régime* and the English in flight. But it is comforting to find that such events did not spell the end of Rome's civilizing influence. Once the Revolution and the Napoleonic Wars were over, another phase opened. A new generation of Grand Tourists arrived and their features are preserved in the busts of Thorvaldsen and the drawings of Ingres. Rome was to find enthusiasts in Keats and Corot and, before long, in Hawthorne, Henry James, Bourget, Ibsen and many others. So the story continues.

By the second half of the century the Jacobites were down on their luck; the days were passed when grand musical evenings at the Pretender's residence, the Palazzo Muti, were eagerly attended by the Roman upper crust. Intrigue was rife in earlier days, when Baron Stosch, a knowledgeable expert on gems and the chief Hanoverian spy in Rome, organized a watch on the comings and goings at the Palazzo. The Jacobites were out of favour at the Vatican by the time such men as Boswell and Jones were in Rome and the last recognition to royalty bestowed upon the fading claimants to the English throne was when public mourning and a state funeral were ordered for the Old Pretender by the Vatican; the requiem mass was sung by Cardinal John Francis Albani, Protector of Scotland. However, no funds were available to execute Pietro Bracchi's monument to him in St. Peter's (Fig. 27). The end of a romantic dream came when Prince Henry Benedict, Cardinal York, died in 1807, an English pensioner. It was not the least of the Prince Regent's more charming gestures that he commissioned Canova to design the monument in St. Peter's that commemorates the House of Stuart.

Eighteenth-century Rome holds a particular fascination, even though we know that there was considerable poverty in the Papal States, especially after the famine of 1762. There was dirt and disease. Thomas Jones and others did not care for the fast days; the Welsh artist longed for roast beef and penned some amusing doggerel about the Italian food. Although cultural life in Rome had

[1] *Born under Saturn*, 1963.
[2] *Hollandse en Vlaamse veduteschilders te Rome 1675–1725*, Van Gorcum and Comp. B. V., 1973. It has an English summary.
[3] A useful account of Italy and the Grand Tour is provided in F. W. Hawcroft's catalogue of the exhibition on this theme held at the Norwich Castle Museum in 1958.
[4] Rudolf Wittkower's fundamental essay 'Lord Burlington and William Kent' has recently been reprinted in *Palladio and English Palladianism*, 1974.
[5] See Maria del Carmen Garcia Sáseta, '*Corrado Giaquinto en España*' and Alfonso E. Pérez Sánchez, '*Alg... ... ras de Giaquinto en colecciones españolas*' in *Atti Convegno di Studi su Corrado Giaquinto*, 1971.
[6] This reference is found in Svend Eriksen's *Early Neo-Classicism in Rome*, 1973, p. 30.
[7] A succinct account of classical archaeology is found in Carlo Pietrangeli's '*Archaeological Excavations in Italy 1750–1850*' in the catalogue *The Age of Neo-Classicism*, 1972. For a recent account of the beginnings of the Pio Clementino Museum, see S. Howard's article in *18th Century Studies*, 1973. 7(1).
[8] A handy account of Piranesi's career is in the catalogue of his etchings exhibited at Colnaghi's in 1973–74.
[9] A useful discussion about recent views on Piranesi is provided by Virginia Tenzer in the catalogue *The Academy of Europe. Rome in the 18th Century*, the William Benton Museum of Art, 1973.
[10] This letter appeared at Sotheby's, 12 March, 1974, Lot 298.

26. Opposite: *Portrait of James Boswell* by George Willison (1741–97) 1765. Oil on canvas, 134×94 cm. National Portrait Gallery, Edinburgh. The artist was in Rome in 1760–67

27. *Project for the tomb of James III (the Old Pretender)* by Pietro Bracci (1700–73), *c.* 1766. Pen and ink with blue, brown and white wash on paper prepared with brown wash, 37·2×25 cm. Art Institute of Chicago. Bracci had sculpted the tomb of Maria Clementina Sobieska, wife of the Pretender in 1739 in St. Peter's, and this design was projected for a monument in the bay opposite the same aisle, but it was never executed

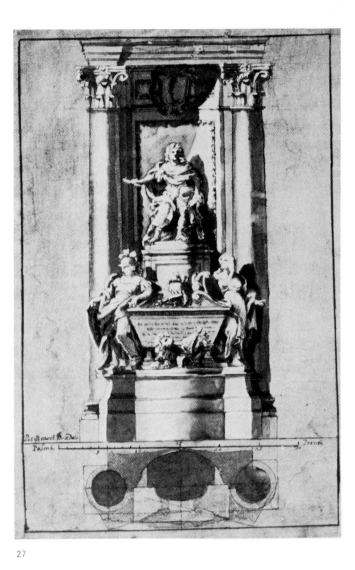

27

28

28. *The Basilica of Constantine and Maxentius with a murder in the foreground* by John Brown (1752–87), *c.* 1774. Pen and brown ink, 37·5×57·2 cm. National Gallery of Scotland, Edinburgh. The subject is akin to those favoured by Fuseli and Runciman. Brown was in Rome during 1771–81

1. *At the Portrait Painter's* by Thomas Rowlandson (1756–1827), 1798. Aquatint. Victoria Art Gallery, Bath. Plate VI from Rowlandson's series of caricatures, *The Comforts of Bath,* inspired by Christopher Anstey's highly successful poem, *New Bath Guide,* 1766. Other plates are reproduced as Figures 5–8 and are in the same gallery

Realms of Enjoyment

A melancholy comment on our era is that controversy should ever have arisen about the need to preserve Bath. This city, demonstrably an architectural masterpiece, is a precious jewel in the European heritage (about which we now hear so much), and it seems hard to credit that in our time destruction has gone so far as it has done and, if the vandals had their way, would go even further. The damage occasioned during the Blitz ought to have been enough for our century!

Bath may have come down in the world, but its somewhat shabby gentility, conducive to nostalgia, and its historical associations possess immense charm and require to be evoked by a latter-day Charles Lamb. Bath belongs to the national patrimony—artistic, literary, political, theatrical and social—and, for those who care about such matters, it has much to offer; the plaques denoting that notables once lived in such and such houses help to evoke the ethos of the city during its golden age.

The approaches to Bath are attractive. The motorist entering the city along the London road finds much to enchant him, not least the subtly curving Paragon with its Tuscan doorways. This street acts as a reminder that the visitor has arrived in a city which Landor once compared to Florence. The view from Lansdown or that from Prior Park reveals an architectural panorama of distinction and perpetual appeal. One pleasing way to come to Bath is to drive down Bathwick Hill, lined with patrician villas and not far from Claverton Manor, now the American Museum, where Sir Winston Churchill gave his first political speech. As the motor hums, the spirit mounts: pleasure lies in store.

The city has much to divert the eye. In addition to the

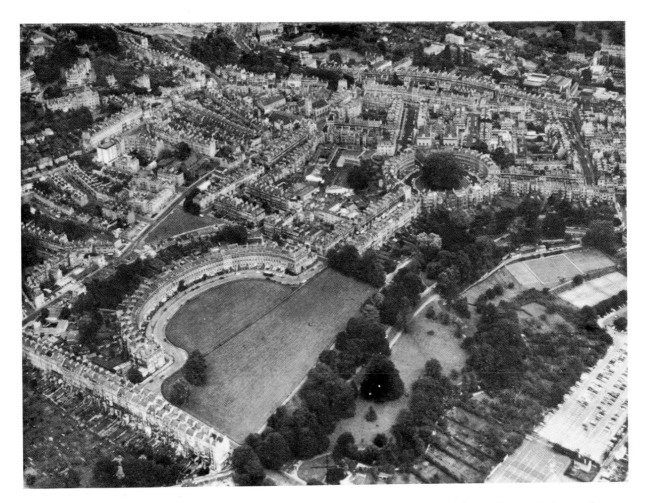

2. *Aerial view of Bath.* This City is the finest surviving example of Georgian town planning and urban architecture in the grand manner. This shows Royal Crescent, the Circus, the new Assembly Rooms and the Paragon. Photograph by Airviews (M/CR)

famous show-places—the Abbey, the Pump Room, the Octagon, the Assembly Rooms, the Circus, Royal Crescent, Pulteney Bridge and Great Pulteney Street—many small houses with elegant doorways and windows survive, even now, after so much alas! has vanished.

Bath is a city where the old tag from Martial—*rus in urbe*—rings true. Fanny Burney, who stayed there in 1780, was justified in speaking of 'the exquisite Crescent that to all the excellence of architecture that adorns the Circus adds all the delights of nature that beautify the Parades'. Despite the traffic, we can breathe in Bath. And its special features include vistas that open out from street to street, from square to square, and from the city to the verdant surroundings, to Beechen Cliff, described by Jane Austen and to Sham Castle, probably designed by Sanderson Miller in about 1755 for Ralph Allen, the generous owner of Prior Park.

Is it surprising that men of letters and artists have fallen in love with Bath? One was Sickert, who came to the city during the First World War and found an absorbing motif in Adam's Pulteney Bridge, with its Venetian echo. He spent his last years in a large and rambling house at Bathampton, with a colourful garden and a fine view of the city. It was a good place at which to end for someone who loved Dieppe and Venice.

Bath had once been a wool trade city. However, its medicinal waters, appreciated since Roman times, began to become increasingly popular in the seventeenth century, and royal visitors included Charles II and Catherine of Braganza and James II and Mary of Modena. However, its appeal as a fashionable resort began only in 1702 and 1703 when Queen Anne paid visits to it. From then on, the ill and the gout-racked and those who wanted a change from London or a chance to pluck the unwary flocked to Bath.

For some natures, watering-places hold strong appeal by providing a cross-section of Vanity Fair and by offering the sort of unexpected encounters that form the stuff of life, and inevitably novelists prowled there. Turgenev would have felt at home in Bath, not that in his time—the mid-Victorian period—he would have met there the sort of cosmopolitan crowd that thronged Baden-Baden, the spa immortalized in *Smoke*, or Wiesbaden, described in *Spring Torrents*. His compatriot, Dostoevsky, a confirmed gambler, would have succumbed to the tables which had such a magnetic attraction for visitors to Bath until the worst excesses of gaming were curbed in the 1740s. But in Germany no Beau Nash was available to stop the tempestuous Russian from venturing another desperate throw.

Eighteenth-century English literature—novels, poems, articles and letters—provides many amusing references to Bath, in the main of a flattering nature. The general sentiment was summed up by Mrs. Pendarves in a letter to Swift in April 1736:

I think Bath a more comfortable place to live in than London, all the entertainments of the place lye in a small compass and you are at your liberty to partake of them or let them alone just as it suits your humour.

Bath's appeal to visitors was largely due to the enterprise of Beau Nash, who arrived in the city in 1705. In 1708 he succeeded Captain Webster, who had fallen in a duel, as Master of Ceremonies.

Nash was amusing and warm-hearted and endowed with the valuable gift of self-assurance, a point made by Oliver Goldsmith in his polished life of the Beau. A true child of the Age of Reason, Nash believed in order, persuading the Corporation to carry out improvements in the city, such as cleaning the streets and installing lighting, and he inspired new buildings, such as Harrison's Assembly Rooms and the first Pump Room. He was a keen supporter of charity and, together with Ralph Allen, Dr. William Oliver, of Bath Oliver biscuit fame, and John Wood, the elder, he played a major role in raising funds for the General Hospital, of which the first stone was laid in 1738. Sporting his picturesque white beaver hat, the 'King of Bath' was an arbiter of taste and manners, laying down that swords were not to be worn in the city. G. M. Trevelyan even went so far as to claim (quoted by David Gadd in his charming *Georgian Summer*, 1971): 'Nash did perhaps as much as any other person even in the eighteenth century to civilize the neglected manners of mankind'.

One of his rules was that the well-born should not snub the less-so; he would put down those who tried to do so. All the same, Smollett gave a waspish picture of Nash in *Peregrine Pickle*, where he is described as being worsted by Miss Snapper.

When Nash was an octogenarian he fell on hard times, being forced to sell his collection of snuff-boxes, of which he was extremely proud. By all accounts he does not seem to have been well treated by the Corporation, which owed him a great debt of gratitude. The role of the Corporation in political and artistic life needs further assessment and a systematic study of the surviving papers.

Not the least of Nash's achievements was to turn the city into a pleasure resort, and it has been called the ancestor of Monte Carlo. Pope wrote to Martha Blount in 1714: 'I have slid, I cant tell how, into all the Amusements of the Place; My whole Day is shar'd by the Pump-Assemblies, the Walks, the Chocolate houses, Raffling Shops, Plays, Medleys, etc.'. The poet was a frequent guest at Ralph Allen's beautiful Palladian mansion, Prior Park, which was designed by John Wood, the elder, and visited by an intellectual élite; its spirit is evoked by James Lees-Milne in this issue.

Visitors of note were well served when they came to Bath. Their arrival was greeted by a peal from the Abbey bells and songs and music by the waits, honours for which remuneration was expected. The daily round centred on the Pump Room and the five baths, where both sexes bathed. Other diversions were numerous. At the start two main coffee-houses existed: Morgan's and the Parade coffee-house. It was customary for men to take breakfast in one of these, where a Bath bun cost fourpence and a dish of chocolate sixpence and a cup of coffee or a dish of tea was to be had for threepence. Ladies had their own coffee-house, where gossip waxed and no doubt talk fell on the delectable silks and ribbons to be bought in Milsom Street. Bath became a major shopping-centre. 'This elegant town', said Dr. Maty, the biographer of Lord Chesterfield, 'much resembles the Bajae of the luxurious Romans.'

Twice a week balls were held—at Simpson's (Tuesdays) and Wiltshire's rooms (Fridays). These started at 6 p.m. when Nash or the two most distinguished visitors present opened the ball with a minuet; an interval for tea, served by the men, took place at 9; and proceedings closed at 11. After all, the City was a health resort! The local guide-books, the first of which came out in 1742, reveal that these rooms were decorated with stucco work and with 'many curious landscapes'. It does not seem to be known who executed the paintings.

Amusements had to be paid for. In the first part of the century it cost two guineas to take out a subscription for the balls and concerts at the Assembly Rooms, and fees were levied for walking in the private gardens, for reading the papers and for the use of pen, ink and writing-materials at the coffee-houses. Above all, money was needed for the gaming tables. Gambling formed the theme of a play by Gabriel Odingsells, *The Bath Unmask'd*, performed at Lincoln's Inn, London, in February 1725 with John Hippisley in a major role, and in this sharpers are portrayed fleecing Lady Ambsace.

In the early years of the century Bath was a small city. To imagine it as it then was, we have to remove, for instance, most of the Bath that we see now: Great Pulteney Street, Queen Square, Royal Crescent and the Upper Town, so that we are left with a concentrated area which made it easy for smart visitors from London to carry on their affairs, both amorous and political. In 1738, to take one instance, Lord Chesterfield met Prince Frederick and the leaders of the Opposition there.

The guide-books remind us that Bath was a city for seasonal visitors: many lodging-houses are listed. Rooms cost ten shillings a week and a servant's garret five shillings; these prices were halved out of season. John Wood's famous description of Bath shows that prices had barely risen by the 1740s and, incidentally, it provides valuable details about the construction of houses; the floors, for instance, were laid with Dutch oak boards. The hotels included the Bear Inn, York House (which still exists) and the White Hart Inn and Tavern.

In the 1780s the last-mentioned was run by an innkeeper called Pickwick—also the name of a village close to Corsham—and readers of Dickens's famous novel will recall that, on Mr. Pickwick and his friends boarding the London coach for Bath, Sam Weller thought that his patron was being made a fool of when he saw the name Moses Pickwick inscribed on the door. Pickwick and his party put up at the White Hart before taking rooms in Queen Square, where poor Winkle got into trouble with Mrs. Dowler—a scene that is as farcical as Feydeau's *Un fil à la patte*.

Writing to Richard Stevens, M.P. for Winscott, Torrington, in 1767, Gainsborough declared: 'I believe Sir it would astonish you to see how the new buildings are extending in

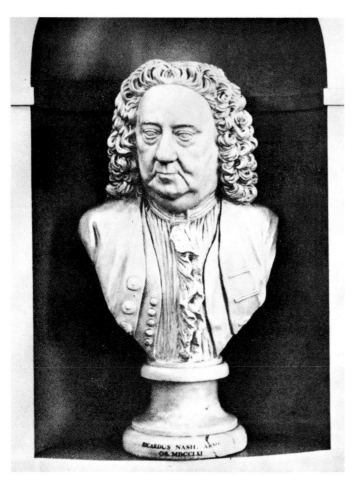

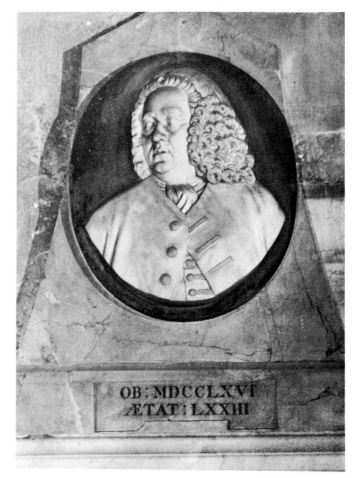

3. *Beau Nash (1674–1762)* by Prince Hoare, the elder (1711–61), 1761. Marble, height 91·4 cm. Victoria Art Gallery, Bath. Nash became Master of Ceremonies at Bath in 1708 and made the city the most famous spa in England

4. *James Quin (1693–1766)* by Thomas King (1741–1841), 1766. Bath Abbey. This memorial has an epitaph by David Garrick to his fellow actor, a 'six-bottle' man

all points from the centre of Bath'. Gainsborough's words denote the extraordinary change that had taken place since John Wood, the elder, began to develop the city from the mid-1720s; the Circus dates from 1759. Walter Ison, to whom all lovers of Bath owe gratitude for his detailed history of the city's architecture in its heyday, emphasizes in his article that Bath presents 'the finest and least impaired example of Georgian town planning and urban architecture in the grand manner'. Wood, the elder, was responsible for much of this and he was inspired by the desire to create a Roman city, with Vitruvius and Palladio in mind. His son, John Wood, the younger, was as gifted as his father: the results of their enterprise and taste are evident in such spectacular features as the Circus and Royal Crescent. Appealing indications of the city's appearance during the eighteenth century are provided by the water-colours and aquatints of Thomas Malton, the younger, who visited Bath on several occasions. J. R. Cozens also drew views of Bath.

The younger Wood was responsible for both Royal Crescent, a delicious achievement, and the New Assembly Rooms, close to the Circus, in the Upper Town. This building, which has been restored since the drubbing it received in the 1939 War, became the focal point of Bath life in the latter part of the eighteenth century, and for many years it contained Gainsborough's dashing portrait of Captain Wade, (Fig. 11), the nephew of Field-Marshal

Wade, who had been the early patron of Ralph Allen. The captain, like the great Nash, was an exigent Master of Ceremonies, insisting that boots should not be worn at evening assemblies and forbidding spurs in the morning; military and naval officers, when attending evening functions in uniform, were enjoined to wear their hair *en queue*.

The Woods were by no means the only architects active in Bath during the second half of the eighteenth century, when it was felt that speculation in real estate could prove profitable, which by no means turned out to be the case. The difference between then and now is that, on the whole, the buildings put up were noble and elegant. Thomas Baldwin, John Palmer and John Eveleigh were among those who contributed to the city's visual splendour.

One major development was financed by Sir William Pulteney. After Robert Adam had designed for him the charming bridge, which may be based on Palladio's projected design for the Rialto, Venice, the area dominated by Great Pulteney Street was opened up. This district contains Sydney Place, for ever associated with Jane Austen, Sydney Hotel (Fig. 14), now the Holburne of Menstrie Museum, and the celebrated Sydney Gardens. This resort, Bath's version of London's pleasure gardens, was popular with all classes. The gardens had waterfalls, Chinese bridges, a sham castle, a labyrinth and a fine Merlin swing, as well as four thatched umbrellas placed at equal

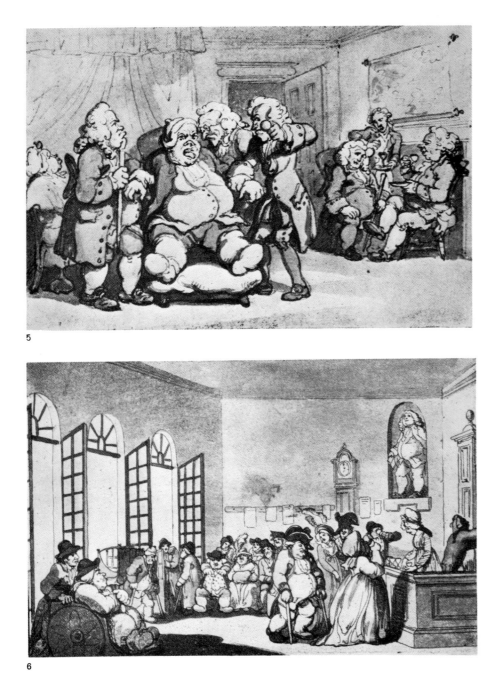

5

6

distances one from another, 'which are intended to serve as shelter from sudden rains and storms'. The firework displays staged there delighted Jane Austen.

In the 1760s Spring Gardens had been opened on the River Avon, opposite the Grove, to which access was gained by a ferry. Public breakfasts were held there twice a week. Tickets cost eighteenpence. Sixpence was charged for ordinary entrance tickets to the Gardens; these permitted the visitor to buy 'any Thing at the Bar to that Value'.

The growth of the city and the increase in the services offered may be gauged from the many contemporary guide-books and directories. They provide a picture of how the city developed and looked and supply the names of the lodging-house keepers and tradesmen, not to mention the doctors, surgeons and apothecaries who flocked to Bath. We find numerous wine merchants (hardly surprising when we recall that James Quin, the retired actor, would polish off six bottles of claret at a sitting!), banks, dancing masters, livery stables and Scrace's riding-school, and tea

merchants and grocers, not to forget Messrs. Shums, the German pork butchers. There were print-sellers and booksellers, the latter headed by James Leake, who were visited by everyone of note.

Sedan-chairs provided the main means of locomotion and, with good reason, Smollett complained of the difficulty of getting about and of the horror of mounting Gay Street in winter. Visitors to the Baths must have presented an odd sight when being carried home, wrapped up against the air. Some chairs were equipped with a clock. (One designed by a local craftsman, Loutier, dating from *c.* 1790, was shown in the recent 'Art Treasures' exhibition at the Assembly Rooms.) The guide-books, which carry information about the distances between places in Bath, also printed details about the rates to be charged by the chairmen. Doubtless arguments took place between an uninitiated visitor and a tough chairman. Returning home after an evening's amusement could be adventurous if the chairmen were in their cups, as was often the case.

Life at Bath was relatively care-free. People from varied

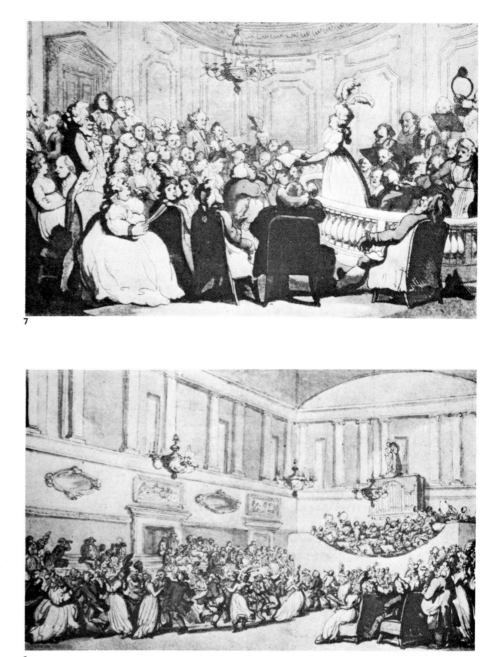

7. *At the Concert* by Rowlandson, 1798. Aquatint. *The Comforts of Bath,* Plate II. Many concerts took place in Bath

8. *The Ball* by Rowlandson, 1798. Watercolour, 12·3 × 20·5 cm. *The Comforts of Bath,* Plate X. The scene is the New Assembly Rooms

backgrounds were able to meet one another in the Pump Room, or at the balls, and opportunity was plentiful for romance, as it is on a cruise. The situation was very different from London with its stricter social barriers. Bath soon established a reputation as a profitable place for the fortune-hunter, as Steele observed in the *Spectator*.

The same point was made by the Abbé Prévost. This gifted novelist and general writer had fled from France in 1728 and spent some time in England, where he became an expert on our way of life and brought out translations of Richardson's novels in the 1740s and 1750s. In the literary periodical, *Pour et Contre*, which he started in 1733, he did much to spread a knowledge in France of English literature; No. 38 (1734) was a special issue devoted to English watering-places, including Bath. In this Prévost declared:

We shall find there at all times, Beauties of all ages who come to show their charms, young Girls and Widows in quest of Husbands, Women who seek Solace for Ones they possess, Players making or becoming dupes, Musicians, Dancers, Actors, growing rich on the pleasure for which others pay, and sharing it with them; finally,

Dealers in all kinds of Jewels, delicacies and gallantries, taking advantage of a kind of enchantment which blinds everyone in these realms of enjoyment to sell for their weight in gold trifles one is ashamed of having bought after leaving the place.

Vanity Fair also provides the Rev. Richard Graves with one of the best scenes in *The Spiritual Quixote or, The Summer's Ramble of Mr. Geoffrey Wildgoose* (1774), where Wildgoose meets Mrs. Booby, who, against her will, had been married off by her scheming mother. Another ambitious parent, Thomas Linley, the musician, tried to persuade his beautiful daughter, Elizabeth, known as the Siren and the Angel, to marry a wealthy Wiltshire landowner, Mr. Long. This lovely girl, whose features were so prettily captured by Gainsborough in a picture at Dulwich, was the subject of advances from the philandering Captain Matthews, and she eloped with Richard Brinsley Sheridan. The pair went to France, where they were married, but Elizabeth retired to a convent and the union was only consummated when they returned to England and were again wedded. Sheridan subsequently fought two

duels with Matthews, in the second of which he was severely wounded. Sheridan's memories of Bath coloured his enchanting plays, *The Rivals* (1775) and *The School for Scandal* (1777).

Romance of a more genteel type forms the theme of Jane Austen's two Bath novels, *Northanger Abbey* and *Persuasion*, written with an interval of some eighteen years between them. Spice is added to these books if we are familiar with the local background; Catherine Morland's first visit to a ball at the Assembly Rooms remains evergreen. Whether the modern visitor would endorse Sir Walter Elliot's view that 'the worst of Bath was the number of plain women' is a matter of speculation, but recent observation suggests that this condescending fellow would have a pleasant surprise if he were to stand today, as he did in his time, in a shop in Bond Street, where he saw eighty-seven women 'go by, one after another without there being a tolerable face among them'.

Jane Austen was good-natured about Bath life. Not so Tobias Smollett, that peevish if keen-eyed writer, who was put out that he failed to win success as a doctor in Bath, despite having published a flattering treatise about its waters. He described the city and its inhabitants in three books, *Roderick Random* (1748), *Peregrine Pickle* (1751) and *Humphrey Clinker* (1771). In the last-mentioned he dismisses the Circus as 'a pretty bauble, designed for shew'. He probably composed the first draft of this book when living in Gay Street in 1766, and he may not have been wide of the mark when he said that 'a very considerable proportion of genteel people are lost in a mob of impatient plebeians'.

Smollett's vivacity of style is excellently shown in the vivid accounts of Bath life supplied by the grumpy invalid Matthew Bramble in this novel. Bramble provided a satirical description of the mob of new rich who crowded into the city—clerks and factors from the East Indies and men from the American colonies, as well as war profiteers. They came, he said,

because here, without any further qualifications, they can mingle with the princes and nobles of the land. Even the wives and daughters of low tradesmen, who like shovel-nosed sharks, prey on the blubber of those uncouth whales of fortune, are infected with the same rage of displaying their importance; and the slightest indisposition serves them for a pretext to insist upon being conveyed to Bath, where they may hobble country dances and cotillons among lordlings, squires, counsellers and clergy.

These words, however jaundiced they may sound, suggest that the old days were over. In 1738, for instance, Lady Mary Wortley Montagu wrote to her friend Lady Pomfret: 'All the polite and gallant are either gone or preparing for the Bath'.

The fashionable world still came to Bath, but there was a tendency to infringe Nash's rule that private entertaining should not take place, and this attitude was reflected in the spacious drawing-rooms of the new houses in Royal Crescent and Great Pulteney Street. Access to London, also, was much easier. In the early years of the century, the journey was something of an adventure with the danger of highwaymen ever present, but by the 1780s for a guinea it was possible to take the 6 a.m. coach and reach London the same evening, Sundays excepted. The postal service was excellent too, thanks to Ralph Allen and John Palmer, who introduced mail-coaches, called 'flying machines'.

Today's Post Office officials should take note!

Fanny Burney's account of Bath in the 1780s is particularly informative. She was there with the Thrales and was joined by Dr. Johnson and Boswell. During her stay she made a special friend of the witty Lord Mulgrave and attended various entertainments, as when, with a critical ear, she heard an amateur, Miss Guest, playing Eichner and Clementi and singing *Io che fedele*. She also went to see Mrs. Siddons as Belvidera in Otway's *Venice Preserv'd*, but was carried away not by this actress but by a player called Lee in the part of Pierre.

This performance was given at the Old Theatre Royal, Orchard Street, in the Upper Town. The idea of building this theatre had been put forward by the actor John Hippisley, and its architect was to be the elder Wood, but, in the event, it was carried out by John Palmer. It existed until 1805 and, besides Mrs. Siddons, other stars, such as John Henderson, played there. Earlier a theatre had stood in Borough Walls (built in 1705), but this had been pulled down in 1737 to make way for the General Hospital. Until the opening of the Orchard Street theatre, plays were performed in what the elder Wood described as 'a cellar under part of the Ball Room of Simpson's Assembly House', and bitter rivalry existed between this establishment, known as Brown's, and the new one. The Orchard Street theatre, in its turn, gave way to the New Theatre Royal, built to a design by George Dance in 1805. The interior was decorated with four paintings by Andrea Casali which Paul Methuen had purchased at the Fonthill sale and presented to the theatre; they are now at Dyrham Park. In its prime the interior of the New Theatre Royal must have produced a glittering effect (Fig. 13).

Music played a large part in local life. One of the eighteenth-century guide-books declares that Nash's first care was the levelling of music subscriptions; public concerts started in 1704. Various intriguing personalities from the the world of music came to the City, including Thomas Linley and the Hanoverian (Sir) William Herschel. The latter was appointed organist at the Octagon Chapel, the most fashionable of the proprietary chapels in Bath, and later he succeeded Linley as director of music at the New Assembly Rooms. Music was not his only occupation and he was already keen on astronomy, about which he contributed several papers to the local Philosophical Society in 1780; two years later, on taking up the appointment of Court astronomer, he left for London.

The most talented musician to settle in Bath was Venanzio Rauzzini (Fig. 12), who was born at Camerino in 1746. He had been a member of the Papal Choir and made his début at the Teatro dell' Valle in 1765 in a female role; he worked in Venice, then for the Elector Max Joseph IV of Bavaria, and later in Milan, where he appeared in Mozart's *Lucio Silla*. Mozart wrote the motet *Exsultate, jubilate* for Rauzzini, who won a reputation as the finest exponent of the *bel canto* technique of the day.

Rauzzini, who sang at the Rotunda, Dublin, in 1778, had arrived in Bath in 1777 and joined with Lamotte in running the concerts at the New Assembly Rooms. He seems to have taken over the management entirely in 1780 and he then became Director. This all-round musician (he composed as well as sang) was a brilliant teacher and won much admiration from his pupils, as may be seen from the

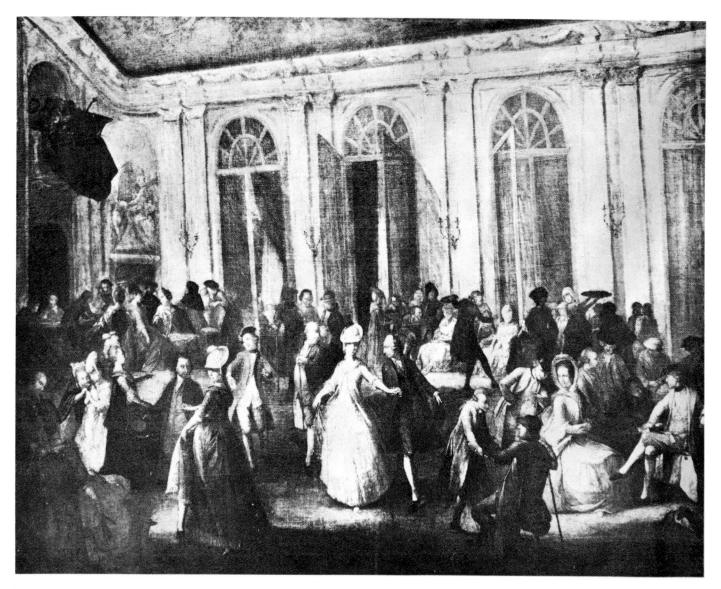

9. *The Pump Room* by John Sanders or Saunders (1750–1825). Oil on canvas, 76·2 × 61 cm. Victoria Art Gallery, Bath. This now hangs in the ante-room to the Pump Room

Memorial (1810) to him in Bath Abbey with its tender tributes from Braham and this singer's mistress, Nancy Storace. The musician kept open house in both his Bath home and his country villa, called Pyramid by Michael Kelly, which was situated in the Merrymead district. Haydn once spent three days there, during which he composed his celebrated round, 'Turk was a faithful dog and not a man'. Rauzzini appeared with the castrato singer Gasparo Pacchierotti, whose voice Dr. Burney compared to a pineapple, so superior was it to 'the generality of vocal sweetness', and G. F. Tenducci (a portrait said to be of him by Gainsborough is in the Barber Institute, Birmingham) in a performance of *Il tributo*, a cantata he composed for Beckford's twenty-first birthday. It was given at Fonthill. This trio also took part in the bizarre Christmas festivities held there the same year.

Fortunately, a first-hand account of musical life in mid-century Bath was provided by Henrietta, wife of Lord Luxborough, later Earl of Catherlough, and half-sister of Henry St. John, Viscount Bolingbroke, the well-known Tory politician in her letters to the poet William Shenstone, famous for his gardens at Leasowes. They were summarized by Marjorie Williams in a little-known and enter-

taining book, *Lady Luxborough goes to Bath* (1946).

Lady Luxborough, who did all the sights, was a frequent visitor to Gills, a celebrated cook-shop, and to Leake's bookshop at No. 5 The Walks, where with her friend, the Rev. Richard Graves (of whom more anon), she saw the bookseller's brother-in-law Samuel Richardson, wearing a plum-coloured velvet jacket. She often attended morning service at the Abbey and listened to the organist, Thomas Chilcot, playing Handel as well as his own compositions, which were in the style of Purcell. Handel, who drank the waters at Bath, was much admired in the city, and his music was frequently performed at the Concert Breakfasts held at Wiltshire's Assembly Rooms.

Another form of entertainment, if this is the correct word, attended by the fashionable world consisted of the sermons given by such leaders of the Methodist movement as John Wesley and George Whitefield (who served as the model for Richard Graves's Wildgoose) in the chapel of 1765, built by that religious enthusiast, Selina, Countess of Huntingdon, in the Paragon. This chapel, which has a charming Gothic manse, is still in use, and to watch the faithful leaving it on a Sunday morning is to be reminded of the strong Low Church tradition in the West Country,

10

10. *Peasants going to Market: Early Morning* by Thomas Gainsborough (1727–88), *c.* 1769. Oil on canvas, 1·21 × 1·47 m. Royal Holloway College, Egham. Henry Hoare, of Stourhead, bought this superb landscape from the artist before 1776

11. Opposite: *Captain William Wade* (d. 1809) by Gainsborough, 1771. Oil on canvas, 2·31 × 1·49 m. Collection Lord Burton, on loan to the City Museum and Art Gallery, Birmingham. Wade was Master of Ceremonies at Bath, 1769–77. Gainsborough later modified the background as the result of contemporary criticism

12. Opposite: *Venanzio Rauzzini* (1746–1810) by Joseph Hutchinson (1747–1830). Oil on canvas, 76·2 × 63·5 cm. Victoria Art Gallery, Bath. This charming Italian singer and composer made a great impact on musical life in Bath

of which Edith Sitwell provided a discerning account in her book on Bath.

A visit to a service at Lady Huntingdon's chapel gave Horace Walpole the chance to send John Chute one of his *bravura* letters, in which wit and observation are well blended. 'I have', he wrote, 'been at one opera, Mr. Wesley's. These have boys and girls with charming voices, that sing hymns, in parts, to Scotch ballad tunes; but so long that one would think they were already in eternity, and knew how much time they had before them. The Chapel is very neat, with true Gothic windows (yet I am not converted); but I was very glad to see that luxury is creeping in upon them before persecution; they have very neat mahogany for branches and brackets of the same in taste.'

Visitors to Bath had time on their hands, and, understandably, painters were able to make a living there. Gainsborough made a sensible move in leaving his native Ipswich for Bath, where he lived from 1759 to 1774. W. T. Whitley in his exhaustive life of the artist suggested that Gainsborough may have fallen out with the proprietors of the *Bath Journal* and *Bath Chronicle*, for he is rarely mentioned in them 'except when he pays for an advertisement, and he obtains at no time the effusive admiration that is bestowed upon immeasurably inferior and now long forgotten men'. He lived in the Circus, near the Duke of Bedford, and in 1763 he moved to Lansdown Road, though keeping his studio and show-room at the former address.

Gainsborough formed a circle of friends in Bath, people such as Walter Wiltshire, who ran a large-scale carrier service, was a staunch patron and became Mayor of Bath, the Linleys, Sir Uvedale Price, David Garrick, who often ran down to Prior Park, where the artist painted the famous

Stratford Portrait, destroyed in a fire, John Henderson and James Quin, whose portrait is in the National Gallery, Dublin; not to forget the terrible viper, Dr. Philip Thicknesse, a character worthy of Balzac, who wrote a life of Gainsborough. Other friends were medical men: Drs. Charlton, Moysey and Schomberg, who were called in for consultations over the mental condition of the artist's unhappy daughter Margaret. He also knew such musical personalities as Tenducci, and, on one occasion, his friend the violinist and prolific composer Felice de Giardini (whose portrait is at Knole) made the happy find of a violin in Bath.

During his years in Bath, Gainsborough, as Ellis Waterhouse points out in this issue, was transformed from a more or less provincial painter to a sophisticated and metropolitan one of European significance. This was hardly surprising in view of the fact that his sitters included the ravishing Mary, Countess of Howe (Kenwood), Lord Rivers and many others. He also was showing his pictures in London, at the Society of Arts and then at the Royal Academy, of which he was a founder member. He had, moreover, the chance of seeing the Van Dycks at Wilton and, no doubt, of visiting Corsham. His friend Dr. Charlton had a good collection of Old Masters and Whitley provides valuable dated information about the works of art shown in the city. In 1765, for instance, 'Mr. Champoine, Italien' advertised an exhibition of 'a large and curious collection of statues modelled from the antiques of Italy and France, and a number of new and old prints after the best masters'. Samuel Dixon and William Jones, 'Fruit Painter', exhibited Old Master paintings, but it is doubtful if they were of quality.

One of Gainsborough's clients was Joseph Langton.

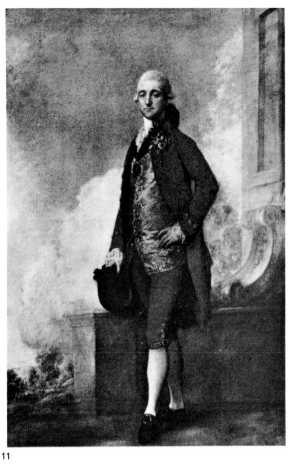

11

12

This well-off man of affairs commissioned full-lengths of himself and his wife; they were destroyed by enemy action during the 1939 War. The Langtons lived at Newton Park, Newton St. Loe, a charming house which possesses, as Sir Nikolaus Pevsner says, 'the noble reticence characteristic of the School of Bath' and at which 'Capability' Brown and later Repton were employed. Langton was related by marriage to Paul Methuen; this was an instance of the close connexions that existed between patrons at this period.

The environs of Bath presented Gainsborough with the chance of painting scenery unlike that of his native Suffolk. The lush nature of Somerset and Wiltshire contributed much to such landscapes as the melodious *Peasants going to Market: Early Morning* (Fig. 10). This was bought by Henry Hoare, of Stourhead, from the artist before 1776 and is now in the Royal Holloway College, Egham.

Gainsborough overshadowed other artists in Bath. His principal rival was William Hoare, who had known Batoni in Rome, and a touch of the polish characteristic of the Sargent of his day rubbed off on to his works. Hoare was a painter of character, could produce a full-length with skill and was adept with pastel. He requires further study.

Residence in Bath, for a painter, was not necessarily synonymous with success and in 1776 Wright of Derby said that he had only received one commission for portrait-painting; he believed he had 'come to the wrong place'. Two years earlier, of course, Gainsborough had left for London.

Another interesting, if obscure, artist to settle in Bath was John Sanders, or Saunders. After studying at the Royal Academy Schools in 1769, he lived in Great Ormond Street, London, and then moved to Norwich. In 1790 he came to

Bath, where he painted portraits, as well as a lively picture of the Pump Room (Fig. 9).

Later Thomas Barker, a jack of all trades, did well in Bath, finding a generous patron in Charles Spackman, who provided him with an attractive neo-classic mansion, Doric House, on the slopes of Sion Hill, designed by J. M. Gandy; Barker painted a frieze on the romantic theme of the massacre at Chios for the interior. The conversation-piece of the Robertson family illustrated in Dr. Holbrook's article is a reminder how rare are the paintings in this pleasing genre to depict the way of life of Bathonians. How sad that Hogarth, Hayman and Highmore never worked in the city and that no counterpart to Pietro Longhi or Carmontelle lived there; the last-mentioned could have made charming drawings of Fanny Burney and her circle.

Miniaturists and silhouettists were in demand in Bath, as may be seen from Mrs. Foskett's article in this issue, but there was never a local School with an identifiable personality. One silhouettist was Jacob Spornberg, born in Finland, who made a name for himself with his Etruscan profiles. He was a friend of the Italian jeweller, Fasana, who had a shop at No. 35 Milsom Street.

No first-class sculptors worked in Bath. However, Prince Hoare, the elder, brother of William Hoare, the painter, who had been a pupil of Scheemakers, showed an understanding of character which is evident in his able and telling busts of Ralph Allen and Beau Nash (Fig. 3). His other busts include one of Lord Chesterfield. Prince Hoare was active in the vicinity of Bath—at Corsham Court, Newton St. Loe, Steeple Ashton and Stourhead. The other local sculptor of talent was Thomas King, who ran a large-scale business, even undertaking work for as far afield as India and the West Indies. His monument of James Quin

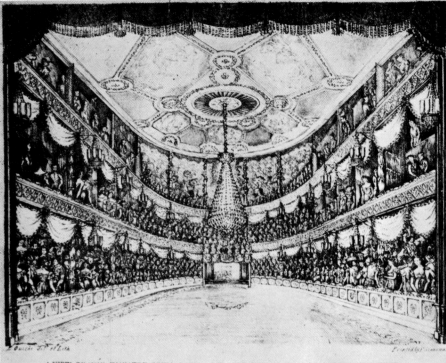

A VIEW OF THE THEATRE ROYAL BATH, AS IT APPEARED AT THE ROYAL DRAMATIC FETE.
IN HONOR OF HIS MAJESTY'S BIRTH-DAY Apr. 23. 1827.

13

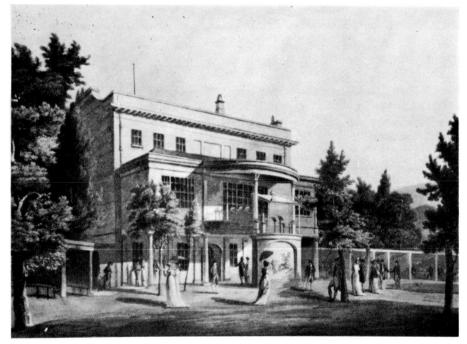

14

13. *The New Theatre Royal,* 1824. This shows the theatre, which was built in 1805 to a design by George Dance, the younger (1741–1825), on the occasion of a performance held to celebrate George IV's birthday

14. *Sydney Hotel* by Charles Harcourt Masters, 1796. Aquatint. From J. C. Nattes's *Views of Bath,* 1806. This building, remodelled, is now the Holburne of Menstrie Museum

15. Opposite: *North Parade,* attributed to Humphry Repton (1752–1818), *c.* 1785–90. Etching. Victoria Art Gallery, Bath

(Fig. 4) in Bath Abbey admirably evokes the spirit of this actor; it is inscribed with an epitaph by Garrick, which pleased Fanny Burney. The Abbey contains works by John Bacon, who did the charming neo-classical monument of Lady Miller, the literary patroness.

One of the most interesting sculptures in Bath is the statue of Nash in the Pump Room which has been given to Hoare. However, it was possibly done by the elder of the Pluras, and, amusingly, it turns up, with the long-case clock which Thomas Tompion gave to the city in 1706, in Rowlandson's drawing of this place (Fig. 6). Joseph Plura, the elder, did the City Arms on the tympanum of the Grammar School and the five busts. A design by the elder

Wood had been submitted to the Corporation in 1742, but, in the event, this excellent Palladian building (1752) was due to Thomas Jelly.

During the eighteenth century, no ceramists, glass-makers or silversmiths rivalled in Bath the sort of work done in other provincial cities; presumably such ware was brought from London. On the other hand furniture-making enjoyed a notable tradition and the many boarding-houses that sprang up required works of quality. Lady Fanny Flurry, Lady Rattle and Lady Riot—to quote characters from Richard Graves's *The Spiritual Quixote*—would not have been willing to take rooms furnished with sticks!

The earliest reference to a cabinet-maker hitherto known

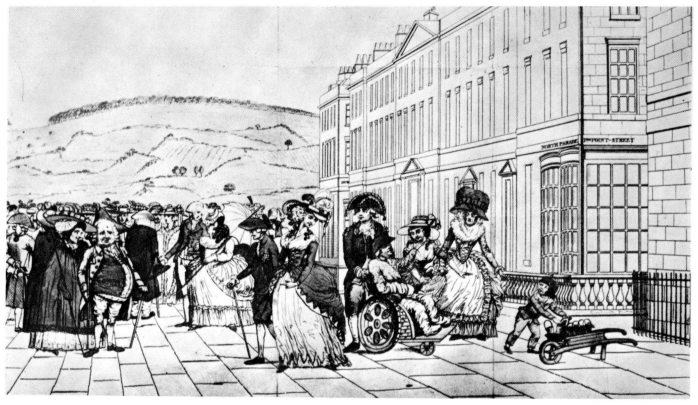

15

is that to W. Hancock in 1740, who advertised in the local Press. Another, Richard Philpot, was the brother-in-law of Sheridan and had his premises in Horse Street. The names occur of George David (Orchard Street); Joseph Albin and Edmond English, who are mentioned in the Bath Directory for 1781, as is William Hayes, painter and japanner; and John Stafford, who in 1793 started a firm in George Street and whose business was taken over by Thomas Knight and transferred to Milsom Street.

When the New Assembly Rooms were erected in 1771, the settees were made by Joseph Walter, cabinet-maker and chair-maker of Westgate Street. Work for the interiors was undertaken by T. G. Eyles and Robert Coxhead, who received orders to make mahogany tables, chairs (fifty at a time), card- and tea-tables, screens, etc. However, the the famous chandeliers came from London.

Local men were called in to undertake plaster-work for interiors, and their names are given in Philippa Bishop's article. She also mentions the vexed question whether or not the Franchini brothers worked in Bath before setting out to execute their delicious stuccoes in Dublin. In any event, a tradition of excellent plaster-work existed in the West Country, as may be seen from such seventeenth-century ceilings as those at Westwood Manor, Bradford-on-Avon. The plaster-work in the music-room, dating from the early part of the seventeenth century, possesses a lightness of touch suggesting how local men were later well equipped to capture the elegance of the Rococo.

Numerous men of letters came to Bath; among them, in addition to Pope, Smollett and Sheridan, were Addison, Dr. Arbuthnot, Defoe, Goldsmith, Steele and Wycherley—not to forget Dr. Johnson and Boswell (who put up at the Pelican Inn). Many derived inspiration from the comedy of manners that life in the City offered them. Their activity was such as to provide the theme for a comprehensive and readable volume, A. Barbeau's *Life and Letters at Bath in the XVIIIth Century* (with a preface by Austin Dobson), published in 1904.

Not all the authors who wrote about Bath were endowed with superior talent. Neither the Rev. Richard Graves nor Christopher Anstey was a professional. Both could be amusing. Graves was Rector of Claverton, close to Bath, and he would walk over to the City almost daily, regularly visiting Joseph Leake's bookshop. He had caused something of a stir by marrying the young daughter of a yeoman where he had lodged. He sent this pretty and charming girl to a boarding-school in London. Lady Luxborough, when visiting Claverton rectory, found her delightful, as she reported in one of her benevolent letters to Shenstone. Her ladyship and Graves became warm friends; they shared a pleasant sense of humour.

Anstey, whose father was a clergyman, went up to King's, Cambridge, where he became a Fellow and turned Gray's *Elegy* into Latin (Fig. 17). He lived in Cambridge until succeeding to the family estates. Although his father-in-law was an M.P., Christopher Anstey was 'an utter stranger to that restless ambition, which repines at the advancement of others', and his son, John Anstey, in a graceful introduction to the collected edition of his father's poetical work (1806) wrote:

Habituated to the charms of literary ease and retirement, passionately fond of the sports of the field, and the amusements of a country life, he followed the bent of his natural genius and inclination without restraint; and in the enjoyment of a competent and independent fortune, found leisure for the study of the Greek and Roman authors, and the poetry and polite literature of his own country.

Anstey won many friends, although sharp-eyed Fanny Burney found him 'shyly important, and silently proud'. But this was after he had produced a best-seller, *New Bath Guide*, which came out in 1766. Horace Walpole was

16

16. *The Bath Beau and the Country Beau* by Rowlandson. Water-colour, 31·11 × 26 cm. City Museum and Art Gallery, Birmingham, J. L. Wright Collection

17. Opposite: *Christopher Anstey* (1724–1805) by William Hoare (1707–92). Oil on canvas, 1·27 × 1·16 m. National Portrait Gallery. Anstey, the author of *New Bath Guide*, 1766, lived in Bath from 1770 until his death

especially fulsome, declaring that Anstey's ear was better than Dryden's or Handel's and that the poem had much wit, humour, fun and poetry and 'so much originality, never met together before'. Gray praised the poem in a letter to Wharton: 'It is the only thing in fashion, and is now a new and original kind of humour'. Fashion is fickle and Edith Sitwell's adverse judgement of his verse is more to the point, but some lines, all the same, were included by Iolo A. Williams in his excellent *The Shorter Poems of the Eighteenth Century* (1923).

Anstey's poem recounts the adventures of Simton Blunderhead, his sister Prudence, their cousin Jenny and a maid, Tabitha Runt. He had the knack of coining amusing names—Captain Cormorant, Mrs. Shemkin Ap Lee, the Duchess of Truffles, Sir Pye Macaroni and Count Vermicelli. Many entertaining passages of observation, doubtless providing a true reflection of life in the watering-place, may be found in it, as when he describes a public breakfast:

And t'was pretty to see how, like birds of a feather,
The people of quality flock'd all together;
All pressing, addressing, caressing and fond,
Just the same as those animals are in a pond.

The world has not changed!

One of Anstey's claims on posterity lies in the inspiration

his poem provided for Thomas Rowlandson, who in 1798 produced a set of twelve caricatures of Bath life based on incidents in it (Figs. 1, 5-8). *The Comforts of Bath* brilliantly shows Rowlandson's comic spirit, but it is as well to remember that the drawings were done nearly a quarter of a century after the poem was written and that his vision presents Regency, rather than Georgian, England.

As a caricaturist Rowlandson went in for exaggeration and the people who appear in his drawings can hardly have looked as he represented them, but, all the same, he makes us aware of what it must have felt like to be tortured by gout or to turn up at a ball at the Assembly Rooms; and whether we like it or not, our visual conception of English life in his day is largely coloured by his interpretation. His drawings for this series have his best qualities: rococo elegance combined with native rumbustiousness. The sardonic and humorous observation for foibles belongs to the national tradition and is one more usually associated with literature: Chaucer and Ben Jonson, Dickens and Trollope, Evelyn Waugh and Anthony Powell, Kingsley Amis and William Trevor.

When Rowlandson was in Bath is not known, but he did other drawings of Bathonian types, such as the superb *The Bath Beau and the Country Beau* (Fig. 16), and a

drawing of Squire Allworthy (who was partly based by Fielding on Allen), as well as a satirical print of a typical figure, a fortune-hunter, in this case an impecunious Irishman, Captain Shelalee, proudly parading his catch, poor overweight Miss Marrowfat in Royal Crescent. Rowlandson could also have found the sort of subject that amused him in the bagnios of Avon Street and in Holloway, the headquarters of the beggars.

Rowlandson was by no means the only caricaturist to find inspiration in Bath. The famous landscape gardener, Humphry Repton, may well be responsible for an amusing etching of *North Parade* (Fig. 15), dating from about 1785-90, and Henry Bunbury did the well-known print, *A long Minuet as danced at Bath*, originally published in sections. Robert Dighton spent his last years in the City, living at No. 17 Green Park, and his caricatures include three studies of old men, General Robert Donkin, Councillor John Morris and Dr. John Shepherd, issued in 1807. Cruikshank made in the 1820s prints of the Baths and Milsom Street.

What a shame that no caricaturist—Rowlandson would have been best of all—levelled his eye at the literary celebrations held by Sir John and Lady Miller at their rather ugly house, Batheaston Villa, now a Vedanta centre!

The Millers had brought home with them from Italy an antique vase which had been excavated at Frascati in 1759. Once a week a group of literati journeyed out to Batheaston and placed their poetical offerings in the vase, which was set up on a modern altar decorated with sprigs of myrtle. The Rev. Richard Graves and Christopher Anstey were of the company. On these occasions one of the ladies present would dip 'her fair hand into the vase' and the selected papers would be read out by one of the men. Then, as Pierce Egan ironically said in his guide:

This process being concluded, a select committee were named to determine upon the merits of the pieces, and adjudge the prizes: these retired into an adjoining room, and fixed upon the four best productions, the blushing authors of which, when they had identified their property by naming their private signatures, were presented by the high priestess, with a fillet of myrtle, and crowned amidst the plaudits of the company. The most sensible feature of the gala, a genteel collation concluded the business.

The harmless, if rather foolish, pastime of the Water-Poets came to an abrupt end when a wag placed in the vase 'some licentious and satyrical compositions to the extreme horror of the ladies assembled'. Needless to say, Iolo A. Williams drew the line at including any of the effusions of these poetasters in his anthology.

Bath's literary tradition did not die out at the close of the century. William Beckford retired there in the 1820s, building Lansdown Tower, which was inspired by the Lysicrates Monument in Athens, and living in Lansdown Crescent; his house made a welcome appearance in the film *The Hireling*, after the novel by L. P. Hartley, who himself lived in Bath. However, it was the film producer who transferred the action of this story from London to Bath.

Landor was a lover of Bath and in the first decade of the 1800s he spent the winters in the South Parade and the summers in Great Pulteney Street. He told Southey 'that there were formerly as many nightingales in the garden, and along the river opposite the South Parade, as ever there was in the bowers of Schiraz. The situation is unparalleled in beauty, and is surely the warmest in

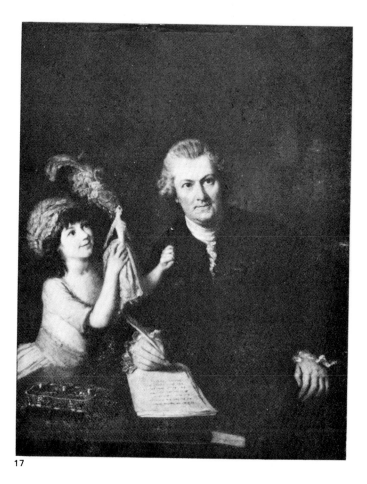

17

England'. Landor returned to Bath in the 1840s. Swinburne, too, evoked the beauty of Bath in lines speaking of 'the lovely city whose grace no grief deflowers'.

How appropriate, too, that the crusty old Tory, George Saintsbury, retired to No. 1 Royal Crescent, Bath, in 1915 when he gave up the Chair of Literature at Edinburgh and in his Indian summer wrote his delightful *Notes on a Cellar Book* and his *Scrap Books*. Saintsbury was typical of the sort of person who settled in Bath when it surrendered its fashionability. In the 1780s Cheltenham had already begun to attract the 'ton' on account of the visits paid to it by George III; then Brighton took the lead, favoured by the Prince Regent and the Lord Steynes of the smart world. Later in the nineteenth century German and Austrian spas offered refreshment to heavy swells, scheming mamas and *chevaliers d'industrie*.

Bath's magic is hard to resist. Pierce Egan was right when he said that 'the tout ensemble operates upon the mind of the stranger, like a well-written preface to an important and superior work, stimulating him eagerly to peruse every page of it, till he becomes completely master of his subject'.

Select Bibliography:
A. Barbeau, *Life and Letters at Bath in the XVIIIth Century*, 1904; Benjamin Boyce, *The Benevolent Man, A Life of Ralph Allen of Bath*, 1967; Pierce Egan, *Walks through Bath*, 1819; Willard Connelly, *Beau Nash*, 1955; Jean Freeman, *Jane Austen in Bath*, 1969; Oliver Goldsmith, *The Life of Richard Nash*, 1762; H. F. Keevil, *The Cabinet Making Trade in Bath, 1740-1964*; Walter Ison, *The Georgian Buildings of Bath from 1700 to 1830*, 1948; Nikolaus Pevsner, *North Somerset and Bristol*, 1958; Edith Sitwell, *Bath*, 1932; A. L. Smith, *Bath*, 1944; S. Sydenham, *Bath Pleasure Gardens of the 18th Century*, 1907 (reprint, 1969); John Walters, *Splendour and Scandal: The Reign of Beau Nash*, 1968; E. K. Waterhouse, *Gainsborough*, 1958; W. H. Whitley, *Thomas Gainsborough*, 1915; Marjorie Williams, *Lady Luxborough goes to Bath*, 1946; John Wood, *An Essay towards a description of Bath*, 1749; *A Select List of Books on Bath*, Bath Municipal Library (Handlist) 1972.

1

The Black Swan of Bom Jesus

Happy is the traveller who spends a few days in Bom Jesus do Monte, one of the most romantic spots in Portugal and the site of a pilgrimage church and a famous sacred garden. The late-eighteenth-century church, designed by Amarante, the son of a choirmaster in near-by Braga, may not have much to recommend it, but the flights of stairs leading up to it, the sculpture and the chapels, with their religious symbolism and the general effect, possess a theatricality worthy of Ferdinando Bibiena. The garden, too, is rich in sculpture, chapels and luscious trees; out of season it is invested with a touch of melancholy, almost Chekhovian in its poignancy, that would have appealed to a man of the theatre such as Alexandre Benois, who found congenial themes in the gardens at Versailles.

In the early part of the year Bom Jesus's gardens lack the profusion of flowers that turn it into a spring-time paradise, but the camellias bloom and near by mimosa abounds. The sky has a radiant intensity.

A few hotels are to be found at Bom Jesus, crowded in summer, but, in the winter months, either shut or only partly occupied and thus particularly attractive. The visitor is more or less cut off from the world: no news, no worries. Yet an old-fashioned carriage-lift takes the visitor down the hillside and then a bus brings him to Braga in ten minutes or so.

Bom Jesus is a place not only for the pious, but for lovers; they can gaze across the succulent Minho landscape and hold hands as the sunset falls. The scene has a Roman touch. What a pity that 'England's wealthiest son' never went there, for Beckford's fluent pen would have left a purple record of it, and that neither J. R. Cozens nor some Northern romantic sketched the view from the terrace.

Fireworks are continually being let off close to Bom Jesus (as they are at other pilgrimage places) in honour of saints, and they act as premature wake-up calls, alas! The atmosphere may be religious, but it is also whimsical. It is in keeping with this mood that the pond close to the church boasts a black swan. Swans have an aristocratic character (as was grasped by the modellers at Meissen) and at Bom Jesus the red-beaked and imperious bird symbolizes the grace and the element of the unexpected that so often occur in Portugal and that characterize the piquant flavour of the numerous mementoes of the eighteenth century that abound in the country.

'Most of the towns in Portugal lie like islands, not unfrequently like enchanted islands, in the midst of a desert sea', declared Professor H. F. Link, of Rostock University, in his account of Portugal published in English in 1801.[1] Braga is certainly an example of this. New buildings have sprung up recently, but, as yet, they have not engulfed this ancient city, which has Roman origins and is the capital of the Province of Minho and the seat of the Primate

of Portugal. It contains early buildings such as the Romanesque-Gothic Cathedral, but the city's main architectural heritage dates from the eighteenth century and was largely owing to the taste of three archbishops, Rodrigo Moura Teles (held office 1704-28), José de Braganca (held office 1741-56), the legitimized brother of João V, and Gaspar de Bragança (held office 1758-89), the illegitimate son of this king. Significantly, when the observant and entertaining Captain Arthur Costigan[2] and his travelling companion Lord Freeman visited the city with John Whitehead, the famous British Consul at Oporto, in the 1780s he was struck by the fact that no fewer than five convents were to be found on three sides on the main square. (He also noted that the Marquis of Pombal's efforts to found a silk-weaving industry at Braga were unsuccessful.)

One of the most attractive squares in the city is the Praça Municipal (Campo dos Touros), near to the Cathedral. This is dominated by the Archbishop's Palace (now the Biblioteca Municipal), which faces the City Hall, designed by André Soares; both are beautiful eighteenth-century buildings. In a square such as this a theatrical note is struck: any moment the curtain will rise, perhaps on a scene from a comic opera. A sense of gaiety is found in religious buildings and predominates in such secular ones as the Casa do Raio, designed by Soares. The Casa do Raio

1. Opposite: *Patricians in a rustic landscape,* blue-and-white tiles (*azulejos*). Palácio dos Biscaínhos, Braga

2. *The Palácio dos Biscaínhos from the gardens.* Probably designed by Manuel Fernandes da Silva, *c.* 1700

3. *The formal garden of the Palácio dos Bisçaínhos*

2

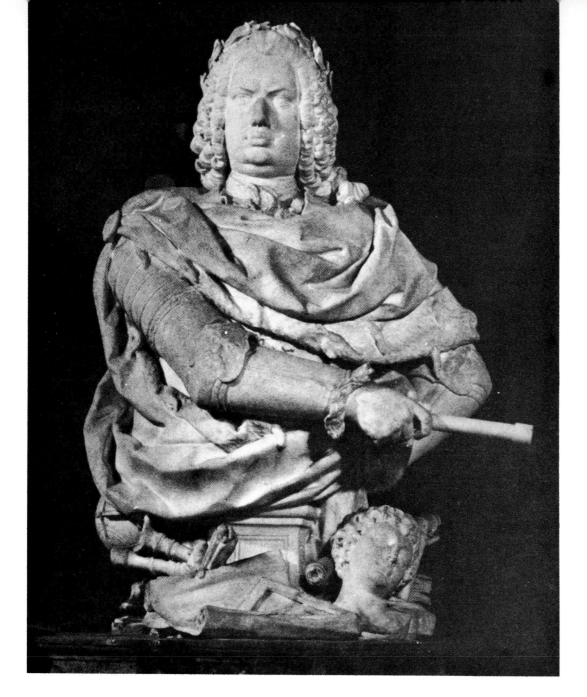

4. *King João V* (reigned 1706–50) by Alessandro Giusti (1715–99). Marble. Palácio de Belém, Lisbon

is one of the most spirited buildings in Portugal with its astonishing façade, as syncopated as a Severini, and its interior, where a stalwart stone Turk greets the visitor as he mounts the stairs. He is a figure of fun, half-way between a performer from a masquerade and one of those stuffed bears that often ornamented Victorian halls. (The old grisly that once stood in the entrance of the Mesdag Museum, The Hague, has been removed by our generation!) Appropriately, at the Casa do Raio a harlequin appears in the blue-and-white tile on the left of the stairs.

Greeting figures are also to be met with in the entrance, a covered courtyard, of the Palácio dos Biscaínhos: these stand on the capitals of the pilasters between the arches leading to the principal stairway. This palace, which until recently belonged to the family of the visconde Paço de Nespereira (which has Lancaster blood in its veins), is substantial and is being restored. It has delightful blue-and-white tiles on the main staircase. Such *azulejos,* with their rustic *fêtes galantes,* form a sort of background music to aristocratic and patrician life of the period and, with their feeling for landscape, recall the tradition of

landscape-painting inaugurated by Gaspard Dughet and appreciated by the sophisticated patrons of Rome.

The blue-and-white tiles in the Palácio dos Biscaínhos (Fig. 1) and the Casa do Raio (as in many other Portuguese houses) possess singular charm. It is tempting to see in these *azulejos* a reflection of some of the qualities which make Eça de Queiroz one of the most appealing nineteenth-century writers, cosmopolitan yet ineradicably Portuguese, as A. F. G. Bell once observed[3]; and we may associate with them the words this great scholar used to describe this novelist's contribution: 'a peculiar and highly seasoned sauce of which one had never previously known the flavour', but which conceals 'a substantial chicken for our consumption'. The same description may also be applied to the luxuriant woodwork (*talha*) that turns so many churches into caves of glittering stalactites.

The gardens at the Palácio dos Biscaínhos are enchanting (Figs. 2 and 3). At the back there is a small enclosed formal garden with fountains, sculpture, high 'mushroom'-structured topiary pavilions and shelter fountains and a gazebo that could well have hidden Dona Gracinda and

5. *The chapel of St. John the Baptist in the church of S. Roque, Lisbon* by Luigi Vanvitelli (1700–73) and Nicola Salvi (1697–1751). Commissioned by King João V in 1742

her admirer Cavaleiro. Colourful tiles are to be found and, as so often, there rises the smell of box-hedge with its slightly sexy tang, which haunts many Portuguese gardens, forming a foil to the stimulating smell of coffee exuded into the streets. This intriguing place is a translation of the more pompous type of garden found in Germany into an intimate form.

The enthusiasm and perception of Professor Robert C. Smith have permitted a deeper knowledge of the art of men such as Marceliano de Araújo, André Soares and Frei José de Santo António Vilaça, whose works make Braga one of the most fascinating cities in Portugal and a treasure-house for the amateur of the Rococo. Marceliano de Araújo carved the superb organ cases in the Cathedral, which present, as Sir Sacheverell Sitwell said,[4] 'an astonishing golden riot of tritons, dolphins, mermen and satyrs or devils'. He added, in a typical comment, that this organ would have been played by Carlos de Seixas, the Cathedral's organist, and a pupil of Domenico Scarlatti.

Braga's Rococo is individual with the explosive quality and humour of a mobile; it is earthy, too. The designers may have owed much to foreign prototypes, so that we may imagine artists and patrons seeking the ingredients for their cocktail in those German decorative engravings which, according to Professor Smith, were available in the great Benedictine monasteries close to the city. Yet, despite reliance on foreign sources, the men at Braga evolved their own style. It is significant that a foreign architect such as Nicolau (Niccolò) Nasoni, a versatile Tuscan, who had spent some time in Malta, did not neglect local

tradition, which had produced the exuberant Gothic-Manueline style, when he designed so many striking buildings for Oporto. He also made full use of the indigenous granite.

One of the most impressive of the convent-churches near Braga is S. Martinho de Tibães. Dilapidated and deserted, it would form an ideal setting for a Graham Greene story or a Buñuel film, and, in keeping with its almost surrealistic character, an elderly and amiable caretaker, improbably speaking mid-west American, shuffles the visitor round. Yet S. Martinho's condition does not detract from the boldness of the wood-carving after designs by Soares done by Frei José de Santo António Vilaça, whose work can be conveniently studied in Professor Smith's recent outstanding monograph published by the Gulbenkian Foundation.

Fortunately, the restoration taking place at S. Martinho should not present too much of a problem, for the region still possesses a fine tradition of craftsmanship; its practitioners may be seen working in the shops of Braga.

Portugal hit the headlines in November 1755 when a large part of Lisbon was destroyed by an earthquake with much loss of life. This tragic event provoked widespread consternation, not least because it dealt a sharp blow to the optimists; its implications were reflected in the writings of Voltaire and Dr. Johnson and later in Goethe's *Dichtung und Wahrheit*. The set of prints published by Le Bas in Paris recorded the ruins—a Piranesi-like image turned into reality. Yet if the earthquake destroyed much of the country's artistic heritage, the aftermath gave rise to a remarkable exercise in city-planning which remains as the most striking record of the Marquis of Pombal's dictatorship.

The half century before the earthquake witnessed a sharp change in the country's situation. The discovery of diamonds and gold in Brazil supplied King João V (reigned 1706-50) with immense resources to draw upon for his patronage of the arts.[5] João was an intriguing character who combined deep religious faith with libertinism; two of his mistresses were nuns. Keen on international prestige, he spent much energy and money in securing from the Holy See the establishment of a Patriarchate in Lisbon, of which the incumbent would be created a Cardinal. It is owing to the embassies sent by the King to the Pope that we owe some of the famous coaches (made in Rome) which are now in the Museu de Coches at Belém, on the outskirts of Lisbon.

King João, an absolute monarch, was rich enough to be able to go his way independently of the Cortes, which he did not summon. He sought to make his capital a centre of civilization, turning to France and Italy. His patronage was necessary, for during the seventeenth century, little of artistic value was achieved in Portugal owing to the Spanish occupation. But the artistic past was glorious: Batalha, Belém, Tomar, the Manueline style and Nuno Gonçalves are names to conjure with.

The King succeeded in securing a number of prominent Italians either to work for him or to come to Lisbon. One who did so was Domenico Scarlatti; he became maestro of the Royal Chapel at Lisbon in about 1720-21 and was there on and off until 1728, arranging a '*festeggio*

armonico' at the Royal Palace in January 1728 on the occasion of the engagement of the Infanta Maria Bárbara to the Prince of Asturias. However, João's ambition to get Juvara to design buildings for Lisbon did not materialize, although in 1719 this architect of Turin spent six months in planning a new palace in Lisbon and a large church for the Patriarchate.

Italian artists must have rubbed their hands with joy when news of the building of the convent-palace at Mafra reached them. The King erected it after a son had been born to him. Mafra was designed by the south German architect João Frederico Ludovice (Johann Friedrich Ludwig) and started in 1717; it echoes Rome and the Escorial and, as Beckford declared[6] with customary insight, it looks 'like the palace of a giant, and the whole country around it as if the monster had eaten it desolate'. In the first instance, it contained an array of pictures by Roman masters of the Rococo such as Giaquinto and Masucci, but, being affected by damp, these were replaced by sculpture. It is now a place of pilgrimage for the lover of Roman Settecento sculpture, for the basilica contains what is almost tantamount to a full flush of work by its main exponents, Bernardino Ludovisi, Monaldo, Corsini, G. B. Rosa and Foggini among them. Alessandro Giusti made the marble bas-reliefs for the altars and the brilliant portrait bust of the King at Belém (Fig. 4).

The admirer of Roman craftsmanship of the eighteenth century will find much to dazzle him in the chapel of St. John the Baptist (Fig. 5), which was commissioned in 1742 by the King from Luigi Vanvitelli and Nicola Salvi and, after having been set up in Rome for Pope Benedict XIV's inspection, was installed in the famous Jesuit church of S. Roque in Lisbon. The interplay of lapis lazuli, porphyry, agate and ormolu, as well as the mosaics after sketches by Masucci, give the interior an astonishing richness, almost Petersburgian in its exotic splendour. The chapel possesses a complement of silver-gilt plate, made by the best Roman craftsmen, such as Arrighi and Gagliardi, and embroidered vestments of superlative quality.

João was an Haroun-al-Raschid. He spent money lavishly, but it is as well to remember that the aqueduct Aguas Livres was put up by the Municipality in 1746-48. One of the most remarkable examples of his patronage was his commission for the building of the Royal Library at the University of Coimbra. A portrait of the King, very much the dandy, probably by Duprà, is seen at the end of that suite of rooms, which makes the Royal Library one of the most exquisite ensembles in existence; it was apparently designed by the Frenchman Cláudio de Laprada (Claude de Laprade). The chinoiserie effects, picked out in gold against the green, red and gold bookcases, have a magical effect which must have made reading there a pleasure for the contemporary student. The tables are no less magnificent, with their intricate design and rich woods, including jacaranda from Brazil. The ceilings by the artist António Simões Ribeiro are among the most accomplished of their type in Portugal.

Laprada was not the only Frenchman to work in Portugal during the eighteenth century. Pierre Antoine

76

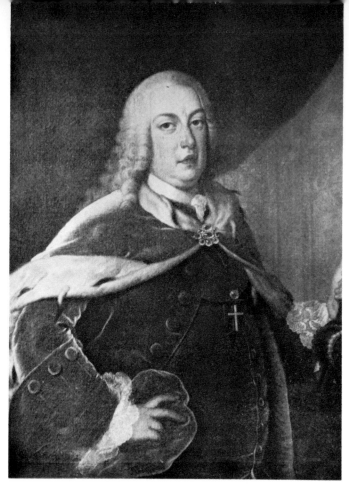

6. *King José I* (reigned 1750–77). Oil on canvas, 99 × 79 cm. Museu Nacional de Arte Antiga, Lisbon

Quillard,[7] a follower of Watteau, was employed by the Duke of Cadaval and painted (with Duprà) a large equestrian portrait of his patron, as well as typical *fêtes galantes*. The King dealt with the celebrated Paris art-dealer Mariette and during 1725-27 bought a group of seventy-five paintings from him; these were mainly Northern, including three works by Rubens and three Van Dycks and a Rembrandt; there was also an Albano, and, needless to say, Luca Giordano was represented! No fewer than 106 volumes of prints were sold by Mariette to João.

The King's delight in distinguished craftsmanship led him to place an enormous order for silver and gold work with the famous Parisian silversmith François-Thomas Germain; the treasure was destroyed during the earthquake. His successor, King José I (reigned 1750-77), patronized the same firm as did the Duke of Aveiro. José (Fig. 6) was not as interested in art as was his father; his passion was for music.

It was indicative of the Italian influence in Portugal that during his reign the plans for a new theatre in Lisbon attached to the Paço da Ribeira were sent to Giovanni Carlo Bibiena, a nephew of the more celebrated Ferdinando. Giovanni Carlo, none too keen on them, arrived in Lisbon with his collaborators in 1753 and two years later, shortly before the earthquake, his new theatre (Opera do Forte), was opened. Considered the most splendid in the world, its decorations, of gold on white, were so stunning that the audience could not concentrate on David Perez's opera *Alessandro nell' Indie*, to a libretto by Metastasio, which was performed on the opening night. This seems to have been a Cecil B. De Mille

7. *The Marquis of Pombal* (1699–1782) by Louis-Michel van Loo (1707–71) and Claude-Joseph Vernet (1714–89). Oil on canvas. Câmara Municipal de Oeiras. The French artists painted the picture on the basis of drawings sent from Lisbon

affair and a corps of cavalry and a Macedonian phalanx took part in the performance.

Perez, a Neapolitan of Spanish blood, is now a forgotten figure, but in his lifetime he was celebrated. José invited him to Lisbon in 1752 and there he composed *Demofoonte* for Gizzielo and the tenor Raaf (the Munich friend of Mozart). Its success was so great that the King bestowed on him the Order of Christ and the lucrative post of maestro at the Portuguese Royal Chapel. When the musician retired to Naples, his ship was captured by pirates and he lost all his possessions.

The old opera house was no less splendid. Lord Hervey, later third Earl of Bristol, who was in Lisbon in 1752 as a sailor, and there had some amusing amorous encounters, recorded in his diary[8] that he attended a performance of Perez's *Il Siroe* in the King's theatre. The theatre was, he wrote, magnificent:

It was built at an immense expense in his own palace, and was the finest theatre of the size in Europe, supported by marble pillars which had conveyances about for water in case of fire. The King's box took up all the front and was most magnificently ornamented, as was the whole, for everything was at the King's expense.

He describes how all the ladies were in boxes, as were the ambassadors, while the nobility (men) were in the pit. Only men sang and danced, as was also the custom at Rome. He reports that the orchestra consisted of about seventy performers 'in rich scarlet and silver clothes'; on each side of the theatre, he goes on, 'was a tribune for French horns, clarinets etc, who played between the acts'. It was difficult to get tickets, for the King 'had it purely for his own amusement'. Lord Hervey was lucky enough

to see the new opera house when it was in the course of construction, but he did not leave any detailed account of it.

Money was lavished by João and José on their amusements, but the economic situation in Portugal was poor; stern measures were required to arouse the country and improve commerce. These Portugal received from the Marquis of Pombal; he held power during the twenty-two years of the reign of José, who was content to leave the conduct of affairs in his hands. The minister, nicknamed the Pasha, was a tough customer; he crushed the power of the old nobility, expelled the Jesuits from the country and sought to limit the privileges of the British port barons. He was eager to establish a class of merchants and started many industries, few of which were successful.[9]

Those who are not specialists may find it difficult to secure a clear picture of the state of painting in Portugal during the eighteenth century; much of relevance perished in the earthquake and much was scattered. Foreign painters were active, such as the Florentine Vincenzo Bacherelli, who was the exponent of a watered-down illusionism, Duprà, Pillement and Delerive. Yet, it is hard not to sympathize with the duc du Châtelet when he called the School disappointing.[10] However, this was not everyone's opinion, for the Irish architect James Murphy, who was in Portugal in 1789, went out of his way to praise Glama Ströberle 'who would do credit to any School in Europe', but was unable to make a living in Oporto.[11] He was employed by Murphy's patron, the Irish dilettante William Burton Conyngham, 'in making drawings and

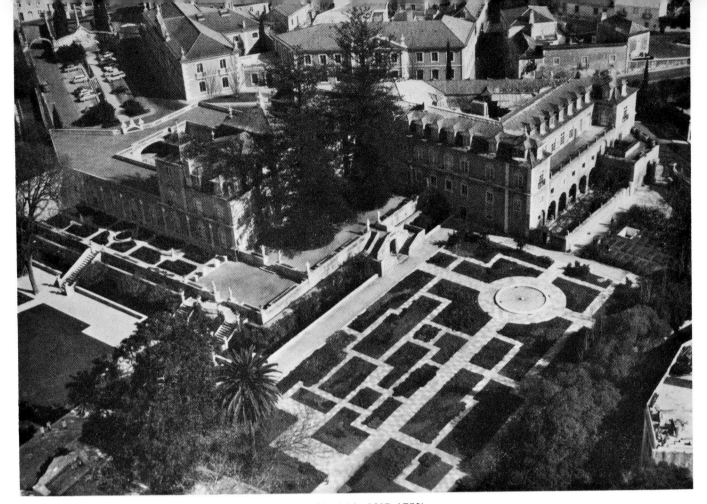

8. *Aerial view of the Pombal Palace, Oeiras,* designed by Carlos Mardel (*c.* 1695–1753)

sketches of antiquities, etc. which may be seen among this gentleman's valuable collection of papers relating to Portugal'. Vieira Lusitano, too, had admirers; Robert Southey when in Lisbon in 1800 was keen on his autobiographical poem, *O Insigne Pintor e Leal Esposo Vieira Lusitano* (1780).[12] This artist was no connexion of the talented Vieira Portuense (1765-1805) who was influenced by Angelica Kauffmann.

One important artist, Domingos António Sequeira (1768-1837), studied under Vieira in Rome and became a teacher at the Accademia di S. Luca there. On his return to Lisbon in 1787, his failure to establish an academy led him to withdraw into the Carthusian monastery at Laveiras where he painted the two unusual paintings of St. Bruno in prayer which are in the Museu Nacional de Arte Antiga, Lisbon, and the Oporto Museum (Fig. 11). and which show him to be a latter-day master of Zurburánesque solitude. He became Court painter and Director of the Art Academy at Oporto. He was compromised by his collaboration with the French invaders but, after serving six months imprisonment, he was restored to favour.

Sequeira began as a relatively graceful if conventional neo-Classicist, but it needed the new century to bring out his true gifts as a portrait-painter; his ability to render the mood of a sitter is admirably shown in the well-known sketchy portrait of King João VI (Fig. 10), so different from the very pedestrian one by the Frenchman Nicolas Delerive at Queluz. (Fig. 9), and in the cool and charming *Count of Farrobo as a boy* (Lisbon), which has an affinity with Goya. In the later phase, Sequeira exhibited a picture on the death of Camões (now lost) at the Salon of 1824

in the company of Delacroix, Constable and Lawrence. He produced dreamy and fantastic religious pictures influenced by Rembrandt and revelled in effects of chiaroscuro that recall Prud'hon. His sensitive and gentle eye is shown in his usually brilliant drawings; these include a portrait of Lord Charles Beresford, who was charged with the re-organization of the army during the Peninsular War.

The campaign against Napoleon was Great Britain's finest hour in Portugal, putting the seal on a treaty of friendship which dates from the fourteenth century and is being commemorated this year (1973). The British made their chief contribution in Oporto, as has been made admirably clear by René Taylor in the pages of the *Architectural Review*. Oporto was the natural recipient of British influence; it was the centre of the port trade which had received considerable stimulus from the famous treaty negotiated by John Methuen in 1703. During the latter part of the century British interests were admirably represented in the city by the Consul, John Whitehead, a bachelor with some of the attributes of a 'universal man'.

The full-length portrait of him that hangs in the Factory in Oporto depicts a bluff, smiling, open-minded character, so that we can well believe his love of experiments. His construction of a lightning conductor on the roof of his house got him into trouble, for, when a flowerpot was shattered by a flash of lightning, the matter was reported to the Inquisition; however, his position enabled him to extricate himself from this harmless scrape.

Whitehead was a talented amateur architect and his

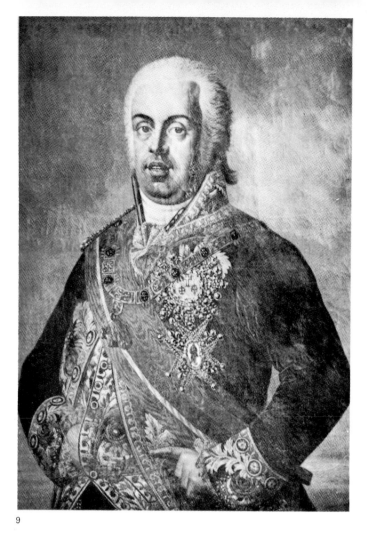

9

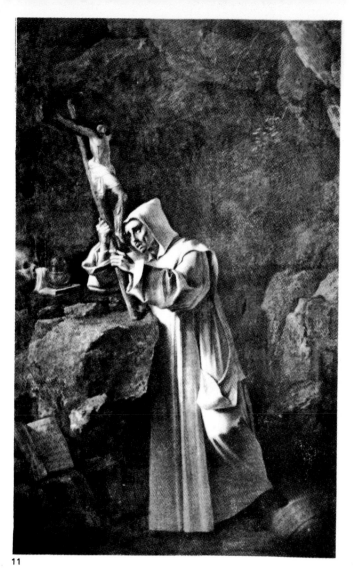

11

10

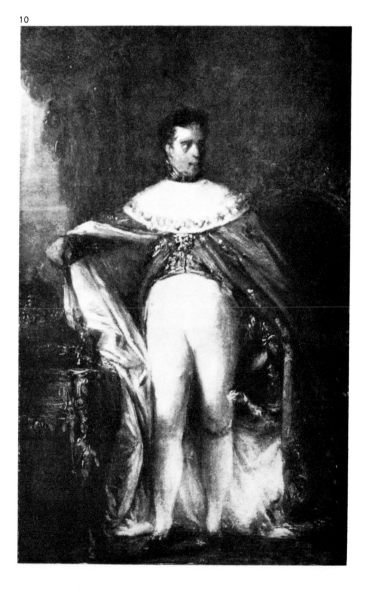

skill is shown in the sober and well-balanced design, inspired by Robert Adam, of the British Factory, which is still a British club, complete with an elegant ballroom, Chippendale-style chairs, and Rockingham china and where admirable port is served. Whitehead formed an alliance with the governor João de Almada, and his son, Francisco, and the British stamp evident in the city was due to this triumvirate. British Palladianism has a splendid monument in John Carr's Hospital of San António, which has bulldog strength and the influence of this style may be discerned in other buildings in Oporto, such as the Palácio dos Carrancas (now the Museum), the University and the Bolsa (Stock Exchange).

Another instance of the way in which the British presence made itself felt in Portugal is provided by the fact that, whereas the marble statues in the gardens of Queluz close to Lisbon, came from Italy, the lead ones were imported from Great Britain. These pieces (which were pigmented) were ordered in 1756 through the Portuguese Ambassador in London and came from the workshop run at Hyde Park Corner by John Cheere (died 1787).[13] One of these is a life-size copy of Giambologna's *Samson and the Philistine* (known in the eighteenth century as 'Cain and Abel') and then in the collection of the Duke of Buckingham at Buckingham House, London; it is now in the Victoria and Albert Museum.

With its tender pink walls, Queluz is one of the most enchanting small Rococo palaces in Europe. The main part was built by Mateus Vicente de Oliveira for Pedro,

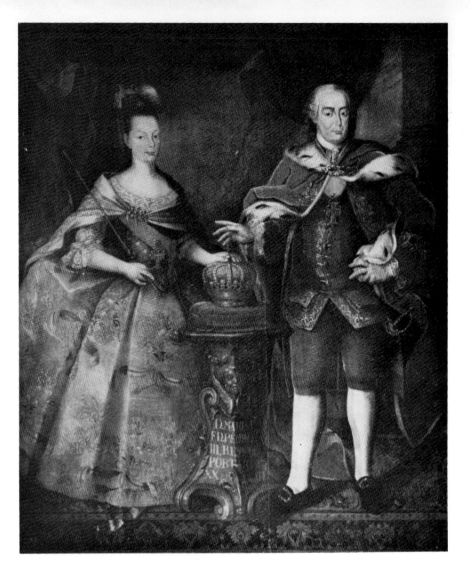

9. (see page 79) *João VI (Prince Regent 1792–1816)* by Nicolas Delerive. (1755–1818). Oil on canvas. Queluz Palace

10. (see page 79) *João VI* by Domingos António Sequeira (1768–1837). Oil on canvas, 32×24 cm. Museu Nacional de Arte Antiga, Lisbon

11. (see page 79) *St. Bruno* by Domingos António Sequeira, 1787. Oil on canvas. Museu Nacional de Soares dos Reis. Painted in the Carthusian monastery of Laveiras

12. *Queen Maria I (reigned 1777–1816) and Dom Pedro (1717–86).* Oil on canvas. Museu de Coches, Belém, Lisbon

the second son of João V, who subsequently married his niece, Queen Maria (Fig. 12). However, when this architect was called upon to assist in the rebuilding of Lisbon, the Gabriel-like western or garden pavilion was designed by J.-B. Robillion, a French architect and silversmith, who also laid out the gardens, which pay subtle homage to Le Nôtre. An unusual and delightful feature of the gardens, which once had a Chinese pavilion and a wooden theatre, is the canal, lined with tiles designed by the Dutchman Gerald van der Kolk under the direction of Robillion. In 1760 Lord Kinnoull, who was engaged on a special mission to José I in connexion with the French hostilities, saw three barges filled with people in allegorical costume sailing on this canal.

The interior is as intimate as a Rococo one should be; it is easy to imagine it filled with Court officials looking like Meissen figures. The music-room and the Hall of the Ambassadors are especially pleasing with their stucco ceilings. No less sympathetic is the breakfast room painted in green, gold and white and decorated with amusing if mediocre pictures of picnics by João Valentin and José Corrado Rosa (Fig. 13), which are related to the sort of works painted by José de Castillo in Spain. After a visit to this sugar-icing Palace, luncheon in the restaurant situated in the old stables is rewarding; the *table d'hôte* can be recommended. What more agreeable than to return to the Palace and visit the gardens.

Beckford haunts the mind at Queluz, for he provided an account of his visit there in 1794 (found in *Recollections of an Excursion to the Monasteries of Alcobaça and Batalha,* of which a new edition by Boyd Alexander was published by the Centaur Press in 1972, £6·50); it is evocative, poignant and revealing. He made a contrast between the starched life indoors and the romantic one outside, when he and Dom Pedro, the son of the Marquis of Marialva, ran a race with two of the forty pretty girls attached to Dona Carlota Joaquina, Princess of Brazil. He also danced the bolero with an Andalusian, who was not quite young enough for his taste. His account ends with his being summoned into the presence of the Prince Regent (João VI) and with his departing to the sound of the cries of the demented Queen Maria.

Queluz is by no means the only eighteenth-century palace in or near Lisbon. One of the few large buildings to survive from the Joanine period is the attractive Palácio de Necessidades (now the Foreign Office), built for King João by Caetano Tomás de Sousa in 1745-50; it enjoys a lovely view over the Tagus, an elegant façade and pretty interiors. The palace-fancier will also enjoy F. S. Fabri's Palácio Castelo-Melhor Fox (headquarters of the National Secretariat of Information), which was built in about 1777 for the Marquis of Castelo-Melhor and lies in the heart of the capital.

Less familiar is the Pombal Palace by Mardel at Oeiras, close to Lisbon (Fig. 8). The appeal of this powerful house in terracotta and white lies not so much in the street façade as in the north façade and back view and its garden with its tiles, fountains and sculptures of Homer,

13. *Breakfast room, Queluz Palace.* The paintings are by João Valentin and José Corrado Rosa

13

Virgil, Tasso and Camões given to Joaquim Machado de Castro, the main Portuguese sculptor of the time to whom is ascribed the enchanting polychromed sculpture in the Museu Regional, Aveiro. The interior contains tiles, painted and stuccoed ceilings and a chapel.

Eighteenth-century Portugal did not have the resources to permit its nobility to build houses of the calibre of Blenheim, or Wentworth Woodhouse, Syon House or the many others that make (or made) Great Britain so rich in domestic architecture of this type. Yet even the hurried traveller realizes that Portugal possesses many delightful small houses (the sort of house depicted in Eça de Queiroz's novel *The Illustrious House of Ramires*) as well as one splendid show place, the Solar de Mateus near Vila Real in the north which is so familiar from the advertisement for *vin rosé*. It is a splendid building with an exciting Italianate façade (as was only to be expected, as Nasoni was the architect), statuary and a huge coat of arms. The interior matches the exterior, as Sir Sacheverell Sitwell pointed out, remarking that this is rarely the case in Portugal.

Although the economic situation was far from bright in late-eighteenth-century Portugal, life could be delightful, especially for the foreign merchants who lived there, men such as Daniel Gildemeester, who had been given the monopoly in diamond exports by Pombal and resided in the charming Quinta da Alegria (now called the Palácio Seteias). The arch and the right-hand portion of this house were added later – Beckford provides a lively account[14] of attending a soirée at the house of this wealthy business-man, who was Dutch Consul-General and had a flighty wife.

One of the most interesting of the wealthy art lovers was Gerard de Visme (*c.* 1725-98), who arrived in Portugal in 1746, remaining there until 1792. He was the fifth son of Philip, comte de Vismes and Marianne, daughter of Piquet, Marquis de Magaens, French Huguenots who had settled in Great Britain. His first business associate was David Purry of Neuchâtel and the two men had received from Pombal the extremely lucrative concession for the

import of Brazilian wood. They were tenants of the Marquis in the Rua Formosa, paying him a considerable rent for the privilege, and, with skilful flattery, they commissioned a portrait of their patron (Fig. 7) in which the figure was painted by L.-M. van Loo and the background by C.-J. Vernet in Paris on the basis of sketches furnished by two Portuguese engravers.

De Visme, who was a member of the British Factory, was responsible for founding the British Hospital at No. 4 rua d'Estrela: it was in use until 1843. He owned the splendid neo-classical style *quinta* at Benfica, outside Lisbon, which was built for him by Inácio de Oliveira Bernardes and owned a collection of antiques, curios and paintings. He entertained there, said William Hickey[16] 'in a manner never surpassed and seldom equalled'. Beckford, another visitor, said it 'eclipses all the glories of Bagnigge Wells, White Conduit House, and Marylebone in leaden statues, Chinese temples, serpentine rivers and dusty hermitages'.[17] To quote Hickey again:

The establishment was in every respect princely, the house a perfect cabinet, the grounds laid out with peculiar taste, having in them all the rarest plants of the European world and some even from Asia and America, but what delighted me was the songs of nightingales innumerable pouring out their sweet notes in broad daylight. Mr. de Visme told us that he had been at great expense in enticing them by various stratagems to his woods, but had at last so completely succeeded as to have their music for full eight months in the year.

De Visme's *quinta* has come down in the world, but fortunately the outside and the enchanting gardens are recorded in two paintings by Nöel in the Philadelphia Museum of Art (Figs. 14 and 15) and four pictures by Pillement in the Musée des Arts Décoratifs, Paris. Pillement, who was denounced to the Inquisition in 1755 as an 'atheist, freemason and sodomite', seems to have painted pictures for the interior and decorations for various *quintas* at Sintra. He also painted a delightful picture of the Tagus which was shown at the Royal Academy French eighteenth-century exhibition in 1968. De Visme owned the *quinta* Montserrate at Sintra, which he built in the medieval taste;[18] and which (rebuilt) was for

14. *View of the De Visme Quinta at Benfica, near Lisbon* by Alexandre-Jean Noël (1752–1834). Oil on canvas 83·7×107 cm. Philadelphia Museum of Art. Gift of John H. McFadden, Jr. Gerard de Visme (*c.* 1725–98) was a wealthy British merchant resident in Portugal

many years in the possession of the Cook family.

The British colony had a pleasant time in Lisbon and William Hickey described his visits to the *quintas* of Sintra and the dinners in the city—a sumptuous one, by the way, at the house of the British Ambassador the Hon. Robert Walpole, and his pretty wife, who would never receive poor Beckford. Hickey lodged at the hotel run by Mrs. Williams, an old Irish widow, which was situated in the Buenos Aires quarter, near the Church of Estrela and commanded a fine view of the Tagus. He had a commodious suite there, dining-hall, breakfast room and drawing-room. His fellow guests included Lord Winchilsea, who had gone to Lisbon for his health, as did Henry Fielding, who died there. The portrait-painter Thomas Hickey (no relation of William Hickey) also lived at Mrs. Williams's hotel in 'four handsome rooms'. After having painted most of the British colony, he was then engaged on doing 'several Portuguese of rank'.

Many British writers and travellers left impressions of Portugal during the eighteenth century—Beckford, Twiss, Wraxall among them. Unfortunately that interesting visitor, William Burton Conyngham (to whom reference has already been made), did not do so. It is thanks to Edward C. McParland[19] that this intriguing dilettante is better known and he points out that he visited Portugal in 1783 with a Colonel Tarrant and a Captain Boughton. On this journey he visited the ruins of the Dominican church and monastery of Batalha and, through him, James Wyatt learnt about this monument of Portuguese architecture, which influenced Wyatt's work at Lee Priory. Conyngham was so excited by Batalha that he commissioned James Murphy to make drawings of the convent with a view to a publication. Murphy accepted and when at Batalha he wrote to his patron that the Bishop of Beja, who financed the excavations there, had declared[20]:

Mr. Conyngham has done more for the Arts than all Portugal put together, and he has now sent us a person to perpetuate those noble Monuments of Antiquity, the pride of our Nature, this little Herculaneum.

Murphy may have been a difficult fellow—known for his bad temper and his inability to make friends—but he was shrewd. It was in keeping with his talents that, in writing to tell his patron that the world 'will have a right to thank your penetration in bringing to light such a masterpiece of hidden Gothic elegance', he took to task his predecessor Twiss, 'who could so minutely describe the wretchedness of an Irish hamlet on the bleak mountains of Tipperary', for seeing nothing in 'this venerable pile'. Murphy had a mind of his own, telling Conyngham that of Whitehead's factory at Oporto, very little can be said, 'being in the anti-Moorish style, like all the modern works of architecture in this country'.

Murphy is now a neglected figure—unjustly, for he not only played a part in his own country as one of the circle associated with Conyngham. Mr. Edward C. McParland observes that Murphy clearly shared his patron's bias against James Gandon, as is seen from his criticism of the Dublin Custom House in *Travels in Portugal*. This book, which came out in 1795, and the *Plans, Elevations Sections and Views of the Church at Batalha* published in the same year (and in a second edition in 1836) suggest that his writings about Portugal's great Gothic church may have contributed much to the diffusion of a taste for this style in Great Britain; it has even been claimed that its influence may well have been comparable with that of Stuart and Revett's *Antiquities of Athens* on the Greek Revival.

When in Portugal, Murphy noted[21] that there was little licentious living and 'the fine arts, which to the superior classes of every nation of Europe are sources of the most

15. *Another view of the De Visme Quinta at Benfica, near Lisbon,* by Alexandre-Jean Noël. Oil on canvas, 83 × 107 cm. Philadelphia Museum of Art. Gift of John H. McFadden Jr.

refined pleasure, are almost entirely neglected by the Nobility'. Nevertheless, in the closing years of the century Pombal's policy of stimulating a rich merchant class had yielded results. There were men such as José Ferreira, who was an important contractor in leatherwork to the army and whose new house on the north side of the Chiado, finished in 1787, provoked sarcastic comments from that *arbiter elegantiarum*, Beckford.

Dr. José-Augusto França in his brilliant and detailed *Une ville des Lumières, la Lisbonne de Pombal* (1965) has provided interesting facts about emergence of new social classes, noting that the town houses of both the 'old' and the 'new' aristocracy were built only some fifteen years after the earthquake. It is a telling comment on the situation at this stage that it was only in 1792 that four families, the Quintelas, Cruz-Sobrals, Bandeiras and Caldases, took steps to secure the building of a new opera house. This was the Teatro de S. Carlos, a very Italianate venture, designed by José de Costa e Silva. It is one of the most elegant neo-classical buildings in Lisbon and it and the church of Estrela (1779-90), which contains pictures by Pompeo Batoni, were the only notable buildings erected in the city during the reign of Queen Maria I.

The architect of the Teatro de S. Carlos collaborated with the Italian F. S. Fabri in designing the interesting Palácio da Ajuda, begun in 1802 and finished in 1835. It is as Professor Smith observes,[22] a building which interestingly shows how echoes from the Villa Albani-Torlonia in Rome and from Piranesi could be combined with earlier elements, as may be seen in the two angle towers that 'go back through the Pombaline pavilions of the Praça do Comercio to the tower of the Casa da India of Lisbon's sixteenth-century Italian architect Filipe Terzi'.

An examination of neo-Classicism in Portugal[23] would take us into the nineteenth century. It is perhaps convenient to end this survey with the departure of the Prince Regent, his family, Court, government and retainers for Brazil on 27 November, 1807, under the protection of a British Fleet. The French under Junot moved into the city, and the curtain came down on the eighteenth century.

[1] *Travels in Portugal and through France and Spain*, translated by John Hinckley, London, 1801, p. 144.

[2] *Sketches of Society and Manners in Portugal*, London, 1787. For an account of Costigan and other visitors to Portugal, see Rose Macaulay, *They Went to Portugal*, 1946.

[3] 'Perspectives of Portuguese Literature' in *Portugal and Brazil*, ed. H. V. Livermore, 1953, p. 128.

[4] *Portugal and Madeira*, 1954, p. 183.

[5] For detailed treatment of this subject, see Ayres de Carvalho, *D. Joao V e a arte seu tempo*, 2 vols., 1962.

[6] *The Journal of William Beckford in Portugal and Spain 1787–1788*, ed. Boyd Alexander, 1954. This exemplary edition contains much valuable information concerning Beckford's contemporaries in Portugal. For a convenient summary of work done at Mafra, see Robert Enggass, 'Bernard Ludovisi—III: His work in Portugal' in *Burlington Magazine*, 101, November, 1968, pp. 613–18.

[7] Information about Quillard and other French painters working in Portugal is contained in Michel N. Benisovich, '*Quelques Artistes Français au Portugal*' in *Gazette des Beaux-Arts*, February, 1952, pp. 114–28.

[8] *Augustus Hervey's Journal*, ed. David Erskine, 1953, pp. 125–26.

[9] W. Stephens ran the glass factory at Marinha Grande.

[10] *Voyage du ci-devant duc du Châtelet en Portugal*, Paris, 1797, 2 vols., II. p. 84.

[11] *Travels in Portugal*, 1795, pp. 9–10.

[12] *Journals of a Residence in Portugal 1800–1801*, ed. Adolfo Cabral, 1960, p. 97.

[13] Information from Terence Hodgkinson, of the Victoria and Albert Museum.

[14] *The Journals. . . .*, p. 145.

[15] See Meta E. Williams, 'Concerning Gerard de Visme, Member of the British Factory in Lisbon', *Fourth Annual Report and Review of the Historical Association* (Lisbon Branch), 1940, pp. 239–45 and Anon. 'Gerard de Visme, Founder of the British Hospital (1793) and Member of the British Factory, Lisbon, *Seventh Annual Report . . .* 1943, pp. 430–35. This contains a portrait of De Visme. (This reference is due to Carlos A. G. Estorninho, Chief Librarian, The British Council, Lisbon.)

[16] *Memoirs of William Hickey*, ed. Alfred Spender, 4 vols (n.d.), 2, p. 377.

[17] *The Journals. . . .*, p. 47.

[18] This was also painted by A.–J. Noël (picture lost): it was engraved by J. Wells, 1794.

[19] 'Late eighteenth century Architecture in Ireland', Ph.D. Thesis for Cambridge University.

[20] Quoted in *Illustrations of the Literary History of the Eighteenth Century*, ed. J. Nichols, 1817–58, 8 vols., 6, pp. 435–44.

[21] *Travels in Portugal*, p. 198.

[22] *The Art of Portugal*, 1968, p. 126.

[23] For a survey of neo-Classicism in Portugal, see José-Augusto França. *A Arte em Portugal no Seculo XIX*, 2 vols., 1966.

Thanks are due to Professor Robert C. Smith who has helped to produce this number and to Dr. José-Augusto França.

A Silver Age in Dutch Art

When in The Hague in August 1781 Sir Joshua Reynolds wrote to Edmund Burke that the city reminded him of Bath, 'where people have nothing to do but talk of each other; and it may be compared to Bath likewise, for its beauty'. 'The city', he remarked, 'abounds in squares which you would be charmed with, as they are full of

la Fargue in a painting of 1762 (Fig. 2) that so admirably evokes the Age of Periwigs.

Reynolds was a polished man of the world and a sharp observer of human foibles (as is attested to by his prose, as well as his painted portraits), but political comment was not his concern on his trip to Holland; his purpose was to study works of art, as transpires from his journal, which records, among other things, his impressions of the splendid Dutch pictures belonging to the banker, John Hope. Amsterdam, 'which is more like Venice than any other place I ever saw', understandably attracted him. But as he was no night bird, he had little occasion to record, as did James Boswell, the city's nocturnal dangers. Boswell's lively journal of his visit to Holland contains valuable information about life there at the time and he spotted the poverty that existed in certain parts of the country.

Unfortunately neither Reynolds nor Boswell wrote about contemporary Dutch art, which was hardly surprising for it was the painting of the previous century that attracted foreign artists and collectors, increasingly

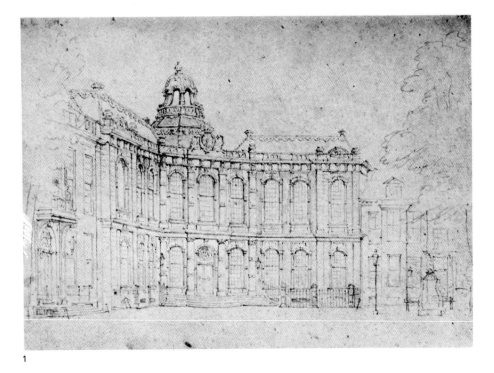

1. *Hotel van Wassenaer* by Daniel Marot (*c.* 1660–1752), *c.* 1720. Pencil drawing possibly by Cornelis Pronk (1691–1759), *c.* 1730. Gemeentemuseum, The Hague. It shows the house in its original state

trees; not disposed in a meagre, scanty row, but are more like woods with walks in the middle.' Since Reynolds's day many changes have inevitably occurred in the Dutch capital, as indeed they have in Bath, and much of beauty has vanished; nevertheless, happily, in both something of the magic of the eighteenth century lingers—its lightness and sense of measure—and the harmonious appearance exerts a soothing effect on waspish nerves in our storm-tossed era.

Time slides away in The Hague as we walk through the Binnenhof and visit the Trèveszaal (Fig. 4) or the Mauritshuis and stroll round the centre of the city, inspecting such eighteenth-century buildings as the Hotel Huguetan (now the Royal Library), the Hotel van Wassenaer (Fig. 1) and the Schuylenburg house. It is a townscape with period charm and the Court Pond at the back of the Mauritshuis looks much as it did when depicted by P. C.

so as the years went by. For long the achievement of the eighteenth century was overshadowed by that of the Golden Age, understandably, for none of its painters could rival the grand masters of the earlier period: Rembrandt or Hals, Terborch or Vermeer, Ruisdael or Koninck. Nevertheless, the patient research of Dr. A. Staring, the pioneer of such studies, and of a younger generation which includes Dr. Niemeijer, Dr. de Bruyn Kops and, recently, Roger Mandle has shown that more of significance was created then than was credited. This is as true of the decorative arts and sculpture as it is of painting; before too long the authorities of the Rijksmuseum should take the plunge and stage a comprehensive exhibition of the period, a successor to the innovatory one held at Rotterdam in 1946. The result would surely be worth while and direct attention to the considerable artistic and intellectual contribution of this silver age.

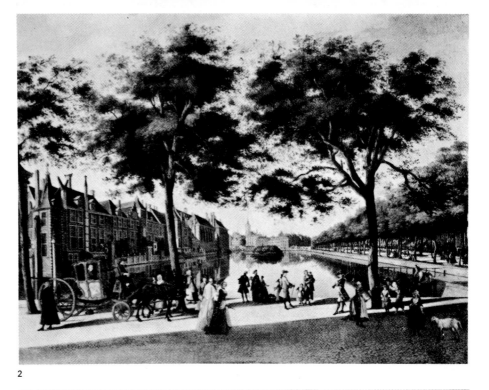

2. *The Court Pond at The Hague, near the Binnenhof* by Paulus Constantijn la Fargue (1729–82), 1762. Oil on canvas, 93·3 × 124 cm. Gemeentemuseum, The Hague. This was a fashionable promenade in the eighteenth century

2

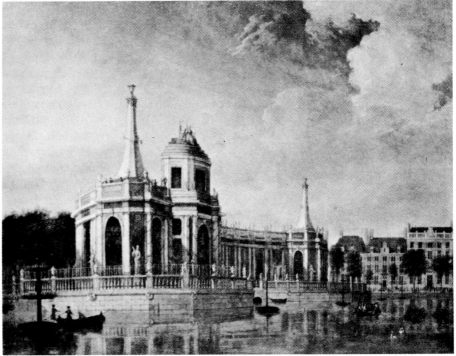

3. *The Fireworks Pavilion in the Court Pond* by Jan ten Compe (1713–61), 1749. Oil on panel, 47·5 × 64 cm. Gemeentemuseum, The Hague. A temporary pavilion erected to celebrate the Peace of Aix-la-Chapelle of 1748

3

The art of this period in Holland, which formed one of the United Provinces, offers an image of calm; placidity rather than conflict is the keynote. However, although this was far from being an era of peace for the country, the Dutch wealthy classes were satisfied with their riches and not in the mood for adventure; they were essentially rentiers and, significantly, Amsterdam was then the centre of the world's money market. Their money on the whole was not employed in developing home industries or even in fostering Dutch shipping. In such situations the rulers of the United Provinces would have been wise to maintain a policy of strict neutrality, but this they were by no means able to do; circumstances were against them.

The United Provinces formed something of a cockpit. They did not constitute a major power, but their support was canvassed by France and England, to each of which certain sections of the country also looked. Some account,

however cursory, of the external and internal affairs of the country helps to explain the background against which art and architecture were created and even gives something of its character, for instance the element of inwardness and refusal to venture too far so evident in the painting.

The English connexion was, of course, a strong one in the early years, for, by the Treaty of Ryswyck (1697), William III, Stadholder of the United Provinces and Captain-General of the Republic, had been recognized as King of England. The new era seemed to open auspiciously, for its provisions granted the Dutch a favourable commercial treaty, as well as the right to garrison the Netherlands border towns, a point on which much store was set. However, this state of affairs lasted only until the early years of the eighteenth century, when Louis XIV ejected the Dutch from these outposts.

When in 1702 William III died childless, instead of a

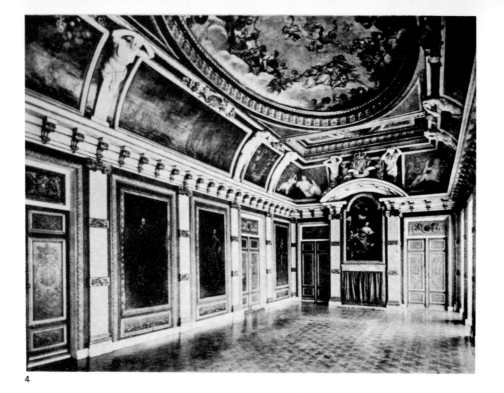

4. *The Trèveszaal in the Binnenhof* decorated by Marot. The ceiling was painted by Theodoor van der Schuer (1628–1707)

5. *Detail of the ceiling in the pavilion of the Greffier Fagel* painted by Mattheus Terwesten (1670–1757) after designs by Marot

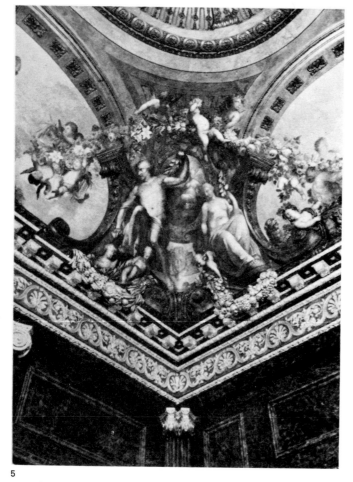

new Stadholder being appointed, the affairs of the Republic were conducted by men such as Anthonie Heinsius, the Grand Pensionary, an office the holder of which was Secretary of the State of Holland, and in the States-General he acted in effect as Foreign Secretary. Heinsius maintained the old relationship with England and, when the War of the Spanish Succession broke out in ,1702, Holland became a virtual outpost of England, with the Duke of Marlborough as Deputy Captain-General and Ambassador to The Hague. After Marlborough's fall

from favour hostilities soon came to an end and, although the United Provinces became trustees of the Spanish Netherlands, the Peace of Utrecht (1713) did not match Dutch expectations. A growing dissatisfaction arose with the English connexion and the general malaise was heightened by the economic situation.

The far-flung nature of Dutch commercial interests made it difficult, when these were attacked, for the United Provinces to sustain a neutral position, as they should have done. When Joseph II of Austria chartered the Ostend East India Company and, by doing so, threatened the Dutch monopoly in that area, the Dutch were able to secure the suppression of the rival concern only by guaranteeing the Pragmatic Sanction of Charles VI, under which his daughter Maria Theresa was to succeed to all her father's hereditary possessions. This commitment obliged the United Provinces to join in the War of the Austrian Succession against France in 1743 and in the following year to participate in the Quadruple Alliance with England, Austria and Saxony as partners. The French invasion of the Dutch territory south of the Scheldt provoked an important domestic change; once again when in dire straits the Dutch turned to a Prince of the House of Orange and William IV became Stadholder. The war terminated with the Peace of Aix-la-Chapelle in 1748. It was indicative of the general rejoicing that to celebrate the peace a temporary pavilion was erected in the Court Pond in The Hague. It provided Jan ten Compe with the theme for an enchanting picture (Fig. 3) which has been justly termed 'a quiet rococo masterpiece'.

Fortunately the United Provinces avoided war for the next twenty or so years and, correspondingly, despite the decline of certain traditional industries and skills, a high degree of prosperity was obtained. The Dutch were able to build up a huge sea-carrying trade with fleets in both hemispheres. Besides this they enjoyed a considerable income from their overseas investments; it was even considered that some twenty-five per cent. of the British National Debt was in Dutch hands, a factor which cer-

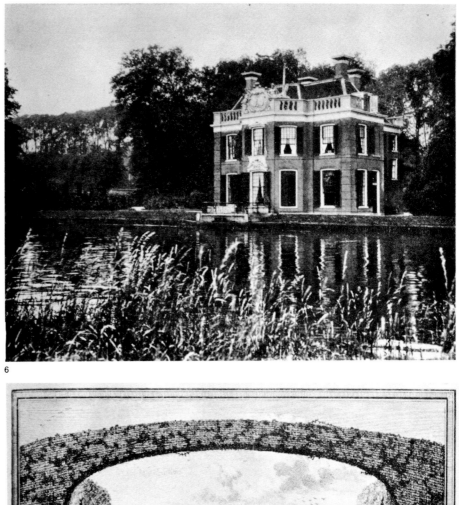

6. *Huis Rupelmonde, Loenen.* One of the fashionable country villas on the River Vecht

6

7. *Out-of-door theatrical performance at Westerwyck* by Hendrik de Leth (1703–66). Engraving. One of the country seats owned by Pieter Pels (1691–1741), an Amsterdam banker and merchant

7

tainly counted with the British government, who were by no means eager to engage in policies that might provoke a large-scale withdrawal of Dutch-held funds from London. It was hardly surprising that Dutch prosperity was reflected in the art world of the day.

The United Provinces were not involved in the Seven Years War between England and France; however, controversy reigned between the United Provinces and England over the vexed question of the right of neutral shipping to carry French goods. It was only as a consequence of the American War of Independence that in 1780 the United Provinces, which had been drawn into the Armed Neutrality pact at the instigation of Catherine of Russia, were embroiled with England. During the war that ensued Dutch commerce was severely damaged and

Dutch colonies were at the mercy of the English fleet. Under the terms of the Peace of Paris (1783) the Dutch, who were abandoned by their allies, were obliged to accept disadvantageous, if not ungenerous, terms.

The local situation was fraught with problems during these years owing to the dislike of the rich mercantile class in Amsterdam—'the Amsterdam Cabal'—for the Stadholderate, which was politically aligned with England and which, in its view, neglected Dutch national interests, above all the furtherance of trade. There also emerged a growing resentment that the administration was controlled by the Regents, a self-perpetuating oligarchy who had become, it was claimed, more or less fossilized. In a cogent study of Anglo-Dutch relations in the years 1774-80 Daniel A. Miller observed how most of the members

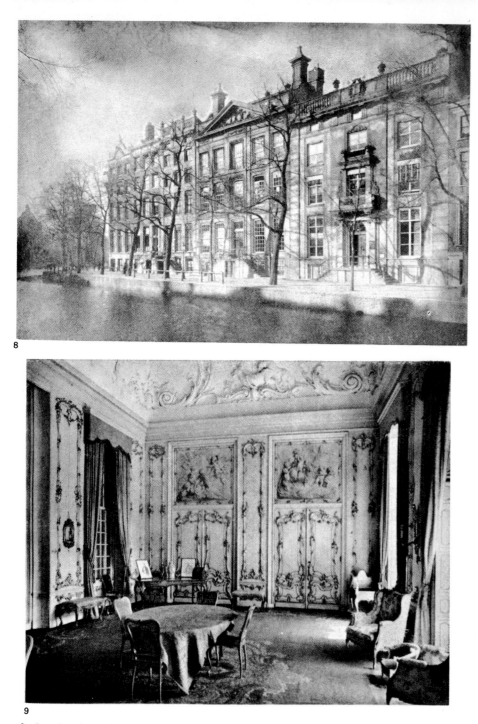

8

9

8. *Heerengracht 487–95, Amsterdam.* The eighteenth-century houses blend with those of an earlier period

9. *A state room in Huis ten Donck, near Rotterdam* decorated by Pietro Castoldi, 1747, for Otto Groenix van Zoelen

10. Opposite: *Carved over-door from a house in Dordrecht,* first half of eighteenth century. Gilt-wood, 1·78×1·87 m. Rijksmuseum, Amsterdam

11. Opposite: *Heerengracht 475, Amsterdam.* Stucco by Jan van Logteren (1709–45)

12. Opposite: *Chimney-piece from Keizersgracht 224, Amsterdam,* now in the Algemene Bank Nederland, The Hague. A good example of carved marble in the Régence style

of the faction that opposed the Regents—the so-called Patriots—'were well-to-do bankers, merchants, clergymen and professors'; however, among the Regents were some who favoured the Patriots. There was another ingredient in the pot. The leader of the Patriots, Joan Derck van der Capellen tot de Poll, believed in the sovereignty of the people and was deeply influenced by the writings of Locke, Rousseau, Montesquiou and Price.

It was the Patriot Party that sought to curb the prerogatives of William V and his active and gifted wife Frederica Wilhelmina, the sister of Frederick of Prussia, and that turned to France for support, thereby becoming a tool of French foreign policy. Prussia and England supported the Stadholder. During this exciting and taxing time Great Britain was represented at The Hague by an exceptionally sharp ambassador, Sir James Harris (later Earl of Malmesbury). He was the right man for the job; he took to cloak and dagger business with alacrity, leaving the Embassy at an early hour in a brown coat and round hat to see his agents. These included the quick-witted if

profligate Count Bentinck van Rhoon and the Sardinian consul in Amsterdam, Triquetti. Harris, who knew how to manoeuvre men and was a clever distributor of bribes, notably the famous Gelderland subsidy, was also a realistic political connoisseur and argued that France would not go to the aid of the United Provinces if Prussia intervened on behalf of William V. His contention was proved right. The French were not prepared to involve themselves, and, as William Pitt wrote to Lord Carmarthen, the Foreign Secretary, 'The French must, as things stand, give up in effect their predominant influence in the Republic or they must determine to *fight for it*'.

In the event William V remained in office for only a few more years; he fell victim to the revolutionary fever that seized the Europe of the *fin de siècle*. The appeal of the French Revolution was to prove persuasive in the United Provinces and in 1795 the French Army marched into the country; the departure of William and his family from Scheveningen was recorded by Jan Bulthuis in a drawing (now at Leiden) which was issued as an engrav-

ing. The old Republic was replaced by the Batavian Republic, which remained in close connexion with France until the end of the Napoleonic Wars. In 1802 Napoleon imposed a constitution on the country and appointed Rutger Schimmelpenninck to head the government. Significantly, Prud'hon painted him and his family (Rijksmuseum) and Napoleon presented him with fine furnitures. He remained in office until 1805, when Napoleon made his brother Louis the first King of Holland. The liberal susceptibilities of the Patriots may have been assuaged by such events, but the economy suffered disastrously as a result; institutions such as the East India Company and the great financial houses of Amsterdam nearly failed.

What is so noticeable at this time—perhaps it is also true of other periods—is that political affiliations did not necessarily affect taste, even when it might be thought

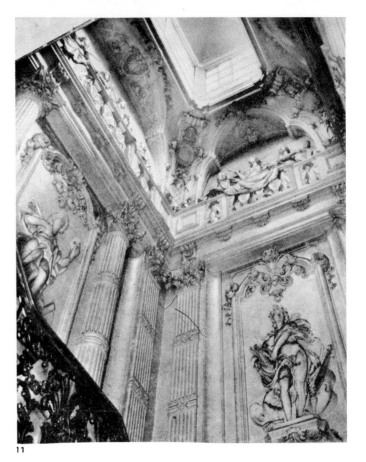

11

10

they would, and it emphasizes the complex interplay of forces cultural, political and social that characterized Holland during the last two decades of the seventeenth century that a member of the House of Orange, a resolute opponent of the aggressive policy of Louis XIV, had no hesitation about employing a French architect, Daniel Marot. Arriving in the country in 1684, the year before the Revocation of the Edict of Nantes, Marot quickly found his feet, working for William III, as both Stadholder and King of England, and being responsible for many elegant buildings in The Hague—the Hotel Van Wassenaer is one (Fig. 1) and the recently restored pavilion of the Greffier Fagel in the grounds of the Royal Palace with its baroque painted ceiling by M. Terwesten (Fig. 5) is another. Marot also designed the interior and park of the Royal Palace at Het Loo, but, on the other hand, the plan and maquette for De Voorst (1695), the well-known country house of Joost van Keppel, first Lord Albemarle, was sent from England.

By bringing the spirit of Versailles to Holland, Marot and his family introduced a 'new look' into Dutch archi-

12

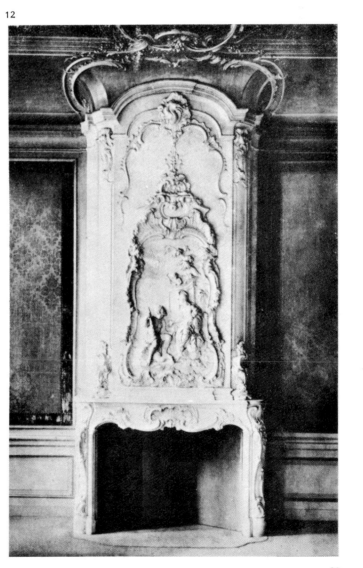

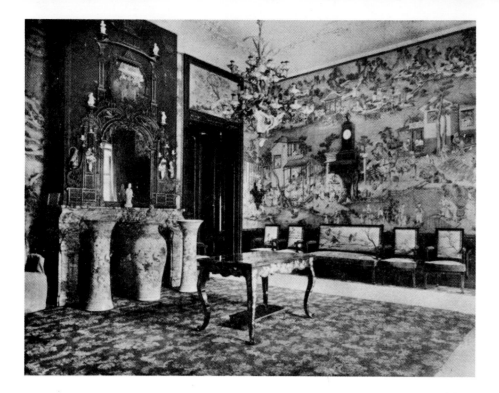

13. *Chinese room from Huis ten Bosch, The Hague.* This, together with other rooms, was a gift from the Chinese Emperor to the Stadholder William V, 1792

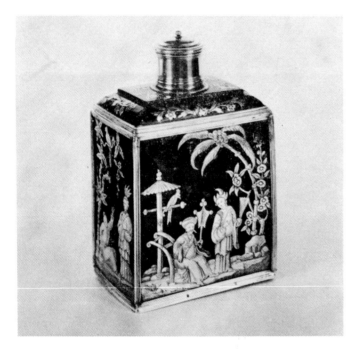

14. *Tea-caddy* by Hendrik Voet, Zwolle, *c.* 1700. Silver with lacquer decoration, height 13·4 cm. Rijksmuseum, Amsterdam

15. *Pagoda in the garden of Oost Capelle* by Jan Arends (1738–1805). Drawing. Private collection, Holland

tecture and interior decoration, and often it can be seen to have been translated into the vernacular, as in the wall cupboards and niches which are so typically Dutch. Yet for all his versatility, Marot was an old-fashioned designer; thus the Louis XIV style was practised in Holland when in France it had surrendered to that of the Régence.

The French influence may also be strongly noted in the second part of the eighteenth century in a building such as the Royal Theatre in The Hague, designed by Pieter de Swart, which, as Professor ter Kuile says, is a 'most refined example of the Louis XVI style *avant la lettre*'. Louis XVI style is also apparent in the slightly frigid but elegant villa at Haarlem which was built by Henry Hope partly to house his famous collection of pictures and which has admirable interior decorations. (Fig. 22.) It was designed by Triquetti, the Sardinian consul in Amsterdam, who acted for Sir James Harris, and was built in 1786-99 by a Flemish architect, J. B. Dubois. It was originally called Welgelegen but, after its acquisition by King Louis Napoleon, it was renamed Het Paviljoen. The chimney-piece which John Hope had commissioned from Piranesi (now in the Rijksmuseum) was transferred from Keizersgracht 382 to Welgelegen. This attractive work was etched by Piranesi in his *Diverse maniere d'adornare i cammini*, Rome, 1769, Plate II. Haarlem itself contains a number of attractive eighteenth-century buildings such as Nieuwegracht 80, which has a fine saloon (Fig. 23), and in the same street, at No. 74, Willem Philips Kop owned a set of Louis XVI furniture dating from *c.* 1790 which is covered with Lyons silk in splendid condition. This furniture, as well as the saloon, are in the Rijksmuseum. It was in this town at about the same date that Barnaart commissioned Van der Hart to build a marble state room for his house, Nieuwegracht 7. These examples provide an indication of the extent of Dutch wealth despite the tense political situation.

No great outburst of private building took place in Amsterdam, presumably because in the seventeenth century the centre had been laid out with such skill and taste, especially the famous and delicious Keizers- Prinsen-

and Heerengracht that are so familiar to the visitor and are recorded for all time in the paintings of Jan van der Heyden. What happened in Amsterdam was that modifications occurred to existing streets, as may be seen from Heerengracht 487-95 (Fig. 8), and the style accords well with that of the earlier buildings. Unfortunately much of significance has perished in Holland, notably the many superb houses that were such prized possessions of Rotterdam, a city on the crest of the wave in the eighteenth century.

Unlike those of England, France, Prussia, Bavaria and Austria, no autocratic Court wielded patronage in Holland, for the Stadholder was no more than the first servant of the Republic. Nor were there any territorial magnates comparable to the Bedfords or Sir Robert Walpole, the German princes or the Russian nobles in a position to commission works on a grand scale. On the whole, patronage lay in the hands of a wealthy merchant class, the men who had largely replaced the earlier aristocracy.

These were the owners of the great houses of Amsterdam and of agreeable country villas on the River Vecht. In those days this river was an important thoroughfare used by the early Hanoverians on their way from Germany to England and its popularity is attested to by the fact that a passenger barge (*Trekschuit*) drawn by horses plied up and down twice a day between Amsterdam and Utrecht. The houses that graced its banks are pictured in the charming engravings made by David Stoopendaal for *La Triomphante Rivière de Vecht*, 1719, and the names of their owners conjure up the image of a society of *haute bourgeoisie* and *haute juiverie*. The prints, even if a shade romanticized, show neat buildings, formal gardens and tea pavilions, and we can imagine the inhabitants enjoying the Dutch equivalent to the *fêtes galantes* of the Régence. This existence is evoked in Hendrik de Leth's prints of Westerwyck, one of which shows an open-air theatre performance (Fig. 7). Its owner was the bachelor Pieter Pels (1691-1741), an Amsterdam banker and merchant, who lived in the Heerengracht and owned as country houses first Voorberg near Muiderberg and afterwards the one illustrated in these prints.

Nowadays, the villas on the Vecht have lost much, but by no means all, their splendour: Huis Rupelmonde (Fig. 6) retains great allure; so does Over-Holland, which was built in 1676 by Jacob Poppe and has a mid-eighteenth-century ballroom with typical painted decorations. They suffice to recall a delightful phase of Dutch life, yet only offer but one example of eighteenth-century country life in Holland, and the recent exhibition at the Prinsenhof, Delft, which dealt with the country-house from the seventeenth century to the end of the nineteenth century, provided an instructive account of a little-known subject, all the more so as the illustrated catalogue contains a summary of architectural development in various regions of the country.

In Holland, as anywhere else away from the main generating force of artistic creation, time-lags may be discovered between local styles and that of the centre and, while some artists and craftsmen were more or less abreast with the modern movement, the old traditions survived to a surprisingly late date and works were

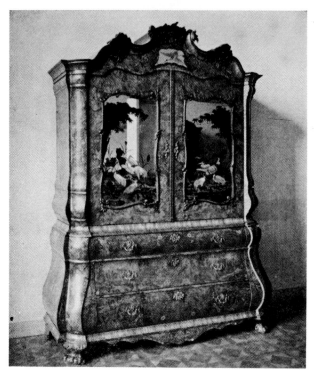

16

17. *Sideboard.* Northern Netherlands, late-eighteenth century. Veneered in various woods, 96×114×58·5 cm. Rijksmuseum, Amsterdam

18. *The Spendthrift* by Cornelis Troost (1697–1750), 1741. Oil on panel, 69×86·5 cm. Rijksmuseum, Amsterdam. This scene is taken from a play by Thomas Asselijn

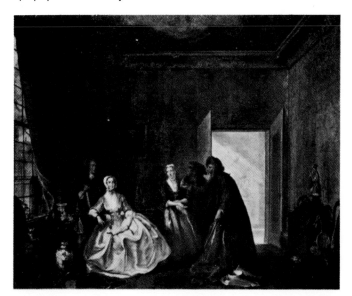

19

20

produced with a pleasing local flavour. No doubt many such examples are to be found in Holland, but one catching the eye in the Rijksmuseum is an attractive cabinet (Fig. 16), which is conceived in robust baroque terms, a concession to the new spirit being acknowledged in the rococo carving and the painted mirrors with their cranes.

The visitor to Holland may find an amusing pastime in seeking out its Rococo. It may be found in the architectural paintings which have been so favoured by the Dutch masters, and in this context a relevant example is Keun's sweet painting of an Amsterdam house and *koetshuis* of 1735 in the Rijksmuseum. Further evidence of the impact of the Rococo may be encountered by sauntering along the Heerengracht and looking at those buildings which exemplify this style. Better still, its influence may be assessed from the interiors of Heerengracht 284 (now the seat of the Vereniging Hendrick de Keyser, which buys and restores old buildings) and Heerengracht 168, which houses the Theatre Museum. In this Museum the interior decorations are by Isaac de Moucheron and Jacob de Wit and the stucco work by Jan van Logteren; in the Keyser building the stuccos are by an unknown artist. Moucheron favoured an Arcadian style and owed something to the designs of Meissonier.

Dutch patrons in general supported their own painters. It says much for the perception of the heirs of Gerrit Maas and his wife, Elisabeth Lasson, that in 1718 they went against this trend and commissioned G. A. Pellegrini, that lively master of the Venetian Rococo, to paint decorative canvases for the large reception room on the ground floor of the Mauritshuis when it was redecorated after the fire caused by the carelessness of one of the Duke of Marlborough's servants. Pellegrini, who won favour in South Germany and England, became a member of the Art Academy in The Hague in the same year and his fluent colouristic style presumably exerted an influence on Jacob de Wit.

Italian stuccoers also worked in Holland, although not, apparently, to such an extent as in England, or, for that matter, Ireland. One of their number, Pietro Castoldi,

was commissioned in 1747 by Otto Groeninx van Zoelen to undertake decorations for his residence Huis ten Donck, not far from Rotterdam. (Fig. 9.) These enchanting rococo designs also pay tribute to the Orangist connexion with England, for Castoldi executed the English coat of arms over a portrait of William III.

Sir Sacheverell Sitwell, a warm lover of the Dutch eighteenth century, has shown how the Rococo had a late flowering in Friesland (where Leeuwarden was the seat of a Stadholderate), for instance in the Workum room, the ceiling of the Raadzaal at Dokkum and the Chinese decorations in the style of Pillement formerly in the Town Hall at Sneek. Although chinoiserie is found with Delftware, silver—a particularly gracious tea-caddy by Hendrik Voet of *c*. 1700 is in the Rijksmuseum (Fig. 14)—and furniture, there seems a surprising absence of Chinese-taste buildings or interior decorations. The delightful Chinese rooms at Huis ten Bosch, the Royal Palace in the wood, were a gift from the Chinese Emperor to William V in 1792. (Fig. 13.) All the more interest, therefore, may be attached to the pagoda once in the garden of Oost Cappelle which was recorded in a drawing by J. Arends of 1772 (Fig. 15), recently on view in the Delft exhibition.

The Dutch painters active in the years that saw the ending of the Golden Age can hardly have found it easy to make a novel contribution; the shadow of the past must have weighed heavily on them. In comparison with Italy or France, where large-scale decoration had so many exponents, there was one major problem facing painters tempted by this genre—climatic conditions discouraged the use of fresco. Nevertheless, men existed who went in for decorative painting, even if they did not use this medium. One gifted and, in his time celebrated, decorative artist was Gerard de Lairesse, whose ravaged features are so familiar from Rembrandt's famous portrait in the Lehman Collection, New York.

Lairesse, known somewhat ambitiously as the Dutch Raphael and the Dutch Poussin, was a prime academic and a refined, if somewhat effete, exponent of the classical

92

19. Opposite: *Pietro Locatelli* (1695–1764) by Troost. Mezzotint. This Italian violinist and composer lived in Amsterdam

20. Opposite: *Décor from a miniature theatre* by Pieter Barbiers (1748–1842), 1781. Made for Baron H. van Slingelandt, one of the Regents of the Amsterdam Theatre. Theatre Museum, Amsterdam

21. *The Children of the Stadholder William V* by Johann Friedrich August Tischbein (1750–1812), 1789. Oil on canvas, 1×1·29 m. Het Loo. Reproduced by gracious permission of H.M. Queen Juliana

22. *Detail of the saloon at Welgelegen* designed by Triquetti, the Sardinian consul in Amsterdam and built by J. B. Dubois, a Flemish architect, 1786–99, for Henry Hope, the banker, to house his collection of paintings. Now known as Het Paviljoen

21

style. His major decoration, consisting of scenes from Roman history, was designed for the Court of Justice in the Binnenhof in The Hague but, it is now no more. However, the *Glories of Amsterdam* painted for a grand house in the city are now to be seen in the Peace Palace in The Hague. His successor, Jacob de Wit, painted decorations for the Town Hall of Amsterdam (they are discussed in this issue) and was influenced by Rubens, and to this extent they illustrate how the Rubenistes were as active in Holland as in France. His agreeable and stylish grisaille counterfeits of stucco are among the most effective of illusionistic paintings.

Understandably, many painters followed in the footsteps of their forbears. The relationship with the cabinet pictures of the earlier generation may be admirably seen in the precise townscapes of Isaak Ouwater and La Fargue (Fig. 2), the *genre* scenes of Abraham van Strij and H. P. Schouten and the flower paintings of Jan van Huysum, Jan van Os and Rachel Ruysch. Yet, oddly enough, the still life tradition associated with Claesz and Heda had no followers, even though in France this *genre* found a major practitioner in Chardin. The tradition of painting group portraits of Regents was maintained by Cornelis Troost, for example. The conversation piece was practised with skill and some influence was derived from England. A sense of continuity gives considerable appeal to Dutch painting at this time, especially if the belief is abandoned that art must necessarily and inevitably be innovational. Eighteenth-century Dutch pictures radiate a delight in the good things of life, evidencing a counting of one's blessings; another facet of the love of the visible world was the preparation of the atlases to which many notable artists contributed.

If Dutch collectors almost exclusively limited their patronage to their own School, the canvases used to decorate their Amsterdam houses were often Arcadian and Italianate in character. Moreover, various artists studied modern foreign movements and visited Paris, London and Italy. One expatriate, Gaspar van Wittel, spent most of his life in Italy and became so integrated into the

22

Roman scene that he is often known under the name of Vanvitelli. This prolific painter and draughtsman, who followed in the footsteps of the *bamboccianti*, was something of an innovator and his lucid and charming works assisted in the development of such *vedute* painters as Carlevaris and Canaletto.

The see-saw between French and English interests broadened the Dutch outlook. The country had a strong intellectual life, as befitted one which had been host to Descartes, and printers and booksellers were available for publications banned by the French censor. It tells much about the country's ethos that Voltaire was a frequent visitor to Holland, where he built up a circle. Paris formed the training ground for many of the upper classes —men such as Gerard Cornelis van Riebeeck, who is so attractively depicted in Matthys Verheijden's stylish portrait in the Rijksmuseum (Fig. 25). Artists such as Perronneau and Liotard (a French-Swiss) found it worth while to work in Holland, painting many portraits of the Dutch upper class. Yet, although French culture was all the rage, Belle van Zuylen, who was portrayed by

93

Quentin La Tour (Fig. 26) and Houdon, did not feel happy in Paris.

The predominating French strain in artistic life by no means excluded the rival appeal of English culture; periodicals were modelled on the *Spectator,* Boswell made friends in Holland and Josiah Wedgwood did business there. What is probably the demonstration piece (now in the Rijksmuseum) used by Wedgwood's agent, was illustrated in October's APOLLO, William Hodges found employment in Holland; so did the German Tischbein. The latter painted a singularly polished and melodious portrait group of the children of the Stadholder William V (Fig. 21). However, it is difficult to determine the extent to which such foreigners influenced the course of Dutch art; in general, local artists remained faithful to their forbears.

The desire to benefit from what was being done elsewhere was reflected in the policy of the Regents of the Amsterdam Theatre, who invited the distinguished Italian musician Vivaldi to compose and perform music for its centenary celebrations in 1739. The roster of foreign musicians who visited Holland is considerable; their number include the brilliant violinist Locatelli, who was born in Bergamo and died in Amsterdam, where his portrait was done by Troost (Fig. 19), Geminiani and Tessarini. In 1765-66 Mozart was in The Hague, where he gave concerts and found time to compose sonatas, arias and a symphony.

The theatre played a large part in Dutch life and the quality of scene painting was exceedingly high. It sheds light on taste, for though neo-Gothic hardly occurs in Dutch art and architecture, it found an echo in such stage sets as the Gothic Hall (1779), designed by the well-known scene-painters P. Barbiers and J. G. Waldorp, and the Gothic Palace (1785). Moreover, it has been pointed out in the catalogue of the Minneapolis exhibition of Dutch eighteenth-century painting (1971) that a theatrical scene painted by Nicholas Muys in 1777, which is probably of L. W. van Winter-van Merken's play *Jacob Simonsz. de Regte* (1774) 'prefigures the interest of the nineteenth century in period drama scenes'. Most of the eighteenth-century theatre scenes in the Amsterdam Theatre Museum show the sort of play or opera that could as well have been staged in London or Paris (Gluck was performed there in 1770), but one, *De Geemeene buurt* by P. W. Haps, is very Dutch in character, or so it seems from J. Punt's engraving after P. van Liender of 1738.

The Dutch love of the stage is excellently illustrated at the Theatre Museum by a singularly evocative relic—the miniature theatre made by Barbiers in 1781 for Baron H. van Slingelandt, one of the Regents of the Amsterdam Theatre, whose son, H. P. van Slingelandt, commissioned the scene-painter François Joseph Pfeiffer to paint the present façade. This model theatre was used by the Regents to try out new sets of scenery and is so constructed that *'changements de vue'* can also be engineered. (See Fig. 20.)

In art the Dutch feeling for theatrical effects (apparent earlier in Honthorst) found its chief exponent in Cornelis Troost, who belonged to the first generation of eighteenth-century Dutch painters. One of the most original artists of his epoch, he discovered much to entertain him in the theatre, as did Hogarth, Gillot and Watteau; for him as for them, no doubt, the world appeared as a stage. He not only painted theatrical scenes but turned his amused and ironic eye on ordinary life, as may be seen from the famous series of gouaches in the Mauritshuis which depict in an elegant interior the various stages of a drinking bout. The scenes suggest an Amsterdam interior or at least one in the Amsterdam style, but it is far from certain that the group was commissioned by a patron from that city. Troost's pictures have a lightness of touch typical of the Régence spirit when artists reacted against the frequently ponderous nature of baroque Classicism. Troost was also an observant portrait-painter and a master of *genre* painting, as in *The Spendthrift* (Fig. 18), which has recently entered the Rijksmuseum and provides information about contemporary interior decoration: it is a delightfully calculated and atmospheric composition.

The prosperity of the country after the Peace of Aix-la-Chapelle of 1748 was reflected in the activity of the art market. Intense and intelligent collecting took place, with the emphasis on the Dutch School of the seventeenth century, an instance, in fact, of children not turning against their fathers! In about 1760, to take one example, a collector Gerrit Braamcamp took a house, Swedenrijck, in the Heerengracht, in order to accommodate his collection of 350 pictures, to which additions were soon made. Old Master drawings found many ardent amateurs, among them Goll van Frankenstein (some of whose drawings later found their way into the cabinets of Sir Thomas Lawrence) and Ploos van Amstel, the son-in-law of Cornelis Troost.

The affection for the Golden Age was understandable, but it not only expressed a chauvinistic trend but characterized a vogue also evident in Paris, London and St. Petersburg and reflected a concern with the 'real' co-existent with the fantasy of the Rococo. This was paralleled by the interest taken by painters such as Boucher, Fragonard and Gainsborough in the Dutch School and the efforts of such collectors as Madame de Verrue and the duc de Choiseul to enrich their cabinets with its prime trophies. An instance of the Dutch love of their artistic past occurred when the famous and highly selective collection formed by Govert van Slingelandt was put up for auction in 1767 and a catalogue was issued; its purchase almost *en bloc* by William V for 50,000 florins established the nucleus of the Royal Collection which is now to be seen in the Mauritshuis and foiled the agents of the Empress Catherine of Russia and Choiseul, who were sniffing around for potential spoils.

A fascinating view of a late-eighteenth-century Dutch collector's house is provided by Adriaan de Lelie's painting of Jan Gildemeester showing his pictures to visitors; this painting is now in the Rijksmuseum. The son of a well-to-do family which enjoyed considerable trade connexions with Portugal, Gildemeester himself was the Portuguese consul in Amsterdam. He played a large part in Amsterdam's commercial life and, on his father's death, he inherited two houses and four shops in the city. The possession of such properties did not prevent Gildemeester, who was a bachelor, from acquiring in 1792

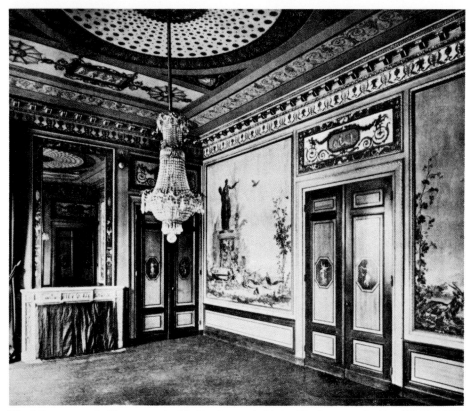

23. *A State room in Nieuwegracht 80, Haarlem* probably by Abraham van der Hart (1747–1820), c. 1790. Many fine houses were being built at this time despite the political troubles

25. *Gerard Cornelis van Riebeek* by Mattheus Verheijden (1700–77), 1755. Oil on canvas, 2·06 × 1·22 m. Rijksmuseum. The sitter was Secretary for Delft

a sumptuous residence in the Heerengracht with a view, so Dr. Arthur van Schendel has suggested, to housing his marvellous collection. His pictures were one of the sights of the city, and Samuel Ireland, who saw them in 1789 (before they were installed in the new setting), declared that his 'collection is formed with more taste than any other I have yet seen'. Some of his masterpieces by Rembrandt, Vermeer, Potter and others are now in famous collections, including that of the English Crown.

Many figures flit across the stage during this interesting, if little-known, period in Dutch life: the Stadholders, the Grand Pensionary Heinsius, Greffier Fagel, who communicated confidential letters to the English, our Ministers at The Hague, bluff Sir Joseph Yorke and the more polished and astute Sir James Harris, the Duke of Bruns-

wick, collectors, artists and rich patricians. But perhaps none is quite so fascinating as Belle van Zuylen, who appealed to James Boswell. Born in 1740 into an aristocratic family, she exemplified much that was best in the eighteenth century—its love of wit, belief in reason and hunger for universal knowledge. She was, said Geoffrey Scott, 'a frond of flame; a frond of frost'. This enchanting blue stocking, who fascinated Benjamin Constant, remains one of the most delightful and memorable figures of Dutch civilization during the eighteenth century with her desire to be a 'citizen of the country of the world'.

Thanks are due to Dr. J. W. Niemeijer and Jhr. Dr. H. W. M. van der Wijck for assistance.

24. *State room in the William V wing of the Binnenhof, The Hague,* late-eighteenth century

26. *Isabelle van Zuylen* by Maurice Quentin La Tour (1704–88), 1766. Pastel, 40 × 32 cm. Musée d'Art et d'Histoire, Geneva. A highly cultivated lady interested in literature and the arts. Executed in the autumn at the Van Zuylen country house near Utrecht

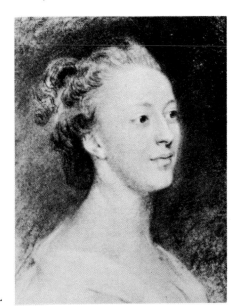

95

The Paradoxes of Neo-Classicism

1. *Furniture Mount,* attributed to Pierre Gouthière (1732–1813/14). Ormolu, height 32 cm. The Metropolitan Museum, New York. Based on the 'Herculaneum dancers' from the Villa of Cicero

Neo-Classicism is upon the town. The pundits will be debating its problems and complexities for a long time to come and, in a lighter vein, the spring will doubtless witness the appearance of a bevy of delectable models dressed in Grecian taste, and a smart tie or two will be spied in Blades's. This is as it should be, for neo-Classicism, although nowadays a minority taste, has much to catch the eye. The shades of La Live de Jully and Thomas Hope, Canova and David, Flaxman and Carstens, Thorvaldsen and Sergel and other heroes of this style will smile benevolently on the international team, headed by Sir John Pope-Hennessy, which is responsible for 'The Age of Neo-Classicism'.

This enormous exhibition, which is distributed between the Royal Academy and the Victoria and Albert Museum (the latter houses the decorative arts), is agreeably wide in range; the stars are flanked by a full supporting cast; and the presentation makes it easier for both layman and scholar to explore what is, after all, relatively uncharted territory. The show has certainly been an expensive undertaking but, the Council of Europe, its sponsor, was no doubt right to celebrate its penultimate offering so lavishly.

The exhibition is appropriately held in London. Although neo-Classicism was cosmopolitan in origin, the English were early in the field and did much to spread a knowledge of ancient art, particularly that of Greece where artists such as William Pars made careful sketches of the Parthenon and the theatre at Miletus. Our role in this respect will be stressed by Dr. Mordaunt Crook in his brilliant book, *The Greek Revival* (to be published shortly by John Murray) in which tribute is properly paid to the Society of Dilettanti, some of whose members were painted by Sir Joshua Reynolds in the two famous group portraits on view, works, incidentally, possessing a spirit of good-fellowship rather rarely seen in the other pictures shown.

One of their number, Sir William Hamilton, is also honoured in an attractive show at the British Museum. A polished representative of the old order, affable and learned, Hamilton, just the same, was touched by the spirit of the age, for he threw caution to the winds by marrying his mistress and is generally remembered as the complaisant husband of the exuberant and handsome, if erring, Emma whose name is ever linked with that of

2. *Attic red-figure water jar (Hydria)* by the 'Meidias Painter'. *c.* 410 B.C. Terracotta, height 52·07 cm. British Museum. This inspired Wedgwood

Lord Nelson and whose beauty fascinated George Romney. He has his place not only in the diffusion of the taste for the Antique but in the undercurrent of Romanticism that is evident behind neo-Classicism.

His career tells much about the start of this movement. He had the good fortune to be posted in 1764 as Envoy Extraordinary to Naples, then the largest city on the Continent. The water-colours of J. R. Cozens, the oil studies of Thomas Jones and the paintings of J. P. Hackert convey much of the charm of the Neapolitan scene in the closing years of the eighteenth century. Naples, as the birthplace of Vico, was also a lively intellectual centre. It had much to offer; shooting, sunshine, opera and, not least, the archaeological discoveries then being made at Herculaneum and Pompeii a knowledge

of which was spread throughout Europe by means of prints and reports to learned journals. Hamilton made his house, the Palazzo Sessa, a rendezvous for amusing and interesting people, helped artists and singers such as Michael Kelly, who became the first English singer to perform on the Italian stage, and collected antiquities.

Hamilton's enterprise in financing the publication of the first part of his collection by D'Harcanville in 1766-67 and its successor by Tischbein in 1791-95 and in writing the text for the latter, helped to introduce entrepreneurs and artists to the splendours of ancient art, Josiah Wedgwood, Flaxman and Fuseli among them, men who also had considerable influence on the Continent. If not the earliest to appreciate ancient vases, he was the first, it seems, to have grasped that the Greeks as well as

the excavating and trading that went on there and refers to the many historians, dealers, painters and collectors involved in such matters, especially in Rome—among them, no small quantity of Englishmen, such as Gavin Hamilton, Thomas Jenkins and Henry Blundell. The correspondence between Gavin Hamilton, who befriended Canova, and Lord Shelburne (later Lord Lansdowne) is especially instructive in this context; the marbles acquired by this noble patron were for long ornaments of his London residence, Lansdowne House, for which Cipriani painted the suitable classical decorations discussed in this issue.

Typical of the contemporary international spirit was that Winckelmann, who settled in Rome, should have become adviser to Cardinal Albani and later, from 1764

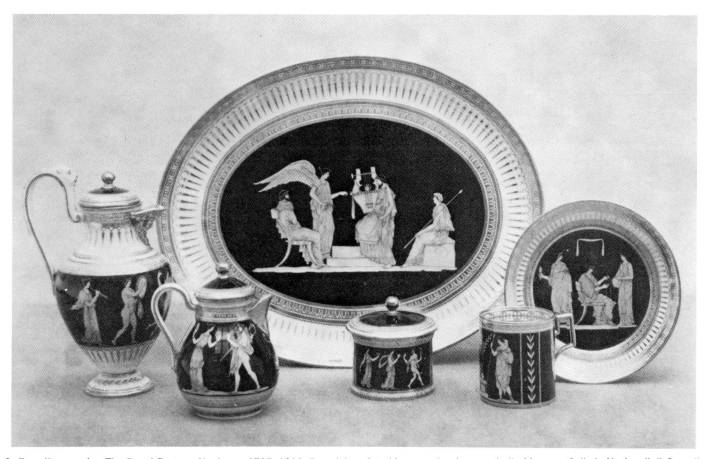

3. *Travelling service.* The Royal Factory, Naples. *c.* 1795–1800. Porcelain painted in enamel-colours and gilt. Museo e Gallerie Nazionali di Capodimonte, Naples. This *tête-à-tête* service shows figures and scenes derived from red-figure vases in the Bourbon Collection

Except for Figures 2, 7 and 26 all the works illustrating this article were in the exhibition 'The Age of Neo-Classicism' which was on view at the Royal Academy and the Victoria and Albert Museum, 1975

the Etruscans painted them. His refined sense of quality is excellently brought out in the British Museum show which includes such wonderful pieces as the archaic Greek gold bowl with bulls in relief from Sicily and the outstanding fifth-century red-figure *hydria* by the 'Meidias Painter' (Fig. 2), which was given star treatment in D'Harcanville's folios and inspired Josiah Wedgwood.

The essential background to the Council of Europe's exhibition is the archaeological activity occurring in Italy in the eighteenth century of which a valuable synopsis is provided by Professor Carlo Pietrangeli in his preface to the impressively annotated catalogue which contains no fewer than eleven other essays. This authority describes

to 1768, the Commissioner for Antiquities. Winckelmann is celebrated for the catalystic nature of his contribution to the spread of a love of ancient art. This *'enthousiaste charmant'*, as Diderot called him, had the single-minded determination required of a taste-maker. It reveals his understanding of the principles of ancient art that (like Robert Adam) he accomplished his mission without visiting Greece and, in this respect, he somewhat resembles Arthur Waley, whose influential translations of Chinese poetry were done without benefit of knowing the Far East. Winckelmann's success was largely due to his literary style and, as Dr. L. D. Ettlinger states, his descriptions of such famous pieces as the *Belvedere Apollo,*

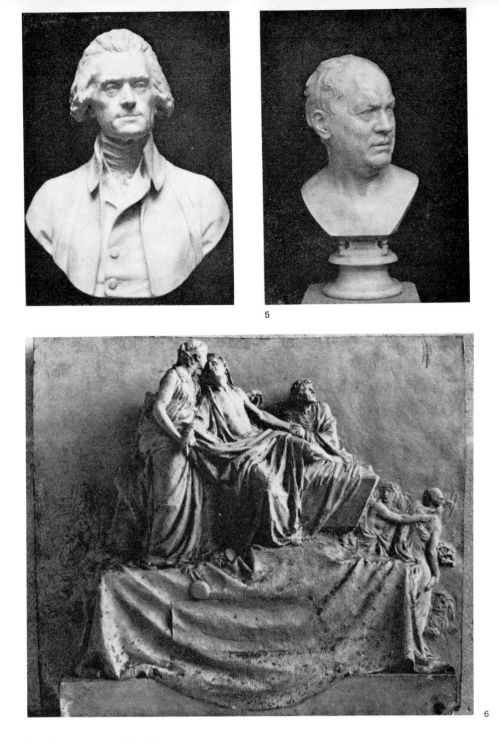

5

4. *Portrait of Thomas Jefferson* by Jean-Antoine Houdon (1741–1828), 1789. Marble, height 68 cm. Museum of Fine Arts, Boston

5. *Portrait of Giovanni Battista Piranesi* by Antonio d'Este (1754–1837). Marble, height 65 cm. Protomeca Capitolina, Rome

6. *Model for the tomb of Prince Alexander Mikhailovitch Galitzine* by Houdon, 1775. Terracotta, height 42 cm. Louvre

7. Opposite: *Medal-cabinet.* English, 1770–75. Marquetry with ormolu mounts. This is possibly by John Linnell (1737?–96) and was part of the original furnishing of Osterley Park. Collection Earl of Jersey

8. Opposite: *Drop-front secretaire* by Georg Haupt (1741–84), 1778. Wood, height 1·25 m. Royal Collection, Tullgarn Palace, Stockholm

6

the *Laocoon* and the *Torso*,
contain hardly a phrase relating the sculptures they describe to the stylistic evolution of Greek art as seen by their author. They are absolute statements feelingly composed to conjure up the spirit which shaped these works. Hence the language employed by Winckelmann is not analytical but evocative playing on the emotions rather than the intellect.

This just interpretation presents Winckelmann in a different role to his usual one—as a pioneer of subjective criticism.

The organizers have drawn attention to the significance of that sultry genius Piranesi and a section at the Victoria and Albert Museum includes not only drawings after the Antique by this imaginative Jack-of-all trades, but works by men such as Petitot, Le Lorrain, Legeay and others associated with the French Academy in Rome during the latter part of the eighteenth century who helped to shape taste in France. It is an ingenious idea, too, to take one typical antique form—the antique tripod with Pompeian derivation—and examine its use by the neo-

Classicists; it even served as the model for a splendid font given by Eugène Beauharnais to the Empress Marie-Louise. The influence of the famous dancers from Herculaneum is demonstrated in the ravishing furniture mounts attributed to Pierre Gouthière (Fig. 1). The nymphs and gods of classical Antiquity had a tonic effect on the decorative arts.

Uniformity of opinion does not reign about the origins, development and scope of neo-Classicism. The use of ancient *motifs* and the interpretation of the antique world infected people of different opinions and backgrounds, men from the Left and the Right, artists, amateurs, leaders of fashion, bankers, diplomats, writers and rulers. For some it offered a means of giving their interiors a new and modish appearance; for others it offered a burning article of faith, a means of embodying an ideal in art.

Thus when perambulating the exhibition it is tempting not so much to propound definitions about neo-Classicism as to consider this style in terms of an aggregation of

7

8

individuals, of whom all—or nearly all—had something to say within the context of its language, sometimes profoundly, sometimes wittily. The problems of neo-Classicism demand the intervention of a writer of the calibre of a Sainte-Beuve, an Edmund Wilson and an Ortega y Gasset, who would write a series of profiles of the principal protagonists. What characters they are: Caylus combining a love of encaustic paintings and pornography; Winckelmann sublimating his paederastry in pedagogy and meeting his end by murder in a shabby inn; Sergel as neurasthenic as a character from Ibsen or Strindberg; Thorvaldsen tortured by ill-health and jilting the luckless Miss Mackenzie; Fagan jumping to his death from a window; and Shelley meeting his by drowning. Then there are the camp-followers, as it were; Thomas Jenkins, expiring on the East Coast, and Emma Hamilton (whose personality is evoked in the Romney exhibition at Kenwood) ending, bloated, drunken and impoverished, in France. The 'noble simplicity and calm grandeur' found by Winckelmann in antique statues was not alas! reflected in the lives of many of the main personalities of the Age of neo-Classicism.

Neo-Classicism was the offspring of dilettantism and also of the Enlightenment; it was both frivolous and moral. It began under the *ancien régime* as a lighthearted reaction against the prevailing rococo taste; was pressed into service during the French Revolution and employed with a good measure of monomania under the Empire; and ended (if indeed it has ever done so) in the Victorian era. And the men and women who created or patronized it did so during a period as momentous as our own. Is this one reason to explain neo-Classicism's appeal to the squad of enthusiasts who feel so passionately about it? Is interest in it partly (and somewhat poignantly) to be explained by the fact that we, too, live when one order is crumbling, if it has not done so already, and another emerging? Are we perhaps experiencing a pre-mature *fin de siècle*? Possibly we also subscribe to what Professor Robert Rosenblum has described as 'the illusive goal of a *tabula rasa,* of a total artistic regeneration'. But another reason may also explain and stimulate such concern for art; by basing their vision on the past many artists of this period demonstrated the appeal and validity of continuity. Consciously or unconsciously we may wish to emulate them by delighting in neo-Classicism.

Nevertheless, neo-Classicism was by no means a retroactive movement. True, it had its share of nostalgia, but many of its protagonists felt that the use of antique *motifs* and subjects was consistent with modernism and expressive of it. Its partisans claim that it is just this quality—that of a *risorgimento*—that can be discovered in Canova and David, Schadow and Boullée, Adam and Soane, Flaxman and Carstens, among others; indeed, as Hugh Honour says, for eyes attuned to the works of such painters, sculptors and architects, there is to be found 'a refreshingly cool and astringent quality which is perennially invigorating' and they 'have an intellectual integrity which commands respect, a deeply moving emotional candour and youthful idealism, and all that ardent generosity and hope and love of humanity which make the period in which they were created one of the greatest in European history'.

The origins of one current of modernism in Greuze and in the conception of history painting which found a champion in D'Angiviller and a transatlantic exponent in Benjamin West have rarely been so clearly presented, visually, as in this show. The sequence becomes clear. In Louis XVI's time D'Angiviller, aware of France's decline in fortune, was eager to revive a manner 'with edifying subjects drawn from ancient or national history'; it was one that linked painting and propaganda. Michel Laclotte observes how David's *Le Serment des Horaces* stands out in this setting 'as an exemplary achievement of the artist's language providing a perfect vehicle for the

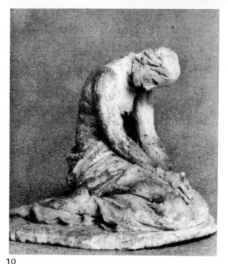

10

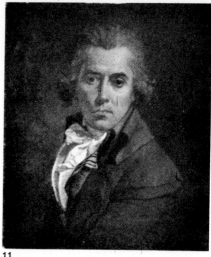

11

9. *Gustavus 111* by Johann Tobias Sergel (1740–1814), 1792. Marble, height 73 cm. National Museum, Stockholm

10. *The Penitent Magdalen* by Antonio Canova (1757–1882), *c.* 1773. Clay, height 22 cm. Museo Correr, Venice

11. *Self-Portrait with a triple collar* by Jacques-Louis David (1748–1825). Oil on canvas, 65×52 cm. Uffizi, Florence

12. *The Riots in Cairo: 21 October 1798* by Anne-Louis Girodet-Trioson (1767–1824), 1810. Oil on canvas, 3·56×5 m. Musée du Château de Versailles

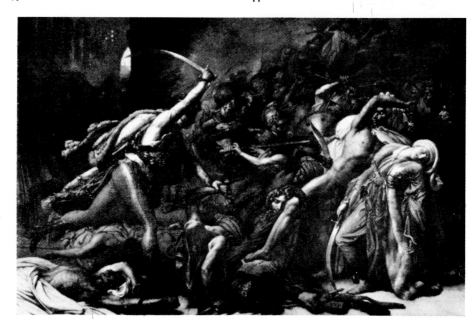

moral he set out to convey'. The battle between the Poussinistes and the Rubenistes may be seen to have been resolved at the close of the eighteenth century in the favour of the former.

David, one of the stalwarts of the exhibition, is represented by several major compositions, including *Le Serment des Horaces* and *Marat assassiné.* Complex and contradictory, this man of steel and champion of authority has often been misunderstood and his pictures have been falsely interpreted. As a human being—though not as an artist—he may displease as many as he attracts, for his treatment of his colleagues during the Revolution was scurvy. He was a regicide, too. He was one of those men (so it appears) who have the ability to ride the storm on nearly every occasion: he was an *arriviste,* and his fate was only just dissimilar from Julien Sorel's. His fascinations are many, not least his almost morbid passion for Napoleon; it was nothing less, the case of one man of destiny calling to another.

His importance as a painter is undoubted, but he probably appeals more to those who, like him, revere austerity and moral purpose in art, however so defined. Although the colour of *Le Serment des Horaces* has charm and subtlety, the essence of his art resides in its structure and geometry and the static quality of the composition. Yet the didactic character of his work, its element of heartlessness and coldness are not endearing to those who feel more

at ease when luxuriating in the fantasy and warmth of Fragonard, or who respond to the dramatic impetuosity of Delacroix, not that the latter failed to admire him.

Didactic pictures of this type—Guérin's noble *The Return of Marcus Sextus* (Fig. 15) lamenting the fate of the émigré is another—remain impressive examples of that recall to order which was so tragically perverted by the Revolution.

Professor R. L. Herbert in his preface (which would have pleased Plekhanov) makes no bones about his interpretation of the pure neo-classical style stating that 'we can regard the planar flatness of neo-Classical art, its most identifiable feature, as a political quality'. He continues:

Its frieze-like, processional organization emphasizes the mural surfaces of public places rather than the illusionistic depths of painting intended for domestic interiors.

Again he remarks how

The same impersonality of style let the Neo-Classic artist present himself as one who set aside purely personal ideals for the grander, more abstract goals of society. To luxury in art was opposed frugality of style, just as to luxury in life, the Revolution opposed the frugality of virtue.

But it is as well to recollect that the Revolution brought in its train spoliation, violence and death, and, if there is to be talk of idealism, then let us remember the thrilling passage about Marie-Antoinette in Edmund Burke's *Reflection on the Revolution in France*:

100

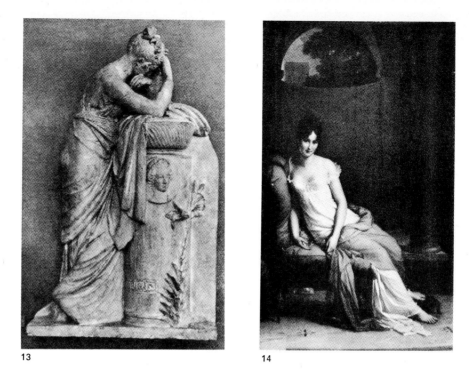

13. *Sketch-model for a monument to the Hon. Barbara Lowther* by John Flaxman (1755–1826), 1805–7. Plaster, in high relief, height 1·16 m. University College, London, on loan to the Victoria and Albert Museum

14. *Portrait of Mme. Récamier* by François Gérard (1770–1837), 1805. Oil on canvas, 2·25×1·48 m. Musée Carnavalet, Paris

13 14

I thought ten thousand swords must have leaped from their scabbards to avenge even a look that threatened her with insult. But the age of Chivalry is gone. That of sophisters, economists and calculators has succeeded, and the glory of Europe is extinguished for ever.

Burke was a classicist in that his oratory descended from the noble traditions of Antiquity!

A particularly interesting feature of the show is its account of the rise of a neo-classical portrait style which found many exponents from Batoni and Mengs onwards and which involved Appiani, Fabre and Fagan, to mention just a few. Many portrait painters gave a static pose to their sitters, placed, as is the case of that charming *petit maître*, Gauffier, against an Italianate sky. There also emerged, with Boilly and others, notably the German and Danish contingent, a simple bourgeois vision. May we include Corot's early portraits in this tradition? Fortunately, too, there is a chance to appreciate the skill and insight of Prud'hon as a portrait-painter, represented as he is by the romantic *Portrait de M. Anthony* (from Lyons) and the less familiar *Sommariva* (from Milan), that admirer of David and Thorvaldsen whose taste has just been described by Francis Haskell. Room has been found for Goya, even though this master was only tangitentially a neo-Classicist; never mind, seeing again the portraits of Dõna Zarate and Jovellanos is always rewarding.

This exponent of the Spanish Enlightenment is shown in a pensive mood. Many portrait-painters during the years on either side of the Revolution treated their sitters in a relatively sombre way, reflecting the seriousness of life; and it is pleasant to come across Greuze's portrait of a young exquisite contemplating an antique work of art with a trace of a smile, thus showing that this master was capable of something more appealing than his moralizing pictures.

The smiling eyes and well-rounded features of many of the most typical *dixhuitième* sitters—the sort found in the paintings of Perronneau and La Tour—seem to exemplify rather better the ideas of 'noble simplicity and calm grandeur' than do those of the frequently hag-ridden features of the new men; David's neurotic-looking *Self-Portrait* (Fig. 11) is an instance of this. And paradoxically, the earlier portraits reflect a more balanced and harmonious civilization than that inaugurated by the Revolution and carried on by Napoleon.

The lure of Rome was all embracing for over a century, until her replacement by Paris as the artist's Mecca. One artist who paid enduring homage to its grandeur and visual beauty was Ingres, and it is to him that we owe a record, almost unsurpassed for its sense of elegance, of the many foreign visitors who flocked to the city after the fall of the Empire, and his skill as a portrait draughtsman was as evident in his studies of men of the world as it is in those of charming youngsters. His drawing of the two Misses Montagu (Fig. 22) has a freshness that is not always associated with this pillar of the Establishment, even in his salad days. The exhibition excellently suggests the range and richness of this astonishing artist whose mysteriously and magically lighted *The Dream of Ossian* (1813)—Fig. 18—illustrates the never-ending and never-to-be-requited affair between Romanticism and Classicism, which is one of the themes of the exhibition.

Painters such as Gérard and Prud'hon had expressed their pleasure in pretty women and elegant men, but it was Ingres who effectively brought back into French art the pleasures of private enjoyment so wonderfully shown in his exquisite female nudes or his superb and sensuous female portraits, such as that of *Madame Moitessier* (National Gallery, London), in which colour, form and psychological insight are happily and appropriately blended. The declamatory style of the Revolution and the Empire had come to an end.

The exhibition abundantly represents the many minor men who, from the 1750s onwards, came within the neo-classical orbit. We are shown the Biedermeier painters from Germany and Austria, the gentle Danes such as Købke who responded to light with such lucidity and delicacy and many others, too. Their presence help to fill in the background and permit the period to be seen in depth. They show, too, that not a few artists were impatient of neo-Classicism unless it helped them to dream about Nature, about the South (Naples was singularly emotive) and about their souls. They reveal that

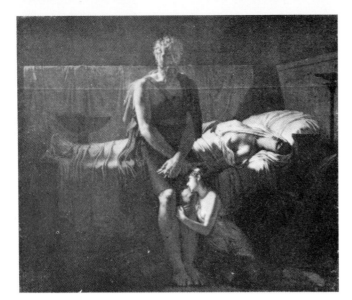

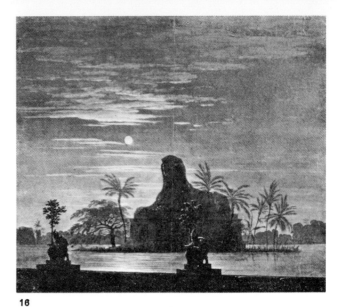

16

15. *The Return of Marcus Sextus* by Pierre-Narcisse Guérin (1744–1833), 1799. Oil on canvas, 24 × 29 cm. Louvre·

16. *Garden with Sphinx in the Moonlight (The Magic Flute)* by Karl Friedrich Schinkel (1781–1841), 1815. Gouache, 50·4 × 59·9 cm. The Staatliche Museen, Berlin

17. *Settee* by Thomas Hope (1769–1831), *c.* 1800–7. Mahogany, painted black and gold with bronze mounts. Length 1·72 m., height 76·2 cm. Trustees of the Faringdon Collection, Buscot Park. From the Egyptian Room, Duchess Street, London

18. Opposite: *The Dream of Ossian* by Jean-Auguste-Dominique Ingres (1780–1867), 1813. Oil on canvas, 3·48 × 2·75 cm. Musée Ingres, Montauban

17

taste for Romanticism which in the event was to secure such wide adherence.

Often, when walking round a gallery or country-house, the visitor is apt to overlook the busts of bygone worthies, often dust-laden and, even to some eyes, at any rate, a shade waxy in appearance. Now there will be no excuse for neglecting the portrait sculpture of this period, for its quality is brought out in the exhibition. Understandably the artists who studied in Rome succeeded in this *genre,* for they could see there the notable portraits of the Republican and Imperial periods. Canova, Chantrey, Nollekens, Banks, Schadow, Danneker, Chinard, Bosio— the list is long of those artists who made striking portraits of their contemporaries and, to take only the case of Thorvaldsen, it may be seen how his search for the ideal formula based on the Antique did not detract from what may be felt to be a true assessment of a sitter's personality.

The contribution of most of the sculptors on view is known only to the specialist, Houdon being the main exception. He triumphs cool, elegant and measured; he is outstanding both as a portrait-sculptor as in the alert bust of Thomas Jefferson (Fig. 4) and as a creator of the funereal statues that were then so popular. His maquette of the monument to Galitzine (Fig. 6) is one of the most exquisite pieces displayed, tender in its rendering of pathos, just in its treatment of form. Another major man who is only now being as widely appreciated as he deserves is Canova, artist of strength and gentleness, who worked on both a monumental and an intimate scale,

and who made his pieces so self-contained in contrast to those of the Baroque. The virtual one-man show of his work is a triumph and reveals not only his refinement and strength but also his Mannerist affiliations, one of the drawings in his sketch-books might well contain an echo of Niccolò dell'Abbate.

The careful choice of the sculpture includes many unfamiliar French and Italian artists (who have a champion in Gérard Hubert) and, by no means least, a strong English contingent. In this connexion, congratulations should go to Timothy Stevens for having arranged at Leeds and Liverpool, a valuable survey of the work of the North Country sculptor Joseph Gott, who settled in Rome after the Napoleonic Wars and was a friend of John Gibson and Joseph Severn; its useful catalogue with letters relating to Canova, Camuccini and Sir Thomas Lawrence ought to be in any neo-Classicist's library. It evokes a time, now more or less forgotten, when, according to T. K. Hervey, the author of *Illustrations in Modern Sculpture* (1834), 'no school of sculpture in Europe can claim to take the lead of that of England'.

Any assessment of neo-classical sculpture would gain greatly from the exercise of relating it to that of the ancient world and of endeavouring to pin-point those works and periods which offer relevant comparisons. For Winckelmann it was primarily Hellenistic art that counted; the influence of this decorative and charming, if by no means, powerful style may be observed in many neo-classical pieces with their almost too attenuated refinement. On the other hand, Canova who had the chance of

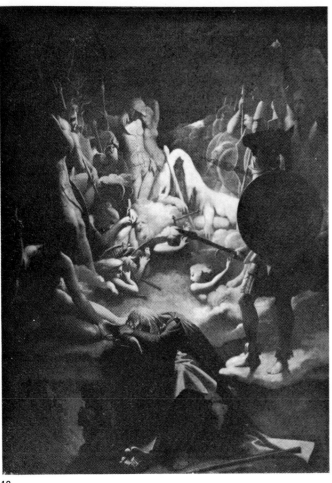

18

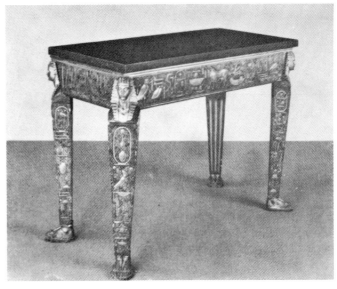

19. *Table.* Italian. Late-eighteenth or early-nineteenth century. Wood painted red and mottled green and black to simulate red Aswan granite, with black marble top. Height 89·8 cm. The Metropolitan Museum, New York

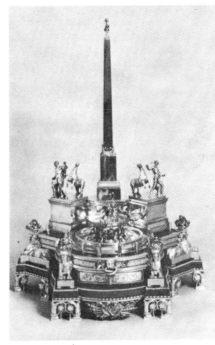

20. *Inkstand in the form of the Quirinal Monument* by Vincenzo Coacci (1756–94). Roman. 1792. Silver, silver-gilt and lapis lazuli on a base of rosso antico. Height 67·9 cm. Minneapolis Institute of Art

seeing the Elgin Marbles—an opportunity which Thorvaldsen never took—realized their grandeur, declaring that their creators were 'true imitators of *la bella natura*'.

Our time has witnessed a growing interest in the decorative arts and a closer study of the relations between designers and patrons; and an interesting study could be devoted to their collaborative efforts in the decoration of houses. Information about such connexions is contained in an important exhibition at Osterley Park House, which is being held in connexion with the Council of Europe's show. Its aim is to offer some account of the way in which four great architects, James 'Athenian' Stuart, Sir William Chambers (no friend to Greek art), Robert Adam and James Wyatt used neo-classical motifs.

The English scene differs considerably from the French in so far as architects were active erecting classical buildings, the offspring of Palladio, at a time when in France, as in many other places on the Continent, the Rococo was all the rage. Naturally the Rococo had some effect in England but reaction against it was as strong as in France.

The material presented by Peter Thornton at Osterley Park makes many original points: this careful and clever juxtaposition of drawings, documents and furniture is most telling. It is a show that gains in interest owing to the light it sheds on Anglo-French relations at this time; the four men who are the heroes of the show had all come into contact with their French colleagues when students in Rome and we can see how the development of neo-Classicism in both countries was similar in style, as would indeed be expected. An interesting example of this is the delightful medal cabinet possibly by John Linnell (Fig.

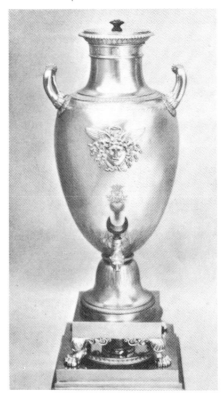

21. *Hot-water urn,* 1794–1814. Silver. The Metropolitan Museum, New York. From the Borghese table service composed of about 1600 pieces, the greater part of which was executed by Biennais and Odiot

103

7), based on a French example, which belonged to the original furnishings at Osterley Park and is lent by the Earl of Jersey.

Another section of the show deals with the work of Robert Adam at Osterley Park and provides fresh information on his role there. It is particularly valuable to be reminded that it was apparently Adam who was solely responsible for the introduction of the Etruscan taste, which was used for a dressing room representing the ultimate in chic in the 1760s and 1770s. Adam was in charge of the entire decoration so that it can be plainly seen that the conception of *gesamtkunstwerk*, about which we have heard so much in connexion with Art Nouveau, was a vital and fertile conception of the eighteenth century.

The highly attractive show of the decorative arts at the Victoria and Albert Museum helps to emphasize the way in which English craftsmen were abreast of modern style; the pottery produced by Josiah Wedgwood with its use of designs by Flaxman, the silver-ware of Matthew Boulton and John Fothergill and the admirable furniture by the principal cabinet-makers show the calibre of the national School. Its quality is only to be expected in view of England's wealth, which was increasingly derived from industrialization.

Thomas Hope's impact on the course of English taste was recently and capably investigated by Dr. David Watkin. Hope, the patron of Thorvaldsen, Flaxman and Canova and the author of a famous treatise *Household Furniture* (1807), was highly influential; his taste was eclectic and, by admiring Greek, Roman, Etruscan and Egyptian art, he stands out as one of the pioneers of the historicist style which assumed such significance in the years to come, and several pieces designed by him are shown (Fig. 17). The idea of relating the decoration of a room to a single work is shown in the colourful reconstruction of his Flaxman Room in his Duchess Street house in London. This was designed to contain the artist's *Cephalus and Aurora*, which Hope had commissioned in 1790 and, to quote his words,

The whole surrounding decoration has been rendered . . . analogous to these personages, and to the face of nature at the moment when the first of the two, the goddess of the morn, is supposed to announce the approaching day.

Political events did not disturb the decorative arts in England; but across the Channel the Revolution spelled the end of the clientele that had patronized the great cabinet-makers. The exhibition contains some of the masterpieces in the neo-classical taste made under the *ancien régime* by *ébénistes* such as Oeben, Leleu and Montigny. This array of treasures is headed by Riesener's splendid jewel cabinet made for Marie-Antoinette and subsequently bought by George IV, a monarch who played no small role in the neo-classical movement. The exhibition does more than offer an anthology of fine French works from the pre-revolutionary era; it underlines, perhaps necessarily, the way in which the Revolution did not destroy this tradition of meticulous craftsmanship and how it received fresh impulse under the Empire.

Debate has taken place as to the degree to which the Empire style represents true neo-Classicism. Hugh Honour, to put it bluntly, maintains that, under the Empire, art abandoned the true ideals associated with this movement and degenerated. Professor Mario Praz will have none of this believing, to quote his preface, that 'it reached its full blossoming during the period which approximately corresponds with the Napoleonic era'. He defends his thesis with ardour and ingenuity.

Obviously, judgement of this problem depends on personal interpretation, yet the period reviewed in this show (some 100 years in fact) was so rich and varied, so complex and contradictory, that room was available for more than one interpretation of Antiquity, more than one approach. The dissimilarities that obtain between artists of the same or different generations who were attracted by Hellenism or Romanism are illustrated in this exhibition, and the opportunity of seeing so many relevant works in such close proximity will inevitably provoke revaluations.

The Empire produced its own style, which was more at the service of one man, the Emperor, than of those ideals, stemming from the Enlightenment, which Mr. Honour finds rightly in the true blues of the movement. In any event, the Empire style makes an immense impact as one fit for heroes, men of authority, and parvenus too. Professor Praz observes how Napoleon tried

to persuade the painters that contemporary subjects were more interesting than antique ones, and in this way he succeeded in part in taking them away from a kind of inspiration which had revealed itself remarkably sterile even during the eighteenth century, and to induce them to cultivate another kind which proved rich in masterpieces, witness David's *Sacre* and Gros's battle scenes.

Napoleon's desire that painters should treat contemporary themes was responsible for a series of remarkable renderings of his campaigns, pictures that still evoke their carnage and horrors. One of the most remarkable is Girodet-Trioson's *Riots in Cairo* (Fig. 12) in which the smells of death and sexuality are fused in a way that presages the weird and uncanny visions of the Romanticists and the decadents. And it is one of those compositions which show the extent to which Delacroix descended from the neo-classical world. the connexion with the *Death of Sardanapalus* being more or less implicit.

In some ways the Empire style (whether intentionally or by chance) dominates the Royal Academy—it was the art of an aggressive nation eager to exert a hegemony over Europe. Yet, although France achieved artistic victories, her political ambitions ended in utter disaster! We should recall Lawrence's great Waterloo Chamber with its portraits of the leaders of the coalition that encompassed Napoleon's final defeat and the figure of the Iron Duke himself, a man of antique mould whose personality is enshrined at Apsley House. It is also as well to remember that, after the Restoration, Lawrence and Constable scored great success at the Paris Salon!

The section of Empire furniture contains many star-pieces such as the Cradle of the King of Rome which was designed by Prud'hon, an artist whose significance as an inspirer of decorative projects is only now being fully realized, the Marriage Casket of the Empress Marie-Louise, the Table of the Grand Commanders and Jacob-Desmalter's jewel-cabinet which was made after a design

23

22. *Portrait of the Misses Montagu* by Ingres, 1815. Pencil, 32×25 cm. The Trustees of the Earl of Sandwich's 1945 settlement

23. *Jewel-cabinet* by F.-H.-G. Jacob-Desmalter (1770–1841), 1812. Burr yew-wood, pear-wood and maple-wood with inlaid mother of pearl, ormolu mounts and porphyry top. Height 98 cm. Louvre. One of a pair ordered by the Empress Marie-Louise.

24. *Arm-chair.* French, *c.* 1790. Height 93 cm. Beech painted white and blue-grey, with the original blue-brocade silk. One of a set ordered by Willem Philips Kop for his house at Haarlem. Rijksmuseum

25. *Chair.* Russian, *c.* 1810. Mahogany with brass detailing, height 1·01 m. Viscount Suirdale

24 25

by Percier (Fig. 23). We are shown the contribution of men such as Biennais, Odiot, Thomire and Auguste and reminded thereby of the way in which Egyptian as well as classical *motifs* appear in the decorative arts of this period. Some may regret the absence of a portrait of Vivant-Denon, a man of the old régime who accommodated himself with the new and worked so ably for the Emperor. The fact that France seized collections in Italy is also, understandably, passed over; yet these spoils were one of the most formative influences of the day, certainly on English artists, including Turner who saw them in Paris during the short-lived Treaty of Amiens (1802).

The exhibition makes a notable contribution in assembling unfamiliar examples of the decorative arts. For instance, it is pleasurable to see these usually lively specimens of Italian Empire; those in Milan or Naples are apt to be overlooked by the tourist on the look-out

for more celebrated items. We are shown that neo-Classicism has its successes in Rome herself and one of the most spectacular items on view is the huge bronze table from the Vatican which commemorates important events in the pontificate of Pius VI; the reliefs by Pietro de Spagna form part of the frieze, which in turn is supported by Herculaneum figures modelled by Vincenzo Pacetti and cast in bronze by Giuseppe Valadier. (Pacetti, one of the most interesting figures of his day, formed the subject of an article by Hugh Honour published in the neo-classical number of APOLLO, November 1963.) Another amusing piece is the table in the Egyptian taste (Fig. 19). Other sections deal with German designers with K. F. Schinkel and Leo von Klenze well to the fore, and there are important items from Russia (Fig. 25), Scandinavia (Fig. 8) and the United States.

Mr. Honour makes an interesting point concerning the

relationship between the drawings made after the model by Canova and the open-air sketches of landscape-painters executed 'not so much in order to work out details for finished pictures so much as to try to penetrate the truths of nature'. Reminding us that Valenciennes's sketches have been interpreted as harbingers of Romanticism, he cites this painter's declaration 'that the greatest artists were those who by closing their eyes have seen nature in her ideal form, clad in the riches of imagination'. He continues:

Like so many of his contemporaries he seems to have adopted a method of working similar to that advocated by Goethe who said that the artist should begin by studying the differences between individuals, then by a leap of the imagination, subsume each individual in one act of vision or intuitive synthesis and thus rising from abstraction to abstraction, finally represent the type or universal seen in its indivisible harmony and purity.

Mr. Honour underlines the importance of the drawn, painted or modelled sketch and quotes Winckelmann's dictum that the sketch 'reveals the true spirit of the artist'. The sketch played a major role in the nineteenth century, eventually becoming a substitute, as it were, for the finished painting as with the Impressionists. Yet this *genre* was also used by many eighteenth-century artists, Tiepolo for one, so that a neo-classical formula was also a rococo one.

The compendious character of the exhibition serves to underline the many currents that co-existed during this dramatic period. At the Academy, for instance, are shown the portraits and books of some of the men who established the intellectual and artistic setting for neo-Classicism: Voltaire, Diderot, Rousseau, Lessing, Goethe and Kant. An interesting anthology of neo-classical poetry could be compiled, one that would include Shelley and Keats, Goethe and Hölderlin, the last-named one of the greatest of them all. This section helps to remind an English public at any rate, of the contribution of the Northerners to the movement and the exhibition rightly includes works by Sergel and Carstens. There is a drawing by Sergel, *Fuseli haunted by Demons*, that recalls how, for certain Northern artists, the new trend evoked a sense of mystery and terror; this element acted as a component in the growth of Romanticism. The connexions between neo-Classicism and the cult of early Christian art is noticeable with the Nazarenes, and this interesting topic is touched on by Lisbeth Balsev Jørgensen in an article in APOLLO (September 1972). Ingres, too, was keen on early Flemish painting as emerges from his astonishing hieratic image of Napoleon.

During the late-eighteenth and early-nineteenth centuries, the love of eroticism was no less vivid than earlier. Hamilton and Richard Payne-Knight had a good deal of fun over the cult of Priapus, and a decided sexual tinge is apparent in many neo-classical works, observed in the pornographic drawings of Fuseli (not shown), Fagan's portrayal of his wife with her pretty breasts open to inspection and perhaps in the delight shown by more than one artist in the explicit male nude. The Régence and Rococo are so often considered the major periods of sexual adventure that it is apt to be overlooked that Restif de la Bretonne and Sade operated in the days of the Enlightenment and that debauchery under the Directoire and the Empire was no whit less fruity than in the earlier eras. Possibly Sade's refusal to respect the value of the individual and his amoralism represented the darker side of the neo-classical movement; it suggests forces that were to be reflected in the imagery of the Romantic agony.

The exhibition is original in so far as its treats of subjects that do not generally find a place in such affairs. Stage design is apt to be disregarded in art-historical studies; here it finds a welcome place. Professor Monteverdi points out that the achievement of the eighteenth century in this department was based on the Italian contribution and that all strictly speaking neo-classical scene designs originated in Italy and had their chief exponent in Paolo Landriani who worked at the great Scala theatre built by Giuseppe Piermarini, one of the major Italian neo-Classicists. The differences of temperament existing on either side of the Alps are shown when Piermarini's drawings are compared with those by K. F. Schinkel. (Fig. 16.)

The now popular subject—town planning—is also represented and it is instructive to see how imaginatively and carefully cities were planned in the eighteenth and nineteenth centuries. Dr. Alistair Rowan, who is responsible for this section, stresses that it was an age of great improvement in urban development, observing:

A new society whose population was increasing at an unprecedented rate forced on planners not only a new scale but a number of new building types called into being to cater for its needs—the hospital, the charitable school, the public gallery and university college—all are typical institutions of the early nineteenth century whose facades, more often than not, played a notable part in the Neo-Classical programme of their towns.

The ideas of Vitruvius found practical translation in the ovals, crescents and circuses that characterize the townscape, and a feature of cities which is taken very much for granted—the open space—was advocated by this theorist. Dr. Rowan emphasizes that 'to Nash and Prince Regent, town planning was the art of linking a set of Elysian scenes', as may be seen at Carlton House Terrace and Regent's Park.

It is difficult to provide a coherent account of the architectural achievement of an age in an exhibition, for plans and projects and even models seem a trifle tame, except to the trained eye, and are obviously never the substitute for the real thing. However, a judicious and large selection of drawings and models such as C. F. Harsdorff's for Frederiks Church, Copenhagen, suggests the impressive character of the neo-classical contribution and many of its monuments still stand. The drawings by Jefferson and Latrobe (Fig. 27) in the exhibition emphasize the way in which the Greek style had many adherents on the other side of the Atlantic, Further visual information about the architecture and interiors of this period is also found in the group of drawings from the Cooper-Hewitt Museum at the Royal Institute of British Architects Galleries which contains an intriguing project of a monument to Dante (Fig. 26).

The architectural development during the long period presented in the Council of Europe's exhibition which was extensive in many countries (Russia among them) may be followed from Dr. Wend von Kalnein's substantial preface and, as far as concerns England, from Dr. Mordaunt Crook's volume to which reference has already

26. *Tomb of Dante* attributed to Mario Asprucci (1764–1804), 1803. Pen and ink with water-colour, 30·48×38·10 cm. The Cooper-Hewitt Museum, New York.

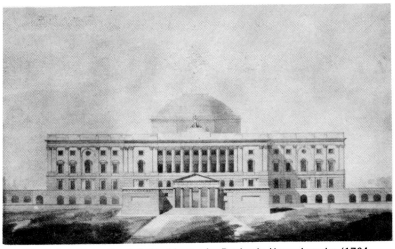

27. *United States Capitol, Washington* by Benjamin Henry Latrobe (1764–1820), 1811. The west elevation with proposed propylea. Library of Congress, Washington D.C.

been made. Dr. von Kalnein, who is a Palladian, maintains that Rome was the true birth-place of the movement; there foreigners were introduced to the antique past, although local architects were not originally excited by the classical heritage on which they had gazed since birth. Neo-Classicists achieve little of significance in Italy until Napoleon's time, when Antolini designed his plan for the Foro Bonaparte in Milan, capital of the Kingdom of Italy, but Luigi Cagnola's triumphal arch was the only part of it to be executed.

What will be new, at any rate to many English visitors, is the extent and importance of neo-Classicism in Germany, conveyed by a plentiful contingent of drawings by Schinkel, Klenze and others. Dr. von Kalnein is instructive on the subject of Schinkel, a figure of international significance, and he points out that this architect was not satisfied with Greek Antiquity alone and that on his first journey to Italy in 1803-5 he 'took more interest in medieval buildings than in the temples of Lower Italy and Sicily'. He declares:

The romantic element in his make-up enabled him to express himself in more than one style. Side by side with his strictly neo-classical masterpieces we find plans of a Gothic character for Queen Luise's mausoleum, a national Cathedral and the Werder Church in Berlin—not to mention his romantic pictures which are not far from the style of Caspar David Friedrich.

Luckily, the exhibition of Friedrich's works at the Tate Gallery provides some indication of the intriguing if complex relationship between neo-Classicism and the burgeoning of Romanticism in Germany, a period of growing nationalism too, with Fichte as a passionate advocate of this concept.

As far as Germany is concerned, neo-Classicism reached its term in Munich with the abdication of Ludwig I in 1848, a watershed in European history when Metternich fled from Vienna. Yet neo-Classicism did not altogether expire and in England it had a final exponent in Alexander 'Greek' Thomson, who is the hero of the last part of Dr. Crook's book. In Munich, too, classical echoes are to be found, as in the interior of Stuck's villa.

Obviously an exhibition has to end somewhere. The lure of Antiquity—the dream of an Arcadia—tempted not a few later creative spirits, Lord Leighton, Puvis de Chavannes and Gauguin among them; then there are Whistler, with his feeling for Tanagra figurines, Alma-Tadema, the master of the swimming-pool, Böcklin and

the vivid collaboration of Richard Strauss and Hugo von Hofmannsthal, and, in our own time, Chirico and Henry Moore. Yet by and large the unadulterated vintage of the 1790s had been transformed into the heady brew of historicism, thus confirming Mr. Honour's thesis.

Any attempt to present the art of such a long period as that influenced by neo-Classicism is obviously a difficult business. Much that is relevant is often unavailable and the works themselves tend to be seen out of the context of the historical background, so it is as well to recall that, in a period when artists were seeking to embody their dreams of Antiquity in images emphasizing ancient virtues or Imperial splendour, people lost their heads under the guillotine, or died in wars and on the retreat from Moscow or during the blood-curdling siege of Saragossa.

Some may feel that the refinement and elegance so characteristic of the Louis XVI and Adam styles were lost once the new and revolutionary world hoped for by some, although by no means all, protagonists of the Enlightenment, came into being. There is a considerable difference in quality, for instance, between the sculpture of Houdon and that of Thorvaldsen and between the painting of Fragonard and Boucher and that of Guérin and Girodet-Trioson. Great figures exist, of course—David and Ingres, and many excellent second-rankers such as Prud'hon—but it is hard not to feel that much of permanent value had gone for ever. It may be, too, that the sense of quality, although surviving with a number of craftsmen, was endangered once industrialization had begun to take effect. The touch of vulgarity in Empire and Regency was by no means surprising, for many of its patrons were upstarts—the Bonaparte clan was a veritable Mafia—who were eager to show off their interiors.

This important exhibition raises many amusing and vital problems. It will help us to understand the age as well as its art; it will add ammunition to those who enjoy debating the perennial problems of the nature of Classicism and Romanticism: and it affirms that the arts can enjoy a striking measure of homogeneity even at a time of political disturbance and warfare. Not the least though one of the happiest of its results may be to send the enquirer off to the British Museum to see how it all began and to make comparisons, even though these are not necessarily favourable to the later artists.

Il Cavaliere Alberto

In the years immediately after Waterloo any English person with pretensions to taste who chanced to be in Rome would make a point of visiting the studio of Bertel Thorvaldsen. This celebrated Danish sculptor had made his home in the city for a long time, becoming one of its sights and enjoying a reputation akin to Henry Moore's in our own period. After the death of Canova in 1822, Thorvaldsen was considered the greatest sculptor of the age, especially in Nordic countries and in England, but less so by the French; Stendhal, for instance, did not care for his work. He was treated with immense respect by kings, princes, great noblemen and the well-to-do; he was much admired by his fellow-artists so that after his return to Rome in 1820 from Copenhagen, a feast was held in his honour in the trattoria in the Palazzo Fiano and, on his visit to Munich in 1830, one was given at the Paradiesgarten and he sat next to the veteran Nazarene, Peter Cornelius. His reputation was widely spread not only on account of his famous monuments and classical figures, but owing to his numerous portrait busts of the international *beau monde* that congregrated in Rome. He has a special claim on English affections as the portraitist of many of our compatriots and his career was saved owing to the intervention of an English patron.

Nowadays Thorvaldsen is rather under a cloud. Specialists have written about him and his work, but little is known about either, outside the land of his birth. He was an interesting personality, however, and his sculpture has charm and quality. Its range can be grasped from the collection in the Thorvaldsen Museum, which lies near the heart of Copenhagen, alongside Frederiksholms Kanal and a stone's throw from Christiansborg Parliament, a former royal palace and the National Museum. The Thorvaldsen Museum is a work of art in its own right, for it was specially designed by M. G. Bindesbøll to house both the sculptor's own work and his large and varied collections after he announced in 1837 his intention of presenting them to the city of Copenhagen.

This building, which has outside walls adorned with frescos relating Thorvaldsen's return to Denmark, symbolizes the long and rewarding Danish love of Rome. This city has cast its spell on many Danish artists—Eckersberg, Constantin Hansen and Købke among them—and it meant much in the development of Hans Christian Andersen; it finds a reflection, too, in the famous collection of Roman Imperial and Republican sculpture in the Ny Carlsberg Glyptotek. Carl Jacobsen, a brewer and the founder of that Museum, was inspired in his enterprise by the example of the Thorvaldsen Museum.

Thorvaldsen's own collections, of which an account is given in this issue, provide a fascinating conspectus of the work done by the sculptor's contemporaries in Rome, his fellow Northerners—Eckersberg, Meyer and Dahl, for instance—the Nazarenes and such English artists as Joseph Severn, Penry Williams and George Wallis. This section of the Museum, with its group of Italian scenes, forms a sort of backcloth to Hans Andersen's vivid book, *The Improvisatore*; it recalls the world of the expatriate artist in Rome, a theme which also served Henry James so well in his life of William Wetmore Story, although this deals with the next generation, and which Sigrid Undset used to such effect in *Jenny*.

The date of Thorvaldsen's birth is not known; it was between 1768-70. It took place in Copenhagen, in Grønnegade, which is a minute or two's walk from the Hotel d'Angleterre and Kongens Nytorv. His father, Gotskalk Thorvaldsen, was an Icelander. He earned a humble living as a woodcarver, making figure-heads for ships, and, it is said, had a taste for the bottle. His mother, Karen Dagnes, 'a pretty, plump little person', was the daughter of a schoolmaster in Jutland and she was devoted to her son; she went to seed in later years.

At the end of the eighteenth century Copenhagen may have been a small and somewhat provincial capital, but a love of art was deeply rooted there, just as it was in the Stockholm of Gustavus III and in certain German Courts. Denmark also produced in Holberg one of the founders of modern drama. French culture was appreciated in Copenhagen and Danish art owed much to the French connexion: J.-F. Saly, a talented sculptor, worked in the city and designed the equestrian statue of King Frederik V in Amalienborg Square.

Thorvaldsen received a sketchy formal education. However, he had the good fortune to attend the flourishing Royal Academy, where his teachers included Johannes Wiedewelt and Nicolai Abildgaard. Both were in touch with modern trends and both had lived in Rome. The former had even shared lodgings with Winckelmann in the city and doubtless told the young Thorvaldsen much about this high priest of the classical revival and, as

1. *Self-portrait,* 1795. Pencil and water-colour, 12·6 × 10 cm. Thorvaldsen was a heavy smoker and is shown filling his pipe in his studio in Copenhagen

2. *Self-portrait,* 1810. Charcoal, 23 × 18 cm. Ny Carlsberg Glyptotek

With the exception of Figures 2, 5, 7, 8 and 34–36, all works reproduced in this Editorial are by Bertel Thorvaldsen (1768/70–1844) and, unless otherwise stated, are in the Thorvaldsen Museum, Copenhagen, and were made in Rome.

3. *Thorvaldsen* by Rudolf Suhrlandt (1781–1862), 1810. Oil on canvas, 61·9 × 49 cm. The sitter's hand rests on the head of his statue *Adonis,* modelled in Rome in 1810 and commissioned in marble by Ludwig I of Bavaria, before he succeeded to the throne

4. *Self-portrait,* 1810. Marble, height 73·8 cm. Royal Danish Academy of Art, Copenhagen. Commissioned by the Danish art collector, Hans West, in Rome, this bust was later presented by him to the Academy

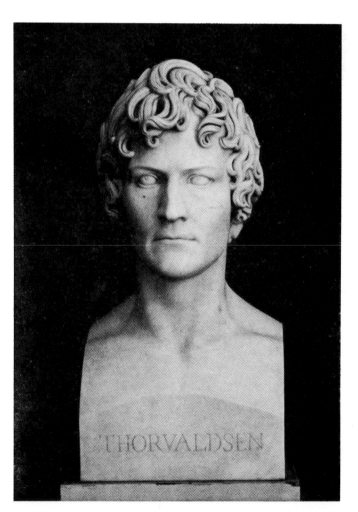

5. *Anna Maria Magnani* by J. A. Jerichau (1816–83). Pencil, 22 × 18·5 cm. The sitter had been Thorvaldsen's mistress, and this drawing was done after he had left Rome in 1838. She died in 1846

6. *Frances Mackenzie Seaforth*. Pencil, 32·7 × 24·2 cm. This Scottish girl, who hoped to marry Thorvaldsen, tore up this drawing and returned it to him when she realized their relationship was over

Rudolf and Margaret Wittkower pointed out, he 'became one of the earliest and most ardent advocates of neo-Classical doctrines'. When luck turned against him and his burdens were too great Wiedewelt committed suicide. Abildgaard studied the Antique in Rome and at the same time worked on a subject from Norse legend with a view to the pictures he was to paint for Christiansborg Palace on his return home, thus providing a fascinating example of the connexion between Northern mythology and the ancient world. After 1800 Abildgaard painted his cycle of four scenes from Terence's *Andria* (State Museum, Copenhagen); this shows the relationship between neo-Classicism and the stage, which also emerges with J. L. David.

Abildgaard took Thorvaldsen under his wing, employing him to assist with the decorations for one of the Amalienborg Palaces; the young artist did *The Seasons* and *The Hours* after the designs of his master. Besides knowing these two men, Thorvaldsen would have seen the work of Jens Juel, an elegant painter whose sophisticated portraits are harbingers of the neo-classical style in this *genre*. Thorvaldsen soon showed his mettle as an independent artist; he made two bas-reliefs, *Priam pleading with Achilles for the body of Hector* and *Hercules and Omphale*, book illustrations and portrait medallions. His competence was revealed in his lively bust of the Danish Prime Minister, Count A. P. Bernstorff (Fig. 37), which was done after a portrait painting. By 1793 he had won the Academy's highest gold medal and was awarded a travelling scholarship to Italy.

Although things were going his way, it was claimed

that Thorvaldsen could not understand how any human being was able to laugh! Whether this be true or not, an early self-portrait (Fig. 1) shows a man with a determined, but not unhumorous, character; significantly he is filling his pipe, for he was a devotee of sweet Lady Nicotine.

Fortunately Thorvaldsen kept a diary of his experiences on first arriving in Italy; Naples was where he disembarked with his dog Hector. This document reveals that he dined with Count Bourke, the Danish Minister to the Neapolitan Court and later the owner of very fine pictures, saw the Farnese Bull and other celebrated antique works and the excavations and came across Professor Tischbein. What a pity that more information is not available about his encounter with this pundit, who published the ancient vases in Sir William Hamilton's collection!

Rome afforded him an intense revelation: 'I was born on 8 March, 1797, up to that time I did not exist'. He soon made friends among the foreign colony, one being the Danish-German artist Asmus Jakob Carstens, who died a year after Thorvaldsen's arrival, but not before he had strongly influenced the young sculptor, who copied many of his drawings. Carstens was one of the many early-nineteenth-century artists who dreamt of creating large-scale decorative schemes and, as his friend Carl Ludwig Fernow wrote to the Danish poet Jens Baggesen (20 February, 1795): 'his soul lives in a world of wars of the Gods, battles of the Titans, in Hesiod and Homer'. He wished to create something analogous to Michelangelo's *Last Judgement*. Thorvaldsen had letters of introduction to Georg Zoëga, the Danish Winckelmann and one of

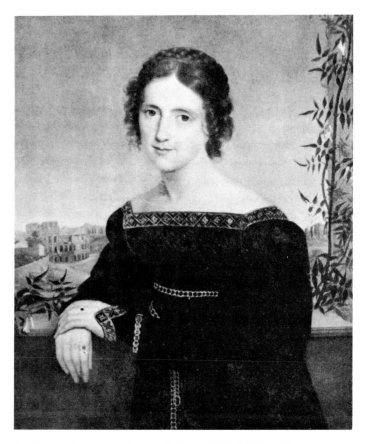

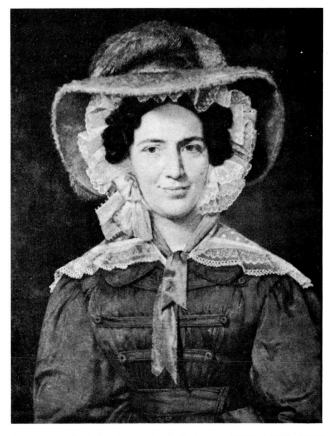

7. *Fanny Caspars* by Louise Seidler (1786–1866). Oil on canvas 74×60·5 cm. While Fanny Caspars was having her portrait painted Thorvaldsen would visit the artist's studio to gaze at the beautiful sitter

8. *Baroness Christine Stampe* by C. A. Jensen (1792–1870), 1827. Oil on canvas, 64·5×51 cm. This portrait was painted in Denmark before the Baroness entered Thorvaldsen's life

the founders of archaeology, who became a good friend to him, although reporting to a Danish correspondent that the young man had much taste and feeling, though he 'is ignorant of everything outside art'.

Thorvaldsen did his best to remedy the defects in his education, which no doubt Zoëga lectured him about. He visited the regulation sights and the Corsini, Colonna and Borghese galleries, as he mentioned in a letter to a friend. However, he had one disappointment, for the bulk of the Papal collections of antique sculpture in the Belvedere was packed up waiting for dispatch to France under the terms of the Treaty of Tolentino (19 February, 1797). Nevertheless, his sketch-book in the Royal Norwegian Society of Sciences, which has been published by Dyveke Helsted, contains copies after Roman sculpture in the Borghese and Giustianini Collections, as well as such things as Giulio Mazzoni's ceiling decoration in the Capella Teodoli in S. Maria del Popolo. It also includes some charming landscape drawings in the outline form then so favoured.

The sculptor found a studio in the Strada Babuino, near the Teatro d'Aliberti. This had been formerly used by Flaxman, and Thorvaldsen retained it until April 1801: it was there, presumably, that he made copies after Roman busts in fulfilment of his instructions to learn the art of cutting marble in this way. He also did a marble of Count Bernstorff in the form of a herm from the mask he brought with him. Later versions assumed a more classical appearance. (Fig. 38.)

Thorvaldsen arrived in Rome at a difficult period; the old order was crumbling. The Papacy had been humiliated by the Directory and lost much territory and many works of art. In December of the year Thorvaldsen settled in Rome fighting broke out; the French Embassy was attacked and the Ambassador, Joseph Bonaparte, fled. However, in February General Berthier entered the city and proclaimed a 'Roman Republic' from the steps of the Capitol, and the elderly Pope, Pius VI, was bundled off to Valence, where he died. Thorvaldsen's reactions to these events is somewhat obscure. It is conceivable that he flirted with Jacobinism, as did some of his compatriots; but he was never the man to be involved in political life and, according to J. M. Thiele, his friend and first biographer, he sought refuge with the Zoëgas. The political situation improved when the Concordat was signed in 1801.

During these years Thorvaldsen was extending his circle. He became a close friend of J. A. Koch, the early Nazarene with whom he shared lodgings in the Via Sistina. One friend he made in these years in Rome was Friederike Brun, who deserves an up-to-date biography. It is possible that they met in Copenhagen in the early 1790s, but no precise information is available on this score. But he sent her a package from Rome in 1800 and two years later (27 November) she mentions him for the first time. Madame Brun had visited Rome before him, for this charming and intense person, an apostle of Romanticism, wrote an amusing and delightful book on the city, *Tagebuch über Rom* (1800), based on her experiences there in 1795-96. It is an important document for the development of sensibility, for in it she described how in walking in the gardens of the Villa Doria Pamphili she

111

9. *Achilles with the dying Penthesilea, Queen of the Amazons*, 1801. Plaster, height 45 cm. This sketch-model was given to the Museum by the sculptor's biographer, J. M. Thiele

10. *Cupid and Psyche reunited in Heaven*, 1807. Plaster, height 1·34 m. Like Canova, Thorvaldsen was intrigued by this subject, which he also reproduced in several reliefs

11. *Jason with the Golden Fleece*, 1803–28. Marble, height 2·42 m. Commissioned by Thomas Hope. It stood at his country seat, The Deepdene, Surrey, until acquired by the Museum in 1917

9 10

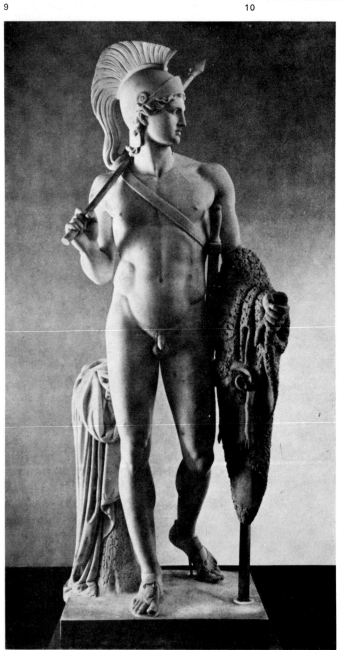

felt ill and sad. She confessed that in the city she found nothing of the world of love and friendship existing on the northern side of the Alps. Thorvaldsen, too, had his share of Nordic sensibility and it colours his art to a considerable extent.

All was not well with Thorvaldsen. Known as something of an idler (the impression he made on the captain of the ship that brought him from Copenhagen), he was a prey to melancholy. He caught malaria and seems to have often suffered from bouts of ill-health which were possibly partly pyschosomatic. His private life was complicated. He seems to have had a sweetheart, Margrethe, back at home; however, she was forgotten when he fell in love with a handsome black-eyed girl, Anna Maria Magnani (Fig. 5), who at one time was a chambermaid to Madame Zoëga. Thiele's story that Thorvaldsen met her when she was single and working for the Zoëgas at their Genzano villa is not true, for when Thorvaldsen came across her she was married to Wilhelm von Uhden, the Prussian Ambassador to the Holy See. Thorvaldsen's love for her presumably caused the break-up of the marriage in June 1803; their liaison lasted for a number of years. Anna Maria gave him a son, Carlo Alberti, who was born in about 1806 and died in 1811, much to his father's distress, and a daughter, Elise. She was born in 1813, married a Dane, Colonel Paulsen, and died in 1870.

Thorvaldsen's melancholy may have been in some respects due to the problems he faced in making his artistic way. It was one thing to be a prizeman in Copenhagen, quite another matter to succeed in Rome, as Roderic Hudson was to discover in due course. There was the immense and rich tradition of the Roman heritage to contend with and the fact that the scene was dominated by Antonio Canova, from whom he derived inspiration on more than one occasion, as Emma Salling explains in her article in this issue.

Whatever Thorvaldsen's view of originality may have been, he had to reckon with the harsh challenge implicit

11

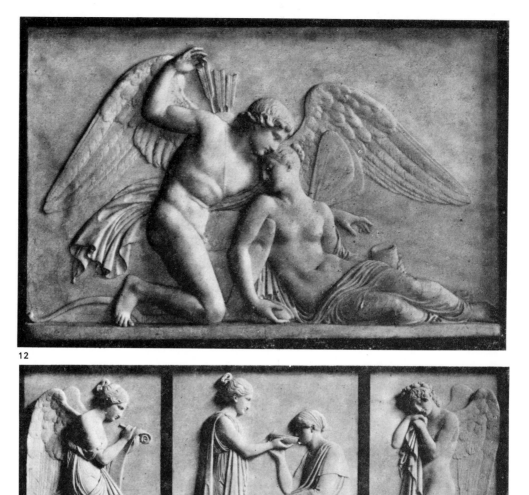

12. *Cupid revives the swooning Psyche*, 1810. Marble, 49·5×78 cm. This marble was executed, largely by Thorvaldsen himself, from a model done at the Schubarts' country-house at Montenero

13. *Reliefs from the tomb of Auguste Böhmer*, 1814. Marble, 77×45·7 cm., 77×163 cm., 77×44·7 cm. These reliefs were commissioned by F. J. Schelling in 1811 but were never delivered. They represent from the left: *Nemesis writing on a scroll, Auguste bitten by a snake while nursing her mother, and a Genius of Death*

12

13

in working in the 'modern style', i.e. one that derived its radicalism from the art of classical times. In his early Roman days, besides a few portraits and copies after classical busts, he produced *Bacchus and seated Ariadne*, 1798 (probably his first original work in Rome) and the admirable sketch-model for a group, *Achilles with the dying Penthesilea, Queen of the Amazons* (Fig. 9), which has almost a balletic quality and shows the extent to which he was able to graft his rococo grace on to classical subject-matter.

By 1803 the sands were running out for Thorvaldsen. His stipend from the Academy was nearing its end; he had not won success; and it seemed that he would be obliged to return home, to a future which was uncertain and must have appeared bleak. It was not that he did not try to create something striking and novel, for he had been working on a large statue, *Jason with the Golden Fleece* (Fig. 11). This piece gave him much trouble, and the first version, which was life-size, broke. However, a new over-life-size model in plaster, for which Friederike Brun paid, caused some stir, for it was seen in his studio by many visitors, including Canova, who generously said

that it was *'in uno stile nuovo e grandioso'*. Yet it had not brought Thorvaldsen any commissions, so the artist had no alternative but to prepare for the retreat to Copenhagen. Just before he was to leave a *deus ex machina* descended in the shape of Thomas Hope, who was taking advantage of the short-lived Treaty of Amiens to visit Rome. Whether Hope had heard of Thorvaldsen's circumstances is not known, but they were doubtless familar in art circles; he may have been told about him by Count C. G. Bernstorff, the son of A. P. Bernstorff, whom he had met at dinner with the Princess of Wales on 21 July, 1801, at her house, or by George Wallis, 'the English Poussin', who was a friend of his and of Thorvaldsen.

Hope, who was a member of a rich banking family of Dutch origin, was no ordinary patron, but one of the most influential and discerning connoisseurs of his time whose personality and taste have been splendidly presented by Dr. David Watkin. He ordered a marble to be made from the model, drew up a proper contract and put down a deposit. However, poor Hope had to wait a very long time—until 1828 in fact—before he received his statue, which he placed in his marvellous house, The

Deepdene, Surrey. Thorvaldsen does not come well out of the affair and, as Dr. Watkin says, 'He is at least revealed for all his austere neo-classical style, as an example of the new Blake—"liberated" artist of the nineteenth century whose elevated conception of his art would not allow him to believe that it could be produced to order'. It is a good point. Later, trouble of a similar nature occurred over the fulfilment of the commission to design a monument to the Duke of Leuchtenberg (Eugène Beauharnais) in Munich, but the formidable widow got her way. The correspondence between the Duchess, who was Ludwig of Bavaria's sister, her agents and the sculptor makes fascinating reading; so does that connected with the equestrian monument of Prince Josef Poniatowski.

Jason may not now seem the masterpiece it did at the time, but it has qualities: a simplicity and linearism that give it purity and force. Vagn Poulsen, one of the few commentators on Thorvaldsen's art to have written about it with a profound knowledge of the Antique, observed that, although the artist claimed that he sought daily inspiration for his work in the Vatican, in fact he 'had had a careful look at a much restored statue of Ares in the cortile of the Palazzo Borghese', and Poulsen noted that his work had precursors in the north, such as Sergel's *Diomedes* and C. F. Stanley's *Amor Patriae*. The extent to which Thorvaldsen was keen on Greek art at this stage is an absorbing topic; Poulsen observed that 'What Greek elements there are in *Jason* point in the direction of the Fifth century B.C. the great era of Phidias and Polyclitus'.

Thorvaldsen's situation, although complicated by the need to support Anna Maria, brightened a shade owing to the commission from Hope and because he met Baron Herman Schubart, Director-General of Danish-Norwegian commercial affairs in Italy, who was in Rome for a few weeks in the autumn of 1803. He had doubtless heard all about Thorvaldsen from the architect C. F. F. Stanley, an old friend of Thorvaldsen who had been cared for in Naples by the Baron and his wife.

Schubart and his wife (Fig. 40) were kind-hearted and generous and did much to help Thorvaldsen. The diplomatist made Thorvaldsen write, at his dictation, a letter to his sister, Countess Schimmelmann, who was influential at Court and whose salon was fashionable. Baroness Schubart also got in touch with a Danish friend on his behalf, declaring that Thorvaldsen would become the Praxiteles of his age and a worthy successor to Canova. With maternal solicitude, she wrote:

Cependant notre Thorvaldsen risque de tomber en mélancholie et de devenir inutile, si on ne relève son courage; il aura besoin pour sa santé d'une nourriture plus succulente que celle de jeunes artistes à Rome, qui souvent . . . sont exposés à des maladies, ce qui a été le cas de Thorvaldsen déjà. Il est rangé, économe et de bonnes moeurs; il ne demandera point de superflu . . .

The Baroness, who was Dutch, may well have been right about Thorvaldsen's diet. It is worth recalling that when Keats was in Rome he was so disgusted by the dinners served to him from a trattoria near his rooms in the Piazza di Spagna that he threw the plates out of the window and only then was he served a proper meal!

The Schubarts' intervention had effect. The Academy

informed the sculptor that not only had the Crown Prince Frederik (later King Frederik VI—Fig. 60) 'expressed his joy at seeing a Dane again in the admiration of connoisseurs in Rome', but the King was awarding him a *douceur* of 300 rix-dollars. Thorvaldsen is often thought of as a cosmopolitan artist alone, and as a consequence it is sometimes overlooked that interest was taken in his work from the start by his compatriots and that he received patronage and honours.

Thorvaldsen needed money, especially as he had to support Anna Maria. However, they never seem to have set up house together; he lived in the Palazzo Buti in the Via Gregoriana, where he remained for the rest of his time in Rome. His mistress made a considerable fuss when he went to stay with the Schubarts at Naples in April 1804 and, after a few days in Rome, set off with the Moltkes to Florence, where, it seems, Anna Maria 'had a rival among the retinue of Countess Moltke'. But Thorvaldsen also impressed the local artists and was appointed a Professor at the Florentine Academy.

A year later he stayed with the Schubarts at Montenero, and once again Anna Maria reproached him for his absence, pursuing him with letters. He treated her somewhat coolly and in a letter to his friend Stanley pointedly ignored her, inquiring about his dog Perrucca. As Thiele writes,

Of course this message, as was intended, came to the signora's ears, who at once wrote to her faithless lover, bitterly complaining of her indisposition and her 'sleepless nights' at the same time upbraiding him for the tender attention he evinced *per una bestia, domandando della salute del vostro cane.*

However, this biographer recounts that the tiff soon blew over and Anna Maria wrote to Thorvaldsen: '*Fatemi il piacere di comperarmi un paija di forbice d'inchittera*' [*sic*].

These absences from Rome did Thorvaldsen's health good, although he still suffered from the attacks of depression which were so frequently mentioned by his friends. The Baroness cured him of smoking, though for how long is not known. His reputation was spreading; so was his clientele. Schubart introduced him to Baron Wilhelm von Humboldt, the influential Prussian Ambassador to the Holy See, whose bust he modelled in 1808. He began to find important foreign clients, such as Princess Galitzine (Fig. 39), with whom Lord Granville was in love, and Count Vorontsov, and he modelled the busts of the two Russians in 1803-4. Vorontsov's mother, Countess Irina, also commissioned works from him. It was a fellow-countryman, however, the poet Count Rantzau-Breitenburg, who purchased one of his pleasing early pieces *Achilles in despair as Agamemnon's heralds bear off the beautiful Briseis* (1803); a later drawing of this theme is reproduced here (Fig. 31). This may have been inspired by Canova's work of the same subject, or by Flaxman's illustration. It was now possible for Zoëga to mention Thorvaldsen in the same breath as Canova.

Thorvaldsen was making his way, but life was not easy for him; these were war years and the all-important English patrons were absent. He made various portraits, two bas-reliefs for Christiansborg Palace and such gracious pieces as *Cupid and Psyche reunited in Heaven* (Fig. 10), *Hebe* and *Cupid stung by a bee complains to*

14. *Reliefs from the tomb of Philip Bethmann-Hollweg,* 1814. Plaster. Original models for the monument in the cemetery at Frankfurt-am-Main. (a) *Mourning mother and sisters,* 89·5 × 93·5 cm. (b) *Nemesis recording the young man's deeds beside the river-god Arno,* 90 × 97·5 cm. The river-god symbolizes Florence, where the young man died. (c) *Symbolic representation of the Austrian Emperor's posthumous award,* 90 × 140 cm.

14a 14b

14c

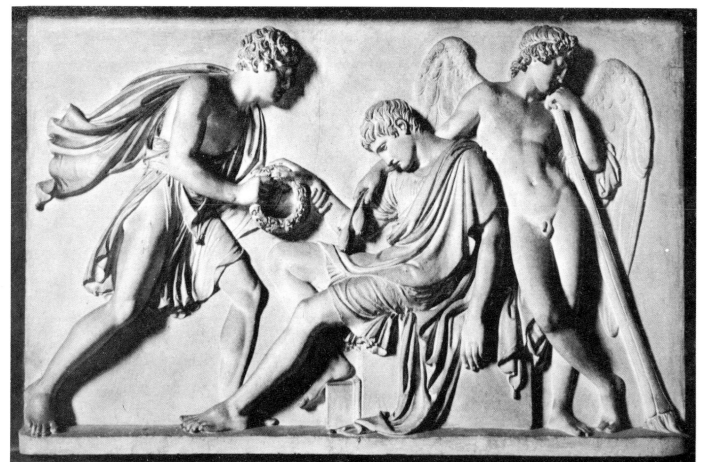

115

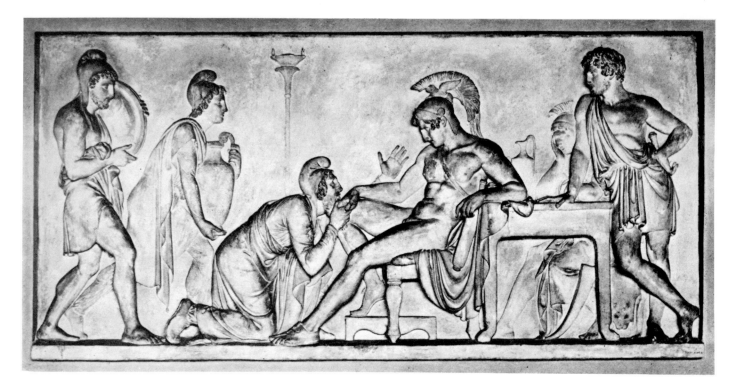

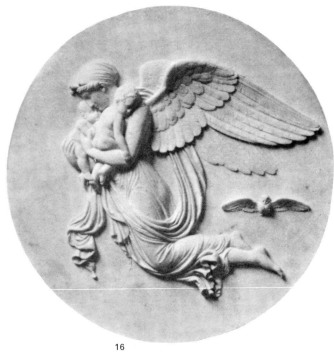

16

Venus. However, his lack of funds and the sorrow he felt at Stanley's death made him once more think about returning home. In Copenhagen he would receive a salary as professor at the Academy and one of his perquisites was a free apartment in Charlottenborg. Yet all was not lost on the Roman front; for instance, *Adonis* caused something of a stir, winning praise from Canova, while the Crown Prince of Bavaria, Ludwig, ordered a copy of it for 2,000 scudi. Yet, for a man approaching his forties, Thorvaldsen may have felt that true success eluded him.

A major change in his career occurred in 1812 when the architect in charge of preparing the Quirinal Palace for the expected visit of Napoleon commissioned him to execute a frieze for one of the salons. Thorvaldsen may have been one of those artists who respond to a challenge, for he completed his task with speed, creating seventeen bas-reliefs in plaster on the theme of the Triumphant Entry of Alexander into Babylon, which may still be seen *in situ*. It is a swift narrative piece which, according to Vagn Poulsen, shows that the artist was aware of the reproductions of the Elgin Marbles which circulated at the time.

Thorvaldsen was on warm terms with Ludwig of Bavaria, who often used to see him when in Rome, and they appear in the well-known painting of the Spanish *osteria* by Franz Catel. He executed Ludwig's bust in 1818 (Fig. 54), and later that of his mistress, the Marchesa Florenzi (Fig. 65). Ludwig bought various works from him and entrusted him with the restoration of the archaic pedimental groups of the Temple of Aegina before their installation in the new Glyptothek at Munich. Poulsen noted that, although 'we could not expect him to be deeply impressed by archaic art, yet he created the statue of *Hope* (1817) in an archaistic style. There is reason to suppose that the Roman *Spes* in the Munich Glyptothek was his real prototype—rather than the genuine acroterial figures from the Aegina'. His ability to assimilate the spirit of Greek art and to create pieces that contain an echo of its lyrical quality as well as something of his own personality may be seen in the two funerary bas-reliefs for Auguste Böhmer, 1814 (Fig. 13) and Philip Bethmann-Hollweg, 1814 (Fig. 14). These works foreshadow the sort of work done by Hildebrand at the end of the century and emphasize the need for a new evaluation of Thorvaldsen's art.

Thorvaldsen's portrait busts led to his growing fame. Two of the most attractive he did around 1810 were of Vincenzo Camuccini (Fig. 42), the leading painter in Rome, and Ida Brun (Fig. 41), the pretty and talented daughter of Friederike Brun. This girl reminded Madame de Staël of her own creation, Corinne, and she won success in the drawing-rooms owing to her antique poses, which were presumably more restrained than those done

17

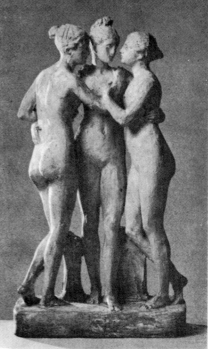

18

15. Opposite: *Priam pleading with Achilles for the body of Hector*, 1815. Plaster, 93·5× 194 cm. A marble copy of this was commissioned by the Duke of Bedford for Woburn Abbey

16. Opposite: *Night with her Children, Sleep and Death*. Marble, diameter 80·5 cm. One of several marble copies of the relief, which was modelled in 1815

17. *Seated Lady*. Plaster, height 42 cm. Possibly a sketch for the statue of Countess Osterman-Tolstoi, modelled in 1815

18. *The Three Graces*, 1817. Plaster, height 58 cm. Sketch-model for the group which Thorvaldsen reworked in 1842 during his last visit to Rome

19. *Ganymede and Jupiter's Eagle*. Marble, height 93·3 cm. One of several marble copies, this being the best, from the statue modelled in 1817. The first version, commissioned by Lord Gower, second Duke of Sutherland, is now in the Minneapolis Institute of Arts

19

by Emma Hamilton. She later married the comte de Bombelles. From the same year dates his own two compelling self-portraits (Figs. 2 and 4) and the portrait by Suhrlandt (Fig. 3), in which his features reflect an intensity that shows him to be a true contemporary of J. L. David.

Thorvaldsen's portrait busts, which have been so admirably discussed and catalogued by Professor Else Kai Sass in her three-volume book on the subject, provide a Who's Who of Roman international society in the years just after the fall of Napoleon. The changing fortunes of the time made him the favourite portrait sculptor of many of the English visitors who swarmed into the city; in this respect he was a latter-day equivalent of Pompeo Batoni. The English were the richest and most powerful patrons

of the time. Thorvaldsen's first bust of an Englishman was of Lord Exmouth, Rear-Admiral of the White, which was done in 1814. It was followed by one of Lord William Cavendish-Bentinck, Commander-in-Chief of the British Expeditionary Force to the Court of the Two Sicilies and later Ambassador Extraordinary there.

In the following year Thorvaldsen made one of his most charming portraits: a figure of Georgiana Russell, daughter of the Duke of Bedford. From now on with ever-growing momentum, English men and women sat to him—Alexander Baillie (Fig. 44) and his life-long intimate friend, the Norwegian merchant Knudtzon (Fig. 43), and Lady Sandwich (Fig. 45), once described as 'fanning every flame into a fire'. His popularity was attested to by Elizabeth Duchess of Devonshire, an amateur of modern

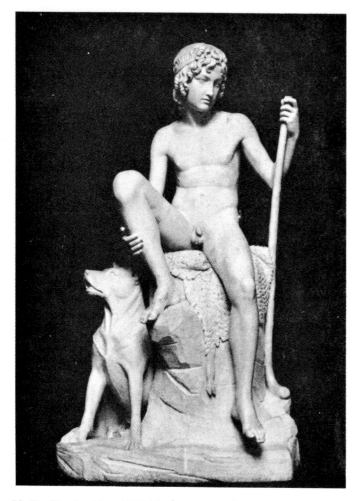

20. *The Shepherd Boy,* 1817. Marble, height 148 cm. The dog is believed to be the sculptor's own dog, Teverino

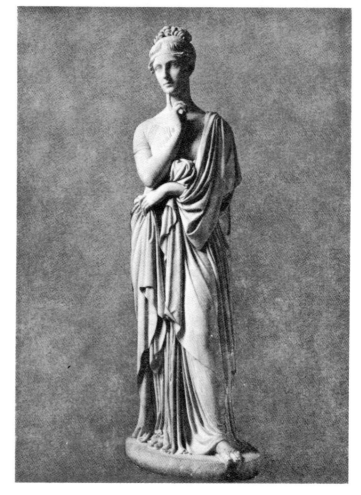

21. *Princess Bariatinski (1793–1858),* 1818. Marble, height 1·80 m. Maria Wilhelmina Louise von Keller was the daughter of the Prussian diplomatist, Count D. L. C. von Keller and married Prince Ivan Ivanovitch Bariatinski in 1813

sculpture, who mentioned his growing success to a friend.

Confirmation of his position came in 1817 when Thomas Hope (Fig. 47), who ever lived in hope of getting *Jason,* sat to him with his family. One of his children was done surreptitiously as a present for Hope. The two men must have had much in common; it is tempting to think that Thorvaldsen's idea of giving his collections to Copenhagen may have been inspired by Hope's Duchess Street house—a veritable museum, of which the implications for taste and museography have been skilfully drawn by Dr. Watkin. Connexions, too, may be found between the love of the picturesque so characteristic of Hope's taste and Thorvaldsen's eclecticism.

The sculptor made something of a catch when Byron sat to him in 1817 (Fig. 48), although Hans Andersen recalled that the poet was none too pleased with the result, for he felt that it did not make him look sufficiently romantic. Thorvaldsen was later asked by the committee headed by Sir Thomas Maitland to design the monument to the poet which is now in Trinity College, Cambridge; he did a bust of Maitland (Fig. 53) after the cast of a sculpture of him probably by the Corfute sculptor Paolo Prossalendi. The English connoisseurs who sat to him included the second Duke of Sutherland (Fig. 50) and George James Welbore Agar Ellis, first Baron Dover (created 1831)—Fig. 52—who was an early buyer of

Guardis and the editor of Pepys's *Diary.* The list of notables sculpted by Thorvaldsen is long—for example Metternich (Fig. 58), Esterhazy (Fig. 49), the Russian diplomatist Golovkin (Fig. 57), Gustav von Ingenheim, Sommariva (Fig. 51), who was also painted by Prud'hon, and the Duke of Augustenborg (Fig. 56). Although the sitters were idealized, a comparison with other portraits of them shows that he caught their character to a remarkable extent.

Thorvaldsen was particularly receptive to women. One of his most fascinating sitters was Wilhelmina Benigna Biron, the eldest daughter of Peter Biron, first Duke of Courland. He modelled her in 1818 and the result is a charming portrait of an innocent-looking young woman (Fig. 55). In fact, Wilhelmina had *une belle carrière amoureuse*—some compared her to Ninon d'Enclos—and three husbands, the Prince de Rohan, Prince Troubetskoy and Count von Schulenburg Witzenburg. She was Metternich's mistress and one of the stars of the Congress of Vienna and achieved a reputation as a graceful and seductive talker and a lover of heroism and grandeur. However, she subsequently became a trifle mad: Prince Metternich wrote to Countess Lieven of her as '*une femme très bizarre*' and stated that her love life was disordered.

One of the most delightful female portraits is that of Princess Bariatinski, the daughter of a Prussian

118

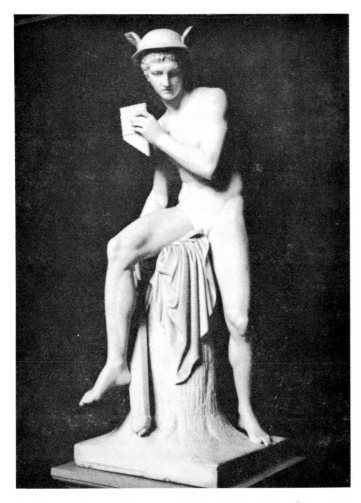

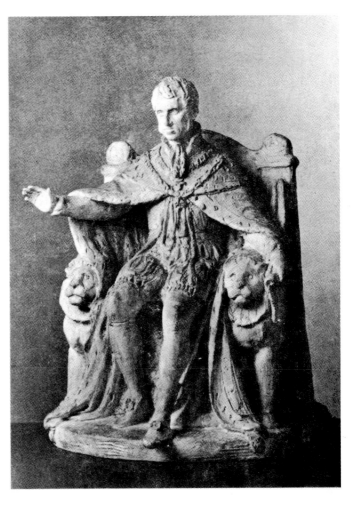

22. *Mercury about to kill Argus*, 1818–22. Marble, height 1·73 m. This statue come from the collection of Lord Ashburton. Thiele relates that Mercury's pose was inspired by a young Roman the sculptor saw in the street

23. *Frederik VI, King of Denmark*, 1840. Plaster, height 45·8 cm. This sketch-model, made in Copenhagen shortly after the king's death in December, 1839, was intended for a monument but it was never executed

diplomatist, Count von Keller. She also served as model, highly idealized, for Thorvaldsen's exquisite full-length statue, which is one of his most beautiful pieces (Fig. 21). She is the epitome of Empire grace as elegant as a drawing by Prud'hon, and we could easily imagine her swooning in a Viennese waltz in a white and gold St. Petersburg salon and as a character in *War and Peace*. Certain features in this work, such as the treatment of the hands and the fall of the draperies, recall Ingres. Indeed both painter and sculptor had clients in common, Baillie, for instance. Not much is known about the relationship of Thorvaldsen and Ingres, although, in 1812, Ingres stayed in the Palazzo Buti, Thorvaldsen's home for so many years. Dyveke Helsted has published an interesting draft-letter from Thorvaldsen to Baron Schubart which shows that, even if he had been lacking in humour as a young man, this was no longer the case. In 1812 Ingres contemplated marriage with Laura Zoëga, the daughter of Thorvaldsen's old friend. Thorvaldsen was the executor of her father's will and Schubart was the girl's guardian. In this draft-letter Enger is Ingres, Budi is Buti and Labrutji is the painter Carlo Labruzzi, who looked after two of Zoëga's children. Thorvaldsen wrote:

Your excellency may learn from the enclosed letter that Mons. Enger claims Sig. Laura Zoëga for wife. These two have for a while made love to each other in a respectable way as far as I know and because of that made some disturbance in Sigr. Budi's house and in the middle of this disorder Mr Enger has declared himself to hold proper intentions about Sig. Zoëga, whether it is only to give it colour or not I do not know.

However if this marriage could take place, it would give her great happiness, for he is a nice person and one of the ablest French painters of History but that I am afraid the two years [wait] would be too long and if, by an allowance, it could be shortened.

Will you be so good as to answer him and also Sig. Labrutji who is a man that . . . takes care of this case, as I am not fit for it.

Ingres wrote to his parents asking permission to marry Laura, but he later broke with her, claiming that his parents were against the match. Family tradition had it that the real reason for the rupture was that the painter saw the young girl at a public ball dancing *'éperdument dans les bras d'un superbe cuirassier'*.

Thorvaldsen was now so well known that he had difficulty in keeping up with his many commissions. A constant series of duns, as it were, were served on him; *Jason* was an old story, but the Duke of Bedford, who when in Rome in 1815 had ordered a portrait of his daughter and a copy of *Achilles and Briseis*, wrote him a sharp letter, asking where they were. He was also being pressed by Prince Christian Frederik (later Christian VIII) to return to Denmark and was later involved in considerable

difficulties over doing two marble versions of the Quirinal frieze, one for Sommariva, one for the Danish Court. Perhaps official commissions bored Thorvaldsen, for at this period he managed to produce a number of enchanting pieces, such as *Ganymede and Jupiter's Eagle* (Fig. 19), which was bought by Lord Gower (later Duke of Sutherland), *The Shepherd Boy* (the dog, Teverino, was probably the artist's)—Fig. 20—and *Mercury* (Fig. 22). It seems as if the last two were based on Roman lads and were to an extent the result of naturalistic observation, although rendered in a classical convention. Such pieces show that Thorvaldsen had the same tender feeling for the Roman scene as did his Northern painter friends.

Some of Thorvaldsen's circle felt that it was time for him to marry, Anna Maria notwithstanding. Their hopes looked like being fulfilled when in the spring of 1818 he met a Scottish spinster, Frances Mackenzie Seaforth (Fig. 6), who was in Rome with her aunt. She was, so Thiele tells us, no longer young and not good-looking, but she

24. *Christ.* Marble, height 3·45 m. Church of Our Lady, Copenhagen. Commissioned during Thorvaldsen's visit to Denmark, 1819–20, and modelled in Rome in 1821. Together with statues of the twelve Apostles it was erected in C. F. Hansen's neo-classical church in 1839

25. *Cupid and Anachreon.* Marble, 48·5 × 70 cm. This marble copy of the relief modelled in 1823 was presented to Thomas Hope as a gift to compensate for the delay of over a quarter of a century in the delivery of *Jason with the Golden Fleece*

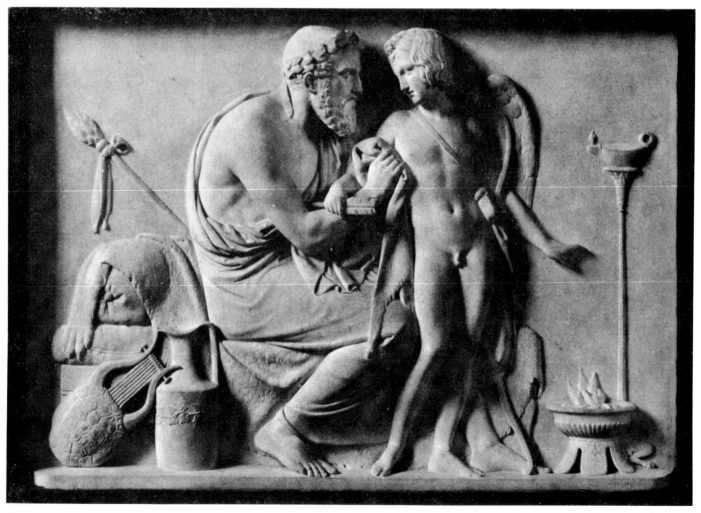

was highly cultivated: 'a lover of art in general, it was to sculpture she more specially devoted her attention'. Louise Seidler confirmed this impression. Miss Seaforth and Thorvaldsen came closer together when she and her aunt looked after him when he fell ill (malaria again, probably). On his recovery they set off for Naples (the aunt presumably in attendance as chaperone). He became so devoted to her that it was generally felt that marriage would result: Louise Seidler claims they were engaged. Miss Seaforth, for her part, encouraged him. Baron Schubart wrote to tell the sculptor that he felt she would 'willingly adopt the little Elise. . . . She is so attached to you that she will die of grief if her hopes are blighted'.

But blighted they were destined to be, for Thorvaldsen landed himself in an even more complicated situation. He had as a matter of course to put up with the tantrums of Anna Maria, but he had met again a delightful girl, Fanny Caspars, 'a lovely child of nature'. Fanny began her career as an actress at a tender age and when only fourteen she charmed Goethe, who was her admirer for many years. She left the stage in 1802 and was in Rome in 1815-16 where she visited Thorvaldsen in his studio. She returned to the city in 1818 as the companion to the Princess Maria Greffalkovicz von Gyarah, née Esterhazy, and came across her old school friend Louise Seidler, who painted her portrait (Fig. 7), and Thorvaldsen would often meet her while she sat for this. It seems as if Thorvaldsen lost his head over her; Fanny for her part wrote him many long and affectionate letters. But nothing came of the relationship; Thorvaldsen saw her again in Vienna in 1820. Three years later she married but continued to send him friendly letters. When the news of this romance reached the ears of Miss Seaforth she asked Thorvaldsen for a straight answer about his intentions. The relationship ended; there was no brother to turn the matter into a tragedy à la Pushkin. They saw each other twice more; she died in Rome and lies in the Protestant cemetery.

In the circumstances it was hardly surprising that Thorvaldsen set off for Copenhagen in 1819. He was received with considerable acclaim. A glimpse of him at the time was provided by Augustus Foster, who, writing to Elizabeth Duchess of Devonshire on 12 October, said:

Thorvaldsen at last arrived here ten days ago, but only called here yesterday. He has been so discoursed to and drank to, praised and panegyrized, that the poor man seems quite bothered; but he was at Albinia's conversazione last night and appeared delighted to find an old Roman acquaintance to talk to in Italian. . . . Thorvaldsen says he must have occupation and means to model through the winter; he left them a model in Alto Relievo for the public walk at Lucerne to be cut out of the rock. I dare say it will be very fine, but he leaves it to the Swiss to execute his design; so the *Mercury* which you admire so much is not yet in marble. He talks of the work in marble as mere mechanical. It certainly is the chief thing, however else we might be satisfied with what the ancients have left us.

While in Copenhagen he made various busts of members of the Danish Royal Family (Fig. 60), but much of his time in Copenhagen was taken up with discussions concerning his work for C. F. Hansen, the great Danish neo-classical architect, who was then designing the Church of Our Lady. We are perhaps so inclined to associate Thorvaldsen exclusively with the Antique that it comes as something of a surprise to find (as Lisbet

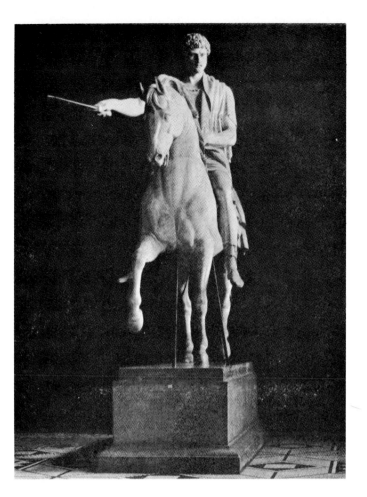

26. *Prince Josef Poniatowski,* 1826–27. Plaster, height 4.60 m. Erection of a bronze cast of this statue for Warsaw was forbidden by Tsar Nicholas I, but it was finally unveiled in 1923 only to be destroyed in the 1939 War. A replacement has been erected

Balslev Jørgensen points out in this issue) that he was so intimately related to the revival of Christian art. He was exceedingly close to the Nazarenes, whose pictures he bought. He himself said that he owed his religious feelings to the influence of Baroness Schubart, and one excuse he offered for not finishing *Jason* was his growing interest in Christian art. Already in the 1800s he had executed various small religious pieces for Denmark, but the commission for the Church of Our Lady was on a large scale —a pediment for the façade and figures of Christ and the twelve Apostles, as well as other items. Small wonder then that on his return to Rome he required a considerable team to assist with the execution of the project. Thorvaldsen already had studios near the Palazzo Barberini, but this considerable commission compelled him to take a large one in this district in 1822. Today perhaps it is none too easy to appreciate such works as they deserve, but Thorvaldsen's religious figures—especially that of Christ (Fig. 24)—have considerable power. They look impressive in the cool and harmonious interior of the church, while the sketch-models for the pediment figures are spirited.

Despite the many claims on his attention, Thorvaldsen accomplished an immense amount of work. He finished many important monuments: *Copernicus* (1822), *Prince Josef Poniatowski* (1827—Fig. 59—), *The Duke of Leuchtenberg* (1827), *Pius VI* for St. Peter's (1824-31) and *Schiller* (1835). One of the finest was the huge and

27

28

27. *Cupid as Lion-tamer.* Marble, 48·4×65·4 cm. Modelled in 1828, this relief symbolizes Cupid's power over Earth and is part of a set representing the Four Elements

28. *Angels playing.* Marble, 37·6×43·2 cm. This relief, modelled in 1833, shows the influence of Biedermeier, which is apparent in Thorvaldsen's work of the 1830s and '40s

29. *Dancing Girl,* 1837. Plaster, height 57·5 cm. The sketch-model for a life-size marble

30. Opposite: *Thorvaldsen at Nysø.* Plaster, 60×99 cm. Thorvaldsen Collection, Nysø. Baroness Stampe reads to Thorvaldsen and her children

31. Opposite: *Achilles and Briseis.* Charcoal, 20×31·4 cm. Thorvaldsen did a relief of this subject in 1803; he transformed it in 1837. This drawing relates to the later version

32. Opposite: *Mercury bringing Psyche to Heaven.* Pen and brown ink. Detail. Figures 32 and 33 are sketches for reliefs for the former Palazzo Torlonia, Rome, modelled by Thorvaldsen's pupil, Pietro Galli

33. Opposite: *Adonis.* Pen and brown ink, 12×8 cm. Sketch for the reliefs representing the *Metamorphoses*

imposing equestrian monument to Poniatowski, based on Roman art (Fig. 26). He produced as well a never-ending stream of busts, such as those of Sir Walter Scott (Fig. 68), the Marchesa Florenzi (Fig. 65), Cardinal Consalvi (Fig. 64), Count Potocki and the banker Torlonia (Fig. 67). In addition he made numerous bas-reliefs.

Thorvaldsen had a passion for antique gems and their influence may be detected in some of the bas-reliefs he made in the 1820s and 1830s. These are private treasures —pieces for connoisseurs—and many of their themes were derived from the translations from the Anacreon or the Anthology made by his friend the poet Cavaliere Ricci,

who published *L'Anacreonte di Thorvaldsen in XXIV basso-relievi* (1828) and *Anacreonte novissimo del Comm. Alberto Thorvaldsen in XXX basso-relievi anacreontici* (1832). The form and subject-matter of Thorvaldsen's bas-reliefs may be classical, but the sentiment is domestic and romantic; they stress the extent to which his art, as Mario Praz once said, was touched by the spirit of Biedermeier. They show him to be at home with the style of *The Keepsake.* Once again his work, with its domestic charm and suggestion of a quiet enjoyment of the Latin world, is in line with the Italian paintings of his Danish friends.

One of Thorvaldsen's attributes was his connoisseur's

30

32

31

33

eye and an analysis of his sources in the creation of his pieces would be an interesting venture. He looked not only at classical art, but possibly at Renaissance sculpture, as may be seen from an enchanting group of playing angels (Fig. 28). It has also been suggested that in making his religious figures for the Church of Our Lady he was influenced by Peter Vischer's famous sculptures on the tomb of St. Sebaldus in Nuremberg.

Like so many other Northerners he was haunted by the ideal of classical beauty and in company with painters and amateurs he was fascinated by the 'perfect' features of a simple peasant girl from Albano named Vittoria Caldoni, who used to be put on exhibition, as it were, at the house of the Von Redens; Reden was the Hanoverian Ambassador to the Holy See. Thorvaldsen made a charming bust of this girl (Fig. 62) which recalls the sort of ideal that later on fascinated Rodin. Vittoria disappointed her admirers by marrying and producing children!

Some of Thorvaldsen's most appealing works are sketch-models which, as Dyveke Helsted observes in her article, formed the second stage in his work, after he had established his concept in a drawing. These usually gracious and elegant pieces show how closely he could approximate to the terracottas of the Hellenistic era and that he was at his happiest when suggesting a gentle mood or rendering the lilt of dancers, as in the piece of 1837 reproduced here (Fig. 29). One aspect of Thorvaldsen's art that would well repay investigation is his connexion with music and the dance; he was a friend of Mendelssohn and of Bournonville, the famous choreographer, and was proficient with the violin, flute and guitar. He enjoyed the sweet and delicate music of Gelli, Carulli, Giuliani and Paër, as well as the Neapolitan tarantella. He greatly admired Jenny Lind, whom he met just before his death.

Thorvaldsen may have suffered from melancholy—the *maladie du siècle*—but his later years in Rome proved enjoyable; he would make his bow in the salons of the great, although Louise Seidler says that he was bored when Miss Seaforth took him to her friends in the evenings. Nevertheless, like many another portrait artist, he must have learnt diplomatic skill of a sort, for he had to navigate through the shoals of Roman life; as George Ticknor, that highly amusing Bostonian, observed, 'These

34

35

34. *Pope Leo XII visiting Thorvaldsen in his studio* by H. D. C. Martens (1795–1864), 1830. Oil on canvas, 1 × 1·38 m. This was the largest of Thorvaldsen's several studios near the Palazzo Barberini in Rome

35. *Thorvaldsen in his studio at Charlottenborg* by F. Richardt (1819–95). Oil on canvas, 44·5 × 57·5 cm. The sculptor was given lodgings here on his return to Copenhagen in 1838

36. Opposite: *Thorvaldsen* by A. C. T. Neubourg, 1840. Daguerreotype. The sculptor is making the sign of the evil eye

cultivated strangers settle down into coteries of their own, generally determined by their nationality. Thus the Germans, the English and French have their separate societies . . . two or three times . . . in the week all the strangers in Rome, with a few of the best of the Italians, a quantity of cardinals, bishops, and ecclesiastics of all names and ranks, are brought together at a grand rout, called a *conversazione*, or *accademia*. . . .'

At heart this large, blond, simple yet shrewd Scandinavian was a Bohemian. Mario Praz has compared him to Schubert in Vienna, for both were the centre of the party, and this writer has evoked the image of Thorvaldsen eating at the Trattoria Reale in the Palazzo Fiano, at the trattoria of Captain Raffaelle Anglada at Ripa Grande, where Ludwig of Bavaria enjoyed shell fish and Spanish wine, and at the tavern at the Palazzo Ruspoli. He and his friends revelled in the sort of life appreciated in the seventeenth century by the Dutch bambocciante. This life was relatively simple. He had seven small rooms in the Palazzo Buti, a small bedroom, a studio and a salon hung with pictures. He cared little for comfort and Louise Seidler pointed out that his rooms were not heated. Nor was his studio and he would wear four or five woollen vests or jackets to ward off the cold. In later years many of his former companions were no longer in Rome. However, one close friend at this time was Horace Vernet, and they made each other's portraits. Thorvaldsen's of Vernet (Fig. 69) is especially striking.

In 1838 Thorvaldsen returned to Copenhagen in the frigate *Rota*. It was an event marked by immense celebra-

36

tions; congratulatory messages poured in, including one from the Art Academy at Rhode Island. However, he went back to Rome from May 1841 to October 1842 under the protection of the formidable Baroness Stampe (Fig. 8). He was no longer 'the careless, clay-bedaubed' Thorvaldsen, but 'dressed up to kill', so John Gibson recounts, with 'superb dressing-gown, Turkish slippers . . . glittering gold earrings' and the look of a grandee of Persia. Baroness Stampe had taken him over and was determined that he should return to Denmark, rather than spend his last days in Rome. However, she did not win easily, for Gibson reported that Thorvaldsen had thrown away his carpets and had a dirty appearance; he also declared that he would never go back to Denmark. However, the revolt was short-lived; the Baroness fell ill and the contrite sculptor evidently put on the yoke again. Lady Eastlake, who was sharp enough, declared: 'After this Thorvaldsen's doom was sealed. A lady of such resolution (and such a name) was not easily baffled'. However, Baroness Stampe trusted him sufficiently to leave Rome with her children four months before he died.

During his final years Thorvaldsen divided his time between his apartments in Charlottenborg and the Stampes' house in South Zealand. This was Nysø near Præstø and a studio was built for his convenience; he left two charming bas-reliefs of life at Nysø, in one of which he is seen gazing at his domineering friend—a Victorian scene (Fig. 30). It was presumably there that the daguerreotype of him was taken which shows him making the sign of the evil eye (Fig. 36). He continued to work hard, making a final self-portrait and a huge statue of Hercules. He died on 24 March, 1844, in his seat at the Royal Theatre at Copenhagen.

Many changes occurred during Thorvaldsen's life, the fall of the *ancien régime*, the turmoils of the revolution in Rome, the collapse of the Empire; he had met hundreds of people—the cream of international society, connoisseurs, artists and writers; he had witnessed stylistic changes, the dying Rococo, the revival of the Antique, the return to a more realistic approach, the rise of Christian art and the spread of sentimentalism. But his own work did not change all that much; he had fallen in love with the antique world and with the views of Winckelmann that art should reflect balance and grace. He accepted the classical style as being the one that best suited his purpose, yet he never bothered to go to London, where he would have been gloriously received, to see the Parthenon pediment. The years in Rome were rich and fruitful for Thorvaldsen: he learned to enjoy life there and he mellowed. He was a bit of a dreamer and a romantic and his sweet and gentle art, his love of feminine beauty and his tender yet discerning appraisal of character offer another side of the age of *Sturm und Drang*.

Thanks are due to Dyveke Helsted and to Bjarne Jørnæs.

A Gallery of Thorvaldsen Portrait Busts

As a portrait sculptor Thorvaldsen was one of the most gifted artists of his day, as may be seen from the varied pieces reproduced on these four pages.

His sitters included many of the distinguished foreigners who visited Rome during the years he resided there.

Unless otherwise stated all the busts reproduced here were executed in Rome and are in the Thorvaldsen Museum, Copenhagen.

Thanks are due to Ole Woldbye who took so many photographs for this issue.

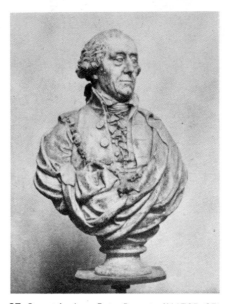

37. *Count Andreas Peter Bernstorff (1735–97)*, Copenhagen, 1795. Plaster, height 80·9 cm. Count Bernstorff, who was of Hanoverian extraction, was Prime Minister of Denmark from 1784 until his death

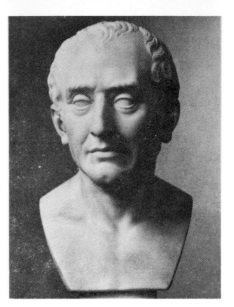

38. *Count Bernstorff*, 1797. Marble, height 47·9 cm. Brahetrolleborg. A later version inspired by Roman portraiture

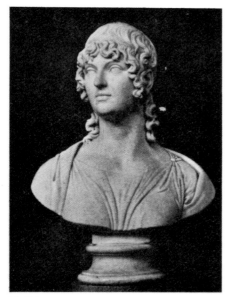

39. *Princess Eudoxia Ivanova Galitzine (1786–1850)* 1803–4. Marble, height 73·1 cm. Née Izmajlov, she married Prince Galitzine in 1799

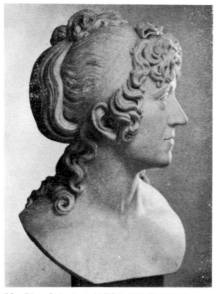

40. *Elise Schubart (1765–1814)*, Montenero, 1804. Marble, height 69·6 cm. Née De Wielinger, she was Dutch and the wife of the Danish diplomatist who took care of Thorvaldsen during his periods of depression

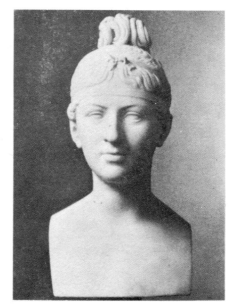

41. *Ida Brun (1792–1857)*, 1810. Marble, height 56·6 cm. The daughter of the poetess Friederike Brun and known for her ability to create 'Attitudes'

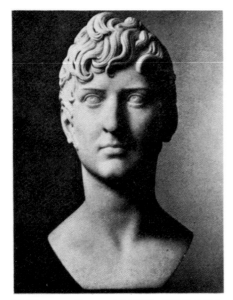

42. *Vincenzo Camuccini (1771–1844)*, 1810. Marble, height 56·2 cm. This Italian painter did a portrait of Thorvaldsen at the same time as this bust

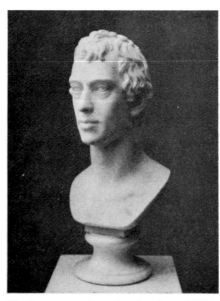

43. *Jørgen von Cappelen Knudtzon (1784–1854)*, 1816. Marble, height 57·7 cm. The Royal Society of Sciences and Letters, Trondheim. Norwegian merchant established at Trondheim

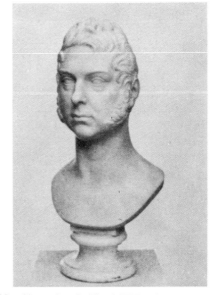

44. *Alexander Baillie (1777–1855)*, 1816. Marble, height 59·9 cm. The Royal Society of Sciences and Letters, Trondheim. Baillie was the Scottish friend of Jørgen Knudtzon

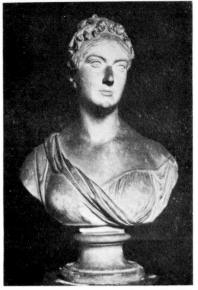

45. *Countess Sandwich (1781–1862)*, 1816. Plaster, height 69·9 cm. Lady Sandwich was the daughter of Armar Corry, Earl of Belmore. In 1804 she married the sixth Earl of Sandwich

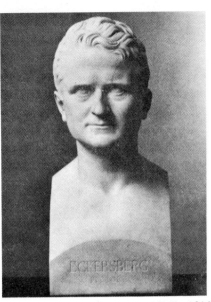

46. *C. W. Eckersberg (1783–1853)*, 1816. Marble, height 54 cm. Eckersberg was a Danish painter who worked in Rome

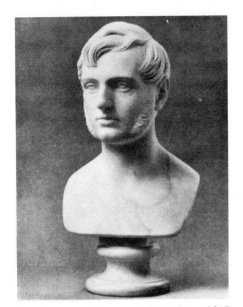

47. *Thomas Hope (1769–1831)*, 1817. Marble, height 55·2 cm. The famous collector and supporter of neo-Classicism who commissioned the statue of Jason which stood at The Deepdene until 1917

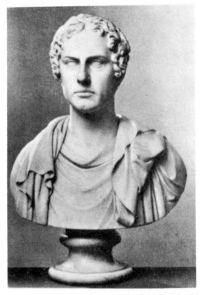

48. *Lord Byron (1788–1824)*, 1817. Marble, height 60 cm. Byron is said not to have been content about his expression in this bust; he had wanted it to appear more romantic

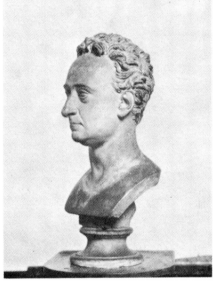

49. *Prince Nicolaus Esterhazy (1765–1833)*, 1817. Plaster, height 53 cm. This Hungarian prince was a patron of Haydn

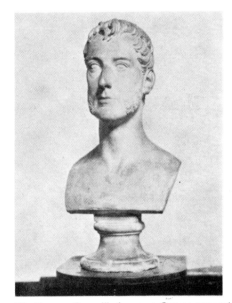

50. *George Granville Leveson Gower, second Duke of Sutherland (1786–1861)*, 1817. Plaster, height 57·1 cm.

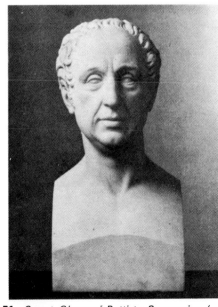

51. *Count Giovanni-Battista Sommeriva (c. 1750–1826)*, 1817–18. Marble, height 51·5 cm. This notable art collector and lawyer acquired works by Canova and Thorvaldsen for his Villa Carlotta on Lake Como

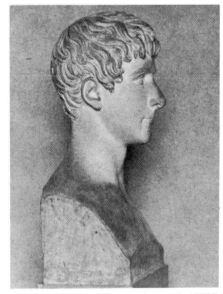

52. *George James Welbore Agar Ellis (1797–1833)*, 1818. Plaster, height 50·6 cm. Created Baron Dover in 1831, he was an historical writer and art collector

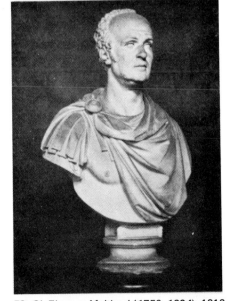

53. *Sir Thomas Maitland (1759–1824)*, 1818. Plaster, height 130·4 cm. After the cast probably done by Paolo Prossalendi. Maitland was Lord High Commissioner of the Ionian Islands

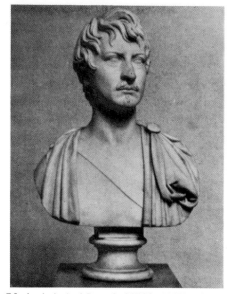

54. *Ludwig I of Bavaria (1786–1868)*, 1818. Marble, height 67·9 cm. Executed while he was Crown Prince; he was a great admirer of Thorvaldsen

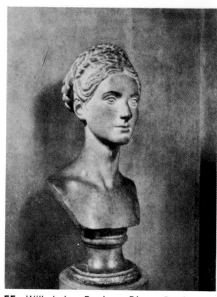

55. *Wilhelmina Benigna Biron, Duchess of Sagan (1781–1839)*, 1818. Plaster, height 58 cm. Daughter of the first Duke of Courland, she was the mistress of Metternich

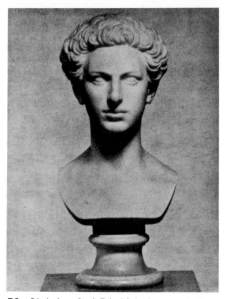

56. *Christian Carl Friedrich August, Duke of Augustenborg (1798–1869)*, 1819. Marble, height 57 cm. This bust was commissioned during the Duke's visit to Rome while on the Grand Tour

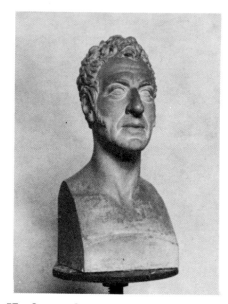

57. *George Golovkin (1762–1846)*, 1819. Plaster, height 54 cm. Golovkin was a distinguished Russian diplomatist and Ambassador to Vienna 1818–22

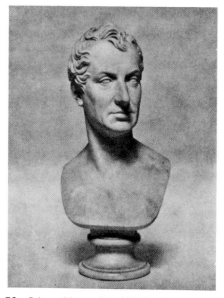

58. *Prince Metternich (1773–1859)*, 1819. Marble, height 61·0 cm. Metternich had accompanied the Emperor Francis I of Austria to Italy

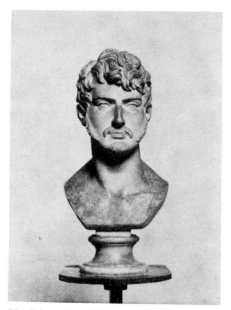

59. *Prince Josef Poniatowski (1763–1813)*, 1827. Plaster, height 59·7 cm. This is a posthumous portrait of the celebrated Polish general

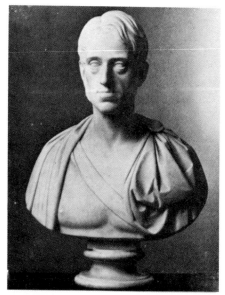

60. *Frederik VI, King of Denmark (1768–1839)*, Copenhagen, 1819–20. Marble, height 69·3 cm. The original model is lost

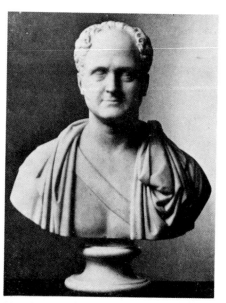

61. *Alexander I, Emperor of Russia (1777–1825)*, Warsaw, 1820. Marble, height 67·8 cm.

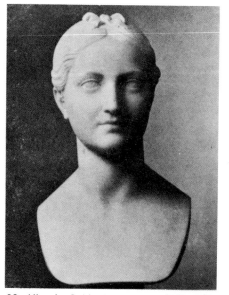

62. *Vittoria Caldoni (born c. 1807)*, 1821. Marble, height 52 cm. A favourite model of the international circle of painters and sculptors in Rome

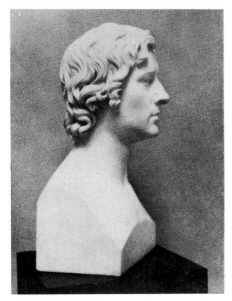

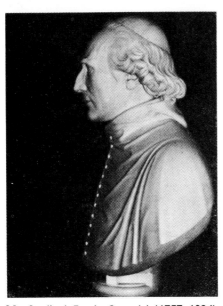

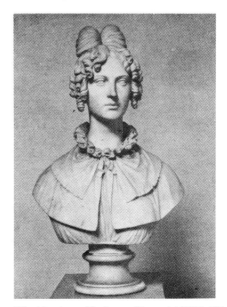

63. *Johan Christian Dahl (1788–1857)*, 1821. Marble, height 50 cm. Picture Gallery, Bergen. Dahl was a Norwegian painter who worked in Italy and whose paintings were bought by Thorvaldsen

64. *Cardinal Ercole Consalvi (1757–1824)* 1824. Marble, height 73 cm. Chatsworth, Derbyshire. This Italian prelate secured the return of the Papal provinces to Pius VII. Photograph courtesy J. Kenworthy-Browne

65. *Marchesa Marianna Florenzi (1802–70)* 1828. Marble, height 74·4 cm. Née Baccinetti, she was the mistress of King Ludwig I of Bavaria. Her second husband was Evelyn Waddington

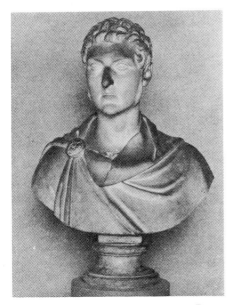

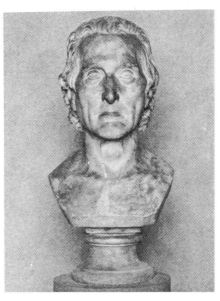

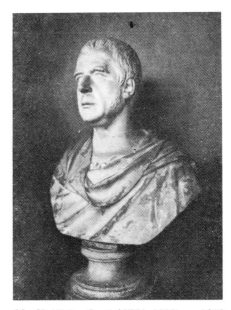

66. *Sir Henry Labouchere, first Baron Taunton (1798–1869)*, 1828. Plaster, height 65·9 cm. Labouchere was a politician who won a reputation as 'a very pretty speaker'

67. *Giovanni Raimondo Torlonia, Duke of Bracciano (1754–1829)*, 1829. Plaster, height 54·2 cm. Torlonia was a well-known banker who acted for Thomas Hope

68. *Sir Walter Scott (1771–1832)*, c. 1832. Plaster, height 73·6 cm. This is probably a posthumous portrait

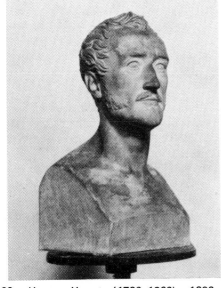

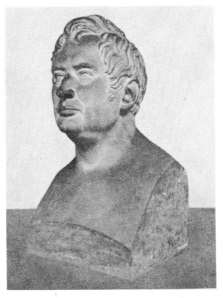

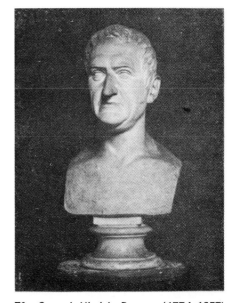

69. *Horace Vernet (1789–1863)*, 1832. Plaster, height 48·9 cm. This French painter did one of the best portraits of Thorvaldsen in old age and was Director of the French Academy in Rome

70. *Adam Oehlenschläger (1779–1850)*, Nysø 1839. Plaster, height 54·1 cm. Oehlenschläger was a celebrated Danish poet. Thorvaldsen did not execute the marble

71. *Conrad Hinrich Donner (1774–1857)*, Copenhagen, 1840. Plaster, height 57·1 cm. Donner was a merchant in Altona and owned sculpture by Thorvaldsen

The Incomparable Josephine

Josephine's astonishing career might easily form the subject of one of Balzac's novels. What could be more Balzacian than an experience that befell her as a young girl in her native island of Martinique. Josephine, who was born Marie-Joseph-Rose de Tascher de la Pagerie, and a distant cousin, Aimée du Buc de Riverny, consulted a native soothsayer called Eliama who predicted that Aimée would become a queen and Josephine something more than that. She was proved right. The ship in which Aimée was travelling to France was captured by the Turks and the desirable girl was sold to the old Bey of Algiers, Selim III; she became the 'sultane française' and the mother of Mahmoud II. After many vicissitudes Josephine wore an Imperial crown.

The Balzacian touch does not end there. In Martinique she met a Scottish Jacobite lad of about her own age called William. She may have had an affair with him, but after her departure for France in 1779 they never met again. William was haunted by her memory and remained single: after 'the ideal of my youth, no woman has ever seemed to me worthy enough to sacrifice my freedom for her' were his words. In 1814 he crossed to Paris and asked if he might visit her. Josephine invited him to dine at Malmaison but when he arrived she was ill and died next morning. The story could come from the *Histoire des Treize*.

Josephine's life never ceases to stimulate interest and even now, after excellent biographies of her have been published, various problems remain to be settled.[1] Each generation fastens on different aspects of her personality. A High Victorian might well have proved censorious of her conduct, but a modern writer would be more indulgent about her stratagems to keep afloat in a revolutionary situation when the world of her youth had been swept away.

Her first husband, Alexandre de Beauharnais, a libertine and something of a prig, was not nearly as well born as is often believed and he did not have the entrée at Court. He was a disciple of J.-J. Rousseau and politically to the Left, and in his eyes Josephine, a child of Nature, was wanting in education. This was true, but her gift of pleasing was compensation for her lack of instruction.

It is easy to fall for Josephine. She was exceedingly warm in her response to human beings, and in her youth too much so in fact, and quick to sympathize with them. Fortitude, at any rate in the early days, was hardly her strong point and she could not emulate the courage of some of the great ladies who were her fellow prisoners during the Revolution; she was constantly in tears. She was a born weeper who knew how to cry to her advantage.

Josephine was a typical offspring of the Directory,[2] a period when the *Merveilleuses* and the *Incroyables* startled visitors to Paris, when the restaurants were crowded and when the music of Grétry and Cherubini was performed at concerts and when new millionaires emerged such as Michel Simons, the son of a carriage maker and Jacques Laffitte, the son of a carpenter. Inflation and deflation played havoc during these years. The time was not altogether dissimilar from our own.

Josephine, who had two children, Eugène and Hortense, and hardly any money had little choice but to find a protector. She may have had an *amant de coeur* in Hoche and was certainly the mistress of Barras, an aristocrat who became one of the Directors and whose licentiousness typifies the period. Josephine had as many fingers in as many pies as possible; for her the '*pot de vin*' was a necessity; she took commissions on army contracts. This sort of conduct was relatively general: Talleyrand was an ace at extorting bribes.

When in 1796 Josephine married Bonaparte, as she always called him, she was by no means in love with him. He adored her and his passionate and intimate letters to her from Italy suggest that her sophistication and versatility, that of the skilled hetaera, intoxicated him, as well it might for someone of his provincial background. Her sex appeal is caught in Appiani's portrait which depicts a determined and exciting woman, who could be playing the part of a queen in a Roman drama (Fig. 1).

Yet one side of Josephine's nature recalls the attitude of a Nana or an Odette de Crécy; her torturing of Bonaparte in the early days of their marriage is comparable to Odette's treatment of Swann in the springtime of their liaison. (Swann, like Charlus, was an admirer of the Empire style.) Josephine was flighty and her affair with Hippolyte Charles, nine years her junior, was shameless, but this handsome Hussar officer made her laugh and presumably he was an accomplished lover.

The principal characters of the Napoleonic era seem so vivid and alive, and not least the members of the Bonaparte clan. It was a veritable mafia, with Madame Mère, who could be a Sicilian *madre* from the pages of Verga, hating Josephine, the jealous sisters, the scheming brothers, the fights over precedence and possessions and the sense of tragedy: Napoleon ever tempted by power and finally overreaching himself. Besides Napoleon, only Jérôme was kind to Josephine, and remembering her love of shawls he sent her some. Josephine's relations with the Bonapartes would not be so intriguing without the presence in the story of her own children: Eugène, whose

1. *Josephine Bonaparte* (1763–1814) by Andrea Appiani (1756–1817), *c.* 1797–1802. Oil on canvas, 75 × 61 cm. Private collection, Paris. Josephine joined Bonaparte, General-in-chief of the Army of Italy, in Milan in 1796. She resided at the Palazzo Serbelloni and returned to Paris in January 1798

loyalty to his step-father, love of his mother and gaiety are endearing, and Hortense. She is a classic type: married off to serve interests—those of her mother—and having a wretched time with her neurasthenic husband Louis; she deserved a better fate.

The main protagonists of the Napoleonic period can generally be seen through the eyes of different witnesses, and the memoirs of Georgette du Crest, the duchesse d'Abrantès and Mademoiselle Avrillion contain amusing stories and telling details about Josephine. How charming to read about her passion for dogs and that when she was ready for sleep, her favourite would happily trot out of the room following the lady-in-waiting to her bedroom, happily resting on a chair until morning!

Josephine's life with Napoleon is rich in human interest. A change in the balance of power took place with the years, largely as the result of her inability to bear Napoleon an heir. He was the one who 'carried on', not her, a reversal of the position in their early time together. She may have played him up, but she came to love him, surely? The story of their married life, which smacks more of Strindberg than of Stendhal, can bring

tears to the eyes. Napoleon did not find it easy to divorce her; and their parting has a tragic character which could form the theme of a play by Corneille, a dramatist much admired by Napoleon, who was a friend of Talma and a lover of the theatre. How often the events of the First Empire assume a neo-classical character, in the sense that they seem to be taking place in an ancient drama; how often those of the Second Empire accord with the mood of an operetta!

Josephine was incomparable, as Napoleon acknowledged, and 'eternally feminine'. She was a terrible fibber and an adroit flatterer and manoeuvrer; she used her art not only to extricate herself from scrapes, but to help others, for her husband could rarely resist her. She managed to save the life of the Prince de Polignac, but not that of the duc d'Enghien, alas!

Napoleon had much to put up with from Josephine: her early infidelities and her scenes about his affairs which were rarely serious, for he was determined not to have a '*maîtresse en titre*'. Then there was her extravagance and even on St. Helena he remembered the sums spent on redecorating their house in the rue Chantereine.

131

She could never keep within her budget, spending wildly on jewellery and clothes; that seemingly endless stream of dresses, stockings, hats and shawls that poured into the Tuileries or Malmaison. Yet how well and stylishly she dressed; how adorable were her hats; and how sad that in our age these adjuncts to feminine allure have been more or less jettisoned!

Josephine is hard to pin down, but this is true of most of her sex. She could enjoy bawdy talk, be capricious to a degree and still shine as Empress. The very contradictions of her personality appeal, and so do her many acts of kindness. Her sweetness appears in the way she treated the Countess Walewska, entertaining her and her infant son, whose father was Napoleon, at Malmaison. The Emperor adored her lovely musical creole voice which she used to good effect when reading to him. Marie-Louise may have given Napoleon a son, but she could never offer him Josephine's understanding. Josephine was rarely provoked by his temper—he could break furniture when enraged—and was able to calm him down.

She was an enchanting hostess, who knew how to put people at their ease; assistance to the socially inept was needed at a time when 'new' men and women were coming to the fore. She would have had her hands full in our parvenu society! Her gift of smoothing ruffled feathers and of charming those who were put off by her husband's brusqueness made her ideally suited for Court life and her tact and generosity to her staff are attractively described by Mademoiselle Avrillion.

Although neither Josephine nor Napoleon was particularly interested in food, she ensured that those who cared for the pleasures of the table were properly catered for at Malmaison. The cellar was well stocked: there was plenty of Chambertin, which Napoleon drank cut with water, Châteaux Margaux, Lafite, Latour, Sillery Champagne, as well as wine from Cyprus and thirty-eight half bottles of Constantia.[3]

Her contributions to the pleasures of life were considerable. She was keen on music and theatre and even played the harp with some skill, and billiards, too, for that matter. Malmaison, the house with which she is closely identified, has a music-room, and in her time access from this could be gained across the Petit Pont to a small octagonal theatre built by Percier and Fontaine. Her fondness for music is commemorated in the library at Malmaison by the scores, bound in red morocco with her arms, of *Six ariettes italiennes et Quatre Nocturnes*, which were dedicated to her by Félix Blangini. Spontini dedicated his opera *La Vestale* to her. Josephine's taste in music was broader than Napoleon's; she liked Mozart as well as French composers but he only cared for the Italians.

Josephine's gentle and sensuous nature made her a devotee of Nature and thus, it might be claimed, she unconsciously took revenge on her first husband, for this love accorded with the principles of his hero, J.-J. Rousseau. However, her prime interest in flowers and plants lay in their visual appeal and scent.

She had bought Malmaison during the Egyptian campaign, in 1799 and the house and grounds (Fig. 2) still have the power to haunt the imagination, although Chateaubriand's threnody on the vanished charms of the place may come to mind. In its heyday Malmaison was an astonishing creation, not so much indoors as outdoors, where the justly famous gardens were at one time cared for by an Englishman, Howatson, whom Napoleon disliked.

Malmaison became a fantasy world for Josephine, in the same way that Neuschwanstein was for Ludwig of Bavaria. She had her Temple de l'Amour with its blaze of rhododendrons (Fig. 3), her menagerie with gazelles and kangaroos, and her Swiss cows attended by Swiss cowherds and milkmaids. There was even a female orang-utan that knew how to curtsey! At times life on the estate must have looked rather like a scene from a musical comedy or a masked fête, for, besides the Swiss in their national costumes, there were Basque servants in theirs.

Vivant Denon must have enjoyed himself going to Malmaison. He was there when in the presence of the Emperor, a small boat was launched which Josephine had ordered from Magin, who had made the larger one presented to her by the City of Paris. It was an expensive toy, decorated with '*fines peintures*'; the benches had cushions in small checks with gold tassels while an embroidered pennant flew at the helm. It was just the sort of vessel in which to embark for the Ile de Cythère.

Josephine's youth in the West Indies gave her a natural love of luxuriant vegetation, and the gardens at Malmaison afforded a testimony to her enterprise in securing as many examples of rare and unusual plants as possible. It is usually stated that between 1804 and 1814 no fewer than 184 new species flowered for the first time at Malmaison. E. J. Knapton in his life of Josephine[4] points out that the gardeners there

were responsible for introducing to France many plants, shrubs, and trees that are now commonplace: eucalyptus, hibiscus, phlox, cactuses, rhododendrons, dahlias, double jacinthas, and rare tulips. As in other respects Josephine was prodigal, willingly spending as much as three thousand francs on a rare bulb and constantly expanding the area devoted to cultivation.

She lavished money on the gardens, as indeed on much else, until the end. The considerable list of creditors drawn up after her death includes Arie Corneille, a merchant in Haarlem who was owed 4,506 francs for sending her rare plants in 1812 and 1813 and Lee and Kennedy, the horticulturists who had a famous establishment at Hammersmith, had long gone without payment: their outstanding account for plants sent in 1809, 1810 and 1811 came to 19,515 francs.[5]

War was not allowed to interfere with Josephine's interests and during the hostilities between France and England, Kennedy had a passport which enabled him to cross to France and bring seeds and plants to Malmaison.[6] The Empress would enrage Napoleon by disregarding the blockade, for she was fond of English muslin, and once he stopped the goods she was importing at the French Customs.

Like many of her compatriots before and since, she looked to England for her horses. In 1801 she can be found writing to Otto, the French Minister Plenipotentiary[7] in London asking him to buy her six riding horses and six carriage horses. Carriages had also been ordered in London; she was happy for the London Press to speak of them as long as her name was kept secret; it

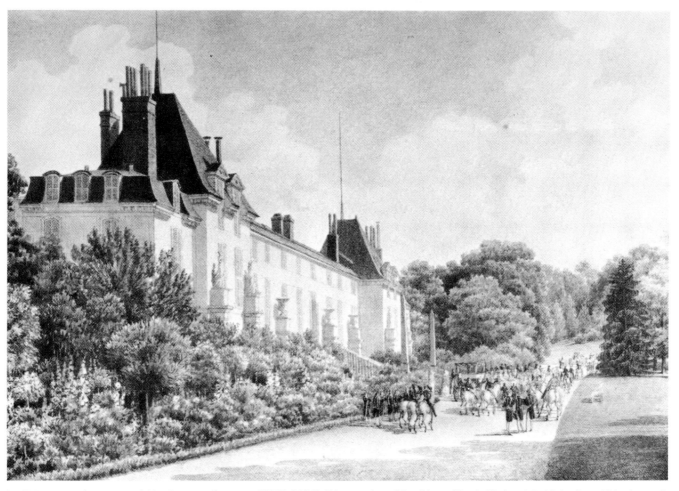

2. *'Départ pour la promenade'* by Auguste Garneray (1785–1824). Water-colour, 18 × 24 cm. Musée National de Malmaison. This shows the garden façade at Malmaison

3. *'Temple de l'Amour' at Malmaison* by Garneray. Water-colour. 18 × 24 cm. Musée National de Malmaison. The gardens at Malmaison were a veritable show place

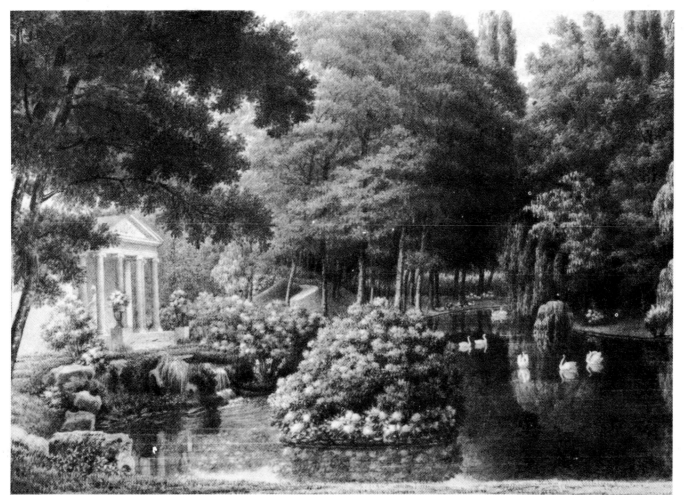

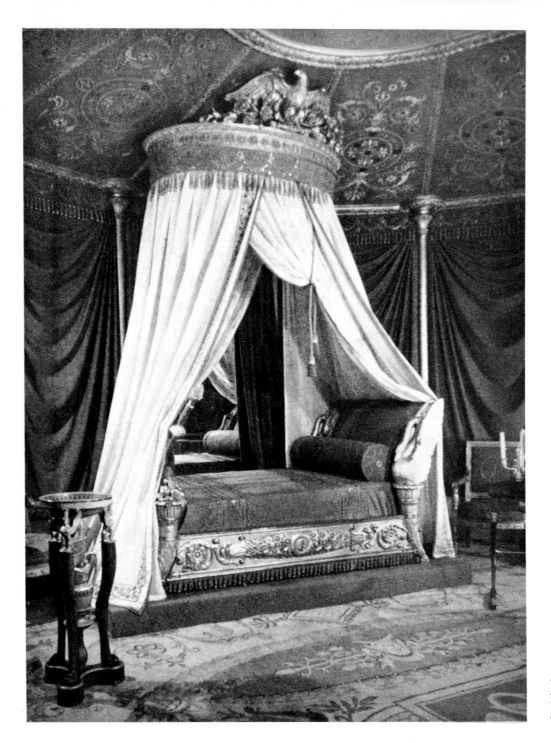

4. *Josephine's bedroom at Mal-maison*. The carved and gilded bed was made for her in 1810 by Jacob-Desmalter

could be given out that the commission was for Lady Kerr or Monsieur de La Borde who would not mind. A second letter to Otto reveals that a carriage with her monogram J.B. had been made; it should be said that this was for 'Milady Cahir'.

Mademoiselle Avrillion, who tended to see *la vie en rose*, has some delightful passages about Josephine's love of the arts and of the pleasure derived by her mistress from the conversations of Vivant Denon. This polished man of the world was a survivor of the *ancien régime* and exceedingly knowledgeable about the arts. He was keen on modern art and Josephine assisted him to secure commissions for some of his hopefuls. One was the sculptor, Bosio, who did a fine idealistic bust of the Empress (Fig. 22).

Josephine took considerable interest in art. A.-P. de Mirimonde has pointed out[8] that she was a subscriber to the *Cours historique et élémentaire de peinture ou galerie complète du Muséum central de France*, published by Filhol with commentaries by Joseph Lavallée and that in 1806

she bought for 1,801 francs the thirty-two issues of *la Galerie de Florence et du Palais Pitti*, illustrated with drawings by Wicar and notes by Mottez.

One of the glories of Malmaison was the picture gallery, which was built by Louis Berthault in 1808–9. It was entered from the music-room, was almost 100 feet long and was decorated '*à la gothique*'; this accorded with her liking for the '*style troubadour*'. The gallery had white silk curtains, the furniture was upholstered in green velvet and the thirty stools, designed by Jacob *frères*, were covered in red morocco. It had skylights and console-tables for the display of her many objects.

Josephine had her own advisers; Guillaume Constantin, a failed painter who loved to puff at his pipe, was the Conservateur of her paintings, Toussaint Hacquin restored her pictures and Alexandre Lenoir counselled her about objects and sculpture. Not much is known about the formation of the collection. The papers relating to her collecting, published by A.-P. de Mirimonde, only

5. *Josephine's dressing-table* by Martin-Guillaume Biennais (1764–1843). Mahogany, silver-gilt and crystal, height 25 cm., width 72 cm. Musée National de Malmaison

6. *Josephine's Mirror* by Jean-Baptiste-Claude Odiot (1763–1850), 1804–5. Silver-gilt, 97 × 83 cm. Private collection, Paris. From the toilet-service given to Josephine by Napoleon over the years

7. *Josephine's comb*, French, early nineteenth century. Tortoise-shell with a cameo and gold and crystal medallions, height 15 cm., width 9 cm. Private collection, Malmaison

5

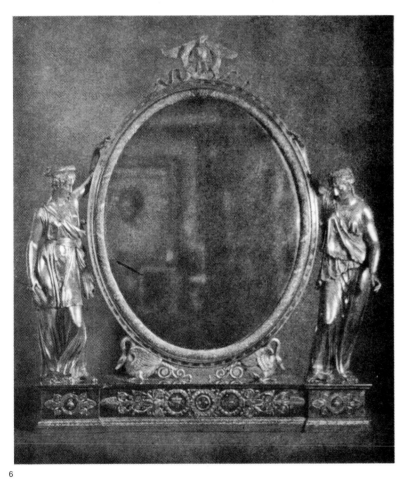

6

7

record two purchases—a Berchem and two pictures by Isaac van Ostade.

Like many eighteenth-century collectors, Madame de Verrue or Choiseul for instance, she appreciated Dutch cabinet-painters and landscape artists. She owned a number of important pictures by Paulus Potter, an artist who later in the century greatly appealed to Fromentin; among them was a splendid picture of a dog, now in the Hermitage (Fig. 16). However, her taste was eclectic and

she possessed numerous Italian Renaissance paintings— Bellini, Ghirlandaio, Perugino, Titian and Veronese are some of those mentioned in the catalogue of the collection or the inventory of her possessions—as well as baroque ones.

In considering her artistic taste, the circumstances attending on the formation of the collection have to be remembered: various items arrived in her hands as gifts— the Pompeian frescoes, for instance, came from the King

8. *Detail of Josephine's parasol handle*, French, early nineteenth century. Ivory, coral, gold, crystal and precious stones, length 60 cm. Private collection. Malmaison

9. *Josephine's watch* by the Maison Lépine – Jean-Antoine Lepine (1720–1814) and his son-in-law Claude-Pierre Raguet (*d.* 1810), early nineteenth century. Gold and translucent blue enamel, diameter 4·3 cm. Private collection, Rueil-Malmaison

10. *Tiara,* Italian, early nineteenth century. A single cameo, carved into medallions and decorated with gold, pearls and precious stones. Musée Masséna, Nice. Given to Josephine by Joachim Murat, King of Naples

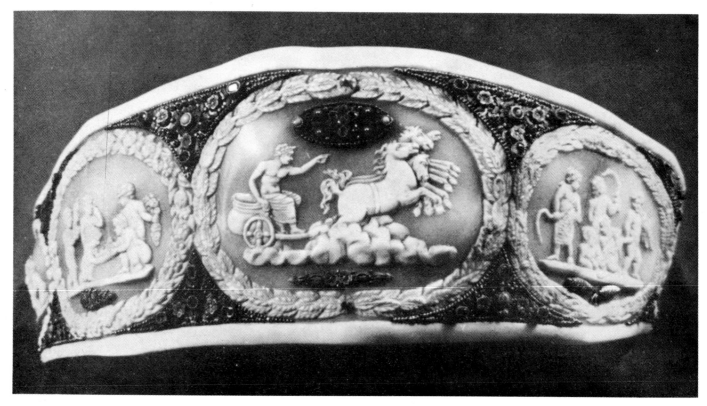

of Naples. A major acquisition consisted of the group of thirty-six pictures from the collection of the Elector of Hesse-Cassel which had been captured by General Lagrange after the Battle of Jena in 1807. Vivant Denon had earmarked them for the Musée Napoléon, but Lagrange, eager to curry favour gave them to the Empress and despite Napoleon's intervention, she retained them. This booty included Claude's *The Hours* (Fig. 17), a *Deposition* by Rembrandt and one by Rubens and Potter's *Farm near Amsterdam*, all now in the Hermitage; they were bought by Tsar Alexander I in 1814.

In addition to her Italian, Dutch and Flemish paintings she owned a Dürer, some Spanish works and examples of various French seventeenth- and eighteenth-century artists, Nattier, Greuze and Carle van Loo (Fig. 18) among them, but nothing by Fragonard or Watteau. Her interest in the eighteenth century was fanned by the sculpture at Malmaison, which included Julien's bas-reliefs for the *laiterie* at Rambouillet. It must have pleased Josephine that they once belonged to Marie-Antoinette, and she furnished her apartments in the Tuileries with pieces that came from the unfortunate Queen. It may be suspected that she had experienced a feeling of embarrassment when Napoleon jocularly

136

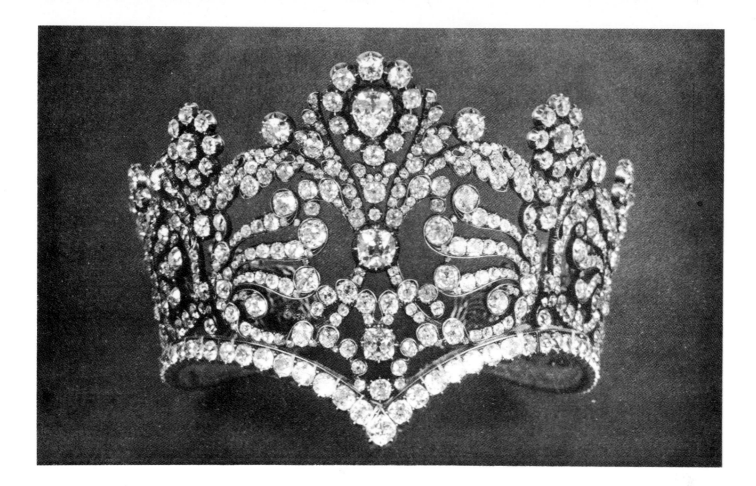

11. *Josephine's tiara.* Composed of 1,049 diamonds, weighing 200 carats, mounted on platinum. Collection Van Cleef & Arpels, New York. Josephine may have worn this on the Coronation Day, 2 December, 1804. She bequeathed it to her daughter Hortense. It passed to her son Napoleon III and was sold by the Empress Eugénie at the beginning of her exile in 1871

12. *Necklace,* French, early nineteenth century. Pearls, gold and diamonds. Private collection, France. Given by Josephine to her godchild Joséphine Poyard, daughter of her lady of the wardrobe at Malmaison

told her when they moved into the palace that she was going to sleep in the bed of her masters.

Josephine showed her originality by commissioning Anicet-Charles-Gabriel Lemonnier, who was then in his sixties and had sent many religious and mythological compositions to the Salon, to paint a most unusual 'history' painting. This was nothing other than a picture of the famous salon of Madame Geoffrin, who had died in 1777 (Fig. 20). It was exhibited at the Salon of 1814 and must rank as one of the first paintings of this genre—one that found a distinguished exponent in Adolf von Menzel. who fell in love with the Frederician Rococo.

The Empress loved gentle landscapes, some of which foreshadow those of the early Corot, flower paintings, as was only to be expected from the protector of Redouté, and historical pictures in the '*style troubadour*', which show the extent to which Ingres, Delacroix and Bonington derived from a tradition. Josephine subscribed to the *Journal des Troubadours,* which was first issued in 1808 and which published 'Gothic' romances and ballads; Napoleon was a devotee of Ossian. Josephine may have picked up a taste for historical paintings from having seen plays based on works by Horace Walpole, Monk Lewis and Kotzebue in Paris during the Directory.

13

14 15

If she had done nothing else than to patronize Redouté, Josephine would have earned herself a secure place in the Pantheon of illustrious protectors of art. Redouté was a man of contrasts. Stocky, thick-lipped and with a head like a 'large flat Dutch cheese' he had exquisite taste and the gift of capturing the essence of the flowers he painted so carefully. What a quirk of history that he should have been appointed draughtsman to the Cabinet of Marie-Antoinette, worked for Josephine and ended by being employed by the Bourbons again! It was Redouté who did the drawings for Ventenat's *Jardin de Malmaison* (1803–14) and Bonpland's *Description des*

plantes rares cultivées à Malmaison et à Navarre (1812–17), which are among the most magnificent examples of botanical illustrations (Fig. 15).

The Empress's affection for Prud'hon, whom Stendhal compared to Mozart, was characteristic of her taste. His celebrated portrait (Fig. 19) shows her breathing in the perfumed air of her garden and perhaps with a touch of melancholy musing on the perils and pleasures of passion. She is idealized and presented as the romantic woman par excellence; the mood of the picture ushers in a new era. Josephine was also an enthusiast for Canova, owning important works by him;

16. *A farm-yard dog outside his kennel* by Paulus Potter (1625–54). Oil on canvas, 96·5 × 132 cm. The Hermitage, Leningrad. Formerly in the collection of Josephine; bought after her death by Tsar Alexander I in 1814

17. *The Hours: Mid-day* by Claude Lorraine (1600–82). Oil on canvas, 1·33 × 1·57 m. The Hermitage, Leningrad. From the series of four illustrations of the hours formerly in the collection of Josephine; bought after her death by Tsar Alexander I in 1814

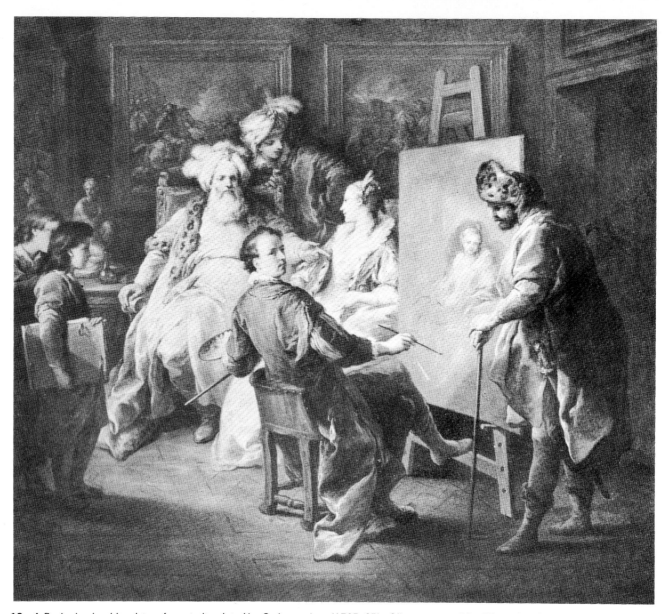

18. *A Pasha having his mistress's portrait painted* by Carle van Loo (1705–65). Oil on canvas, 66 × 76 cm. Virginia Museum, Richmond. Formerly in Josephine's collection and an example of her liking for eighteenth-century painting

19. Opposite: *The Empress Josephine at Malmaison* by Pierre-Paul Prud'hon (1758–1823), 1805. Oil on canvas, 2·44×1·79 m. Louvre. Josephine was a great admirer of this artist

her appreciation of his charming art is hardly surprising; and a recent scholar has detected affinities between the work of the Italian sculptor and Prud'hon.[9] The sweetness and elegance found in Prud'hon and Canova, in Van Daël and Redouté and in the 'troubadour' painters and such landscapists as Turpin de Crissé are endearing; such artists form a gentle counter-movement to the more ponderous features of the Empire style. At first sight the Empire style seems a predominantly masculine one, with powerful pieces of furniture worthy of dashing soldiers and virile portraits of men, but it also had a more delicate side which stemmed from the elegance and purity of Louis XVI design.

Besides appreciating modern art, Josephine admired Greek and Etruscan vases and eighteenth-century sculpture and furniture. Thanks to Madame Ledoux-Lebard and Madame Jarry, among others, a clearer idea can be obtained than used to be the case in regard to her taste in interior decoration.[10] Already in her bedroom in the rue Chantereine she showed her liking for novelty and chic; she had a military décor in which tables were designed as

drums. She loved mirrors, muslin, draped curtains in the Italian fashion, soft materials and pleasing colours and favoured the use of white. (She would have seen eye to eye with Whistler about decoration; for he was one of the chief pioneers of the revival of the Empire style.) Napoleon did not agree with Josephine's views about decorations considering her taste too feminine and too much like that of a kept woman. She had a quick eye for talent, employing Jacob *frères* at the rue Chantereine and presenting Fontaine to Napoleon when he was First Consul. However, she was a maddening client, constantly changing her mind and interfering; again, a most feminine trait!

The various pieces of the silver-gilt coffee- and tea-service and toilet-service made for her by J.-B.-C. Odiot (now in a private collection) were done at Napoleon's behest over the years. One of the most entrancing of these is the mirror with its elegant figures and swans (Fig. 6). How emotive to think of Josephine making up in front of it, and by no means sparing the rouge, for the Emperor disliked pale faces! One leading silversmith, Henri Auguste, never worked for her, although the silver-gilt Coronation Service

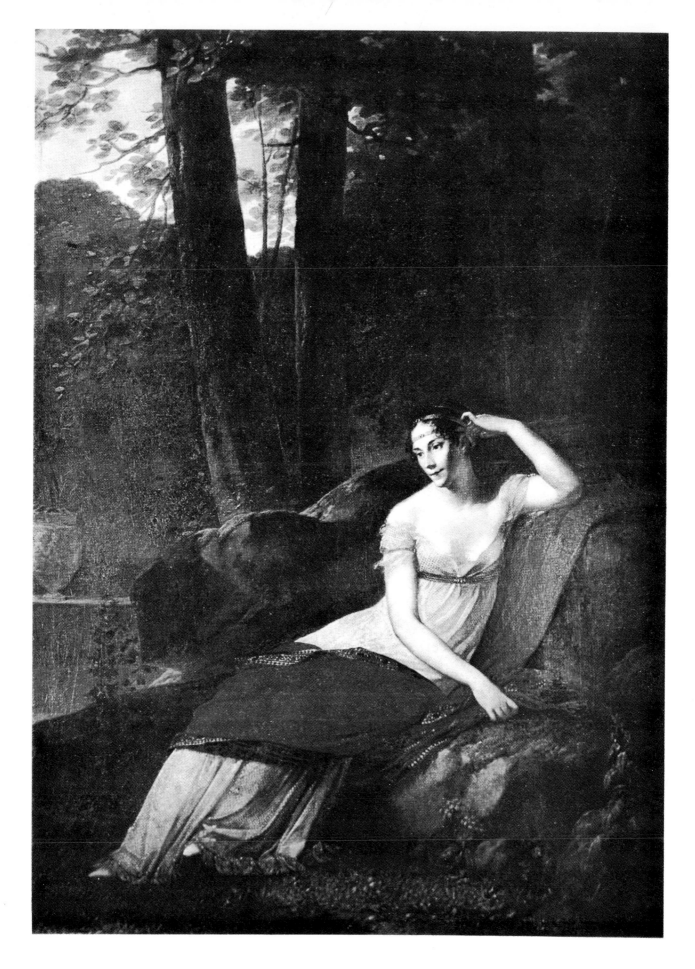

presented to the Emperor by the City of Paris in 1804 included a *cadenas* (ceremonial platter) for her use.[11] As this silversmith made items for the Bey of Algiers, does it mean that the influence of Josephine's old friend Aimé was at work?

The Empress had the opportunity of talking about art with one of her chamberlains, the romantically named Lancelot-Théodore Turpin de Crissé, who had the graces of the *ancien régime*. He was an accomplished artist in a minor key and had won the attention of the diplomat and

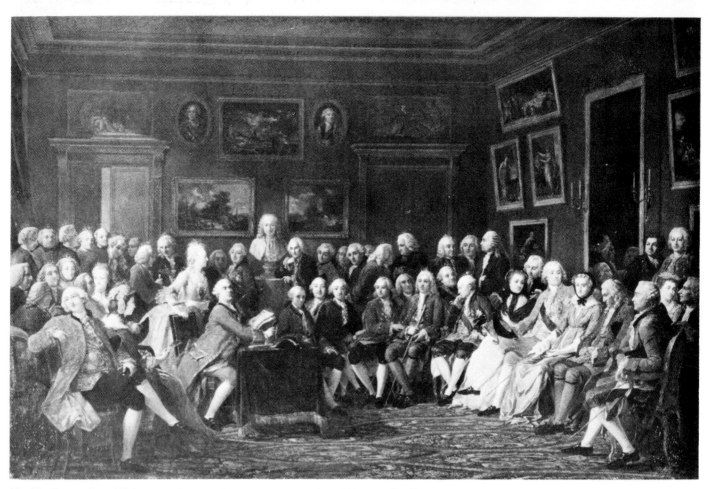

20. *The first reading of Voltaire's 'L'Orphelin de la Chine' in the salon of Madame Geoffrin* by Anicet-Charles-Gabriel Lemonnier (1743–1824), 1812. Oil on canvas, 1·26 1·95 m. Musée National de Malmaison. Commissioned by Josephine and exhibited in the Salon of 1814. Madame Geoffrin died in 1777

21. *'Déjeuner de l'Impératrice à Cervos'* by Lancelot-Théodore Turpin de Crissé (1781–1859), 1810. Pen and sepia wash. From *Album de voyage de l'Impératrice Joséphine en Savoie et en Suisse*. Musée National de Malmaison. The artist, who was Josephine's chamberlain and is reputed to have been her lover, accompanied her on excursions to Savoy and Switzerland

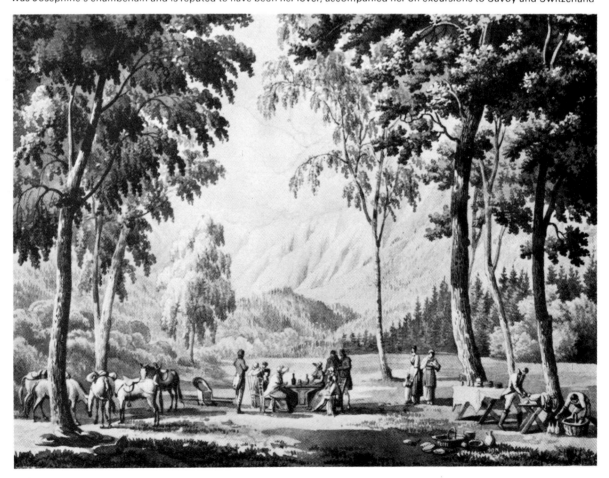

archaeologist Choiseul-Gouffier who had sent him to Switzerland and Rome. Hortense presented the young man to the Empress who acquired six of his paintings.

Several of Josephine's contemporaries and some later authorities—André Castelot among them[12]—have maintained that Turpin de Crissé was her lover. He was much younger than the Empress, but what is twenty years when one has kept good health and *joie de vivre* and one hates to be disobliging. Moreover, Josephine required consolation; Napoleon had insisted on her 'exile' to the damp and desolate château de Navarre at Evreux. Life at the château, as recounted by Mademoiselle Avrillion, has a piquancy of its own, that of a little court in exile and it could have provided many *données* for a Benjamin Constant or a Mérimée or a Gobineau. And the spirit of Romance hovered over the château, as if in a picture by Prud'hon.

In 1810 Turpin de Crissé, Pourtalès and the comtesse d'Audenarde accompanied Josephine on a trip to Aix. It was said by Count Charles Clary and Aldringen to be a veritable '*partie carrée*'; Josephine and the comtesse were installed in the maison Chevalley and the two men put up in a nearby châlet. They would make trips to the surrounding countryside and excursions to Savoy and Switzerland; mementos of these are to be found in a sketch-book by Turpin de Crissé at Malmaison (Fig. 21). This attractive figure married in 1813, served Charles X and never revealed the true nature of his relations with the Empress.

Josephine had her failings—very human ones—but her virtues were no less evident and her charm and consideration for others, her delight in the luxuries of life and her desire to preserve the graces of the *ancien régime* in a hard and military epoch do her credit. She remained loyal to the Emperor when fate struck him. After her death Dr. Horeau told Napoleon who visited Malmaison on his return from Elba:

She once said that if she had still been Empress of France she would have crossed Paris in a carriage drawn by eight horses with her entire household in full livery to join you at Fontainebleau and thereafter never leave your side.

Napoleon replied: 'She would have done it too, Monsieur: she was quite capable of it'. These words constitute a fitting tribute to the adorable Josephine.

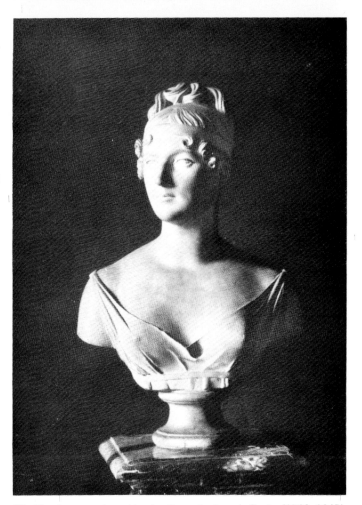

22. *The Empress Josephine* by François-Joseph Bosio (1768–1845), *c.* 1809. Plaster, height 72 cm. Musée National de Malmaison. An idealized portrait in the spirit of Canova

23. *The Empress Josephine* by Ferdinand Quaglia (1780–1830), 1814. Miniature, oil on ivory, 11 × 8·8 cm. The Wallace Collection, London. Painted in the year of her death

[1] Nina Epton has some interesting observations about Josephine's physiology in *Josephine The Empress and Her Children*, 1975.
[2] For a recent account of French life at this period, see Jacques Godechot, *La Vie Quotidienne en France sous le Directoire*, 1977. The author is most informative on economic conditions and emphasizes the number of aristocrats that remained in France despite the Revolution and the Terror.
[3] See Serge Grandjean, *Inventaire après décès de l'Impératrice Joséphine à Malmaison*, 1964.
[4] *Empress Josephine*, (Penguin), 1974, pp. 288–89.
[5] See E. T. Willson, *James Lee and the Vineyard Nursery Hammersmith*, 1961, p. 54.
[6] The letters are in the Musée de Malmaison.
[7] Serge Grandjean, 'Les Créanciers de Malmaison après la mort de l'Impératrice', *Revue de l'Institut Napoléon*, April 1965, pp. 97–105.
[8] 'Les Dépenses d'Art des Impératrices Joséphine et Marie-Louise' (*I. Joséphine*)', *Gazette des Beaux-Arts*, July–August, 1957, pp. 89–107.
[9] See Hélène Toussaint's entries for the paintings by Prud'hon in the catalogue of The Age of Neo-Classicism, 1972, pp. 136–39.
[10] See Denise Ledoux-Lebard, 'The Refurnishing of the Tuileries under the Consulate' and Madeleine Jarry, 'Napoleon and the decoration of the Imperial Residences (especially Malmaison and Compiègne)', APOLLO, LXXX, September 1964, pp. 199–205, and pp. 213–19. See also Denys Sutton, 'The Hôtel de Beauharnais', APOLLO, CII, June 1976, p. 505.
[11] See Serge Grandjean, *L'Orfèverie du XIX Siècle en Europe*, 1962.
[12] André Castelot, *Josephine*, 1964 and Maurice Dernelle in his edition of the *Mémoires de Mademoiselle Avrillion*, 1969.
Bibliographical Note: The biographies of Josephine in English by Hubert Cole (1962), Ernest John Knapton (1963, 1974) and Nina Epton (1975) contain much useful information. The memoirs of the period are referred to in the books mentioned above.
Specialist studies on different aspects of Josephine and the arts have been written by Gérard Hubert, Nicole Hubert, Serge Grandjean, Denise Ledoux-Lebard, Madeleine Jarry, G. Ledoux-Lebard, Pierre Schommer and A.-P. de Mirimonde.
Thanks are due to Gérard and Nicole Hubert and Barbara Scott for their active assistance in the preparation of this number.

The Prisoner

1. *The small hours in the 'sixties at 16, Cheyne Walk.—Algernon reading 'Anactoria' to Gabriel and William* by Max Beerbohm (1872–1956). A caricature from *Rossetti and his Circle* (1922). It shows Swinburne, Rossetti (reclining) and his brother William. The original is in the Tate Gallery

Except for Figure 1 all the works illustrating this article are by Dante Gabriel Rossetti (1828–82) and were in the exhibition at the Royal Academy, 13 January–11 March, 1973

Max Beerbohm's range was relatively narrow, but, as he mixed in the great world and was a shrewd judge of men and manners, his opinions deserve listening to with attention. He felt that Rossetti should be classed with Byron and Disraeli as one of the three most interesting men produced in England during the nineteenth century; he might not be out of place in the Quattrocento or by the Arno, but, 'in London, in the great days of a deep, smug, thick, rich, drab, industrial complacency, Rossetti shone, for the men and women, who knew him, with the ambiguous light of a red torch somewhere in a

dense fog'. For Max, Rossetti continued to shine, as he still does for many devotees.

This band will rejoice that the Royal Academy has staged a major exhibition of Rossetti's work. It was a happy thought on the part of the organizers to present some of Max's cartoons, although these do not include the one reproduced on this page (Fig. 1), a drawing which perceptively suggests the moodiness and melancholy that beset the painter-poet in his later years when living in Tudor House, Chelsea.

This exhibition is appropriately timed, for a younger

generation finds much to excite it in the art of the Pre-Raphaelites and the Symbolists. These artists provide an opportunity for discoveries of a sociological as well as an aesthetic sort, and they match the mood of the day. Once the rather claustrophobic nature of such work drove us out on to the front at Dieppe or for a stroll in the fields and towns of the environs of Paris, but such experiences now seem a little too familiar, so that the introverted and intricate art of Rossetti and others of the same sort,

He has never quite been out of favour, for his poetry has always been read and admired and, even when the rest of the period was in the doldrums, his painting has had its champions; Evelyn Waugh's monograph on him came out in the 1920's. Perhaps the first to attempt to revalue Rossetti in art-historical terms was Robin Ironside, who worked at the Tate Gallery as well as being a painter, stage-designer and gifted writer. He was a pioneer in the appreciation of the Pre-Raphaelites and poetic painting

2. *Ford Madox Brown,* 1852. Pencil, 16·5 × 11·4 cm. National Portrait Gallery

3. *Borgia: Study for the dancing girl, c.* 1850. Pencil and black chalk, 48·6 × 26·3 cm. Private collection

whose dreams were embodied in Symbolism, has a renewed appeal.

Victorian art may be regarded in different ways. For some, it offers the reflection of a cosy world in which hierarchy was pre-eminent, very pleasant too, but, for others, it is the sexual secrets of the time that offer a thrill. It has to be admitted that much went on behind closed doors and that the sort of life led by the queer fish Munby was odd, to say the least. There is no denying also that many aspects of Victorian art demand elucidation.

Rossetti is one of the most intriguing of the Victorians.

generally. Although he did not live long enough to write a full-scale volume on the subject, he was the joint-author of a notable 1948 Phaidon book on the Pre-Raphaelites. His colleague in this venture, John Gere, of the British Museum, is responsible for the elegant and understanding introduction to the exhibition catalogue, which is compiled by Virginia Surtees.

Another and compelling reason explains why Rossetti has never lacked friends: the fascination of his dominating personality. He was certainly the most complex member of the Pre-Raphaelite Brotherhood. He touched the

145

4. *Elizabeth Siddal,* 1854. Pencil, pen and Indian ink, 20·2×23·8 cm. Fitzwilliam Museum, Cambridge

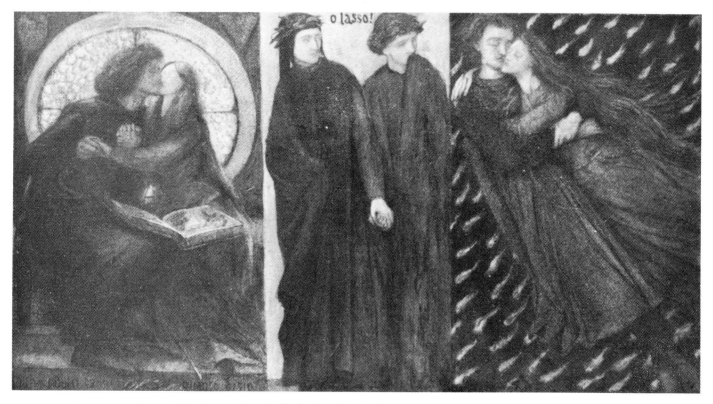

5. *Paolo and Francesca da Rimini,* 1855. Water-colour, 24·8×44·5 cm. Tate Gallery

art and literary world of his era in varied ways and the story of his life makes for compelling reading, even though a number of problems connected with it demand explanation.

He may have had a romantic disposition, but his early letters show that he was more mature than many young men of his generation in England. It was hardly surprising that he was bright, for he came from an intellectual home, his father being a sort of Don Quixote of Dante studies. Rossetti himself was steeped in medieval Italian poetry and his role as an artist was complemented by that of a poet and a translator, not only of Dante but of Guido Cavalcanti, whose verse was later deeply appreciated by Ezra Pound. There is nothing forced about Rossetti's concept of ideal love; it was a legacy from his forbears.

He was a man of paradox, combining a keen love of

beauty and a certain degree of impracticability with a shrewd sense of business. His letters, for instance, show that he grasped the importance of keeping up the prices of his pictures at auction. He was also sharp enough to inveigle some buyers into acquiring the drawing for a painting as well as the finished product. A streak of realism marked his nature, a touch of naughtiness too; and he was not above producing pot-boilers when hard up. His letters shed considerable light on his relations with his patrons, Ruskin at the start and then men such as William Graham, Leathart and Rae. And it should never be overlooked that, once launched, Rossetti was able to live more or less independently, thanks to their support.

A conflict between idealism and realism runs through Rossetti's life. Typically, his love for Elizabeth Siddal did not prevent him from having an affair with the pneumatic Fanny Cornforth, a free and easy girl about town. Like many other Victorian artists and writers, Rossetti was excited by the thought of moulding a young girl from a different class to his own. Lizzie was a shop assistant to suit his fancy. This ambition may be seen as a reflection of the do-goodism that has been characteristic of English life, and Rosalie Mander in her perceptive study of Rossetti (the best book on him to have

to live up to her new station, but, as John Gere says, 'she seems to have had no original creative power: she was as the moon to his sun, merely reflecting his light'. What a strain it must have been to hold her own in his circle, and Dr. Acland, who looked after her when she was in Oxford, felt that she was suffering from mental strain.

It was in keeping with the doomed nature of Lizzie's life that she produced a still-born child. Even though Rossetti adored her when they first met and she inspired some of his finest work, it is hard not to suspect that he made a grave error in marrying an old *collage*; he might well have echoed Swann's words about his marriage to Odette that he had spoiled his life for a woman who was not his type. Rossetti was a sensual man and Lizzie, it may be suspected, was frigid; she answered his dreams but not his needs.

Their life together has been described by biographers such as Professor Oswald Doughty and Lady Mander. It has much that strikes a contemporary note; their sponging on Ruskin, the Bohemian disorder and even Lizzie's death. This beautiful dream child was also a dope-fiend and had started to take laudanum to cure her neuralgia and the sufferings caused by sorrow at losing her child. The end came after she and Rossetti had dined at La

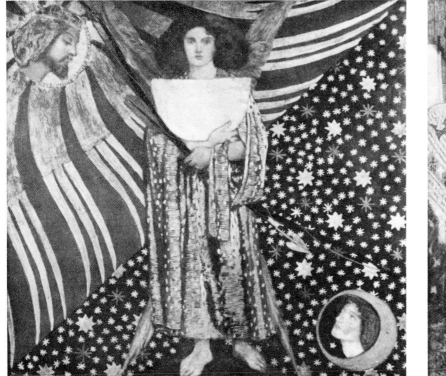

6. *The Wedding of St. George and the Princess Sabra,* 1857. Watercolour, 34·3 × 34·3 cm. Tate Gallery

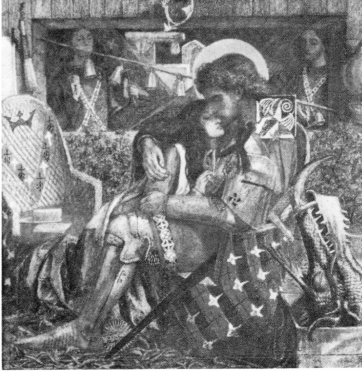

7. *Dantis Amor,* 1860. Oil on panel, 74·9 × 81·3 cm. Tate Gallery

been written) rightly refers to the English governess side of Rossetti's nature. His drawings of Lizzie, one of which is reproduced here (Fig. 4), have considerable charm and freshness and convey the springtime quality of his early passion.

Lizzie is a pathetic figure. She was beautiful, even though the drawings of her do depict a rather wishy-washy personality. We may sympathize with her efforts

Sablonière, a restaurant in Leicester Square, later frequented by Rimbaud. Under the influence of drugs, she behaved so queerly that Rossetti took her home, and then went out alone. Left to her own devices, she took an overdose of laudanum with fatal results. The exact circumstances of her death remain a shade mysterious, but the suggestion that Rossetti murdered her is far-fetched, perhaps reflecting romantic excitability. Yet,

for someone of Rossetti's temperament, her death was likely to prey on his nerves. It would be too much to say that he went downhill completely, but he was a changed man. Rosalie Mander has made it clear, for instance, that chloral, which he began to take to cure his insomnia, was not in itself a fatal drug: the damage was done by his washing it down with tots of whisky. Surely he suffered from remorse, for during his marriage he had embarked

found much to talk about, for both derived inspiration from Edgar Allan Poe and admired Delacroix, whose illustrations to *Faust* had influenced Rossetti when young. It is sometimes tempting to wonder what would have happened to Rossetti if his father had elected to settle in Paris rather than London, as he might well have done, and if his *femme fatale* had been Jeanne Duval rather than Jane Morris. What is worth emphasizing is that as a

8. *Found,* early 1850s. Pen and ink on black-edged writing-paper, 9·5×8·0 cm. Collection William E. Fredeman

9. *Found,* begun 1854. Oil on canvas, 91·4×80·0 cm. Wilmington Society of Fine Arts, Delaware

10. Opposite: *The Beloved: Study for the Gypsy Bridesmaid,* 1865. Pencil, 47·6×34·3 cm. Victoria and Albert Museum

11. Opposite: *Mrs. William Morris,* 1865. Black chalk, 41·5×33·9 cm. Collection Sir Rupert Hart-Davis

on his affair with Fanny and begun perhaps to realize that he was in love with Jane Morris: these were complications enough for anyone. Yet he was tough and it says much for his constitution that he indulged himself in drink and drugs, but was able to go for six-mile walks and even climb a mountain!

Rossetti belongs to the ranks of the *poétes maudits* whose tormented existences form such a feature of nineteenth-century artistic life, but he never plumbed the depths as did Baudelaire and Verlaine; perhaps if he had done so, his art might have been deeper and more poignant than it is. There is a touch of cottonwool about his vision.

Unfortunately he just missed Baudelaire when he was in Paris in 1864, but he may well have read his poetry, which was appreciated by Swinburne. They would have

youngster he appreciated Gavarni, that recorder of the *lorettes* of Paris.

However, Rossetti's John Bullish character was shown in the fact that he never visited Italy, although he liked Italian art; he was blinkered to the art of Manet, a painter of 'mere scrawls' in his view. But he admired Millet and seems to have appreciated Courbet, whose portrait of the voluptuous Jo Heffernan, Whistler's mistress, would have appealed to him if he had known it. Yet this man of dreams was hardly likely to favour the realism which was the dominating characteristic of contemporary French art. The difference between his outlook and that of Baudelaire is made explicit when his poem, 'Jenny', which deals with the fate of a prostitute, is compared with poems with similar subjects in *Les Fleurs du Mal.* However, the poem he wrote about the liberation of Italy by

the French, which was published only in 1904, shows that he could be daring.

Rossetti's poetry does not lack appeal, only it is expressed in a convention far removed from the one favoured by Baudelaire. He had a lyric gift and an eye for detail which bespoke a painter's sensibility. The sequence, 'The House of Life', has magnificent lines and subtle sentiments, evident in such poignant poems as 'Known in Vain', 'A Superscription' and 'The One Hope'. But Rossetti could only express himself fully as a painter when avoiding contemporary themes and, significantly, he was unable to finish *Found* (Fig. 9), a painting describing the encounter in London between a drover and his former sweetheart, who had become a prostitute. The first sketch for the painting (Fig. 8) shows how dramatically and forcefully he conceived the subject. It was unusual for this period in England, but very familiar to such a night owl as Rossetti.

Rossetti is hardly a major artist. This exhibition brings out both his merits and defects. It shows that he is not comparable to his great French contemporaries. For all the poetic intensity of his vision, his paintings and drawings have the touch of a dilettante. Large-scale composition troubled him, so that he was often most effective when using water-colour, a medium which did not over-tax him and permitted him to evoke moods. Mr. Gere rightly observes that his 'water-colours are less successful as they are more abstract. His imagination was essentially dramatic, and his best drawings are those showing the protagonists at some intensely charged moment of spiritual or emotional crisis'.

Yet are we right to think of Rossetti only as a literary artist? Nicolete Gray in her fascinating *Rossetti, Dante and Ourselves* (1947) argued, in fact, that he 'liked using literary figures because he did not want to tell a story. For the means which he uses are, when we come to examine them, purely pictorial'. She goes on: 'The intensity of his conception is not conveyed—as in expressionist painting, for instance, by facial expression. Primarily it is conveyed by the rhythm of the composition. . . .' In her concentrated analysis of Rossetti's art, which deserves to be widely known, she argues that Rossetti used 'other people's characters because he found their mythical allusions useful'.

It is an indication of Rossetti's originality that he proposed his own interpretation of Dante. The poems of Dante or Malory's *Morte D'Arthur* were very real to him; more real than the people whom he knew. It was central to Rossetti's art and to the tradition of the troubadours to whom, in part, he was the heir, that he paid homage to woman. Lizzie and Jane were the stars who illuminated his life and enthralled him.

The triangular relationship between him, Jane Morris and William Morris has aroused much interest; speculation has also taken place as to whether or not it found physical expression. Yet it falls into perspective if seen in terms of Italian tradition: it was in his blood to play *cavaliere servente* to Jane Morris, the Egeria of his later life, just as it was part of the literary and artistic convention of the day to view her as a Medusa-like figure. His late paintings of her as Mariana and as

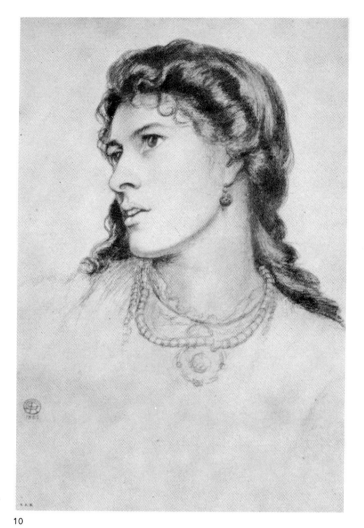

10

11

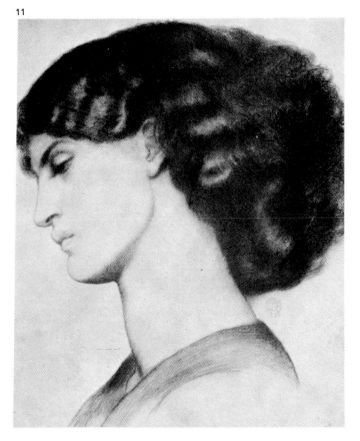

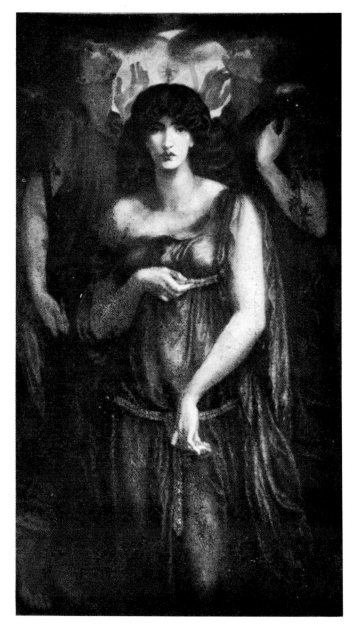

12. *Astarte Syriaca*, 1877. Oil on canvas, 182·9×106·7 cm. City Art Galleries, Manchester

13. Opposite: *Mariana*, 1870. Oil on canvas, 109·2×88·9 cm. Art Gallery and Museum, Aberdeen

Astarte Syriaca (Figs. 13 and 12) announced the symbolism of the *fin de siècle*.

Rossetti's art has a claustrophobic quality, apparent in his treatment of space. He was not so much interested in attempting to render three-dimensional space as in seeking to create a two-dimensional flat pattern in which, John Gere observes, 'colour is used with an almost heraldic irrevelance'. This way of planning his compositions relates him to later French painters such as Sérusier. However, it was the content, not the formal character, of his art that appealed to the French.

It is worth recalling, in this connexion, that Rossetti was appreciated by Debussy, who set to music 'The Blessed Damozel'; the score was illustrated by Maurice Denis. Edward Lockspeiser has pointed out in his life of Debussy that this composer's score 'brings us very near

to a purely visual conception of music: the decorative Pre-Raphaelite curves are projected or translated into the long sinuous arabesques of the Damozel's aria'. Thus Rossetti may be seen to have been a source for an advanced European movement.

Rossetti as a man and artist has stirred various pens in recent years, but there is still room for a study in depth, which would treat of his art in its own right and in relation to the contemporary movement, and it is to be hoped that Mr. Gere will attempt the task. There is much that remains to be examined; for instance, the influence on him of the early Flemish masters he saw on the 1849 trip to Belgium and of the Germans. To what extent did he care for illuminated manuscripts? Dr. A. N. L. Munby in his charming and informative volume, *Connoisseurs and Medieval Miniatures 1750-1850* (Clarendon Press: Oxford University Press, 1972) has investigated the rise of the taste for this art form during the eighteenth and nineteenth centuries and shown that one of its prime lovers was Ruskin. Ruskin's liking for Rossetti may have been spurred on by the fact that this artist, like so many of the Pre-Raphaelite circle, gave his painting the finish and concentration of a miniature.

Collecting appealed to Rossetti—blue-and-white, early furniture and Japanese art—and his brother William wrote an excellent article about the last-mentioned subject. Rossetti was also fond of Venetian Cinquecento painting, as were many English collectors and painters; his letters refer to Palma and his later half-length pictures of beautiful women acknowledge a debt to this period in Venetian art. The exhibition includes photographs of Rossetti and his circle. This is only to be expected, since he was a friend of Julia Cameron and interested in photography, but the fact that his pictures were painted after the model implies that he did not call on photographs for assistance, as did Degas and Sickert. He was an all-round man and not his least claim on posterity is his appreciation of Blake.

For the psychologist, Rossetti has much to offer. His passion for undulating hair was typical of the period; it provided a means by which sensuous movement could be suggested and has, of course, a fetishist note. He responded to Sade, whose *Justine* was read aloud at Tudor House, and the sado-masochistic character of some of his works is in tune with the *fin de siècle*. Years ago, Mario Praz included him in the ranks of the Romantic Agony, noting that he showed 'a conspicuous preference for the sad and cruel; the Middle Ages, to him, are a legend of blood: besides his Beata Beatrix stand magical, evil creatures'. His later works underline the change that had overtaken the artist who had painted in his youth such devotional works as *The Girlhood of Mary* and *Ecce Ancilla Domini*, both in the Tate Gallery.

Rossetti, according to Mr. Gere, is a genius 'whose personality seems somehow greater than his work'. This is a valid judgement, borne out by the exhibition. He is a brooding, introspective master, enmeshed in the chains of his love for Jane Morris and haunted by medieval dreams and a latter-day romantic in an age of increasing industrialization; he could appear in one of his own pictures as both captive and victim.

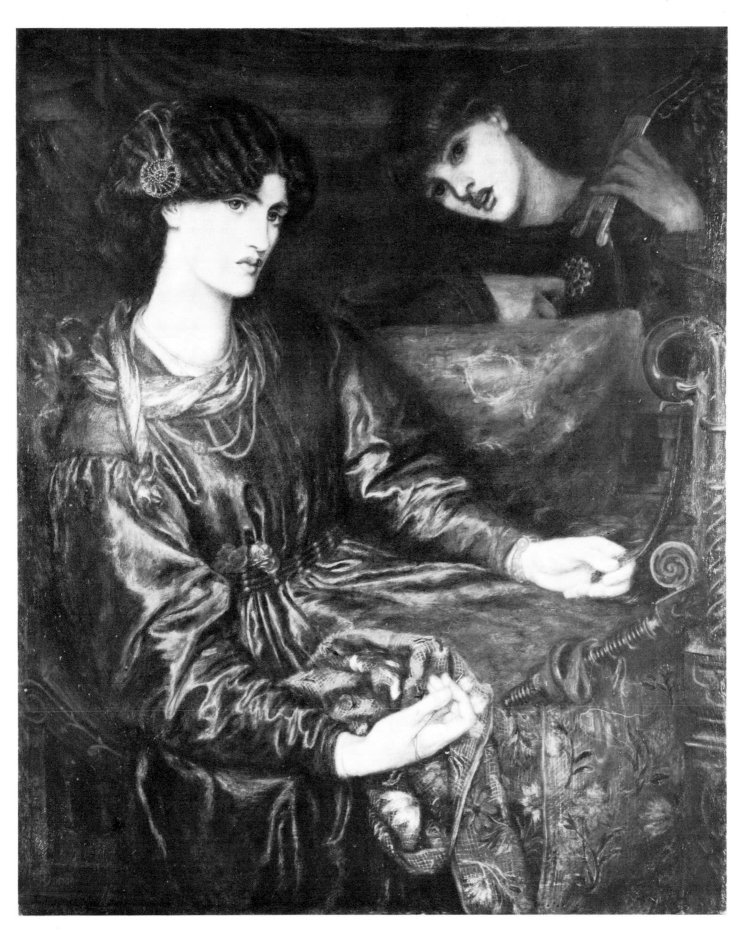

Celtic and Classical Dreams

Harold Acton recalls in his memoir of Nancy Mitford that Victorian art was fashionable among the bright young things at Oxford in the 1920s and that one of the main devotees was Robert Byron. The art historical detective could undertake an amusing task by seeking to ascertain if this gifted scholar's love of Byzantine art resulted from an expedition to Brompton cemetery which contains the Byzantine sarcophagus designed by Burne-Jones for his old friend and patron F. R. Leyland. This artist also designed mosaics for the American Church in Rome.

Burne-Jones has now made something of a come-back into favour, and the exhibition at the Hayward Gallery will provide the opportunity for a long overdue revaluation of his art. In his time *Punch* wrote that his work represented 'the quaint, the queer, the mystic overmuch'. How does this judgement stand today, or has the recent intensive study of late-nineteenth-century symbolism given more savour to a painter, far from insular in his range?

Although considerable information about Burne-Jones's life and opinions was provided by his wife, Georgiana, in her *Memorials*, understandably she drew a veil over his romances. Burne-Jones had a keen eye for women and in general was attracted by young fragile virginal types whose ethereal appearance formed a contrast to the flamboyance of the street-walkers, then such a feature of the London scene.

His one serious affair was with Mary Zambaco. This alluring redhead with an exquisite white skin was born a Cassavettis and was a member of the colony of rich Greek merchants which did much for art in England. One member of the clan was Alexander Ionides whose collection, now in the Victoria and Albert Museum, with its early Italians, Delacroixes, Millet, Courbet and Le Nain, is proof of his discernment. He also owned a Burne-Jones.

The circumstances of Burne-Jones's liaison with Mary Zambaco, with whom he nearly bolted, are recounted with wit and sympathy by Penelope Fitzgerald in her engaging biography of Burne-Jones (Michael Joseph, £8·50), and she charmingly writes that 'Warmth and sexual generosity were the note of Mary's beauty.' This enchanting *femme fatale*, who has the richness and vitality of a character by Tolstoy or Ibsen, made a considerable impact on Burne-Jones; as Mrs. Fitzgerald points out she gave him 'a new image of beauty and a new depth of happiness and unhappiness'.

Without women Burne-Jones was lost. Like many men he needed feminine support and inspiration: sympathetic females helped to fend off the melancholy which preyed on him in later years and which Bastien-Lepage captured in a water-colour in the Birmingham City

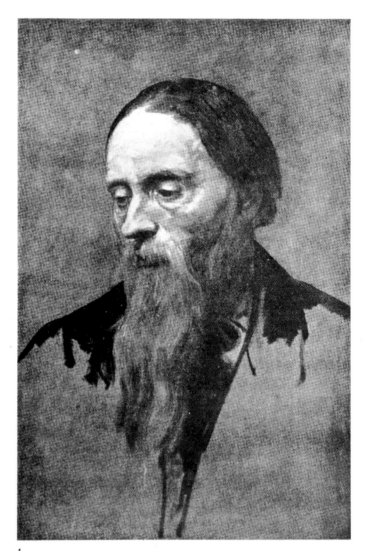

1

Museum and Art Gallery. His dependence on Mary Gaskell was touching. She was the wife of a captain in the Ninth Lancers with a taste for barrack-room jokes and a hot temper, but otherwise a good fellow. Mrs. Fitzgerald observed that the painter would write to his confidante as often as five or six times a day. Georgiana had a lot to put up with, but found consolation in an *amitié amoureuse* with William Morris and local politics at Rottingdean.

Mrs. Fitzgerald is less concerned with commenting on Burne-Jones's art, though she makes some shrewd comments, than in providing a clear account of his career. He was not only a dreamer, but a man with a rollicking sense of humour. He loved the music-hall and enjoyed taking his wife to dine at 'pothouses'—Solferino's in Rupert Street, De Maria's in Kensington, the Cavour

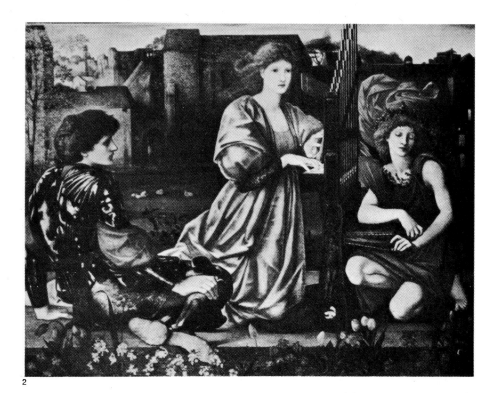

2

3

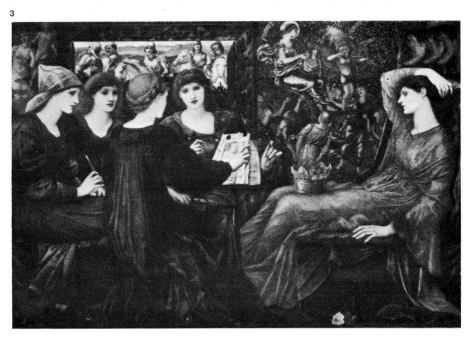

1. Opposite: *Portrait of Edward Burne-Jones* by Alphonse Legros (1837–1911). Water-colour, 32·72 × 22·56 cm. Victoria and Albert Museum

2. *Chant d'Amour* by Sir Edward Burne-Jones (1833–98), 1863–73. Oil on canvas, 44 × 60 cm. The Metropolitan Museum, New York.

3. *Laus Veneris* by Burne-Jones, 1873–75. Oil on cavas, 47 × 71 cm. Laing Art Gallery, Newcastle-on-Tyne

in Leicester Square and the grill-room, but never the restaurant, in the South Kensington (Victoria and Albert) Museum. Mrs. Fitzgerald is excellent at sketching in the background and at describing his relations with Rossetti and Morris, Ruskin and Swinburne (whose splendid letters were burnt by the artist). She discusses his trips to Italy, his intellectual and artistic preoccupations and his courageous attitude when Wilde was in trouble. He lent Constance Wilde £150 and told Mary Drew, to quote Mrs. Fitzgerald, 'If Wilde liked the worst society as well as the best, "I undertake to say that [the worst] is more serviceable to art . . . and knowing Oscar's many generous actions and the heavy merciless fist of London society . . . [I] shall speak up for him whenever I hear him abused".'

Those less than enthusiastic about Burne-Jones the artist can hardly fail to respond to him as a man. Mrs. Fitzgerald's volume helps to fill in many details about

Victorian art and life; so do several other recent publications that have made this year a bumper one for Victorian studies. They help to show that the age was one of High Drama as well as of High Ideals and to identify the coteries that existed in English art from the 1850s onwards. Now the Pattles and Prinseps, the Ionideses and the Howards, the Batterseas and the Lindsays fall into position. Moreover, proper recognition is given to the role of those two considerable patrons, William Graham, a Presbyterian and a Liberal M.P. and F. R. Leyland, described by Mrs. Fitzgerald as 'a kind of saint of patronage'. The conflicting claims of Bohemia and Society on artists may also be more easily assessed. In the case of Burne-Jones, Mrs. Fitzgerald is understanding about his connexions with the Souls, a refined and talented group that included the Duke and Duchess of Rutland, the Earl and Countess of Pembroke, A. J. Balfour, George Curzon and Frances Horner. 'In deliberate contrast to the

amusements of Prince Tum-Tum and his intimates', the author says, 'the Souls were moved only by beauty and the intensity of friendship.' Burne-Jones was their Court painter, not that he was quite of them and, 'In his own phrase, he was an occasional Soul'.

Scholars are now examining the visual sources of Burne-Jones's art, above all his debt to Italian art. He owed much to the Primitives and to Botticelli; he was an enthusiast for Signorelli (anticipating Roger Fry) and for Piero della Francesca. His debt to Michelangelo hardly needs emphasis; oddly enough Burne-Jones's manneristic figures foreshadow those of Wyndham Lewis. He adored Mantegna and took good care to show his prints by this master to Aubrey Beardsley. Venetian painting cast its spell on him and the influence of Bellini and Giorgione may be detected in *The Passing of Venus*, which hangs in the Junior Common Room of his old college, Exeter, at Oxford.

Emphasis is often and rightly placed on the impact made by Japanese art in the West during the nineteenth century, but another current, less strong, but with considerable significance, was provided by Islamic art and literature. Persia was to Burne-Jones 'like a far-off country home', his wife wrote, 'for in imagination, he lived and travelled there from boyhood'. Swinburne introduced him to Fitzgerald's translation of *The Rubáiyát of Omar Khayyám* and he decorated with pictures a manuscript copy of the poem which Morris gave him. The influence of Islamic decoration on Burne-Jones's work may be greater than is realized.

His wife's recollections reveal that he soon came across the themes that fascinated him, above all Malory's *Morte d'Arthur*. But other influences were at work. His aunt, Mrs. James Catherwood, was the sister-in-law of the famous explorer Frederick Catherwood who took an interest in the young man. While turning over the pages of Catherwood's books with their drawings of the ruined civilizations of Egypt and Central America, he entered a new world, one that may well have contributed to the preoccupation with decay that characterizes his later years.

How intriguing to find that in 1853 he succumbed to the magic of Edgar Allan Poe, although none too keen about some of his tales! But as a whole he found them 'marvellously startling', one of his favourites being 'The Fall of the House of Usher', which he considered 'very grand'. Burne-Jones could not have been more in accord with advanced taste: a few years later Baudelaire produced his famous translations of Poe. In accord with many continental artists Burne-Jones was keen on the dance— Katie Vaughan was his favourite performer—and Rodin would have sympathized with his admiration for a Javanese troupe when it came to London. The figures in *The Garden of Hesperides* (Private collection) have the lilting movement of the dance, thereby showing that his art has some affinities with that of Rodin, Munch and Matisse.

Burne-Jones was one of the few English painters, as opposed to designers, who had some influence abroad. He exhibited in Paris and his foreign admirers included Puvis de Chavannes, Paul Bourget, Robert de la Sizéranne and Fernand Khnopff and his work exerted an influence in the Barcelona of Picasso's youth. Mrs. Fitzgerald is most amusing about his French admirers, and reports Burne-Jones as saying, when they arrived at The Grange in Rottingdean, 'William announces, "It's the French, sir"', as though it was the Battle of Hastings'. One of his chief fans was the 'Baronne' Deslandes, 'a tiny, formidable, blonde Jewish *lionne*, mysterious as to age and provenance, given to strange gestures and long, swimming, short-sighted glances'. She wrote a rhapsody about him in *Figaro* and got round him to paint her portrait.

W. B. Yeats once wrote that 'the imagination of the world is as ready as it was at the coming of the tales of Arthur and the Grail for a new intoxication'. This was Burne-Jones's view, but, for him intoxication lay with the Arthurian legend. He was conscious of his Welsh ancestry and was a pioneer student of the Celtic tradition and in this respect his approach may be related to that of a painter such as Sérusier who found congenial themes in Brittany: both artists composed their paintings as if they were tapestries.

Burne-Jones was a Symbolist. Mrs. Fitzgerald notes that the flowers in the *Chant d'Amour* (Fig. 2) are tulips and wall-flowers, which were 'emblems respectively of ardent love and of bitterness' in the Victorian iconography of flowers. Burne-Jones was clear in his mind about the role of symbolism, as opposed to expression, in art. 'The only expression allowable in great portraiture', he wrote, 'is the expression of character and moral quality, not of anything temporary, fleeting, accidental. Apart from portraiture you don't want even so much, or very seldom: in fact you only want types, symbols, suggestions.' Of the queens in *Arthur in Avalon* (Fig. 4) he said: 'They are queens of undying mystery and their names are Lamentation and Mourning and Woe'. This painting—his masterpiece—took him many years (1881–98) to complete and he so identified himself with Arthur that he even slept in the same pose as that given to the king in this picture. It is a melancholy work; the Round Table has been dissolved.

Romantic chivalry haunted Burne-Jones; for him it was the antithesis of the materialism of the age. He believed that aesthetic perfection was possible, especially if touched with Celtic romance. He declared, in fact, that he 'wanted to track that blissful sweet song piteous into the thick of the forest, and I did it at last'. Georgiana noted that he 'knew it wherever he met it and in whatever form'. In general he did not care for Wagner, but *Parsifal*, which he heard at the Albert Hall in 1884, won him. 'He made sounds', he said, 'that are really and truly (I assure you, and I ought to know) the very sounds that were to be heard in the Sangraal Chapel, I recognized them in a moment and knew that he had done it accurately.'

Philippe Jullian in *Dreamers and Decadents* suggested that Burne-Jones may not have been very intelligent and contrasted him, as others have done, with Gustave Moreau, observing that his women 'are always modest, desirable, vulnerable, never cruel'. Yet does this matter? Women do not have to be Medusas, though, in fact, Burne-Jones drew one. The young women who appear in his pictures are innocent *jeunes filles en fleur*—those in the *Wedding of Pysche* (Musée d'Art Moderne, Brussels) are thin and wan. Burne-Jones now seems little more than a tentative contributor to the romantic agony, but this is not

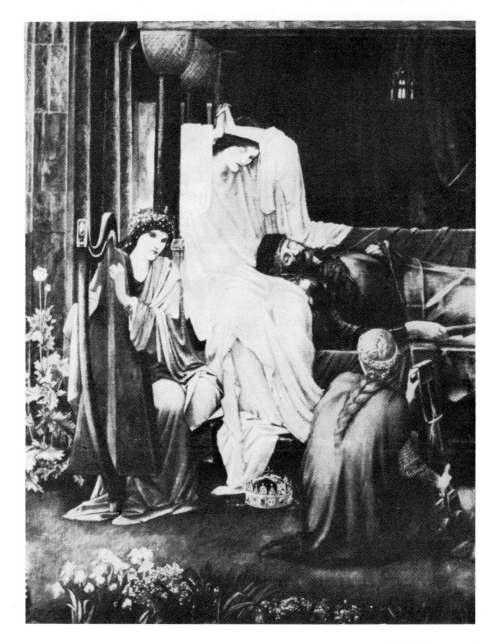

4. *The Sleep of King Arthur in Avalon* (detail) by Burne-Jones, 1881–98. Museo de Arte de Ponce, The Luis A. Ferré Foundation Inc., Puerto Rico

how he appeared in his own generation and Henry James even claimed about the Venus is *Laus Veneris* (Fig. 3) that she had 'the aspect of a person who has had what the French call an "intimate" acquaintance with life'. This and other contemporary opinions about the artist are discussed by Barrie Bullen in his article in this issue; they shed amusing light on the changing nature of taste.

Burne-Jones's world was the shadowy one of a Maeterlinck play; however his colour could be robust, even if his technique was often faulty. He turned his back on reality, refusing to read Zola or Tolstoy because they were 'just like life'. Though he loved and admired Turgenev 'beyond words' and read two of his books, he refused to tackle any more: he knew the Russians could make 'splended women in their books: and I know that ours are but poor things in our books—but I do really suffer when I read them and get demoralized with miserable reflections'.

There is little point in reproaching Burne-Jones for not painting as vigorously as a Manet or a Degas, or for his failure to create form; he was essentially a decorative linear artist who sought to embody a cerebral ideal of beauty in his art. Lord David Cecil has noted that, like Palmer, Burne-Jones strove to unveil what the earlier romantic called 'the heavenly face of Beauty' and that 'in his unsubstantial land of day dream' he was not able to

'forget for long his sense of an ultimate disillusionment'. Burne-Jones once declared: 'The world now very much wants to go back into barbarism. It is sick and tired of all the arts: it is tired of beauty'. Was the Celtic prophet altogether wrong and was his quest for a form of 'beauty', however artificial, claustrophobic and world-weary, one reason that explains his appeal to many of the young? After all, he was activated by idealism.

Burne-Jones had an admirer in Leighton, although their friendship was marked by a temporary coolness in 1867. Leighton bought at least two of his early watercolours and Burne-Jones's *Chaucer's Dream of Good Women* hung above his bed. Both shared a love of Islamic art and music; Burne-Jones was one of those who would attend Leighton's famous musical At Homes at Leighton House, where Joachim performed with such verve.

Leighton was the more worldly of the two men but, like Burne-Jones, he disliked showing his feelings; however, more of the latter's nature is revealed in his art than Leighton's is in his. Leighton always guarded an extreme reserve. All the more understandable, then, that Leonée and Richard Ormond should have been tempted by the far from easy task of writing his life. The result, which is published by the Paul Mellon Centre for Studies in British Art (Yale University Press, £19·50), is a major contribu-

5. *Self-portrait* by Lord Leighton (1830–96), 1880. Oil on canvas, 76·52 × 64·13 cm. Uffizi, Florence

tion to the study of Victorian art. It is a handsome book with good colour plates and many black-and-white illustrations; it includes a catalogue of the painter's *oeuvre*.

The Ormonds have broken new ground. Leighton is in many ways a mystery man. Many years ago Mrs. Russell Barrington, who makes an amusing appearance in Wilfrid Blunt's recent book on Watts, wrote a two-volume biography which is hagiographical in tone. However, it includes many of Leighton's early letters written when he lived abroad, which are highly informative about his artistic development and circle.

The Ormonds have greatly improved on their predecessor. They have drawn on unpublished letters and rare memoirs with the result that for the first time Leighton may be seen in depth. Their book is more than a study of the artist; it is rich in information about the art life of the age. They show, to take one instance, that the Prince of Wales (Edward VII) played a larger role in the art world than is generally recognized.

The Prince and Leighton became good friends: they had much in common: cosmopolitanism and urbanity, for example. Unlike many of his colleagues, Leighton was eminently a man of the world, although, doubtless to the Prince's amusement, he did make rather a fool of himself in later years when he threw discretion aside to push an aspiring young actress, Dorothy Dene. How sympathetic to find that Leighton, paragon of social virtues, had a weak spot!

The authors rightly underline that Leighton had a decided neurotic streak which he almost invariably masked behind a stiff façade. They do not shirk facing the problem of his private life, but they do so with commendable discretion and commonsense; they do not accept that his

tastes lay in the direction of his own sex. He certainly liked handsome young men, but a response to male beauty is not necessarily an indication of homosexuality. Leighton was no less keen on attractive women and many of his paintings offer delectation to the connoisseur of female beauty. It is true that he gave several young men an allowance, but a well-off bachelor had no reason to blush for stretching out a helping hand to those less fortunate than himself. He enjoyed his trips to North Africa but not every visitor was a Gide.

Leighton's major relationship was with a woman, Adelaide Sartoris, who seems to have played a part in his existence rather similar to that enjoyed by Pauline Viardot in Turgenev's. She came from a well-known theatrical family, the Kembles, and was a sister of Fanny Kemble, who was to send Leighton entertaining and informative letters when on tour in the United States.

Adelaide Sartoris, who put on a good deal of weight with the years, had a fine voice and had scored an immense success in the title role of Bellini's *Norma*, but had abandoned her career on marriage. Whether Leighton was her *amant de coeur* or her *cicisbeo* remains speculative, but contemporary gossip suggests that he fulfilled the former part.

He had met Mrs. Sartoris and her husband in Rome in 1853, writing about her enthusiastically to his mother. The Ormonds' biography and Leighton's letters, bring home the easy way in which an artist with the proper credentials and the requisite social graces could join in a charming international set, with artistic and intellectual interests. Leighton, who could step out of the pages of a James novel, was well equipped for this sort of life. Although born in Scarborough, then a fashionable water-ing-place (as Osbert and Sacheverell Sitwell were to recall), he had spent most of his early life on the Continent—his father practised medicine in Frankfurt-am-Main—and he became an accomplished linguist. He was adroit at making his way in Society but could prove touchy if he felt that he was being treated with less consideration than his due. On one occasion in 1891 the Prince of Wales sensed that Leighton felt that he had been slighted over an exhibition in Berlin and wrote to his sister, the Empress Frederick, asking her to get Seckendorf to send him a line. Prince Tum-Tum knew how to oil the wheels.

This detailed and well-balanced biography shows the extent to which Leighton touched life at many points. His friendship with Browning is excellently described and so is his immense activity as President of the Royal Academy; he was responsible for starting the series of Old Master exhibitions that have done much to spread a knowledge of art in England.

Leighton had an extensive knowledge of art, as befitted a typical representative of nineteenth-century historicism. He was especially devoted to Masaccio and was a devotee of the Venetians, as may be seen from his own work: Venetian art was a notable influence on Victorian painting. He was by no means blind to the French moderns, buying works by Delacroix (though none of his Arab scenes) and Corot and admiring Daubigny and Millet; some of his own paintings are in tune with those of such academic artists as Cabanel.

Leighton's considerable artistic culture is revealed, not only by his taste for Islamic art—the Arab Hall at Leighton House remains as a witness to this—but in his Royal Academy lectures which reflect the taste of a much travelled and cultivated artist. He is interesting on Etruscan art (which appealed to Burne-Jones) and discoursed enthusiastically about an Etruscan bronze lamp in the Museum at Cortona and talked about 'that Assyrian edginess of touch which marks the Etruscan chisel'. Leighton enjoyed movement and drama in art and in talking about the Assyrian royal hunting pieces, he told his audience that he knew 'nothing quite equal to the portrayal by Assyrian artists of lions maddened or struck down by the chase'.

Leighton was one of the many artists of his day who succumbed to the lure of Spain and his lecture on Spanish art (1889) was one of the best he gave, although, in line with contemporary taste, he was critical of Alonso Berruguete whose reputation, he considered, was not justified by 'his lumbering and mannered works' and he dubbed Juan de Juanes a 'most turgid contortionist'. Although entertaining some reservations about Velázquez's imagination, he did not hesitate to speak of 'the wizardry and the luscious fascination of the brush of this most modern of the old masters'. In making this claim, Leighton was in line with advanced opinion in Paris and a few years later, R. A. M. Stevenson was to capture the imagination of the younger generation with his brilliant book on Velázquez (1893). Zurbarán was, however, his favourite; he saw him as an artist 'in whom, more than in any of his contemporaries, the various essential characteristics of his race were gathered up—its defiant temper, its dramatic bent, its indifference to beauty, its love of fact, its imaginative force, its gloomy fervour, its poetry, in fact, and its prose'.

Leighton had an unusual artistic training. At the Städel Institute in Frankfurt-am-Main, he had been reared in the traditions of the Nazarenes; he owed much to the encouragement of its professor of history painting, Edward von Steinle, a friend of Overbeck and Veit. The Ormonds give an admirable account of this period in Leighton's life and point out that Steinle turned him into a medievalist. But this was not the only German current that counted in his development and when in Rome as a young man he painted the model, Nanna, who sat to Feuerbach. His own pictures were to assume some of the measured dignity of this German artist. Leighton's connexions with Germany are a reminder that the cultural entente between England and Germany was strong last century, and it might be worth reflecting on whether or not the suspicion of French modern art was partly motivated by this alliance.

The German element in Leighton's outlook is significant and his ideas were powerfully influenced by his early training in Germany, and his contact with German thought; his father was an admirer of Hegel. To what extent, it may be asked, did Leighton's concept of classicism derive from the German one, from the ideas of Winckelmann, Hölderlin and even Nietzsche? Most English classicism of the Victorian era has a decorative touch. This is not the case with Leighton's. His is more full-blooded and dionysian.

6. *Clytie* by Leighton, *c.* 1895–96. Oil on canvas, 1·56 × 1·36 m. Private collection, India. Leighton's last painting, modelled from Dorothy Dene the actress. The landscape was painted in Donegal

His love of music may well have influenced his paintings—another manifestation of Baudelaire's theory of 'correspondance'—and he was a frequent visitor to the theatre. The relationship between painting and the stage was significant in nineteenth-century art, not least in England. Many of Leighton's classical pictures give the impression that the action is taking place on stage and in one of the most important late ones, *Clytie* (Fig. 6), the curtain could be about to come down at the conclusion of an aria. The heady world of Strauss is in the offing.

Leighton's paintings have the opulence of a ripe patrician culture, but they do not possess the *fin de siècle* neurosis of a Stück. He was a confident colourist who enjoyed clothing his sumptuous models in radiant garments and, unlike Burne-Jones, he had no fear of flesh. His sketches, which have an appealing directness, supply one reason for his love of Delacroix, not that he rivalled the genius of the French master. The delight in the sun that led him to North Africa and is found in his painting relates him, somewhat surprisingly, to the Fauves; he would have subscribed to Maurice Denis's views about the role of the sun in art.

Leighton does not measure up to the major European artists of his day but, as with so many of the half-forgotten 'academic' painters, more qualities are to be found in his painting than used to be believed. The problem is that it is by no means easy to see his works and this able book should encourage an exhibition; only then will it be possible for the public to make up their minds about a fallen giant. What hardly needs emphasizing is that the history of nineteenth-century art remains in a revisionist stage. The art historian has no need to fear that his work is done.

A Long Affair

There is a celebrated passage in *The Ambassadors* which describes how Strether, setting out on his trip beyond the *banlieue* of Paris, is excited by the thought that he will see 'something somewhere that would remind him of a certain small Lambinet that had charmed him, long years before, at a Boston dealer's and that he had quite absurdly never forgotten'. Unfortunately the price was more than Strether could afford, but the memory of the work, as James says, 'abode with him as the picture he would have bought'. The novelist knew exactly what he was about, for Bostonian collectors were among the first to appreciate the qualities of the French School of 1830 and their followers.

The delight which so many nineteenth-century Bostonians found in the paintings of Millet or Troyon, of Rousseau or Daubigny was so marked as to constitute a special feature of the artistic life of the city in the nineteenth century. Indeed by the time the Museum of Fine Arts was established in 1870, Boston amateurs had kept abreast of modern French art for nearly twenty years. Their acquisition of so many fine examples of this School (of which a number are to be found in the Museum) shows that their perception was as acute in this domain as was that of those men who later assembled the more celebrated Oriental and Greek treasures in the Museum. Some account of these was provided in the December 1969 issue of APOLLO.

Bostonians' appreciation of the French landscapists who worked in Barbizon and elsewhere in France was understandable, for such painting has a freshness and vigour well suited to appeal to their nature. It was realistic, straightforward work, not without moral undertones—and, as such, likely to win the heart of the contemporaries of Emerson and Longfellow. There is nothing highfalutin about Barbizon painting. The early buyers may also have detected some relationship between the savage scenery of the Forest of Fontainebleau and that of the New World. In any event, it is impossible to think about the rise to international favour of the School of 1830 without recalling those eager Bostonian collectors or painters who cherished its productions; their enthusiasm recalls that which greeted the novels of Turgenev in Boston[1] in the 1860s.

Interest in modern art in Boston was no new development and in the first part of the century painters such as Washington Allston, so deeply admired by Coleridge, and

William Page, one of the most poignant of American portraitists, were especially distinguished ornaments of the local School. Naturally artists were anxious to cross to Europe and to study art at the source; they went to Rome, Munich and Düsseldorf and more than a small contingent settled in Paris. The lure of Paris was easily understood. It was the capital of a dramatic and revolutionary artistic movement with Delacroix and Géricault at its head, and significantly John B. Johnston would recall his thrill as a student in coming across Géricault's *Horse Race* in the Louvre. It was hardly surprising that by the mid-century at least five or six Bostonian artists were working under Thomas Couture; and it was as a consequence of this alliance that this artist's *Study for 'The Volunteers of 1792'* (Fig 2) was presented to the Museum by contribution in 1877.

The rising passion for modern art was not confined to the young painters. It was shared by the delightful Thomas Gold Appleton (1812-84), the author of the famous phrase, 'Good Americans, when they die, go to Paris'. He had abandoned the law, to which his father had destined him, in order to travel and cultivate himself, thus becoming an archetypal dilettante. He told his father:

I cannot see that a man, improving his character and mind, living modestly on a moderate income, is wholly despicable. If he tries to do good and to find the truth and speak it, I cannot see that he is inferior to a man who merely toils, nobly to be sure, but still without leaving himself time for much of these...My ambition is my own, and it is as strong as any man's, but it has not triumphs which the world can appreciate or behold. It may not be a lofty or a very useful one, but it is to the best of my abilities.[2]

Although he spent some time copying in the Italian galleries, and no doubt did a *pochade* or so, he had neither the drive nor the need to become a fully fledged painter. Van Wyck Brooks, in fact, compared him to Bromfield Carey in W. D. Howells's novel *The Rise of Silas Lapham*: 'It was absurd for him to paint portraits for pay and ridiculous to paint them for nothing, so he did not paint them at all'.

Appleton's dilettantism did not prevent him from spending a happy and useful life. During the 1840s and '50s he travelled in Europe. While in England he saw *The Angel releasing Saint Peter from Prison*, which had been painted by Washington Allston for Sir George Beaumont, and it was his admiration for this work which induced Dr. R. W. Hunter to acquire it in 1859

1. *Village on the Sea* by Emile Lambinet (1815–77), 1866. Oil on canvas, 29·5×46 cm. Bequest of Ernest Wadsworth Longfellow, 1937. Lambinet was greatly admired by Strether in *The Ambassadors* by Henry James The works illustrated are in the Museum of Fine Arts, Boston

from the baronet's nephew. In the same year Appleton came across William Morris Hunt, the painter, in Paris and the two men joined up with some of the former's relatives to make a trip to Constantinople and Greece. Appleton's letters to his father tell of his dining with Ary Scheffer and of his buying 'a little Diaz [Fig. 5]—the French Rubens—Spanish blood and Murillo stealing constantly into his pictures'.[3] Appleton was not a dedicated comprehensive collector but a man who liked to be surrounded by pleasant things — in his case pictures by Troyon, an artist whom he knew, or Rousseau. In all he owned some thirty paintings. These, together with his Tanagra figurines, Greek vases and masses of books, must have made his house a most cosy and civilized place. He had built it in the 1860s in Commonwealth Avenue near the Public Garden in the Back Bay area and next door to his great friend Erastus Bigelow.

By the late 1850s French pictures were beginning to turn up in Boston; for instance, the well-known art dealer Gambart made two trips to the city in 1857 and 1860, and, on the second occasion, his consignment was shown at the Athenaeum, where B. F. Burgess bought *The Hay-Cart* by Troyon and Benjamin Rotch a landscape by Lambinet. William Howe Downes pointed out[4] that 'the success of Lambinet in Boston, by the way, has always been out of proportion to his reputation in France; and no private collection has been considered complete without at least one example of his work'. He had a magical appeal for certain Boston eyes; Richard H. Fuller, a night-watchman in Chelsea (Boston), who was a self-taught

2. *Study for 'The Volunteers of 1792'* by Thomas Couture (1815–79). Oil on canvas, 81×65 cm. Gift by contribution, 1877. By the mid-nineteenth century at least five or six Bostonians were working under Thomas Couture

artist, 'was captivated by Lambinet, whose method and scheme of color he absorbed, as is more or less evident in all his canvases'.

Downes provides us with valuable information about the steady development of interest in French art, recording that Thomas Wigglesworth and Hitchcock began to buy French painting during the Civil War, 1861-66. One is tempted to wonder if the considerable English support for the Southern cause had some effect in making Bostonian collectors look more favourably at the French School. In 1864, on leaving the States, Hitchcock sold his collection, which included a Millet (bought from William Morris Hunt) and a Rousseau, to one of the new enthusiasts, Henry Sayles. This amateur, like many other contemporary collectors, was advised by an artist resident in France—J. Foxcroft Cole. This painter-agent was apparently the first American to buy a Corot, although the earliest one sold in Boston was handled by the dealer Cadart. In 1867-75 Cole also acted for his friends—among others Peter C. Brooks, H. P. Kidder, Alexander Cochrane and Dr. H. C. Angell. Pictures from their collections are now in the Museum. Mrs. Samuel D. Warren was another lover of Barbizon pictures at that time.

Yet the main whipper-up of enthusiasm for French painting was William Morris Hunt (1824-79). Born in Vermont, he had attended Harvard, but owing to illness, his mother removed him from college, taking him and her other children to Europe. One of his brothers Richard Morris Hunt became one of the most distinguished architects of his generation and was the first American to study at the Ecole des Beaux-Arts in Paris, acting as the assistant, as well as a pupil, of Hector Lefuel. William Morris Hunt seems to have spent some time with Barye, but, after seeing Couture's *Falconer* in Deforge's art gallery, went to work under him. The 'mad American', as he was known in Paris, had a quick eye for pictures; he was sufficiently excited to buy Millet's *The Sower* (Fig 7), which he had seen in the Salon of 1852. He also prevailed upon his compatriot William Babcock, the first American to know Millet, to take him out to Barbizon and introduce him to the artist, where, so the story goes, he found him painting *The Sheep-Shearers* in a cellar. The two men took to each other and Millet is recorded by Edward Wheelwright[5] as saying that the American became his most intimate friend; he 'came into his life like a flash of sunshine' (Helen M. Knowlton). Millet, as Mahonri Sharp Young has well said[6] became Hunt's *guru*. His art was a revelation to Hunt, who stated:

When I came to know Millet I took broader views of humanity, of the world, of life. If he painted a hay-stack it suggested life, animal as well as vegetable, and the life of man. His fields were fields in which men and animals worked; where both laid down their lives; where the bones of the animals were ground up to nourish the soil, and the endless turning of the wheel of existence went on.

He was the greatest man in Europe. I give you his poetical side; but he was immense, tremendous—so great that very few could get near him. He read only such things as would help him; knew Shakespeare and Homer by heart; and was like Abraham Lincoln in caring only for a few books. He loved Hamlet; and I once found him laughing over the *Clouds* of Aristophanes. It was splendid to hear him read the Bible.[7]

This passage supplies various clues as to the reasons which prompted so many Bostonians to admire Millet and to consider him as the greatest modern painter. In the first instance, he was an artist who seemed to celebrate the simple life—and thus to correspond to the puritan ideal of the world; he represented those virtues which Olive Chancellor saw in dear sweet Miss Birdseye: 'the heroic age of New England life—the age of plain thinking, of pure ideals and earnest effort, of moral passion and noble experiment'. Then, too, his realism (as that of Courbet) corresponded to that strain in the modern French novel which W. D. Howells and James were to discuss and which became familiar in Boston owing to the various essays published in *The Atlantic Monthly*. Howells became sub-editor of this important review in 1866 and its editor in July 1871; he resigned in 1881.

Hunt's enthusiasm had a practical side to it; he not only bought pictures from Millet, but persuaded such influential Bostonians as Martin Brimmer, the future President of the Museum of Fine Arts, to acquire his works, including *The Harvesters reaping (Ruth and Boaz)*, which was shown in the Salon of 1853. Brimmer, who had excellent taste, also bought a still life by Chardin. Hunt knew many painters and his work was admired by no less a person than Delacroix, who invited him to his studio. Diaz considered him the cleverest person he had ever met. Hunt was a particular champion of Barye, who found other American supporters in George A. Lucas and W. T. Walters.[8]

In 1855 Hunt returned to America, spending some time at Newport, where he had the distinction of teaching art to William and Henry James, Thomas Sergeant Perry and John La Farge and of introducing them to the novels of Balzac. His opportunities to do more for his favourite painters were furthered by his marriage in 1855 to Louisa Dumeresq Perkins of Boston, and 'he entered at once into the charmed circles of what was considered the best society of the city'. He moved to Boston in 1862, taking a studio first in the Highland Hall Building, on the corner of Walnut Avenue and Warren Street, Roxbury (where he painted portraits of Martin Brimmer and Mrs. Brimmer), and in 1864 he arranged a large studio in the old Mercantile Building in Summer Street. He set himself up as a painter-prince in the contemporary fashion and his biographer, Helen M. Knowlton (who was also a pupil), declares:

Early in the spring he gave his first reception in Boston, and it is said to have been as brilliant as it was original. The walls of the great room were covered with paintings by him and Jean François Millet. Other receptions followed, in which were introduced tableaux and impromptu acting in which the host took part, to the delight of all whom he had assembled around him.[9]

In her valuable book Helen Knowlton observes, with some shrewdness, that Hunt's social life may have impaired his artistic development; he had no one to look up to as a superior—no figure who would spur him on. So, as she writes, 'like all noble souls, he found consolation in helping those who needed encouragement and assistance'. He was eager to proselytize, for, to quote his words, 'There are a good many people in Boston who would like to do something for art, but the trouble is to agree to what is good art. Now, it is our duty to teach

3. *Thomas Gold Appleton* (1812–84), **photograph** by F. Gutekunst. He was the first collector of contemporary French art in Boston

6. *Self-portrait* by William Morris Hunt (1824–79), 1879. Oil on canvas, 51 × 43·5 cm. Gift of Mrs. Richard M. Saltonstall, 1920

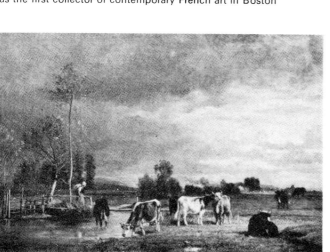

4. *Landscape near Dieppe* by Constant Troyon (1810–65). Oil on canvas, 52·5 × 82 cm. Bequest of Thomas Gold Appleton, 1884

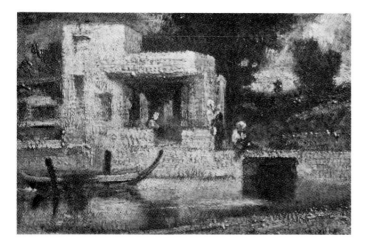

them and not to allow them to tell us what is good in art'. His teaching classes were celebrated and on the instigation of Lowes Dickinson, an English painter then visiting Boston and the father of the writer, his precepts were surreptitiously taken down by Miss Knowles and published as *Talks on Art*. This pithy volume was also issued in London. He had become a *guru* himself; however his later years, when things went wrong, were sad, and he is thought to have taken his own life.

Yet in the 1860s he was a magnet for the young men who were back from Paris—Cole, Thomas Robinson and A. H. Bicknell, for instance. These artists, as well as colleagues such as Mark Fisher, who later worked in England, winning praise from George Moore, W. Allen Gay, Frank Hill Smith and Virgil Williams, came together to found an artists' club—the Allston Club.

It was this body which made the immense effort of buying[10] Courbet's *La Curée* (Fig 8) in the spring of 1866. The picture had been brought over from Paris by Cadart the dealer and was on view at his premises in Bromfield Street. There it was seen by Bicknell, who was determined that the Club should acquire it; the price was 5,000 dollars. Cadart gave him a three-day option and with the aid of Robinson, who himself was a disciple of Courbet, and later worked with S. M. Vose, a Boston dealer, and with contributions for their fellow artists, the sum was raised. During part of May and June the picture was shown at the Club and a banner eight by six feet in

5. *A Turkish Café* by N. Diaz de la Peña (1808–76). Oil on cardboard, 14 × 22 cm. Bequest of Thomas Gold Appleton, 1884. This painting was exhibited at the Boston Athenaeum in 1858

7. *The Sower* by Jean-François Millet (1814–75), *c.* 1850. Oil on canvas, 101 × 82·5 cm. Gift of Quincy Adams Shaw, Jr., and Marian Shaw Haughton, 1917. This painting was previously owned by William Morris Hunt, who had seen it in the Salon of 1852 and who became an intimate friend of the artist

dimensions swung from a window at the Studio Building with the words:

> Allston Club
> on exhibition
> Courbet's great painting
> La Curée.

Although the critics were hostile to this startling example of realism, the francophile painters were exultant. It was an immense triumph to have bought, and have hanging, such a masterpiece of modern art. When Bicknell told Hunt that it was worthy of Veronese, Hunt is said to have answered: 'I will go further than that. In painting, he never surpassed it'. After the Club closed down a year or so later—art clubs did not flourish as well as literary ones in Boston—the picture was acquired by Henry Sayles. After being on view at the Athenaeum for some time, it was transferred to the Museum in 1877 and entered the permanent collection in 1918.

The daring of the Club's purchase deserves emphasis, for at that time Courbet had few admirers in France. Out of gratitude he sent several lithographic reproductions of the picture to the Club through the good offices of Cadart. According to Armand Gautier, he declared

on receiving the money for the picture, which was presumably on commission, 'What care I for honours when the art students of a new and great country know and appreciate and buy my works'. This was not the only major work by him to be seen in Boston at that time. Thomas Wigglesworth at some date in the 1860s acquired *Les Demoiselles de village* (The Metropolitan Museum of Art, New York), which had been purchased secretly by the duc de Morny before the opening of the 1852 Salon.

By 1875 Appleton, who had a finger on the public pulse, had every reason to declare: 'As our physicians gave up the training of England for that of Paris, so a kind of distaste even of English methods of art, and the keenest enjoyment of that of the best French school, has of late come about'.[11] No doubt, many of the painters who had their studios in Tremont Street were jealous that so much support went to their foreign colleagues, and controversy broke out over an exhibition of French painting at the Athenaeum.[12] Nevertheless, the French School exerted a decided influence on the local men, and it would be an interesting exercise to decide in what way this operated at the time. John La Farge, who was in a

8. *La Curée* by Gustave Courbet (1819–77). Oil on canvas, 210·8 × 180·3 cm. Henry Lillie Pierce Fund, 1918. This painting was exhibited in the Salon of 1857 and was purchased for the Allston Club, in 1866, by a group of its members, who were all painters

position to judge, suggested that before crossing over to Europe Winslow Homer knew French works not only from reproductions but from originals, especially Millets; he even went so far as to maintain that 'The foundation then in great part of such an independent talent —I may say more than talent of such a genius as Mr. Winslow Homer's—refers back then to this school and to the teachings, the inevitable teachings, even from studying them in translations'.[13]

Another leading artist, George Inness, was surely affected by the French pictures available in Boston. In 1859 he settled in Medfield, some twenty miles south-west of the city, and his tender landscapes show affinities with those of the Barbizon masters. However, the Boston dealers Williams and Everett felt that his work would benefit from exposure to European art and sent him across to Europe in 1870. His later paintings reveal what E. P. Richardson has termed 'a Tennysonian trance-like idealism in which the note of reality, like the echo of calling, grew ever fainter',[14] and they reflected the change in mood that was to occur in Boston in the latter part of the century.

Inevitably, the Museum benefited from this wave of interest in French art. One of the chief patrons was Quincy Adams Shaw (1823-1908), who was a friend and relative of Parkman, the historian, with whom he made a trip out West.[15] He undertook the Boston patrician's customary Grand Tour, visiting Egypt and Palestine in 1849-50 with George William Curtis, who later married his niece, Anna Shaw. Then he set off for Paris, remaining in the city for seven or eight years. Through his sister, Mrs. William Batchelder Greene, he became an habitué of the celebrated salon of Madame Mohl, which was frequented by the literary, artistic and scientific society of Paris. One of his intimate friends was Hunt, through whom he met various artists; however, he did not come across Millet at this period.

Although Shaw had heard about this artist from Hunt, he was only to meet him when he and his wife, Pauline Agassiz, the daughter of the scientist, whom he married in 1860, went to Europe to see his sister. At her house they encountered William James Stillman, the journalist and one time Pre-Raphaelite, who effected an introduction to Millet. Shaw bought a few French pictures, possibly the fine Corot *Dante and Virgil entering Inferno* (Fig. 11)—just the subject for a Bostonian—which he

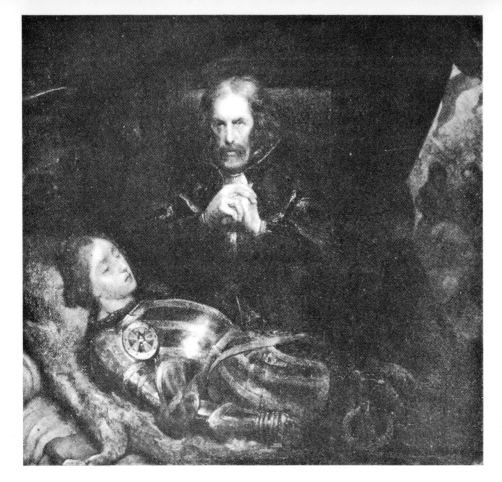

9. *Eberhard, Count of Württemberg mourning over the body of his Son* by Ary Scheffer (1795–1858). Oil on canvas, 155×165 cm. Deposited by the Boston Athenaeum, 1876

10. *The Entombment* by Eugène Delacroix (1798–1863), 1848. Oil on canvas, 161×130·5 cm. Gift by contribution in memory of Martin Brimmer, 1896

11. *Dante and Virgil entering Inferno* by Jean Baptiste Corot (1796–1875), 1859. Oil on canvas, 258×168·5 cm. Gift of Quincy Adams Shaw, 1875

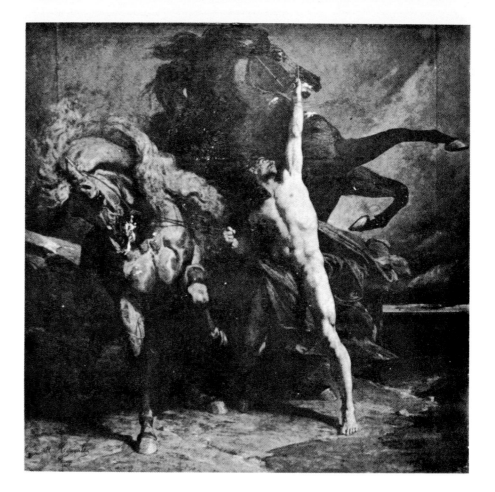

12. *Automedon with the Horses of Achilles* by Alexandre Regnault (1843–71), 1868. Oil on canvas, 3·15×3·29 m. Gift by subscription, 1890. This picture was painted in Rome

presented to the Museum in 1877, but he did not acquire any work by Millet at this time. He only started to do so in the 1870s when he was once again in Paris, and even then he was sufficiently strong-minded to turn down *L'Angélus* which he had had in his apartment on approval. It was on this trip that he and his wife went out to Barbizon to see the painter, and, in a letter to Alfred Sensier, Millet reported that he had agreed to paint for them *The Priory at Vauville*. This was the subject they had selected 'from among the drawings they saw here'. It is a valuable comment on the artist's methods of work that he painted a picture on demand in this way. In 1874 Shaw purchased five works by the master from Hunt. These were in this painter's house and not in his studio, which was destroyed with all its contents in the terrible fire of 1872.

In the span of twenty years Shaw built up a collection totalling twenty-six oils, twenty-seven pastels, two etchings and one etching washed with colour. His pastels were acquired by him from Emile Gavet,[16] who had bought them direct from the artist. It was hardly surprising that when Wilhelm von Bode, the famous director of the Kaiser Friedrich Museum, visited Shaw's house at Jamaica Pond (built in 1862) he should have become convinced 'of the commanding superiority of this master over all the painters of our modern times'. He was equally impressed by the quality of the collection of Italian sculpture which was also to be seen there, as well he might have been, for it included Donatello's *Madonna in the Clouds* and Luca della Robbia's *The Madonna of the Niche*.

Shaw's blending of a taste for Italian sculpture (his group was acquired in Italy[17]) with a love of Millet was not altogether surprising, for one of the appeals of the painter's art, in the eyes of many of his contemporaries, was its plastic quality. The particular aspect of his pictures which struck such a sensitive and refined contemporary admirer as John La Farge was their reflection of the idealism which Millet disengaged from his realistic observation of life and Nature. For La Farge, his paintings did not represent *a* sower, *a* reaper, *a* gleaner, but *the* sower, *the* reaper, *the* gleaner. 'In that', he went on, 'he resembles the Greek masters, who have expressed themselves under the form of sculpture, let us say, and who have given us great types which may or may not be portraits, but which have fixed the expression of certain human conditions in such a way that we unconsciously think of them as the definition of things.'[18] Millet, who was the supreme realist for some, could also appear to others as the master of idealism and as such expressive of one strong and consistent tendency in Bostonian thought.

In sketching the evolution of taste for French art in Boston, it is as well to recall the decided francophile touch in some of the buildings that were being put up from the 1840s onwards. Deacon House, built in 1848, is the most famous example, and this sheltered some superb examples of the French decorative arts which had been gathered by Edward Preble Deacon. This intriguing fellow, 'without visible property' when he came to Boston, could figure in a novel by James. He was yet another American who flowered in the generous atmosphere of Paris. He was there in the '40s and it would be interesting to know if he met William Morris Hunt, who, like himself, made an advantageous Boston match.

Nineteenth-century Paris was an attractive place, despite the infernal noise that must have been created by Baron Haussmann's urban alterations, and understandably the Second Empire style caught on in Boston. In his

13

14

15

13. Thomas Sargeant Perry (1845–1928) and Claude Monet (1840–1926). This photograph was taken at Giverny

14. *Ravine of the Creuse* by Claude Monet (1840–1926), 1889. Oil on canvas, 65 × 79 cm. Gift of Denman Waldo Ross, 1906. This was the first Monet painting to enter the Museum

15. *Race Horses* by Edgar Degas (1834–1917), *c.* 1873. Oil on canvas, 30·5 × 40 cm. Purchased S. A. Denio Collection, 1903

charming description of Boston's topographical history, Mr. Whitehill[19] has drawn attention to the Commodore Hotel in Washington Street, the St. James Hotel in Newton Street, facing Franklin Square, and the City Hall (1862), which was modelled by Bryant and Arthur Gilman on the Tuileries and the Louvre. The Bostonian with longings for Paris would have found much to remind him of that city and to tempt him to board the next ship for Europe. For instance, after the burning of the Tuileries during the post-Commune riots of 1871, the iron balconies from this palace were salvaged and installed at 32 Hereford Street, on the corner of Commonwealth Avenue.

The situation would not be seen in proportion if it

were thought that only Millet and the Barbizon painters were admired in Boston; Ary Scheffer (Fig. 9) and Gérôme, of course, had their partisans and Delacroix was so esteemed that one of his most fervent religious paintings, *The Entombment* (Fig 10), which James hoped[20] would find a home in America, was given to the Museum in memory of Brimmer in 1896. Some collectors favoured the School of The Hague and Fortuny—one of his pictures could be found in Howells's study—and the English; Turner's *The Slave Ship* caused a stir when exhibited in 1876 and Norton championed the Pre-Raphaelites. Yet the taste for the Barbizon masters persisted for a long time, but it can be seen from James's unsigned review[21]

of an exhibition of French pictures held in 1872 at Doll and Richard's at 145 Tremont Street (a show which also contained a few American works) that a new mood was in the air. This article closed with a reference to a picture by Elihu Vedder, that remarkable artist who spent his closing years in Rome, where Roger Fry once met him. James said:

We must note, in conclusion, a small picture by Vedder—a little pictorial lyric, as we have heard it called, on the theme of faded stuffs. A young woman, dressed in a charming bedimmed old silken gown, stands before an antique escritoire in relief against a *passé* hanging of tapestry, opening a box of jewels. The tone of the picture is suffused by a hint of that elegant and melancholy hue which is known, we believe, by the name of ashes-of-roses. A certain flatness and semi-decorative monotony of touch is very discreetly apportioned, and operates as an additional charm.

The trend towards an idealistic decorative style in Boston corresponded to the emergence of a new spirit—that of cultivated eclecticism which had its apogee in the varied collections formed by Mrs. Jack Gardner and which was also implicit in the taste of Denman Waldo Ross or the broad range of the Harvard art historians. It was an artist of French extraction, John La Farge, who embodied this idealism in his painted decorations and stained glass for H. H. Richardson's Trinity Church, Copley Square, which was built in 1873-77. La Farge foreshadowed the *fin de siècle*. This Philadelphian, who became a 'naturalized' Bostonian, was the friend of James and Henry Adams, undertaking a famous voyage with the latter to the South Seas. He was a keen admirer of Delacroix and his volume of lectures about the Barbizon School entitled *The Higher Life in Art* attests to his perception as a critic.

Many Bostonian amateurs recognized that the world was moving in different directions—directions that did not necessarily appeal to them — and their nostalgia for the past helped to turn them away from modern art. There were still those who were able to follow the new trends; for instance, when Mary Cassatt exhibited *After the Bull Fight*, *The Music Lesson* and *At the Français* at the thirteenth exhibition of the Department of Fine Arts of the Massachusetts Charitable Mechanics Association in 1878, her father was able to tell Alex. Cassatt that they 'have received flattering notices from the papers particularly the *Transcript* and William [and Everett] the picture dealers have asked to have the agency for her pictures in Boston'.[22]

However, when Madame Emile Ambre, the opera singer, who had brought over Manet's *Execution of Maximilian* as a 'sort of extra attraction to her concert tour', showed this picture in Boston in November 1879, it had a poor reception. Nor was there any improvement when two Manets, three Monets, six Pissarros and three Renoirs were sent by Durand-Ruel to the foreign exhibition at the Mechanics Building, in Boston, in September 1883.

Interest in modern art, as in the modern movement generally, had shifted from Boston to New York and Chicago, and Howells's surrender of the editorship of *The Atlantic* in favour of *Scribner's* was an instance of this alteration in the intellectual climate.

16. *Street Singer* by Edouard Manet (1832–83), 1862. Oil on canvas, 175·2 × 108·5 cm. Bequest of Sarah Choate Sears, 1957. This painting was formerly owned by Mrs. J. Montgomery Sears

Yet there was one French painter who was to become all the rage in Boston—Claude Monet. He had all the ingredients that make for success; his output was prolific, his presence impressive and he lived within striking distance of Paris, at Giverny, so that it was easily possible to make an outing from the capital to see him. He had that touch of the prophet which can cast a spell and he soon gathered a little body of American devotees around him. One of these, Theodore Robinson from Vermont, wrote some interesting memoirs[23] about Monet, which recall the sort of accounts that had been devoted to Millet.

It was while they were in Germany that Thomas Sergeant Perry and his wife Lilla, the daughter of Dr. and Mrs. Samuel Lowell Cabot and herself a painter, heard about the artists' colony at Giverny and determined to go there. It is worth devoting a few words to Perry, for he was one of the most fascinating Bostonians of his period. On his mother's side he was a direct descendant of Thomas Jefferson. He moved in the best circles and was an intimate friend of William and Henry James and Howells and survived long enough to know Van Wyck Brooks. He was a curious person. In the early days he had been an energetic writer (though not a careful one) and published books on German and English eighteenth-century literature and Greek literature (1890) and an

17

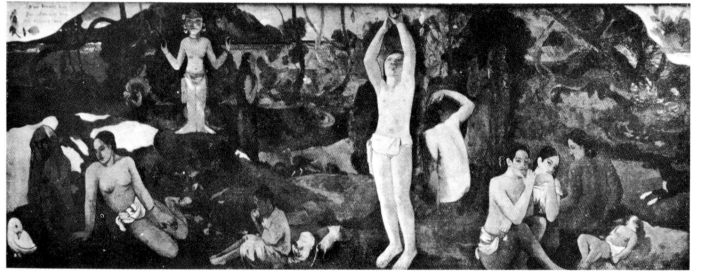

18

17. *A la Mie* by Henri de Toulouse-Lautrec (1864–1901), 1891. Water-colour and gouache on millboard, 53×68 cm. Purchased S. A. Denio Fund and General Income for 1940

18. *D'où venons-nous, que sommes-nous, où allons-nous?* by Paul Gauguin (1848–1903), 1897. Oil on canvas, 139×374·5 cm. Arthur Gordon Tompkins Residuary Fund, 1936

19. Opposite: *Le Bal à Bougival* by Pierre-Auguste Renoir (1841–1919), 1883. Oil on canvas, 179×98 cm. Purchased, Anna Mitchell Richards Fund and Contributions

entertaining small volume, *The Evolution of the Snob* (1877), and he reviewed a wide range of books for *The Atlantic* and other periodicals. Then he gave up publishing, though writing innumerable letters; he was content to become, to quote Edwin Arlington Robinson, 'one of the great appreciators, without whom there would be no great writers, or artists of any sort'. It was this gift which enabled him to perceive the qualities of Monet.

The Perrys arrived in Giverny in 1889 and, in an amusing account of the American Colony, Perry told Leonard Opdyke that 'the stream of American humour flows on unceasingly, & in the intervals of, or after, painting, the tennis racket is br'ot forth & the game is played'.[24] According to his wife she and her husband called on the artist in the company of a sculptor armed with a letter of introduction; however, her husband's recent biographer indicates that they went to see him in order to fulfil a request from Dr. William Pepper, who had married Perry's sister Fanny and was the Provost of the University of Pennsylvania, to buy a picture from him. Perry's

description of Monet, 'a jolly looking old cove', in a letter to Fay is worth quoting:

He is shortish, stocky, with a shortish black beard, the honestest eyes that ever gazed into & thru another man. He is as simple and direct as a man can be . . . He is as straightforward as a bullet from a Springfield rifle, & that is a pleasant sort of man to meet, especially in France! [25]

The picture which the Perrys acquired from the artist was a view of Etretat and, as Mrs. Perry wrote years later, 'Monet said he had to do something to the sky before delivering it as the clouds did not quite suit him, and, characteristically, to do this he must needs go down to Etretat, and wait for a day with as near as possible the same sky and atmosphere, so it was some little time before I could take possession of the picture'.[26] When she took it back with her to Boston in the autumn 'to my great astonishment, hardly anyone liked it, the one exception being John La Farge'. He was her brother-in-law. When Perry himself tried to publish an article about Monet in *Scribner's* his offer was 'respectfully but firmly declined';

as for Julius H. Ward, editor of the Boston *Herald,* he did not even bother to acknowledge the contribution. The Perrys became friends of Monet (Fig. 13), spending in all ten summers at Giverny; their last visit was in 1907.

News about this painter — and other French modern artists—must have filtered back to Boston in other ways, for, in this cosmopolitan era, Bostonians were frequently flitting across to Paris. Back home they could have heard about such painting from Edward Boit, who went to Paris in the 1870s and was a close friend of Sargent and a friend and admirer of Monet. Sargent himself came to Boston in 1887-88 in order to paint Mrs. Boit, her children having sat to him in Paris in 1882. Durand-Ruel, who paid nine visits to America between 1886 and 1888, undoubtedly did business in Boston; and it would be interesting to know how many Impressionist pictures were on consignment with the Boston dealers. It was a Bostonian by adoption, Desmond Fitzgerald, who wrote the preface about Monet's paintings for an exhibition of the work of this artist, Pissarro and Sisley held by Durand-Ruel at his New York gallery in 1891; the preface for Sisley was contributed by the painter Frederick P. Vinton and that for Pissarro was by an anonymous author.

Desmond Fitzgerald (1846-1926) was an unusual personality. The son of a British Army captain and of a mother connected with the Browns of Rhode Island, he was born in the Bahamas, but passed much of his early life in Providence. When he was twelve he spent a year in Paris studying to be a sculptor. But this ambition was unfulfilled and he returned to attend the Phillips Academy, Andover. Later he took up a position as deputy-secretary of Rhode Island and then as private secretary to General Burnside, the Governor of the State.

Fitzgerald did not remain an administrator for long. In 1870 he married Elizabeth Parker Clark Salisbury of Brookline and in 1871-73 he was chief engineer of the Boston and Albany Railroad. He swiftly became one of the leading hydraulic engineers in the country, publishing books on the subject and obviously making a fortune.

As soon as circumstances permitted, Fitzgerald started to collect and over the years he amassed a heterogeneous collection[27] of modern French and American pictures and Korean and Chinese pottery which was displayed in the gallery built in his house at Brookline (a suburb of Boston) in 1913. It seems that he was introduced to Monet's work by Mrs. Perry and eventually owned nine works by this painter, as well as two by Sisley, one by Degas and one by Renoir. He was not the only Boston collector to succumb to modern French art. One of the most perceptive was Mrs. J. Montgomery Sears, social leader and spiritualist, who bought wisely, largely on the advice of Mary Cassatt. Her purchases included Manet's *Street Singer* (Fig. 16), which she acquired from Durand-Ruel; this is now in the Museum.

Mary Cassatt herself came to Boston in 1895, staying at the Hotel Vendôme (still standing), painting the children of Mr. and Mrs. Gardiner Greene Hammond and spreading news about the 'little band of Independents', as she called the Impressionists. She was none too happy about the Museum, saying that she never met any one

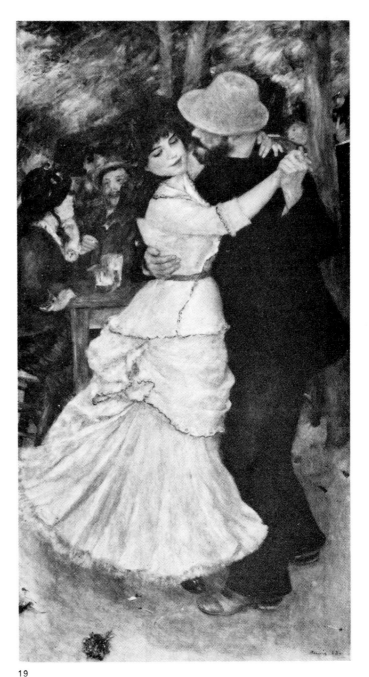

19

there and that 'the state the pictures are in is a disgrace to the Directors'.[28]

This talented artist was never identified with Boston in the way that Sargent was, for he became the chosen Society portraitist. In addition he was commissioned in 1890 to decorate the Boston Public Library, where Saint-Gaudens and Puvis de Chavannes were also employed. It would be outside the scope of this article to provide a detailed account of Sargent's work in Boston,[29] but mention deserves to be made of the decorations he painted for the rotunda and stairway of the Museum of Fine Arts. His first commission for the Museum came in 1916 and the second in 1921. It supplies a charming period touch to recall that three girls from the Ziegfeld Follies, who were then performing in Boston, posed as the models for the three Danaides in the lunette near the stairs.

Although the contribution of Boston's painters in the 1890s and 1900s does not, on the whole, compare with that of previous years, more activity went on than is often remembered today and an exhibition of the various

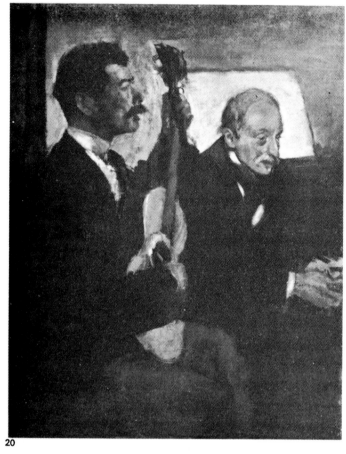

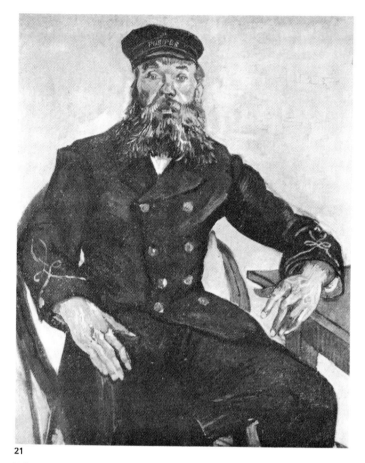

20

21

trends then existing might prove worthwhile. There were men such as Philip L. Hale, independent-minded art writer, as well as painter, who employed a watered-down Impressionism, and Dodge MacKnight. This artist, who had known Van Gogh and married a girl from Arles, lived at Cape Cod but became one of the circle—Isabella's Club—that centred on Mrs. Jack Gardner.[30] She bought a number of his slight water-colours and his exhibitions at Doll and Richard's were successful affairs. The group of aesthetes which included Denman Waldo Ross and Matthew Pritchard, who became secretary of the Museum and enjoyed something of a spree as temporary Director, well repays investigation, as does the taste of the musicians, among them Charles M. Loeffler, then living in Boston. Pritchard, who was English, was a fascinating character, a disciple of Bergson, an apostle of Byzantine art and a friend of Matisse, and if he had remained in Boston his influence might have made the city open to the new forces that were appearing in the art world.

Nevertheless, one painter, Maurice Prendergast, did grasp the implications and his work has the closest and most meaningful affinities with the French School. He is the American Nabi. Although it is possible that he visited Paris in 1886 (as Van Wyck Brooks stated), it was in 1891 that he spent some time in this city studying at the Académie Julian and becoming friends with the Canadian painter J. W. Morrice. He returned to America in 1894 and lived at Winchester, Massachusetts, until 1905; at some time between then and 1908 he moved to 56 Mount Vernon Street, Boston. Subsequently he settled in New York, where he died. He gave various shows in Boston and his work was admired by Mrs. J. Montgomery Sears, but, sad to relate, nothing was bought by the

Museum in his lifetime, despite the fact, as Mr. Perry T. Rathbone has pointed out, that 'in the historical development of modern art this lonely citizen of Boston has a significance which has yet to be recognized. He was the harbinger for America of the revolutionary course of painting in the twentieth century'.[31] His enchanting water-colours and oils not only evoke the pleasures and ease of the *fin de siècle* but contain the germs of future developments.

Despite the existence of a handful of lovers of modern art and of the French School in Boston in the years just before the first World War—Denman Waldo Ross, Mrs. Walter Scott Fitz, Alexander Cochrane and John Pickering Lyman all bought Impressionists—there was a resistance to the new movements. When the Foreign Section of the famous New York Armory show was exhibited at the Copley Society in 1913, it was a flop. As Milton W. Brown has remarked,[32] it did not provoke bitter hostility; it was cold-shouldered. In fact, only five very minor works were purchased, and the two buyers, Walter C. Arensberg and Thomas W. Bowers, were both out-of-town students at Harvard. For the record it should be remembered that two Boston collectors lent works by Cézanne to the show —Mrs. J. Montgomery Sears and Professor John C. Sumner.

Between the two wars, some Boston collectors maintained an interest in French art; Mrs. Juliana Cheney Edwards, for instance, acquired a number of splendid Impressionists, at the instigation of Desmond Fitzgerald.[33] The principal collector was John T. Spaulding, the son of a wealthy sugar merchant, who lived at 99 Beacon Street (now destroyed) and at his summer residence at Pride's Crossing on the north shore of Boston; he would

22

20. Opposite: *Degas père écoutant Pagans* by Edgar Degas, *c.* 1872. Oil on canvas 61 × 50 cm. Bequest of John T. Spaulding, 1948

21. Opposite: *The Postman Roulin* by Vincent van Gogh (1853–90), 1888. Oil on canvas, 81 × 65 cm. Gift of Robert Treat Paine, 2nd, 1935

22. *Rue Gauguet* by Nicolas de Staël (1914–55), 1949. Oil on panel, 199 × 240 cm. Arthur Gordon Tompkins Residuary Fund, 1957

travel between the two places in his yacht the *Isis*. Together with his brother William he formed a superb collection which contained such masterpieces as *Degas père écoutant Pagans* by Degas (Fig. 20); he also bought a strong contingent of the modern American School.

Although Robert Treat Paine, 2nd did not collect on such a grand scale as did Spaulding, he secured a number of undoubted masterpieces of French nineteenth-century painting, including Van Gogh's *The Postman Roulin* (Fig. 21) and Degas's *The Duke and Duchess of Morbilli* in which the aristocratic aloofness of the sitters seems to correspond with that of the Brahmins.

During the Depression of the 1930s the Museum was able to acquire the much loved *Le Bal à Bougival* (Fig. 19) by Renoir, chiefly through the intervention of two Trustees, Paul J. Sachs and W. G. Russell Allen, and Gauguin's no less famous *D'où venons-nous, que sommes-nous, où allons-nous* (Fig. 18). The second work was purchased from Marie Harriman in 1936 for 85,000 dollars. In 1940 the Museum astutely secured Toulouse-Lautrec's *A La Mie* (Fig. 17). The tradition of obtaining the significant picture when opportunities arose has been followed in recent years and, under the guidance of the present Director, Monet's early masterpiece, *La Japonaise,* Picasso's *Rape of the Sabines* and the superb *Rue Gauguet* (Fig. 22) by Nicolas de Staël have entered the Museum.

It is a feature of the Museum that its varied contents invariably reveal the impress of personal taste. This is no less true of the collection of modern French painting, ranging from the men of 1830 to those of our time, and by implication it is an activity that provides a fascinating sidelight into the social and spiritual history of Boston.

[1] Cf. Van Wyck Brooks, *New England: Indian Summer 1865–1915*, 1941, pp. 232–35.
[2] *Life and Letters of Thomas Gold Appleton*, ed. Susan Hale, 1885, p. 253.
[3] Hale, op. cit., p. 282.
[4] William Howe Downes, 'Boston Painters and Paintings I–VI' in *The Atlantic Monthly*, July–December 1888, p. 781, VI (December).
[5] 'Personal Recollections of Jean-François Millet' in *The Atlantic Monthly*, XXXVIII, September 1876, p. 257. Wheelwright went to Barbizon in 1855 with a letter of introduction from W. H. Hunt.
[6] 'William Morris Hunt: a proper Bostonian' in Apollo, LXXXIII, January 1966, pp. 24–29.
[7] Helen M. Knowlton, *The Art Life of William Morris Hunt*, 1899, p. 12.
[8] Cf. Editorial, 'Connoisseur's Haven', in Apollo, LXXXIV, December 1966, pp. 422–33.
[9] Knowlton, op. cit., p. 36.
[10] Downes, op. cit., IV (October), pp. 503–5.
[11] Quoted by Van Wyck Brooks, op. cit., p. 163.
[12] Cf. the interesting letter from W. H. Hunt to the *Boston Daily Advertiser* defending modern French art published in Knowlton, op. cit., pp. 68–69.
[13] *The Higher Life in Art*, 1908, p. 172.
[14] *Painting in America*, 1956, p. 305.
[15] These details are derived from the introduction to the catalogue of the Quincy Adams Shaw Bequest issued by the Boston Museum of Fine Arts, 1918.
[16] Cf. 'Mémoires de Paul Durand-Ruel' in *Les Archives de l'Impressionisme*, ed. L. Venturi, 1939, II, p. 203.
[17] It would be interesting to know if Shaw was guided or influenced by C. C. Perkins in his love of Italian sculpture.
[18] *The Higher Life in Art*, p. 88.
[19] *Boston: A Topographical History*, 1959.
[20] 'Two Pictures by Delacroix' in the *New York Tribune*, 19 February, 1876, reprinted in *The Painter's Eye*, ed. John L. Sweeney, p. 113.
[21] 'French Pictures in Boston' in *The Atlantic Monthly*, January 1872, reprinted in *The Painter's Eye*, 1956, p. 49.
[22] Cited by Frederick A. Sweet, *Miss Mary Cassatt Impressionist from Pennsylvania*, 1966, p. 47.
[23] Cf. Francis Lewison, 'Theodore Robinson and Claude Monet' in Apollo, LXXVIII, September 1963, pp. 208–11.
[24] Virginia Harlow, *Thomas Sergeant Perry: A Biography*, 1950, p. 110. This enjoyable book contains a group of letters to Perry from William, Henry and Garth James. For further information on Mrs. Perry, see Stuart P. Feld's useful introduction to the catalogue of the Lilla Cabot Perry exhibition, Hirschl and Adler Gallery, New York, 1969.
[25] Op. cit., p. 111.
[26] 'Reminiscences of Claude Monet from 1890 to 1909' in *American Magazine of Art*, XVIII, March 1927, pp. 119–25.
[27] His collection was sold at the American Art Association, New York, in 1927. The American paintings were sold on 19–20 April and the Impressionist one on 21–22 April.
[28] Quoted by Sweet, op. cit., p. 151.
[29] Cf. David McKibbin, *Sargent's Boston*, catalogue of an exhibition held at the Museum of Fine Arts, Boston, 1956.
[30] Cf. Louise Hall Tharp, *Mrs. Jack*, 1965, pp. 258–60.
[31] In foreword to Hedley Howell Rhys's *Maurice Prendergast 1859–1924*, catalogue of an exhibition held at the Museum of Fine Arts, Boston, 1960, p. 13.
[32] *The Story of the Armory Show*, 1963, pp. 184–89.
[33] W. G. Constable, *Art Collecting in the United States of America*, 1964, p. 80.

Munich: City of the Arts

A city which hums with activity but which retains a strong touch of the past is a rare find, for now too many cities, even famous ones, are moving towards destruction, their skylines ruined by ungainly skyscrapers and their centres crushed by ugly commercial office blocks, sad symbols of our materialist society. Munich is an exception. Despite the damage received during the 1939 War, much of which has been put right, and a few unfortunate innovations, the city has allure. The centre preserves its identity. It is possible to walk down the Maximilianstrasse and the Briennerstrasse or look at Karolinenplatz or Odeonsplatz

without feeling too much of a ghost, even though, understandably, the purist will experience something of a shock on discovering a strip-tease joint close to the Hotel Marienbad, where Jacob Burckhardt, Rainer Maria Rilke and Hugo von Hofmannstahl stayed. On the other hand, lovers of continuity—more of whom exist than is often believed—may well be pleased to find that the trams are painted in the same colour, blue, as when Thomas Mann described them in his novel *Doktor Faustus*.

Only a short time ago the 'historicist' and eclectic character of much of Munich's nineteenth-century

2

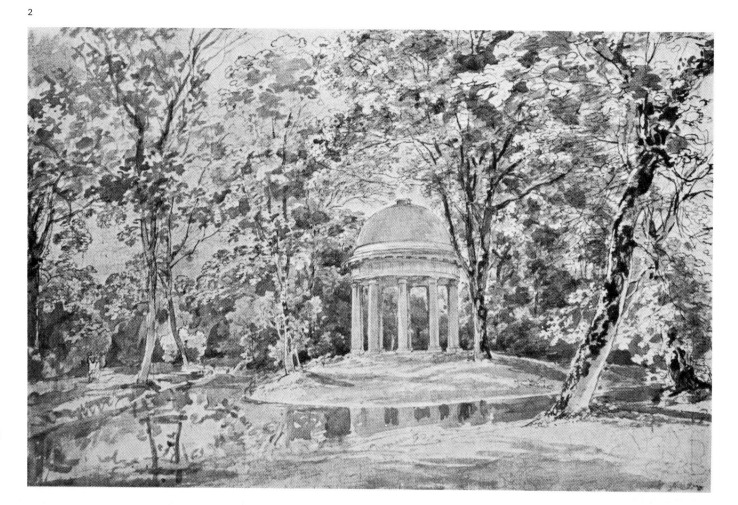

1. Opposite: Detail from the *Bacchus Frieze* by Ludwig Schwanthaler (1802–48), 1828–29. Formerly in the Palace of Duke Maximilian, now in the Landeszentral Bank. The whole frieze represents the birth of Bacchus and continues up to his wedding on Naxos

2. Opposite: *The Temple of Apollo in the Englische Garten* by Johann Georg von Dillis (1759–1841), c. 1810. Pencil, pen and watercolour, 27×41·4 cm. Collection Dr. Alfred Winterstein, Munich

3. *Crown Prince Ludwig of Bavaria in the Spanish osteria in Rome* by Franz Ludwig Catel (1778–1856), 1824. Oil on canvas, 63×73 cm. Neue Pinakothek. Thorvaldsen is also represented in the painting

4. *The Hall of the Gods in the Glyptothek* by Peter Cornelius (1824–74). The room has been destroyed

5. *The Saal des Verrates in the Residenz* by Julius Schnorr von Carolsfeld (1794–1872), 1845. The fresco shows Hagen slaying Siegfried

3

architecture aroused derision. Now these essays in the Byzantine, Gothic, Florentine Renaissance and Baroque styles have a period flavour—one of patrician high hopes —that gives them charm. We realize that they came into being as the result of a forward-looking desire to give the city an artistic character, to make it, in fact, an aesthete's paradise. For many visitors in the past century, however, Munich was praised, paradoxically enough, for its modernity. One who felt this way was Edward Wilberforce, the shrewd and witty author of an amusing volume, *Social Life in Munich* (1862). It is a book that might well be translated into German, for it provides such a judicious picture of life there; among other things, the author observed that the city was exceedingly cheap, but bewailed the lack of good servants. He also emphasized that Munich was known as a haunt of artists; some thousand in fact. Among them, by the way, was Oswald Sickert; his son Walter Richard was born there. Wilberforce's book stresses that Munich was already appreciated not only as an artistic centre but as a pleasure spot, with its concerts and operas and its festivals culminating in the great October beer festival which was started by

4

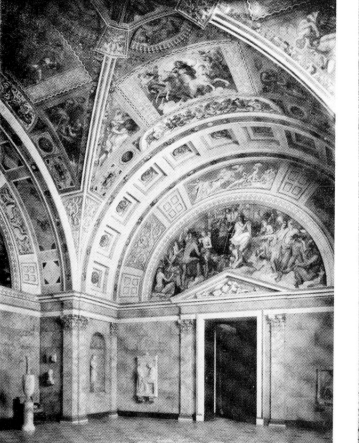

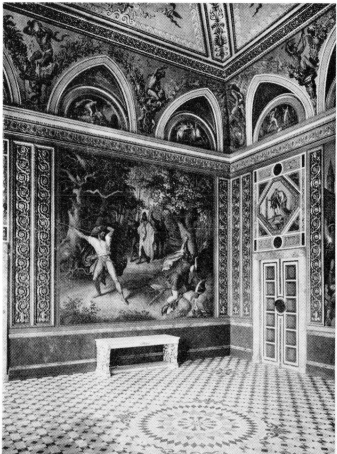

7

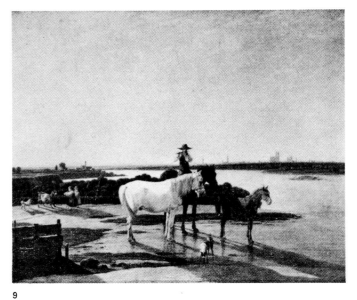

9

8

Ludwig I. Later it was renowned for its *Künstlerkneipen* that turned Schwabing into a German equivalent of Montmartre or Montparnasse in the palmy days.

Munich kept this character up to the First World War. In a speech delivered in 1926 at the Tonhalle in Munich, Thomas Mann, who spent much of his life in the city, observed that, before 1914, Munich was renowned for its individualism and that the contrast with Berlin was considerable. In Munich, he said, 'One was artistic, there politically conscious and economic-minded. Here one

was democratic, there feudal and military. Here one enjoyed a joyful humanity, while in the sharper atmosphere of the metropolis of the North a certain hostility to mankind was not lacking'. Naturally, like all such generalizations, this has to be qualified, but there is much in Mann's words. It was significant of the liberal atmosphere that reigned in Munich that when Hugo von Tschudi, Director of the Nationalgalerie in Berlin, fell out with the Kaiser and Bode over policy—he was a supporter of El Greco and modern art—he found refuge in Munich, where in 1907 he was appointed Director of the State galleries and his enlightened acquisitions included Matisse's famous *Still Life*.

During the nineteenth century and until 1918 the monarchy was a direct patron of the arts in Munich. The glamorous and eccentric figure of Ludwig II whose life and character have attracted recent attention—with his love of opera and his fantastic Bavarian castles, has tended to take the limelight off the artistic taste of his immediate predecessors and successors. But a stroll round the city shows how much Munich owes to their enterprise; for instance, the foundation of the Alte Pinakothek, one of the great European treasure-houses, was due to the initiative of Maximilian I and the Nationalmuseum, to which we devoted a special number in December 1970, was the outcome of the patriotism of Maximilian II and his advisers.

Munich underwent considerable expansion at the turn of the century especially after the establishment of the Kingdom in 1808. By 1789 the beautiful and romantic

10. *Ludwig I* by Wilhelm von Kaulbach (1805–74), 1845. Oil on canvas, 3·37×2·5 m. Neue Pinakothek

11. *Adolf Friedrich Graf von Schack* by Franz von Lenbach (1836–1940), 1870. Oil on panel, 95×72·2 cm. Schack-Galerie

Englische Garten (Fig. 2) had been laid out by the eccentric Benjamin Thompson, the self-styled Count Rumford, who had such an extraordinary career. Born in 1753, he served as a major in the British Army in America and became Secretary of State for American Affairs; later on he was Minister of War and Police in Bavaria. His range of interests was wide, for he experimented in physics and designed what is more or less the present-day heating system; he was a champion of social reform and started soup kitchens for the poor. He died in 1814. The city soon became a monument to the neo-classical style with such buildings as Karl von Fischer's fine National Theatre, Leo von Klenze's Glyptothek and Propyläen, Thorvaldsen's monument to Eugène Beauharnais (Duke of Leuchtenberg) in St. Michael's church and the sculpture of Ludwig Schwanthaler. One of this artist's most attractive pieces was the *Bacchus Frieze* of 1828-29, formerly in the Palace of Duke Maximilian (destroyed) and now in the Landeszentral Bank (Fig. 1). There was much else besides.

Much support for the arts came from Ludwig I. He was especially perceptive in his youth when he was Crown Prince and before he was besotted by Lola Montez. Like many of his generation, he was enamoured of Italy and went there on several occasions. One delightful memento of his visits to Rome is Catel's painting of 1824 (Fig. 3) in the Neue Pinakothek, which shows him in the Spanish *osteria* with such companions as Thorvaldsen (whose patron he was), Julius Schnorr von Carolsfeld and the artist himself.

One of Ludwig's most valuable achievements was the formation of a collection of Classical antiquities, which contained not only such pieces as the *Barberini Muse*, much admired by Winckelmann, and the *Medusa Rondanini* but early work from the Archaic period, which then enjoyed limited appeal. He managed to secure in 1812 the splendid sculptures from a Temple of Minerva on the island of Aegina, just before an offer was made for them by the British Government, and the Apollo of Tenea. These works were housed in the Glyptothek, for which the Nazarene Peter Cornelius was commissioned to paint decorations. Against such a background, it is hardly surprising that a taste for the Antique forms a *leit-motif* in Munich's cultural life; it helps to explain the love of German Romanist painting manifested by Count Schack, the Classical pieces bought by Lenbach for his villa and the 'Attic' style of the Villa Stuck, to which an article is devoted in this issue.

Modern art was not neglected in Munich. In 1808 the Akademie der bildenden Künste was founded with the philosopher Schelling as its general secretary and in 1824 the Kunstverein came into being. As Norbert Lieb points out in the revised and expanded edition of his excellent *München. Die Geschichte seiner Kunst* (Callway, 1971), this latter organization had 272 members at the start but by 1842 or so there were no fewer than 3,000. The exhibitions were seen not only by the King and the aristocracy but by the middle class, which took an increasing interest in the arts.

The dawn of a golden age seemed to be at hand when

175

12. *Seni at the body of Wallenstein* by **Karl Theodor von Piloty** (1826–86), 1855. Oil on canvas, 3·12 × 3·65 m. Neue Pinakothek

14. *Der arme Poet* by **Carl Spitzweg** (1808–85), 1839. Oil on canvas, 36 × 44 cm. Neue Pinakothek

13. *Rübezahl* by **Moritz von Schwind** (1804–71), 1851-59. Oil on canvas, 64·4 × 39·9 cm. Schack-Galerie

15. *Blüte der Kunst in München* by **Eugen Napoleon Neureuther** (1806–82), 1861. Oil on cardboard laid on canvas, 75·4 × 102 cm. Schack-Galerie

16. Opposite: *Frau Gedon* by William Leibl (1844–1900), 1867–68. Oil on canvas, 119·5 × 95·7 cm. Neue Pinakothek

17. Opposite: *Still life with a pewter tankard* by Charles Schuch (1846–1903), c. 1876. Oil on canvas, 69·3 × 92·2 cm. Neue Pinakothek

18. Opposite: *Double-portrait of Marées and Lenbach* by Hans von Marées (1837–87), 1863. Oil on canvas, 54·3 × 62 cm. Neue Pinakothek

Peter Cornelius was brought to Munich by the King in 1819; for a time his services were shared by the Art Academy in Düsseldorf, to the directorship of which he had been appointed by the Prussian Government. His first task in Munich was the decoration of the Glyptothek with a scheme relating the interaction of the gods and mankind (Fig. 4); the acceptance by an artist who was a 'Brother of St. Luke' of a commission to illustrate a Classical theme not unnaturally disappointed his friends in Rome. Cornelius was increasingly interested in moral questions and, as Keith Andrews observed in his important book *The Nazarenes* (published in 1964), his

pronounced stress on didactic as against purely artistic values became even more apparent in his next great work for Ludwig, who had succeeded to the throne in 1825. In the newly built Ludwigskirche in the centre of Munich Cornelius envisaged a veritable epic of the Christian religion in a grandiose decorative scheme which was to fill the whole of the Church.

The King, spurred on by Leo von Klenze and Friedrich von Gärtner, did not take to the frescoes and in 1840 a break occurred between monarch and painter. Mr. Andrews notes: 'In a savage drawing (Copenhagen, Glyptotek), depicting the King as the Devil, correct with all the traditional attributes, Cornelius gave vent to his feelings'. It was a foreshadowing of Whistler's famous

caricature of Leyland after the fiasco of the Peacock Room.

Cornelius's departure from Munich for Berlin did not mean that 'the father of German art', as he was termed, failed to retain a hold on the affection of the Munichers. This is clear from Wilberforce's attractive account of the master's return to the city to attend a celebration held in his honour in the West End Halle, one of the largest beer and dancing saloons in Munich. After the seventy-year-old painter and his young Italian wife had retired, jollification ensued. Wilberforce himself did not care for Cornelius's style: 'It is', he said, 'merely as a duty that the student of art goes to look on Cornelius; no charm attends the study, no pleasure is derived from it'. He was no less critical about Wilhelm von Kaulbach, in his opinion a draughtsman rather than a colourist. However, he appreciated this artist's drawings for *Reineke Fuchs,* which won quite a reputation in England during Victorian times. Wilberforce observed perceptively: 'It is a question if King Ludwig's patronage did Kaulbach more harm than the teaching of Cornelius, and yet it is a question what he might have done without his patron and his teacher'. It is to Kaulbach that we owe an excellent portrait of the King in later years (Fig. 10).

A modern study of Ludwig I as a patron and connoisseur would make interesting reading. The story of the King's relations with Schnorr von Carolsfeld is a case in point. The King had originally commissioned this Nazarene to paint for the Glyptothek a series of frescoes based on the *Odyssey* and in preparation for this congenial task the painter visited Sicily. However, as Keith Andrews points out, 'before he had time even to begin his preliminary studies, the King—by now wedded to the propagation of a more narrowly nationalistic art —dropped the plan in favour of a representation of the *Nibelungen Saga'.* These were created to decorate the Königsbau, the new wing to the Residenz, which was designed by Klenze in imitation of the Palazzo Pitti. The story of the tribulations which attended the execution of these decorations (Fig. 5) is painful; they were started in 1827 when the artist arrived in Munich and took forty years to complete. The poor painter was in a sense trapped, for not only had he to work on this series but he had to decorate the State rooms with scenes from German history, depicting Charlemagne, Barbarossa and Rudolf of Habsburg. When he was offered the directorship of the Academy at Dresden, the King made no attempt to keep him in Munich. 'With his departure', to quote Mr. Andrews again, 'Schnorr's career as a fresco-painter ended, and Cornelius's dream of the dynamic impact of large-scale mural paintings ended too.'

Talented landscape painters also emerged in Munich in the early years of the century. One was William von Kobell, who followed the Dutch tradition (Fig. 9), and rightly Goethe related him to Karel Du Jardin and Wouvermans. One of the most enchanting of the *petits maîtres* to go in for landscape was Johann Georg von Dillis (Fig. 2), a fine connoisseur of Old Masters, who painted three beautiful studies of Rome (now in the Schack Galerie). These pictures, which have affinities with the painting of Corot and Købke, were done when he

16

17

18

19

20

accompanied the Crown Prince Ludwig, Count Seinsheim, Baron von Sceberras Testa Ferrata and Johann Nepomuk Ringseis to Rome, Naples and Sicily in 1817-18. The extent to which landscape was admired as a separate genre in Munich is stressed by the fact that a professorship of landscape painting was established at the Akademie, a post which Dillis held from 1808 to 1814; interestingly, it was combined with that of the Curatorship of the Royal Collection of drawings.

The decided love of Italy shown in early-nineteenth-century Munich found a reflection in the series of Italian views painted in 1830–37 by Karl Rottmann (Fig. 7) for the north wing of the west arcade of the Hofgarten. They are now in the Residenz. These fascinating and lyrical pictures were complemented by verses composed by the King and placed on the walls; they are among the most impressive examples of classical landscape of the nineteenth century. They combine a reverence for the past with a love of Nature as a continuing feature of life; and their classical content is tempered by a romantic spirit. Rottmann, an artist who deserves to be better known, also painted some delightful views of the Bavarian mountains (Fig. 6) and had an apt pupil in Christian Morgenstern (Fig. 8).

The variety of painting in Munich in the years between about 1850 and 1870 was considerable. It can be conveniently assessed by a visit to the Schack-Galerie in Prinzregentenstrasse. There can be seen heroes of the day such as Moritz von Schwind (Fig. 13), the Schubertian Viennese master of late Biedermeier, whose *Die Morgenstunde,* painted at his home near Starnbergersee, is one of the prettiest offerings of Romanticism in its final phase. Another artist admirably displayed in this collection is Carl Spitzweg, an intriguing painter and draughtsman:

he was a contributor to the *Fliegende Blätter,* founded in 1845, which became one of the most famous papers of the day. His bitter-sweet mood is seen in *Ein Hypochonder* or *Einsiedler, Violine spielend*, and his famous painting *Der arme Poet* (Fig. 14), in the Neue Pinakothek, which was bought by public subscription when exhibited at the Kunstverein in 1839, is unlike anything else painted at the time.

Munich's art life was given a fillip by the emergence on the scene in 1854 of Adolf Friedrich Graf von Schack (Fig. 11), who came to the city at the invitation of Maximilian II. Schack, who was born in 1815 in Schwerin, had seen service as a diplomat. He was a man of many parts, a true dilettante in the best sense of the word, like Harry Graf Kessler. He was a fervent hispanophile, translated Spanish and Persian poetry and was a poet in his own right. He was a great globe-trotter and, above all, a discerning Maecenas whose collection, according to Alfred Lichtwark, has the character of a work of art. In short, he is a personality who would well merit an up-to-date biography.

Although there was some talk about his stinginess, his patronage helped many young artists. Among the painters he assisted was the Swiss Arnold Böcklin. This artist arrived in Munich in 1858 and his *Pan im Schilf* won praise when shown at the exhibition of the Künstlergesellschaft; he met Schack owing to an introduction from Paul Heyse, the writer. Another of the chief German painters of the period, Anselm Feuerbach, came to be known in Munich through Schack. Feuerbach had spent two years there in his youth in 1848-50, but Schack only came across his work in 1862, buying from him *Garten des Ariosto* and *Porträt einer Römerin* and commissioning him to paint a picture of the Madonna; his support

21

came at the most critical period in Feuerbach's life. The third of the major painters indebted to Schack was Hans von Marées, who lived in Munich from 1857 to 1865; the count acquired *Die Schwemme* when it was shown at the Kunstverein in 1864. Marées was one of the artists —Lenbach was another—whom Schack sent to Italy to paint copies after the Old Masters. Many of the pictures copied were by Cinquecento Venetians whose colouristic qualities may well have formed a welcome alternative to the predominantly linear style of the Nazarenes. The periods these painters spent in Munich were not of great significance for their artistic development; nevertheless it was during his time in the city that Marées painted the haunting portrait of himself and Lenbach (Fig. 18).

In the 1850s and 1860s Munich achieved a world-wide reputation as a centre for history painting. The chief exponent of this once popular genre was Karl Theodor von Piloty. He began as a pupil of Schnorr von Carolsfeld and was deeply influenced by an exhibition of Belgian painting held in Munich in 1842, thus affording another example of the status enjoyed by this School only twelve years after Belgium's emergence as a nation. He spent a period in Antwerp in 1852 and was particularly taken by the work of Louis Gaillat; he then went to Paris, where, naturally, Paul Delaroche appealed to him. He won great success with his *Seni at the body of Wallenstein* (Fig. 12) and became a professor at, and later director of, the Kunstakademie.

The determination of Munich's artists to champion contemporary trends was proved when in 1869 the first international art exhibition was held at the Glaspalast, a building modelled on the Crystal Palace. This large show was opened by Prince Adalbert of Bavaria and,

among other works, included items by Courbet, Corot, Manet, Millet and Daubigny. Courbet was the star of the affair and the seven pictures by him on view, which included *The Stone-Breakers,* had been selected by Edouard Schleich, 'the father of South German mood-painting'.

It was through this artist's good offices that Courbet and Corot were decorated with the Order of St. Michael (First Class). This distinction greatly pleased Courbet, who enjoyed his stay in Munich, where he painted copies after Hals, Rembrandt and Velázquez and drank in homage to young artists. Writing to the critic Castagnary, on 20 November, 1869, from Interlaken, he gave his impressions of the art situation in Germany, where in his opinion good painting was hardly known. German artists had all the negative qualities, and one of the principal artistic virtues for them, he wrote, was perspective, about which they talked all day long. However, he noted with satisfaction that Cornelius, Kaulbach and Schwind had had their day and '*Chenavard surtout, son tableau a été [l'objet] d'une risée générale; comme ils sont très forts dans ce genre-là ils ont retrouvé toutes les figures, tous les groupes pris dans les tableaux italiens'.*

Courbet understandably felt at ease in Munich, for one of his fellow exhibitors, William Leibl, broadly speaking shared similar aims to his own. The realistic element in Leibl's work was not due to the French masters, for his harmonious portrait of Frau Gedon (Fig. 16), painted before 1869, shows that he was already a master of direct painting and delicate tonal values. Later he knew Courbet well in Paris. His search for truth took a different direction from this artist's and he retired to the Bavarian countryside and painted pictures of peasant life which, if now somewhat frowned upon by fashion, have their own flavour. Leibl was by no means the only Munich master

22. *Die Tafelrunde Münchner Bürger in der Loge in Treue Fest* by Lovis Corinth (1858–1952), 1898–99. Oil on canvas, 1·13 × 1·62 m. Städtische Galerie im Lenbachhaus

22

to espouse Realism—others were Wilhelm Trübner, Charles Schuch, a Viennese keen on still life (Fig. 17), Hans Thoma and Louis Eysen—and the low-toned, if boldly treated, portraits, genre pictures and landscapes produced by these men have individuality, even if of a rather provincial sort. The influence of the Munich Realists may also be noted in the work of the American painter William Merritt Chase, who came to the city to study under Piloty, and Frank Duveneck, who studied under Wilhelm von Diez in 1870-73 and in 1875-77.

One of the paradoxes of the artistic situation in Munich is that, while the Realist current gained ascendancy during the years from around 1869 to 1880, another trend is discernible—the romantic and fantastic style associated with Ludwig II. In this connexion, however, as Dr. Fischer points out in his article in this issue, if the ideas held by the King and Gottfried Semper, his chief architect in the first part of his reign, had been put into effect 'they would have given Munich the first place in Europe for creative architecture'. Nowadays Ludwig is generally remembered as the magician who produced the Rococo-style rooms in the Residenz, Herrenchiemsee, which was based on Versailles, the romantic Neuschwanstein and Linderhof, with its Moorish and Chinese pavilions. The richness, fantasy and eclecticism of Ludwig's creations were astonishing, as was brought out in an exhibition held in Munich in 1968.

During the period from 1880 to 1904, the city's art life was dominated by Franz von Lenbach (Fig. 29), the Sargent of Germany. As already stated, when young he had been sent to Italy by Schack to execute copies after the Old Masters, a task at which he was singularly proficient; it was there that he painted his charming *The Arch of Titus* and *Der Hirtenknabe*; later he visited Spain and Cairo, as did Sargent, bringing back good figure and landscape studies. Yet portrait-painting was his chief activity and his numerous portraits provide an unrivalled picture of German high society in the '80s and '90s, of the Kaiser, Bismarck, one of his favourite models, princes, generals,

industrialists and fashionable ladies. Today he is out of fashion. Yet Maximilian Harden said in a brilliant essay:

the historian will learn from Lenbach. His portraits will upset the equanimity of many a legend. William the Great? This kindly, tired, not in the least heroic old man, with a mixture of sadness and bucolic cunning in his glance? . . . The historian will, then, probably, fetch the portraits of the second and third emperor out of their dark corner; they did not please those who ordered them . . . Friedrich's son [i.e. Kaiser Wilhelm] has thrown back his head, as though about to challenge his century, and to harangue aeons, but is not quite sure whether the century will answer his call and whether the aeons will listen.

Harden felt that Lenbach was best with men and that his portraits of women were much less successful. He was a determined scrutinizer of his own features, mild and melancholic: one of his most intriguing works of this type is a *Self-portrait with his wife and family* (Fig. 24), a latter-day example of Mannerism.

Lenbach was an artist-prince who modelled himself on Titian. Even today the Florentine-style villa which Gabriel von Seidl built for him retains its charm. It is a pretty sight to see the flowers in the garden and to hear the fountain playing—an echo of 'old' Munich. Not much remains of the original decoration of the interior (Figs. 20 and 21), but sufficient is left to show the artist's love of the Renaissance. In his house, Harden observed, 'everything as old-fashioned as possible; it was noticeable; nothing is there to recall everyday life, contemporary life, contemporary art'. And he was a collector, too, of old furniture, tapestries, brocades and 'glorious rubbish' but also of major works, including two fine pictures by Titian.

The *Raumkunst* which Lenbach and Seidl favoured and which is also to be seen in the Künstlerhaus in Lenbachplatz, for which they were responsible, was a rich expression of the ripe, some would claim overripe, culture of Munich in the *fin de siècle*. This was evoked by Thomas Mann in his short-story *Gladius Dei* with its celebrated description of the passion for art, '*Der Hunger nach Kunst*', which gripped the city. Lenbach's world existed under the benign rule of the Prince Regent Luitpold,

23. *Portrait of Albert Langen, the Munich publisher,* by Thomas Theodor Heine (1867–1948). Oil on panel, 42·2 × 54·2 cm. Städtische Galerie im Lenbachhaus

23

24. *Self-portrait with his wife and family* by Franz von Lenbach. 1903. Oil on cardboard, 96 × 122 cm. Städtische Galerie im Lenbachaus

24

another Bavarian ruler in love with art, who would often visit his cronies in the Café Luitpold, that celebrated meeting-place which survives.

The counterpart in sculpture to Lenbach was Adolf von Hildebrand, who was one of the most intellectually capable and talented artists of his day and the author of an important treatise on form (read by Wölfflin in manuscript) that may well have influenced the Berensonian idea of tactile values. As Professor Braunfels's article shows, he made more than eighty portraits—among them those of the Prince Regent Luitpold and the Crown Prince Rupprecht, a gifted collector and patron of art and a close friend of the sculptor. Hildebrand was a devoted student of Italian Renaissance art and spent

part of the year at his beautiful house, San Francesco, at Fiesole; the influence of Italian sculpture may be seen in his terracotta of the mother of Conrad Fiedler. Fiedler himself deserves a biography; wealthy, much-travelled and neurasthenic, he was an aesthete to his finger-tips. He married Mary, the daughter of the art historian and museum official Julius Meyer. This brilliant, elegant and intellectual woman was in love with Hermann Levi, the chief conductor in Munich, whom, when he was old and ill, she married after the death of her husband. Fiedler was a devoted patron of Marées and bequeathed his notable art collection of the master's work to the Neue Pinakothek. The intellectual calibre and distinction of this circle may be gathered from the collection of letters

published by Bernard Sattler in *Adolf von Hildebrand und seine Welt* (1962).

The position of the old guard was changing in the 1890s, for in 1893 a Secession group was founded, the first of its kind in Central Europe. Its leaders were Franz von Stuck, Fritz von Uhde and Gotthard Kuhl, and local Impressionists such as Hugo von Habermann and August Keller belonged to it. The painters who exhibited at its first exhibition in the Prinzregentenstrasse included Max Liebermann, Lovis Corinth and Max Slevogt. The two last-mentioned men spent some time in the city, and while there the former painted his sturdy group portrait, *Die Tafelrunde Münchner Bürger in der Loge in Treue Fest* (Fig. 22), which affords a remarkable image of bourgeois society, and the latter vivid sketches of Court ceremonies. However, neither settled down there and both went to Berlin. Corinth returned later and painted vigorous, almost expressionistic, views of the Walchensee.

The 1890s form a particularly fascinating period in the long history of Munich's artistic life. The magnetic personality was Franz von Stuck, whose character had been superbly hit off by Olaf Gulbransson in a telling caricature (Fig. 28). He was an exponent of the heavily perfumed Symbolism of the period, so pungently expressed in his pictures of women. These are erotic and mood-ridden works in which woman is seen as a Medusa-like figure; they sound the note of the sex war which is quite the rage in our own time. He came too at the tail-end of neo-Classicism, conjuring up that note of febrile decadence which can be tasted so scrumptiously in the music of Richard Strauss (Fig. 26). Yet his dabbling in unfamiliar fields—his passion for forbidden fruit—constituted a call for freedom; he struck a blow against the limitations and the frowziness of conventional society. Yet even Stuck had his limitations. When in 1902 it was proposed that Isadora Duncan should dance at the Künstlerhaus, a project approved of by Lenbach, Stuck opposed the idea—in his view a temple of art ought not to be desecrated by a dance programme. However, the dauntless Isadora tackled the painter by giving him a four-hour lecture, which, as he told his friends, quite overcame him.

Munich had been an outpost of neo-Classicism; now it became a chief centre of the *Jugendstil,* for in the same year that the Secession held its first show Hermann Obrist exhibited his embroideries. The movement gained ground rapidly and *Pan,* founded in 1895, *Jugend* and *Simplicissimus* appeared in the city, the two last-mentioned from 1896 onwards.

Jugend was an extremely lively review, which reflects many of the activities of the central European *avant-garde*. Its founder and editor was Georg Hirth, who married Elise Knorr, the daughter of the editor of the liberal newspaper *Münchner Neuesten Nachrichten,* and, after the death of his father-in-law, became its part owner and editor. He started a publishing firm which produced a number of important volumes dealing with art and interior decoration and he himself wrote various useful books. Linda Koreska-Hartmann, in her admirable *Jugendstil—Stil der Jugend* (1969), relates that Hirth decorated his house on the Proplyäen in the Renaissance style

and propagated the concept of the *altdeutsche Zimmer,* once so popular. Of unquenchable enthusiasm and optimism, he was just the man to run a review; he had experience and, what is more, he had the finance to back the venture. Until the end of his life he wrote the leaders and undertook reporting for the magazine. *Jugend* was not exclusively devoted to art and literature; it was opposed to the Junkers and South German clericalism. Not surprisingly it was considered as the platform for philosophical Nihilists, atheists and anti-Christians. Hirth started the first number with an appeal to youth: 'Youth is life, Youth is colour, Form and Light . . . Nothing bad can greet us or our enterprise; for the sign under which we fight is much too good'. This optimism should be recalled in view of the usual interpretation of the *fin de siècle* as being invariably pessimistic in outlook.

The anthology of writings and illustrations from *Jugend* compiled by Linda Koreska-Hartmann shows its wealth of material: verses by Rilke, Otto Julius Bierbaum (Fig. 30), Stefan George, Ricarda Huch, Hugo von Hofmannsthal, Richard Dehmel and Otto Erich Hartleben, among others; parodies and satires and amusing and witty drawings by the many talented black-and-white men who then existed. When this review and the many other intellectual and artistic activities that took place in Munich are examined the correctness is realized of Thomas Mann's declaration that Munich shone. There were exceptions to this happy state of affairs of course. The Munichers took offence at Richard Strauss's opera *Feuersnot,* which contained a hidden criticism of the stodgy outlook of bourgeois society, and only forgave the composer very late in his life. Strauss for his part saw to it that nearly all the first performances of his works were held in Dresden, where, for instance, one of the most magical of his operas, *Der Rosenkavalier,* was given its premiere in 1910.

Dr. H. K. Röthel has pointed out that 'The fermenting atmosphere of Munich during the 'nineties attracted art-smitten youths from Chicago to Moscow to the banks of the Isar'. Among those who came to the city during the 1890s were Jawlensky, Marianne von Werefkin, Kandinsky, Kubin, Klee, Berchtejeff and the Burliuk brothers. Kandinsky took the lead in organizing the avant-garde into a new movement. After staging various exhibitions which helped to spread a knowledge of modern French painting in Munich (he himself was strongly influenced by pointillism) he founded the Neue Künstlervereinigung, München, which held an exhibition in 1909 and included works by Alexander Kanoldt and Adolf Erblöh. The group stood for the rejection of the *plein-air* painting associated with the Secession. In 1910 a second show was held at which Braque, Kees van Dongen, Picasso, Rouault and Vlaminck were guests, and two French painters, Le Fauconnier and Pierre Paul Girieud, became members. It is fascinating to find that Burliuk, in his preface to the catalogue, spoke of the 'archaic' and the 'wonderful fairy-tale world of Scythian plastic art'; the point was that civilized refinement was to be confronted with the naïve. Burliuk was by no means the first to direct attention to archaic art. Already in 1906 the great archaeologist Adolf Furtwängler

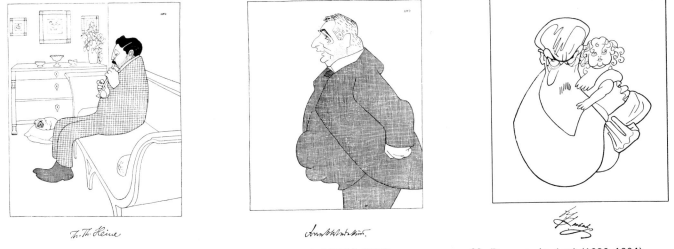

25. *Thomas Theodor Heine* (1867–1948) **27.** *Frank Wedekind* (1864–1918) **29.** *Franz von Lenbach* (1836–1904)

These illustrations are from *Berühmte Zeitgenossen*, 1905, a collection of caricatures by Olaf Gulbransson (1873–1958). They represent some of the outstanding figures in the Munich art world of the time.

26. *Richard Strauss* (1864–1949) **28.** *Franz von Stuck* (1863–1928) **30.** *Otto Julius Bierbaum* (1865–1910)

had rediscovered the importance of Archaic Greek art, naturally through the Aegina sculptures in the Glyptothek, but, although he reconstructed them theoretically, he did not remove Thorvaldsen's restorations, and this has only recently been done. Such swings in taste were the outcome of an understandably natural reaction against the hothouse culture of the 'patina' style and against the cult of the Renaissance which reached such a peak in Munich. The new brigade called for 'spiritual experience', a cry often heard in those years. Kandinsky put forth his own definition of art: 'The communication of what is secret—by means of a secret—is not that the content?'

However, when preparations were under way for the third exhibition, in 1911, schism developed in the ranks of the contributors. This led to the formation by Kandinsky and his friends of the Blaue Reiter group, which issued an almanack with this title which was appropriately dedicated to Hugo von Tschudi. The group held two exhibitions, the first of paintings, the second of graphic work.

The evolution of the Blaue Reiter is far too well known to require any elaboration here. Yet it deserves to be pointed out, within the context of this Editorial, how greatly an artist such as Kandinsky was indebted to his time in Munich. He found, as did his fellow Russian, Jawlensky, a congenial landscape in Murnau (Fig. 34); he owed much to Bavarian *Hinterglasmalerei* and perhaps the very concept of explosive improvisation that burgeoned in his abstract paintings of 1911 (Fig. 32) may be related, not only to the linear preoccupations of the exponents of the *Jugendstil,* but to the vivid stucco decorations and ceiling paintings of the Rococo artists that are such a glorious feature of the south German scene. Curiously enough, the one artist connected with the Blaue Reiter born in Munich, Franz Marc (Fig. 31), was not interested in line. Yet, the love of Nature and the piety that inform his work are in tune with the ethos of Bavaria. As for Klee, the other major artist of this group, his debt to Munich emerges from his *Journal*.

Munich, in the immediate pre-war epoch, had a

31

32
33

haunting, legendary quality; it was where so much was going on, the plays of Wedekind (Fig. 27), for instance. Much of the most fertile artistic activity took place in Schwabing and, as Kandinsky pointed out to Paul Westheim many years later, anyone who walked about there 'without palette, or without canvas, or without at least a portfolio, immediately attracted attention. Just like a "stranger" in a village. Everybody painted, or wrote poetry, or composed music or danced. In every house there were at least two studios, and, even if there was not always a great deal of painting done, a great deal of discussion, disputation, philosophizing (this last being more dependent on the purse than on moral outlook)'. The excitements and amorous adventures that befell many of the young painters as they spent their salad days in Schwabing or Munich are reflected in the *Journal* which Paul Klee kept during his period there. The following two extracts of 1900 and 1901 give the flavour of those happy-going times:

The most agitated days pleased me especially. I drew compositions in the morning (*The Boys*). Then my mistress declared herself pregnant. In the afternoon I took my studies and compositions to Stuck, who accepted me in his autumn class at the Academy. In the evening I met Fräulein Schiawago at the Kaim concert. If I didn't sleep deeply and soundly that night!

In the spring of 1901 I drew up the following programme: First of all, the art of life; then, as an ideal profession, poetry and philosophy; as real profession, the plastic arts: and finally, for lack of an income, drawing illustrations.

This was a city where art and the art of life were attractively combined, a city where youth had a fling. The mood was crystallized by T. S. Eliot in his well-known lines:

Summer surprised us, coming over the Starnbergersee.
With a shower of rain: we stopped in the colonnade,
And went on in sunlight, into the Hofgarten
And drank coffee, and talked for an hour.

One who found a congenial setting in Munich in these years was Joachim Ringelnatz, world traveller, night-bird and writer of witty verse and songs. In his entertaining memoirs, *Mein Leben bis zum Krieg* (1931), he described the famous cabaret Simplicissimus run by Kathi Kobus in the Türkenstrasse. Its walls were hung with pictures, prints, posters and photographs; and every evening a congenial crowd thronged the place—men about town on the razzle, artists, girls. Ringelnatz soon became a star entertainer at this sympathetic haunt, which kept a spark of life even during the hard days of the 1930s. The easygoing, sexy and often complicated existence that was the common diet of Schwabing is part of Munich's legend— it found a High Priestess in Gräfin Franziska zu Reventlow, a beautiful and neurotic painter and writer whose memorable diaries, a log-book of Bohemianism, have recently been published in a new edition.

Inevitably, the outbreak of the First World War brought an end to the glittering and exciting art life of Munich— the old days were over and the foreigners dispersed to their respective countries. Two of the Blaue Reiter group, Marc and Macke, were killed in the trenches. Yet art did not expire altogether; the opera and theatre continued and it is even heartening to find those two pillars of the old order, Adolf von Hildebrand, who was never again to see his beloved San Francesco, and Crown Prince

184

31. Opposite: *Im Regen* by Franz Marc (1880–1916), 1912. Oil on canvas, 81·5× 106 cm. Städtische Galerie im Lenbachhaus

32. Opposite: *Improvisation No. 19a* by Wassily Kandinsky (1866–1944), 1911. Oil on canvas, 97×106 cm. Städtische Galerie im Lenbachhaus

33. Opposite: *Bahnhof* by Paul Klee (1879–1940), 1911. Dry-point etching, 14·5×19·8 cm. Städtische Galerie im Lenbachhaus

34. *Murnau* by Wassily Kandinsky, 1909. Oil on cardboard, 33×45 cm. Städtische Galerie im Lenbachhaus

Rupprecht, who was at the German High Command, exchanging letters on artistic matters.

During part of the war Munich was the home of Rainer Maria Rilke, one of the most refined spirits of the old aristocratic cosmopolitan culture that had received a death blow. He hurried to Munich as soon as war broke out and in the days immediately after the declaration wrote the five well-known odes, *Fünf Gesänge,* in which his emotions were poured forth and his excitement was mingled with a sense of foreboding. It was in Munich, too, that he composed the tragic Fourth Elegy of his masterpiece, the *Duino Elegies.* He had the good fortune to stay in the flat of Frau Hertha Koenig, who then owned Picasso's great picture *Les Saltimbanques* (National Gallery, Washington), which contributed to the mood of the Fifth Elegy,

though this was written after the war when he was living at the château de Muzot, in Switzerland. After his military service in Vienna, an episode which seems like a passage from Musil's novel *The Man without Qualities,* he returned to a war-saddened Munich and found consolation in two love affairs, one physical, one idyllic. He greeted the Revolution at the start with a touch of enthusiasm, but by 1919 he wrote to Dr. Kippenberg: 'Most people believe that this harmless Munich is going to be an evil, restless spot, and this, unfortunately not out of dynamism, but owing to the inertia of the mass that has been set in motion'. The truth of his observation was to be shown before long, and terribly.

Thanks for assistance are due to Keith Andrews, Dr. Gustl Böhler, Patrick Carnegy, Dr. Manfred F. Fischer, Peter Labanyi and Dr. Erika Hanfstaengl.

1. *The Nevsky Prospekt, St. Petersburg* by Ilya Efimovich Repin (1844–1930), 1887. Black chalk, 25·6 × 41 cm. Russian Museum, Leningrad

Wanderers and Aesthetes

It is an eerie experience to look out of a bedroom window at the Hotel Astoria in Leningrad at night when snow is on the ground, catching perhaps a glimpse of the cupola of Montferrand's St. Isaac's Cathedral in the process. Few people are about. No sustained buzz of traffic is to be heard as it is in Paris, London, New York, or Madrid. Yet there is sound, the sound of history. The Astoria itself is something of a landmark. It was built in 1913 and, during the First World War, British officers put up there; Hugh Walpole, then in the Russian capital as head of the Anglo-Russian Bureau with its 'colossal toy map of the London Tube' and its library from Chaucer to D. H. Lawrence, recalled that none of these men was harmed when revolutionaries burst into the hotel.

The past seems close in Russia. Nowadays quite an effort is required to find souvenirs of Dickens's world in London, but in Leningrad, with its exquisite eighteenth-century and neo-classical architecture and its sense of ever-present fate, the city, which haunted Dostoevsky, Tolstoy and Bely, lies to hand. Sometimes, too, we may spy in the streets, or in the foyer of the Astoria, a figure recalling the drunken violinist Albert, one of Tolstoy's most enduring minor creations.

History is near and relevant in Russia because the Revolution of 1917 was one of the most determining events in the modern world—a watershed, when one form of civilization began to totter to its close, or so now it seems. Revolutions had occurred before—those of 1798 and 1848 and the Commune of 1870—but the fall of the Romanovs (which by no means spelt the end of Russian imperial

186

ambitions) was a sign of a general crack-up of the old aristocratic and patrician Europe; Hohenzollerns, Wittelsbachs and Habsburgs were done for.

The Russian Revolution has such emotive force; the sheer misery that followed the initial outburst of hope, when a belief in Utopia was entertained by the unwary, still saddens the heart, an experience poetically evoked by Boris Pasternak in his novel, *Dr. Zhivago*. It gives a clue to the prevailing mood of optimism that Hugh Walpole, in a brilliant dispatch to A. J. Balfour, the British Foreign Secretary, which contains a lively account of the arrival in power of the Provisional Government, noted, among other things: 'Already the artists and musicians were eagerly discussing the wonderful new era that was to transform the art world'.

An idea of life in high circles and of the accelerating tempo before the fall of the monarchy is provided by Maurice Paléologue, the last French Ambassador to the Imperial Court. This shrewd observer knew much about Russian culture and psychology, as is revealed in his brilliant memoirs, and he often tapped the brains of Alexandre Benois, the famous stage designer, who was in touch with liberal circles. In March 1917 Benois called at the French Embassy and, in telling Paléologue that the internal situation was grave, informed him that Russia should make immediate peace with Germany: 'necessity is the law of history' were his words. From the point of view of a Russian, Benois was right in his diagnosis: the horrible loss of life endured by the army, dramatically described by Alexander Solzhenitsyn in his novel, *August 1914*, and the food shortage aggravated the situation. The Imperial Government was astonishingly ham-fisted. How tactless to permit the Alexandra Theatre to stage, as it did on 8 March, a gorgeous revival of Lermontov's *Masquerade*, which had been ten years in preparation; outside the poor queued for food.

Yet the February Revolution must be seen in the right perspective and a salutary corrective to legend is provided by George Katkov in his outstanding book, *Russia 1917* (1967), which examines the role of the Germans in stirring up trouble, the secret societies and the struggles between Milyukov and Kerensky in the Provisional Government. Professor Katkov makes mincemeat of the contention that the Revolution was a spontaneous affair: alas if only more people had realized the implications of the sealed train that brought Lenin to the Finland Station in Petrograd and that led on to the tragic events of October!

Curiosity about the Revolution and the Civil War remains intense, not only about the political aspects but about the details. What was the fate of the English bookshop, Watkins, at No. 36 Bolshaya Morskaya, now Herzen Street? An Englishman may also be forgiven for wondering about the final scenes at the Petersburg clubs, such as the English Club, founded by Gardener in 1770, in Dvortsovaya Naberezhnaya, the Nobles' Club, founded by Prince Dolgoruky in 1783 in the Nevsky Prospekt, and the Merchants' Club on the English Quay, which dated from 1785. Like the others, the last-named was famous for its excellent dinners and the foreign papers were available. When did the last copies of *The Times* and *Le Temps* arrive? What were the reactions when the Russian Press closed down? Trifles of history, but not without macabre fascination,

2. *Portrait of the writer Nestor Vasilyevich Kukolnik* (1809–68) by Karl Pavlovich Bryullov (1799–1852), 1836. Oil on canvas, 117×81·7 cm. Tretyakov Gallery, Moscow

3. *Head of a Woman* by Alexander Andreyevich Ivanov (1806–58). Oil on canvas, 57×44 cm. Tretyakov Gallery, Moscow. A study for the figure of St. John the Baptist in *Appearance of the Messiah* in this gallery

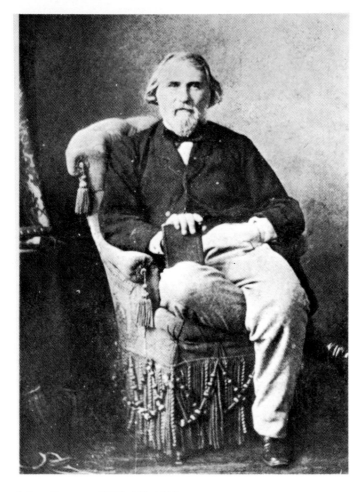

now that we live in a rapidly changing era and when the threat of wholesale nationalization and bureaucratic control ventilated by the English Left should not be shrugged off too lightly.

The impression is sometimes given that life in Russia in the years just before 1914 was one of unmitigated horror, an impression that has been heightened by propaganda and by such films as *Battleship Potemkin*. The urban proletariat and many of the peasants suffered, but conditions were not easy for these groups in other parts of the world: think only of the slums of New York, with their swarms of immigrants, Irish, Italian and Jewish. Although in Russia the level of material progress lagged behind that of many other countries, economic and social conditions had improved considerably. This is shown, perhaps, by one small detail: St. Petersburg had no fewer than 25,000 telephones in 1913.

Many changes took place in the country during last century, of which the most significant was the ostensible liberation of the serfs in 1861. One tragedy was the assassination of the relatively liberal Emperor, Alexander II, in 1881. His successor, Alexander III, understandably took a hard line. Another misfortune, to say the least, was that such determined reactionaries as Pobedonostsov (Fig. 27), the Procurator of the Holy Synod, and G. N. Katkov exerted decisive influence on the régime and later on Nicholas II.

This is not the place to muse upon Russian history or the Russian 'soul', but a strong streak of continuity in Russian intellectual and political life is evident, as may be seen from reading the Marquis de Custine's famous letters, or Paléologue's book. The latter reports a fascinating

4. *Ivan Turgenev* (1818–83), 1844

5

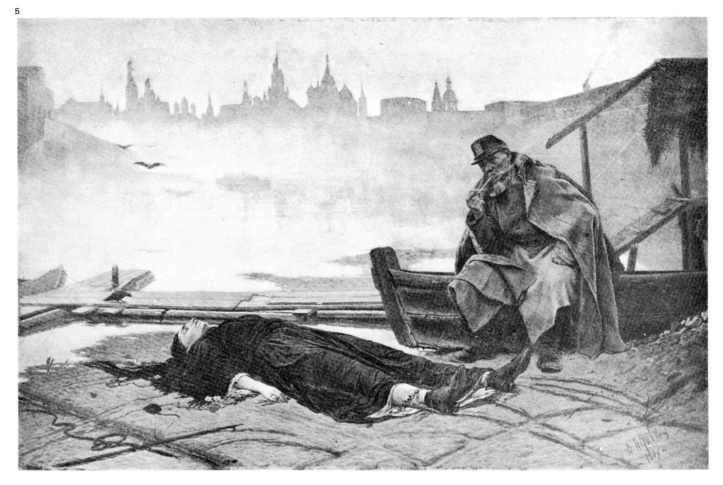

188

6

5. Opposite: *The Drowned Woman* by Vassilii Perov (1834–82), 1867. Oil on canvas, 48 × 186 cm. Tretyakov Gallery, Moscow. The city in the background is Moscow

6. *Volga Boatmen Hauling* by Repin, 1870. Pencil, 32·7 × 181·3 cm. Tretyakov Gallery, Moscow. The first sketch for Repin's famous picture in the Russian Museum, Leningrad

7. *On the Boulevard* by Vladimir Egovovich Makovsky (1846–1920), 1886. Oil on canvas, 53 × 68 cm. Tretyakov Gallery, Moscow. The scene depicts a young man who had left his village to work in Moscow being visited by his wife

7

conversation with old Prince Viazemski at the Yacht Club. This ultra-reactionary and inveterate grumbler told the Ambassador that he had little time for liberals, for they were leading the country into the revolution that 'will certainly swallow them up on the first day'. He claimed that autocracy, i.e. Tsarism, 'is Russia itself'. He went on:

The Russian nation is the most docile of all when it is strictly ruled, but it is incapable of governing itself. The moment it is given its head it lapses into anarchy . . . It needs a master, an absolute master; it walks straight only when it feels a mailed fist above its head

It is worth brooding about his views, at a moment of *détente*.

Many visitors to Russia in the nineteenth century and early part of the twentieth century found the country exciting, and by the 1890s it was certainly more comfortable than half a century earlier, when Lady Londonderry spent some time in St. Petersburg. The country attracted a growing number of businessmen and tourists, a point sometimes

overlooked. International expresses linked St. Petersburg with the West, the journey taking fifty-two hours from London, forty-six from Paris and twenty-eight from Berlin. One attractive way of reaching the capital was by ship. Various lines were available to the traveller and a convenient ship was the 2,000-ton steamer that left London for St. Petersburg every Friday evening, via the Kiel Canal; a first-class return ticket cost eleven guineas.

Hotels and restaurants were numerous: the Hôtel d'Europe at St. Petersburg and the Hotels Dresden and Metropole at Moscow are often mentioned. The ebullient Ruth Kedzie Wood went out of her way in *The Tourist's Russia* (1913) to underline the copiousness and excellence of Russian food; the *zakuski*, the fish soup, the sturgeon and caviar, the *shashlik*, the grouse and the partridge. And, in her eyes, the salads and dressings were worthy of special consideration. The Russians were hearty eaters and drinkers who believed, as Maurice Baring observed, in

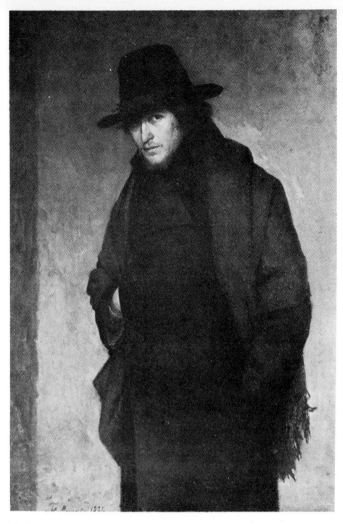

8. *The Student* by Nikolai Alexandrovich Yaroshenko (1846–98) 1881.
Oil on canvas, 87 × 60 cm. Tretyakov Gallery, Moscow

having more rather than less; a commendable practice in some eyes!

The rather breathless Miss Wood wrote about the restaurants. Besides those in the main hotels in St. Petersburg, there were such first-class places as Donon, Privato, which served Italian food, the Bear and Cubat. Less expensive, but good, were Dominique, which had draught beer, Solovyev and Palkin; the last-named, a typical Russian establishment, was famous for its splendid and colourful organ-music.

As for Moscow, the visitor could eat there at the Slaviansky Bazaar, where the *zakuski* table stood beneath a large painting by Repin; upstairs the ball and assembly room was hung with portraits of Pushkin, Gogol, Prince Galitzine and others. However, Miss Wood noted: 'Under one painting the brass name plate had been removed, because, explains the head waiter, this was an author "who had written bad things of Russia".' Who was the offender, we may wonder; surely not Herzen, who had been dead some thirty years.

Another excellent restaurant was the Ermitage, and such places—at any rate in the 1890s—had their *cabinets particuliers*. There were also such typical Russian *traktirs* as the Bolshaya Moskovskaya Gostinitsa, Tiestov and the Prague. Baring lunched at Tiestov's when he first visited Moscow, but when he asked for caviar, *ikra*, the waiter thought he said *igra*, play, and the great mechanical organ which the restaurant boasted burst into sound. Thus, the noise that accompanies eating out in modern Russia is no new thing. The Prague is still going; it keeps an excellent table and, ten years or so ago, the hazel grouse was pronounced memorable.

Miss Wood was struck by the crowds who frequented the

9

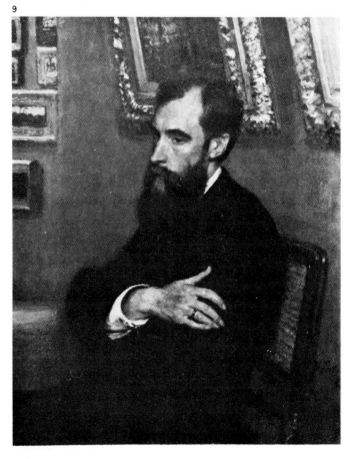

10

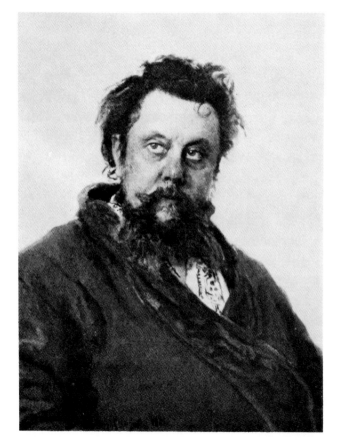

190

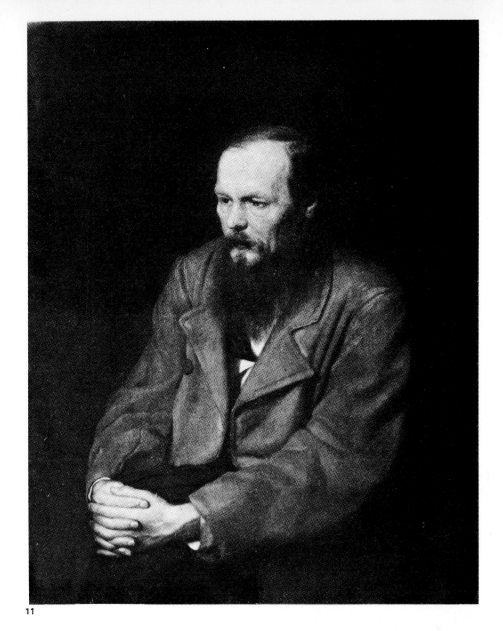

9. Opposite: *Portrait of Pavel Mikhailovich Tretyakov* (1832–98) by Repin, 1883. Oil on canvas, 98×76 cm. Tretyakov Gallery, Moscow

10. Opposite: *Portrait of Modest Petrovich Mussorgsky* (1839–81) by Repin, 1881. Oil on canvas, 69×57 cm. Tretyakov Gallery, Moscow

11. *Portrait of Feodor Mikhailovich Dostoevsky* (1822–81) by Perov, 1872. Oil on canvas, 99×80·5 cm. Tretyakov Gallery, Moscow

11

restaurants. One feature of life in the capital or Moscow was the pleasure gardens, where the man-about-town, if dining alone, could pick up a local variant of the geisha girl who would entertain him with 'trifling chatter or perhaps a song'. In return, Miss Wood wrote, perhaps a shade naïvely,

he gives gold to the siren, or, possibly, the jewel from his cravat, if she had pleased him uncommon much. As compensation for an hour of glitter and banter these birds of passage sometimes received a palmful of gems to deck their plumage, or a cheque of staggering proportions. She who pleases a Russian pleases a generous child. The interview is at an end, he rises from the table and bids his entertainer a polite adieu.

Then, there were crisp *troika* drives to such night spots as Samarkand and Igels on the island of the Apothecaries (Apterkarskii-ostrov) at St. Petersburg, where the gipsies would sing until dawn, as the champagne corks popped and the balalaikas strummed.

A well-known Moscow night club was the Yar, where Rasputin once held an orgy that caused consternation in polite society, owing to his uncouth remarks about the Empress. The celebrated gipsy singer Vara Panina was an attraction at the Yar, and, although she was not good-looking, the range of her voice and its beauty delighted the audience. This passionate creature, the victim of an unrequited love for a member of the Imperial Guard, took poison and died on the stage in front of him, singing 'My

heart is breaking'. The force of her personality was captured in a remarkable Fabergé piece (Fig. 25).

One unusual Moscow cabaret was The Bat, a sort of offspring of the Moscow Art Theatre, run by Nikita Balieff, where Walpole came across Chaliapin, Gorky and Lykiardopoulis, secretary of the Art Theatre and a well-known translator. Under Stanislavsky the Moscow Art Theatre was one of the most exciting theatrical ventures of its kind anywhere, and it was there that Maeterlinck's *L'Oiseau bleu* had its world première and Baring saw Chekhov's *Uncle Vanya* and *The Cherry Orchard*.

Lovers of the opera and the stage could derive immense pleasure at the various state theatres in St. Petersburg and Moscow. In the latter city symphony concerts were given in the Nobles' Hall in the Bolshaya Dmitrovka, at the instigation of Nikolai Rubinstein. However, by 1910 there was a brand new concert hall for the Philharmonic Society in Moscow which had been built by private generosity and, according to Juliette Adam, it was exquisite with its Byzantine decoration: 'it was white without crudity and the acoustics were marvellous'. Madame Adam's book, *Impressions Françaises en Russie* (1912), is interesting, for she draws attention to the munificent scale of private charities, particularly those of Madame Kuznetsova at Moscow, and to the activities of Princess Tenisheva and others in supporting the arts and crafts.

191

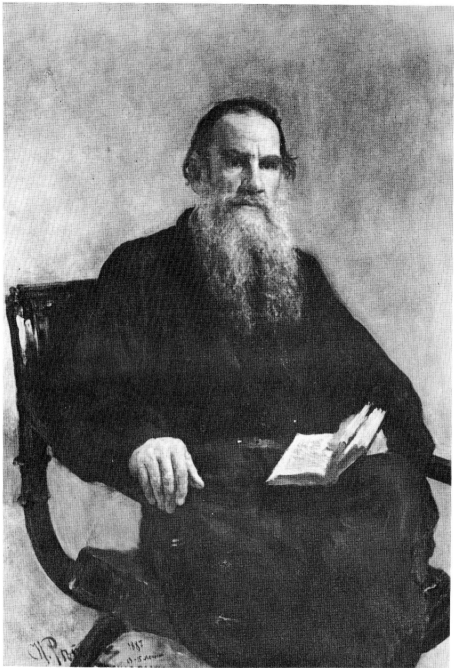

12

St. Petersburg was a Mecca for the art lover. Besides the Hermitage with its immense range of treasures, visitors could see the Yusupov Collection at No. 94 Moika, the Stroganov Palace, built by Rastrelli, at No. 17 Moika and the collection of Count Paul Stroganov on the corner of Mokhovaya and Sergievskaya, with its beautiful Filippino Lippi and classical sculpture, the Stroganov *Apollo*.

Another collection open to the public was Semenov's, which had no fewer than 500 Dutch and Flemish paintings by 350 artists. The Alexander III Museum of Russian Art, then as now, was in the former palace of the Grand Duke Michael, and the Imperial Public Library had a huge collection of books and manuscripts. It is worth emphasizing that visitors could gain access to the various Imperial palaces in the environs: Peterhof, Tsarskoe Selo and Gatchina.

Anyone in the city in 1905 had the chance, too, of visiting the great and never-to-be-repeated exhibition of eighteenth-century Russian portraits staged by Diaghilev at Starov's

Tauride Palace, later the seat of the Duma, or, if in Moscow in 1913, the 'Second All-Russian Exhibition of Arts and Crafts' held in honour of the tercentenary of the Romanov dynasty. The exhibition of icons was particularly important, for many of the works in it were specially cleaned for the occasion and their dazzling appearance made an impact on the young Natalia Goncharova.

Much else was available, too, in Moscow, the Kremlin and the Museum of Industrial Art, founded in 1868, for instance, and places such as the Ovchinnikov studio which went in for icons and church decoration. Lacquer-work was a speciality of Moscow province and sold at Lukutin's in the Tverskaia, and Miss Kennedy reminds us that the father of the Russian enamel industry was an American, Henry Hiller, known as Andrei Andreyeivich, who was the second American to visit Siberia. Fabergé had a branch in Moscow as they had in Odessa (and for a short time in Kiev), but their headquarters was in Morskaya Street, St. Petersburg. This firm produced such delightful popular

Russian types as those illustrated in (Fig. 28), as well as the more familiar *objets d'art*.

Interest in Russia grew in the West, as its literature became better known; Melchior de Voguë's book *Le Roman russe*, which treated of Turgenev, Tolstoy and Dostoevsky, came out in 1886; Turgenev was a friend of

of Pushkin and Fet, Blok and Balmont. Access is much easier to prose in translation: Gogol, Turgenev, Goncharov, Dostoevsky, Leskov, Tolstoy, Gorky, Bunin, Bely, Pasternak and Solzhenitsyn take us into a rich and fantastic, compelling and emotional world, different from anything to be found elsewhere. It is a literature that has produced

13

several leading French men of letters and of Henry James, who was influenced by him. He visited England, and the first idea of his famous novel, *Fathers and Children*, came to him when sea-bathing at Ventnor on the Isle of Wight. Tolstoy was internationally famous, to such an extent that his final hours in the station-master's house at Astapovo were filmed by newsreel men. Dostoevsky had many adherents as an apocalyptic religious figure. Not that everyone fell under his spell; for instance, Henry James wrote to Walpole:

Tolstoi and D. are fluid pudding, though not tasteless, because the amount of their own minds and souls in solution in the broth gives it savour and flavour, thanks to the strong, rank quality of their genius and their experience.

Characteristically, he took exception to their 'lack of composition, their defiance of economy and architecture'.

Russian literature has a magnetic attraction. Unless one has knowledge of the language, the poetry remains difficult to appreciate, even though it is possible to sense the quality

characters who seem as familiar to us as if we knew them personally: Pierre Bezukhov, Raskolnikov, Natasha Rostov, Levin, Katyushka, Oblomov, Bazarov, Rudin, Anna Karenina, Vronsky and many others. Chekhov's figures continue to haunt the mind, too.

Russian fiction is plentiful in astonishing encounters and dramatic scenes: the meetings between Raskolnikov and the police inspector, the trial in *Brothers Karamazov*, the opening of *The Idiot* as the train approaches St. Petersburg, the column of prisoners on the way to Siberia in *Resurrection*, Pierre Bezukhov's escapade with the bear at Kuragin's party in *War and Peace*, Chichikov and the paper serfs in Gogol's *Dead Souls*, the ride to the woods by Sanin and Maria Nicolaevena in *Spring Torrents*, just to mention a few. What characterizes such passages is not only their dramatic content, but their visual tangibility: scenes are created that remain fixed in the mind as if we had experienced them. What could be more telling than the episode in *Resurrection* in which Katyushka runs to the station to see

14

if she can talk to her young seducer Nekhludov as his train arrives. She is unlucky: the train, as it pulls out of the station, seals her fate. Trains play a large part in Russian fiction, down to *Dr. Zhivago*, at any rate.

The extraordinary world portrayed in the Russian novel might seem exaggerated if we did not know about Russian life itself and the amazing people and events found there. Turgenev's mother, the monster Varvara Petrovna, is one; another is Rasputin. And the intrigues described by Professor Katkov and the roles of such odd middlemen or spies as Prince M. M. Andronnikov and Prince D. O. Bebutov are almost unbelievable, but they are only too true.

Discussion, relentless talk about life and death, about religion and destiny, forms the ground-swell of the Russian novel. How different is the world of Russian novelists from that of, say, Trollope setting off for the Post Office, or even that of Balzac with his compulsive debts. The struggle with the authorities assumes a large place in Russian writing. Pushkin was under police surveillance; Dostoevsky, an admirer of Dickens, narrowly escaped execution; Herzen was an exile; Gogol and Turgenev spent years out of the country; it is a tradition that continues. The torments of existence did not even desert the octogenarian Tolstoy: he

fled from Yasnaia Polyana, 'leaving this worldly life in order to live out my last days in peace and solitude'.

Russian literature is haunted by politics and dialectics. But we have to be careful to avoid interpreting it in a way not justified by the text. Stanislavsky, in his production of *The Cherry Orchard* at the Moscow Art Theatre, set the example even during the author's lifetime. How far this producer went in taking liberties is brought out in David Magarshack's brilliant book, *The Real Chekhov* (1972) compulsory reading for those who both love the great dramatist and suffer when his late masterpieces are misrepresented, as is often the case.

The embracing emotional force of the Russian artistic genius is radiantly expressed in music and, from Glinka onwards, composers such as Borodin, Mussorgsky (Fig. 10), Glazunov and Rimsky-Korsakov created an individual national School. It was national, not only in the sense that it drew upon the tradition of popular music, but because, as may be seen with *Boris Godunov* and *Khovanstchina*, operatic themes were derived from Russian history. Music, too, exerted an influence on Russian art of the *fin de siècle*.

What of Russian painting? Understandably, curiosity about this has increased, now that Russia can be seen, more than ever, as a dominant world power, rejoicing in

194

15. *After the Rain* by Isaak Illyich Levitan (1860–1900), 1889. Oil on canvas, 80× 125 cm. Tretyakov Gallery, Moscow

15

16. *Early Spring* by Levitan, *c.* 1898. Oil on canvas, 41·5×65·3 cm. Russian Museum, Leningrad

16

the possession of far-flung territories which would have gladdened the heart of the most dyed-in-the-wool Pan-Slavist of Imperial days. Pioneer historians, both Russian and foreign—Benois, Grabar, Lazarev and G. H. Hamilton —have done much to spread a knowledge of Russian art.

With the passion for the modern movement, characteristic of our epoch, Russian art in the years just before and after 1914 now arouses considerable attention. In the first instance this has been due to the popularity of Kandinsky, who, often and wrongly, is seen as a German Expressionist. Now there is enthusiasm for Malevich, El Lissitsky and Tatlin and, increasingly too, a delight in Larionov and Natalia Goncharova. This revival owes much, in Western Europe, to Camilla Gray's notable book, and to research by Mary Chamot, John E. Bowlt and Madame Valentine Marcadé. A posse of staunch historians is also active in Russia, where *avant-garde* art of the 1910s and 1920s is increasingly on view: Tatlin is now shown in the Russian Museum, Leningrad.

Russian art of the years on either side of the 1917 Revolution can be appreciated, however, only when the nineteenth-century School is remembered. With Russian painting of this period, as with Russian literature, an eye must ever be cocked on political and ideological questions.

We have to keep in mind the role of the Populists (analyzed by Professor Franco Venturi in a major work translated into English by Francis Haskell), the Old Believers and the Nihilists, the battle between the Westerners and the Slavophils and the constant fight against autocracy. We have to remember the Slavic revival and the Hasidic tradition, and, as far as concerns the Symbolists, the intense influence of philosophy: such elements contribute to the vitality and fascination of Russian art.

The Russian painters of the eighteenth century—Levitsky and Borovikovsky—have charm, as Diaghilev was one of the first to realize: he wrote a book on the former and organized the Tauride Palace exhibition of 1905. Both painters were in tune with the temper of the Court at St. Petersburg, but neither achieved anything resembling an international reputation; they were tasteful epigones of an international style.

A different note was discernible in Kiprensky, whose romantic painting, akin to that of Géricault, has the panache of Pushkin. Karl Bryullov made a name for himself in Western Europe as an elegant portrait-painter (Fig. 2) and his *Last Days of Pompeii* provided Bulwer Lytton with the theme for his once famous novel of the same title. Another painter of this generation to make an impact abroad was

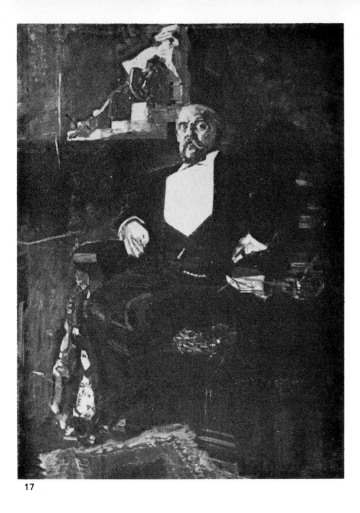

17

18

Ivanov, whose style was close to that of the Nazarenes. He spent many years in Rome trying to finish a large-scale religious painting, *Appearance of the Messiah*, which, however, failed to arouse enthusiasm when shown in Russia. Perhaps he is now best remembered as the subject of a profile by Turgenev, who noted the painter's growing mental disorder. 'Ivanov died', said Herzen, 'still knocking; the door was not opened to him.' In his search for a new religious type, which he could find nowhere in the world about him, Ivanov was characteristic of the mystically inclined Russian artist; he may be considered as an ancestor of Kandinsky.

Other sides of Russian art may be noticed in the first part of the century; for instance, the delight in Nature that radiates the exquisite landscapes of Venetsianov, which, as G. H. Hamilton wrote, possess spiritual calm. Another was the humorous observation evident in the paintings of Fedotov, whose social comments, the same authority declares, have more than a touch of Gogol about them.

Controversy is life-blood to the Russian. Belinsky, the father of Russian criticism, was, as Maurice Baring wrote, 'a polemical and fanatical knight errant' on behalf of the Western ideal and a lively critic. Turgenev sketched his personality in an essay that is as amusing as it is profound for the light it sheds on the Russian nature. But to quote Baring again:

The didactic stamp which he [Belinsky] gave to Russian aesthetic and literary criticism has remained on it ever since, and differentiates it from the literary and aesthetic criticism of the rest of Europe, not only from that school of criticism which wrote and writes exclusively under the banner of 'Art for Art's sake', but from those Western critics who championed the importance of moral ideas in literature, just as ardently as he did himself, and who deprecated the theory of 'Art for Art's sake' just as strongly. Thus it is that, from the beginning of Russian criticism down to the present day, a truly objective criticism scarcely exists in Russian literature. Aesthetic criticism became a political weapon. 'Are you in my camp?', if so you are a good writer. 'Are you in my opponent's camp?' Then your god-gifted genius is mere dross.

This attitude was inevitable in the circumstances and the polemics that attended Turgenev's novel, *Fathers and Children*, are related by Sir Isaiah Berlin in his Romanes Lecture of 1970 on this author. Indeed, for many Russian writers and critics aesthetic considerations took second place, if any at all, until the 1890s. Turgenev was a notable exception, and, for all his own lack of formal quality, Dostoevsky was ready to scoff at Chernyshevsky. This influential theorist argued in *The Aesthetic Relations of Reality to Art* (1855) that reality was more important than its imitation in art, the real apple better than the painted one (provoking Dostoevsky's sense of the ridiculous) and, for a generation, subject-matter was more significant than form—a view that still has strong partisans in Russia.

The move towards realism was evident in an artist such as Perov, who painted a searching picture of Dostoevsky (Fig. 11). The new spirit was also shown when in 1863 a

17. *Portrait of Savva Mamontov (1841–1918)* by Mikhail Vrubel (1856–1910), 1897. Oil on canvas, 187 × 142·5 cm. Tretyakov Gallery, Moscow

18. *Leon Bakst Waiting for the Train at Martychkino Station, near St. Petersburg,* by Alexandre Benois (1870–1960). 1896. Drawing. Private collection, Paris

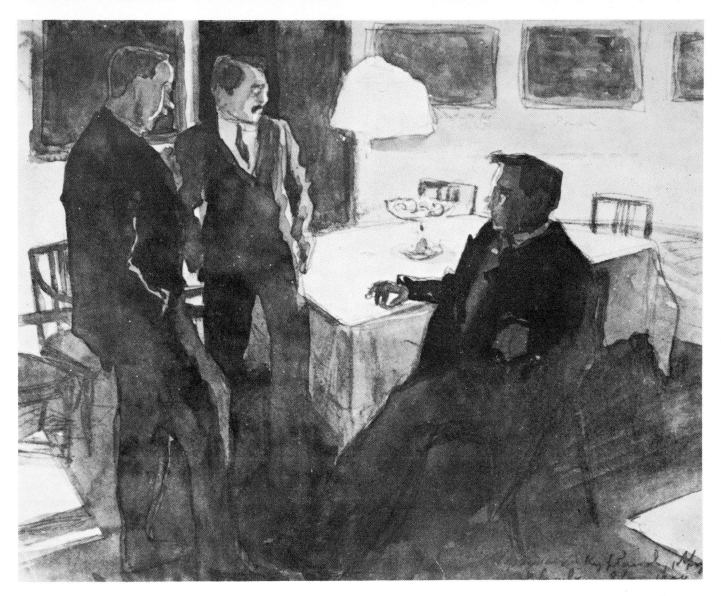

19. *An Evening at Benois's, St. Petersburg* by Benois, 1904. Wash drawing. Private collection, Paris. The drawing shows the historian Kourbatov, Prince Argoutinsky-Dolgoruky and the artist Somov

group of painters, The Thirteen Contestants, among them Kramskoi, turned against the Art Academy in St. Petersburg. They and their associates formed an Artists' Co-operative Society for the exhibition of their work. This gave rise in 1870 to the novel idea of founding a society for travelling art exhibitions so as to bring works of art to cities other than St. Petersburg and Moscow; its members, known as the *peredvizhniki*, travellers or wanderers, included most of the leading artists of the time.

Now that Victorian genre painting has its advocates, the Russian realists may be seen with more sympathetic eyes than was the case even a decade ago, although G. H. Hamilton's contention that their failure to evolve new forms must be counted against them. Painters such as Kramskoi, V. Makovsky and Repin painted pictures with a social message with greater or lesser degrees of success. Although the desire to preach preoccupied many of them, this did not prevent their painting appealing pictures such as V. Makovsky's *On the Boulevard*, 1886 (Fig. 7). This represents a young peasant who had come to seek employment in the city being visited by his wife. Their work, in any event, is interesting for the comment it provides on local life, as in Savitsky's *Repair of the Railway lines*, 1874, in the Tretyakov Gallery.

An especially fascinating picture is Yaroshenko's *The Student*, 1881 (Fig. 8), which surely arouses a sympathetic spark in many a modern student; his is the face that launches a thousand demonstrations! He painted a female student two years later (Museum of Russian Art, Kiev), one of those daring young women who galvanized the male into further desperate action. But a book is required to analyse the Russian *femme fatale*, who haunted the imagination of many a nineteenth-century novelist; Turgenev was one of the first to catch her character in *Spring Torrents*. Paléologue, sharp as ever, on seeing a girl student in the street 'with bright, hard eyes under her astrakhan cap', observed that the share of women in terrorist plots was very important and often decisive.

The most celebrated realist of his generation was Ilya Repin, who was born in 1844 and lived until 1930. He was the son of a farmer and studied at the St. Petersburg Academy, and he spent 1873–76 in Paris. He possessed a natural gift for painting, using a rich and powerful brush and a curry-hot colour scheme. This all-rounder painted such forceful social documents as *Volga Boatmen Hauling* (1872—Fig. 6)—a later version of this picture aroused the enthusiasm of Dostoevsky—dramatic interiors, religious pictures and tender studies of women. One, of his wife, shows a young woman who seems to step out of the pages of a Turgenev novel. He did a remarkably composed portrait

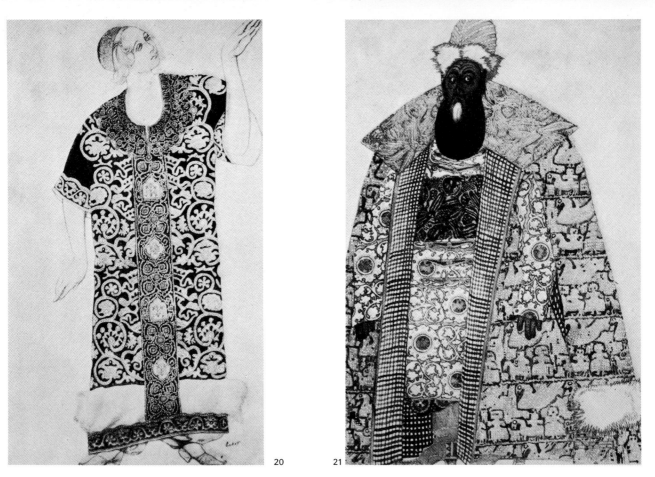

20. *Costume design* by Leon Bakst (1866–1924), 1911. Pencil, water-colour and gouache. Galleria del Levante, Milan. This and Figure 21 are designs for the ballet *Sadko,* which was first performed at the Théâtre du Chatêlet, Paris, in June 1911

21. *Costume design for the Eight Boyars* by Bakst, 1911. Pencil, water-colour and gouache, 49 × 33 cm. Collection Denys Lasdun

group of the members of the Imperial State Council, now in the Russian Museum, Leningrad, that provides an informative comment on the upper ranks of official Russia. The sharpness of execution evident in the sketches for this work suggests that even after thirty years Repin had not forgotten the *élan* of French painting; not that he cared for Impressionism. He was an admirable draughtsman, as may be seen from his charming drawing of St. Petersburg's main thoroughfare, the Nevsky Prospekt (Fig. 1).

The connexions between French and Russian painting were evident enough in the years of the birth of the modern movement, when Morosov and Shchukin bought master-pieces of the School of Paris, but a relationship existed earlier in the century. Vasilii Vereshchagin, 'an apostle of peace tinged with Nihilism', as Alexandre Benois called him, studied under Gérôme in Paris, and the influence of this painter, who is winning fresh admirers, is evident in his technique. Vereshchagin's battle pictures were painted in the same period in which Tolstoy's *War and Peace* was published and show the sanguinary and horrific, not the heroic, sides of war. He himself went down in a warship during the Russo-Japanese War.

His painting had more than a local reputation. It was shown, for instance, at Kroll's gallery in Berlin in 1882. On this occasion his pictures, Benois said, were 'not to be seen by day, but only under electric light. Concealed by curtains was an harmonium, upon which war-songs were played, accompanied by subdued choruses. And the hall was decorated with Indian and Tibetan carpets, embroideries and furniture, weapons of every description, images and

sacred pictures, musical instruments, antlers, bear skins, and stuffed Indian vultures'. This quotation is worth giving because it shows that the modern cult of 'showmanship' is no novelty.

The Realists' concern with social and philosophical problems did not exclude a delight in Nature, hardly sur-prising in view of the astonishing and poetical descriptions of the countryside found in Turgenev and Tolstoy and the variety of the Russian scene.

The continuing love of Nature in Russia is shown in Andrei Konchalovsky's remarkable and poetic film after Turgenev's novel, *A Nest of Gentlefolk.* It contains marvel-lous and romantic shots of the Russian countryside and of the Lavretsky and Kalatin houses (neo-classical decora-tion is noticeable in them) which would have appealed to the World of Art painters and writers. There is also a splendid scene dealing with a horse fair, in which we can almost smell the dung and hear the neighing of the horses: this demands the brush or pencil of Repin. This film, in which social comment is avoided, is a masterpiece in its genre, remarkable for the tender and emotive performances of Irina Kupchenko as Liza and Leonid Kulagin, every inch a dreamy country gentleman, as Feodor Lavretsky.

Already, as we have seen, Venetsianov captured the silent quality of the Russian landscape and, in the days of the Wanderers, Shishkin, Polenov, Vasnetsov, Korovin and Arkhipov conveyed the flavour of their native land in their pictures. What connexions, if any, had these men with the Barbizon painters?

The most exquisite Russian landscape-painter of the day

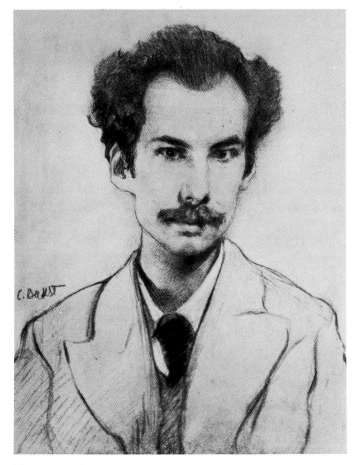

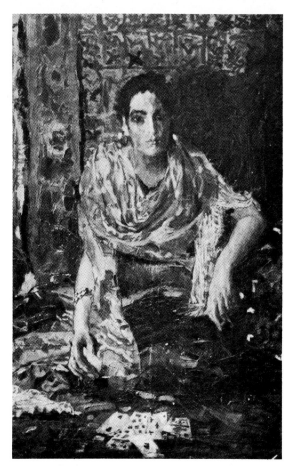

22. *Portrait of Andrei Bely* (1880–1934) by Bakst, *c.* 1905–6. Black and red chalk on light brown paper, white chalk on background, and blue and green on the costume, 45·8×34 cm. Ashmolean Museum, Oxford

24. *A Fortune-Teller* by Vrubel (1856–1910), 1895. Oil on canvas, 135·5×86·5 cm. Tretyakov Galleries, Moscow

23. *Alexander Blok* (1880–1921) by Konstantin Somov (1869–1939). Tretyakov Gallery, Moscow

25. *Vara Panina*, composed of various coloured stones, Fabergé. Height 17·7 cm. Private collection, U.S.A. This gipsy singer at the Yar Moscow, killed herself on stage for love of a member of the Imperial Guard

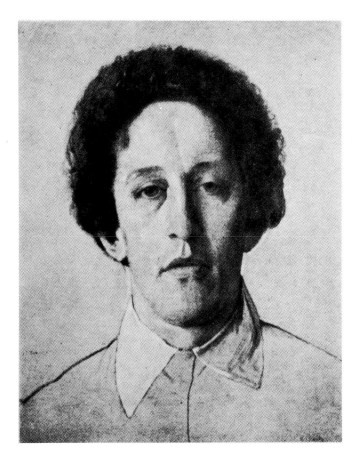

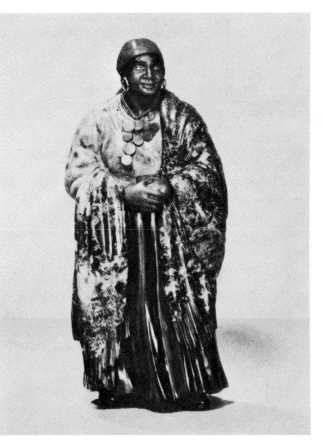

26
27

was Isaak Levitan, who started to exhibit with the Wanderers in 1884 and taught landscape-painting at the Moscow Art Academy in 1898–1900. He had a sensitive eye for tone and his feelings for solitary places and the desolation of wintry scenes possess their own special 'Levitanian' flavour, as Chekhov wrote when comparing the painter's vision of Northern Russian landscape with the nature of the more clement Southern regions. *Early Spring, c.* 1898 (Fig. 16), conjures up the atmosphere of a typical Russian waterway; the technique, with its use of separate passages of colour, looks ahead to de Staël's non-representational works, thereby stressing the essentially Russian character of the later master.

Levitan was a notorious lady's man whose escapades furnished his friend Chekhov with copy. The story *The Grasshopper* is based on Levitan's liaison with Sophie Petrovna, the wife of Dmitri Pavolovich K. He spent a summer on the Volga and another at Slavianskaya Sloboda with her, which caused something of a scandal. When the story appeared, Levitan went to see Chekhov about it, and some thought that the result might be a duel, but the writer turned the affair into a bitter ironic joke.

On another occasion the painter was involved in a complicated love affair when staying in the country, near the Rybinsk railway; this nearly had a tragic denouement. He attempted to commit suicide, but only grazed his head. The two women involved in the drama, who were not keen on consulting the local doctor for fear of scandal, telegraphed for Chekhov. He was met at the station by Levitan 'with a black bandage on his head, which the artist during the explanation with the ladies tore off and threw on the floor. Levitan then took a gun and went to the lake. He returned to his lady with a shot seagull which he threw at this lady's feet'. Thus Levitan provided two *données* for *The Seagull*.

Chekhov considered that towards the end of his life Levitan had spent himself on women and that his painting lacked a youthful touch: instead he worked with bravura. A landscape-painter, in Chekhov's view, could paint only with pathos and ecstasy 'and ecstasy is impossible when one has gorged oneself. If I were a landscape-painter, I would lead a life almost ascetic'. Levitan's landscapes inspired the sets used by Stanislavsky for his Chekhov productions at the Moscow Art Theatre.

The latter-day Medici was no isolated phenomenon in the golden age of capitalism: John Sheepshanks and Joseph Gillot were two who flourished in England and supported local men. But perhaps no patron played such a role in any country at this time as Pavel Mikhailovich Tretyakov. This rich Moscow industrialist, who in Repin's portrait (Fig. 9) looks like a poet, devoted time and fortune to forming an extensive collection of contemporary Russian art, which, together with the paintings (mostly foreign) belonging to his brother, he gave to the City of Moscow in 1892. He became the curator of his own Museum. Tretyakov was also keen on literature—his friends included

26. *Princess O. K. Orlova* by Valentin Serov (1865–1911). 1910. Oil on canvas. Russian Museum, Leningrad

27. *Portrait of Konstantin P. Pobedonostsov, the Procurator of the Holy Synod* by Serov, 1902. Chalk and pencil on grey paper, 56×43 cm. Russian Museum, Leningrad

28. *Ten Russian national types.* Fabergé, *c.* 1895. Heights from 11·43 cm to 17·15 cm. Formerly collection Sir William Seeds. Courtesy Wartski

Dostoevsky, Turgenev and Tolstoy—and built up a portrait gallery of such men and other Russian notables.

Tretyakov's example was followed by other wealthy merchants who at a period when many of the nobility were impoverished played an ever-increasing part in art life, although it is as well to recall in aristocratic circles the charming Princess Tenisheva and Prince Shcherbatov. Some account of the Princess and of Savva Mamontov is given in this issue. Mamontov, a Moscow, not a St. Petersburg, man, founded his own private opera company in 1885, two years after an Imperial Decree ended the Tsarist monopoly of opera productions, and thereby did much to stimulate that great outburst of stage design which is such a feature of the time; the designs of Korovin, Vasnetsov and Vrubel show how the sort of work associated with Diaghilev's ballet company had their origins in Mamontov's circle. Both he and the Princess were followers of Stasov in the sense that they believed that much should be done to revive the decorative arts, and, in doing so, they turned to the peasant art and crafts. Russia participated in the general movement, which had much of its origins in the ideas and examples of William Morris.

Mamontov's main centre of activity was his country-place at Abramtsevo, which is close to the route from Moscow to Zagorsk. It was formerly the home of Sergei Aksakov, a noted Slavophil and the author of a delightful book, *A Russian Country Gentleman*, which distils much of the essence of Russian rural life in the Victorian period. The house itself is a charming wooden building. Recently, in the meadow close by we saw a painter seated before his easel. Was he the ghost of Levitan or of Repin? Wars, revolutions and turmoil slid away: we were back in the happy times of Mamontov and his friends, who made of this spot an artist's colony that may be related to Pont-Aven and Worpswede.

For many Westerners in the years just before and after the First World War, Russian art was mainly associated with Chaliapin's singing and the Russian ballets which were successfully promoted by Sergei Diaghilev and which revolutionized taste. Jean Cocteau's perfumed appreciation of Bakst's designs—neo-classical, erotic and essentially eclectic—are splendid period pieces, and it was perhaps appropriate that they were translated into English by Harry Melvill, a dandy of the '90s vintage, who sat for

29. *The Café* by Marianne von Werefkin (1860–1938), 1910. Tempera on cardboard, 67·58×87·63 cm. Marianne von Werefkin Stiftung, Ascona

30. Opposite: *Anton Pavlovich Chekhov in Melikhovo* (1860–1904), 1897

J.-E. Blanche. This sumptuous era is admirably expressed in such ballets as *Sheherazade*, *Sadko* (Figs. 20 and 21) and *L'Après-Midi d'un faune*, which present a world of exotic and sensuous dreams, corresponding to one side of the Russian temperament.

In those days, few outside Russia would have seen the famous magazine *Mir Iskusstva* (*The World of Art*), which was the organ of the movement that found its most appealing expression in the *Ballets Russes*. The publication was started by Sergei Diaghilev and Alexandre Benois. The latter gives an amusing account of the event in the second volume of his memoirs and a drawing by him, illustrated here (Fig. 19), evokes the mood of the time. Mamontov and Princess Tenisheva financed it at the start: then Nicholas II was the patron. Space was given to Beardsley and Mackintosh, and, significantly, to Vasnetsov (the first number), as to the writings of Balmont, Blok and Merezhkovsky and to music. The banner under which the review sailed—'Art is Free, Life is Paralysed'—shows that its supporters were adherents to the 'art for art's sake' theory, which, if then relatively common in England or France, was an innovation in Russia, where intellectual discussion about heavy moral problems was as much a staple part of the diet as rye bread or *kvass*. *The World of Art* forms a graceful intermezzo before pressing political considerations once again made their impact in Russia.

The World of Art movement could only have flourished in cosmopolitan St. Petersburg. Benois, a latter-day man of the eighteenth century, found a spiritual home in the Palmyra of the North, or else at Versailles, which formed the theme of his first ballet, *Le Pavillon d'Armide*. Significantly, too, he was a brilliant illustrator of Pushkin's poem,

The Bronze Horseman, which is set in St. Petersburg. Perhaps Benois's most appealing ballet was *Petrushka*, first performed in Paris in 1911 and given many times since then. This is appropriately set in the city which its designer loved deeply and the ballet evokes St. Petersburg's fairytale appearance under a covering of snow. Not that the ballet lacks pathos: the sense that life is illusion, expressed in the tragic clown.

Benois's connexion with the theatre and ballet was important, for, as he worked not only as a designer but as a scenario writer and a producer; his prolific activity underlined the way in which in Russia the artist was more intimately related to the theatre than in other countries. This helps to explain how theatre craft was original and innovatory there, providing an example of the *Gesamtkunst* longed for by Wagner and inherent in the principles of Art Nouveau.

One of the most fascinating late-nineteenth-century Russian painters was Mikhail Vrubel, who endured poverty and lost his reason. As a young man he had discovered Byzantine art when restoring the wall paintings in St. Cyril in Kiev, and later he studied in Venice. He was one of the Mamontov circle and reacted against the social painting of his first master, Repin, evolving a style akin to that of the Art Nouveau painters. He won a reputation with his water-colours and oils on the subject of the Demon, as a result of a commission to illustrate Lermontov's poem, *The Demon*, in 1890. When Maurice Denis was in Russia in 1907 (Diaghilev gave him dinner at Cubat's), he noted how collectors were keen to own pictures of devils by Vrubel. Vrubel's brilliance is revealed in his unfinished portrait of Bryusov. A close friend of Vrubel was Valentin

Serov, who did for Russian High Society what Sargent and Blanche did for the London and Paris upper crust; his portraits include a touching one of Nicholas II and a delicious one of Princess Orlova (Fig. 26). He had a strong technique and his portrait of Korovin in the Tretyakov Gallery, Moscow, is a masterpiece of its type. Recently a two-volume edition of Serov's journal, memoirs and letters has been published in Russia.

Another artist of merit was K. A. Somov, whose father wrote the catalogue of the Old Masters in the Hermitage; the son, according to Walpole, was a 'sad, charming ugly man, a little like Reggie Turner and Robbie Ross'. Walpole shared a flat with him in St. Petersburg and considered him to be 'the most famous Russian painter living—very cosmopolitan, has lived much in Paris and Berlin'. Somov's erotic drawings and evocative paintings have a *fin de siècle* charm, reminiscent of Conder's. What a pity, however, that Walpole, who was very fond of him, did not tell us more about him, but he does record that when the troubles broke out they would often go to the circus in the evening. Some connexions may be seen between Somov's work and the early paintings of Kandinsky.

The work of Serov and Somov was far removed from politics and from the new situation that developed after the abortive revolution of 1905, which engaged the attention of many writers such as Bely, whose brilliant novel, *St. Petersburg*, is in the tradition of *War and Peace*. The repercussions of this dramatic event can be followed in the writings of Maurice Baring. He was a former diplomat, turned journalist, who was an excellent translator of Russian poetry and later a polished novelist delighting in the great world of the pre-1914 era. He wrote an account of Russian life, *A Year in Russia* (1907), which was banned by the Imperial censor. He was at home not only in Moscow and St. Petersburg, where he succeeded Harold Munro (Saki) as correspondent of the *Morning Post*, but in the country, where he would stay with the Benckendorfs at Sosnofka. He had covered the Russo-Japanese War and he was in a position to evaluate the Russian internal situation; he spotted the importance of Stolypin, who was assassinated in September 1911. Baring summed up this statesman's role as follows:

Stolypin's policy of 'Order first, Reform afterwards', had two results: firstly, as soon as order was restored by Stolypin, all ideas of reform were shelved by his successors. Stolypin himself was assassinated. Secondly, in the eyes of the Administration criticism became the greatest crime, because criticism was held to be subversive to the prestige of the Government. The officials, and especially the secret police, throve and battened on this situation. Accordingly, as order was restored material prosperity increased: but this was a palliative and not a remedy to the fundamental discontent. It only led to moral stagnation.

Stolypin remains a controversial figure. Those who feel that he was one of the most positive men of his time, whose plans for agrarian reforms hold a solution for Russia and who might have saved his country from its fate, would do well to read the brilliant contributions by Harry T. Willetts and Karl C. Thalheim to *Russia Enters the Twentieth Century*; these confirm his stature.

The years leading up to the War and the Revolution were rich in artistic activity and the increased prosperity of the country no doubt had something to do with this flourishing situation, as any good Marxist would doubtless admit. In

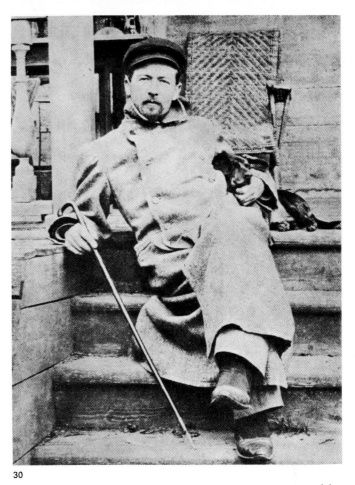

30

Western Europe there has been an increasing recognition of the achievement of the Russian Symbolists, above all the poets, and the way ahead was shown as long ago as 1943 by C. M. Bowra in *The Heritage of Symbolism*, which placed Alexander Blok as a contemporary of Valéry, Rilke, George and Yeats. Since then the general reader has learnt to value other Russian symbolist poets such as Anna Akhmatova.

As yet, however, the achievement of the Russian Symbolist painters is not so familiar as it deserves to be, although recently the personality of Borisov-Musatov is becoming better known. He spent many years in Paris but he died in Tarnsa, Russia, in 1905 and John E. Bowlt, who has studied his work and that of his contemporaries, has rightly compared certain of his pictures with Blok's poetry.

An interesting new group was the Blue Rose movement, which reflected the aspirations of the second wave of the Russian Symbolists, and in this issue we publish an article by Mr. Bowlt dealing with the astonishing personality of Ryabushinsky, who financed the short-lived review, *Zolotoye runo* (*The Golden Fleece*). The Blue Rose artists and those connected with the magazine shunned social criticism and delighted in a world of exquisite sensations, that never-never-land that ended in 1917. The headquarters of the Blue Rose were in Moscow, where they frequented the Greek Café in Tverskoy Boulevard. Sergei Polyakov, Editor of the Symbolist review *The Scales*, recalled: 'I think their main occupation was to sit in the "Greek", to argue, to discuss matters of art, to dream irrepressibly, to build fantastic plans and to subject all they had seen at exhibitions to the cruellest criticisms'. The work of artists such as Pavel Kuznetsov, Utkin and Sudeikin was shown at Moscow in the spring of 1907 at the building of the Kuznetsov firm in Myasnitskaya Street in the centre of the city; it was presented in the careful and aesthetic way

inaugurated by Whistler. John E. Bowlt admirably describes the scene:

the walls of the rooms were covered in dark-grey material and the floor was carpeted throughout; the scent of hyacinths, lilies and daffodils and the strains of a string quartet pervaded the atmosphere; in the evenings fashionable 'Art Performances' were given at which Bely, Bruysov and Remizov read their works; Cherepnin, Rebikov and Scryabin played their music and a certain Madame K - ya performed Greek dances; the artists themselves were present, well dressed and with asters in their button holes . . .

The exhibition, wrote one critic, was like a chapel; his words provide an instance of the developing idea of art as a sort of holy vision; the pictures, to quote him again, 'are like prayers'. Be this as it may, the religious and mystical strain in Russian painting and literature at this time was powerful: the influence of Solovyev's philosophy was a vital force. The search for a spiritual element provided, too, a strong impulse towards abstraction.

Madame Marcadé in her valuable book provides useful information about the way in which Russian artists in the 1890s and 1900s went to Western Europe in search of artistic instruction. One who did so was A. Ostroumova-Lebedeva, who studied under Whistler at his studio in Paris in 1898–99. Another was the fascinating Marianne von Werefkin, the daughter of the Governor of the Fortress of St. Peter and St. Paul in St. Petersburg, where political prisoners were incarcerated. She and Jawlensky went to Munich in 1896; the choice, as Grabar wittily said, was between Paris, which represented women, and Munich, which stood for beer! Marianne and Jawlensky settled in the Gisellastrasse in Schwabing, the artists' quarter, which, by the way, has an excellent Russian restaurant. They brought with them icons, family portraits, a *samovar* and old furniture, turning their studio and flat into a centre frequented by other Russian and local artists, and not only those of Munich's Bohemia, but birds of passage such as Pavlova, Nijinsky, Diaghilev and Eleonora Duse. It was characteristic of the aesthetic attitude of Marianne and her friends, who included Kandinsky, that she confided to her diary: 'Everything bores me in the world of objects. I created for myself a life of illusions. In this everything is marvellous and visionary'.

The development of abstract art in the Russian artistic colony in Munich is a familiar story. We now see that the ideas of Kandinsky assume their full relevance only when placed in the context of Russian mysticism and the Orthodox religion. Kandinsky was a theorist as well as an artist whose book, *The Art of Spiritual Harmony* (translated into English in 1914), was read aloud and debated at the Congress of the Pan-Russia artists held in St. Petersburg in 1911–12. His contention that the artist's creation had an autonomous life, 'animated by spiritual breath, a being', must have provoked intense discussion among the audience. The banner headlines for the protagonists of abstraction over the coming years were provided by his words: 'As every other living being, it [a painting] is endowed with active powers, its creative force which does not wear itself out. It lives, acts, it participates in the creation of spiritual atmosphere'.

The considerable artistic activity of a radical sort that went on in St. Petersburg and Moscow in the years before 1917 shows that these cities may be placed alongside Paris or Munich as launching pads for a new vision of art. There were periodicals, books and exhibitions, such as the 'Knave of Diamonds' and 'Donkey's Tail', and activators such as the Burliuks, Chagall, Mikhail Larionov and Natalia Goncharova threw themselves into battle. Larionov took the lead in organizing the avant-garde; he and Natalia Goncharova favoured a colourful form of neo-Primitivism which leant on peasant art. Their lively style, sense of design and humour explain how they became such brilliant decorators for the stage. Larionov's versatility was astonishing and he has a claim on the history of modern art for his creation of a form of abstraction, rayonism, that dates from around 1912. Futurists and Cubists were also active. However, as Camilla Gray emphasizes, the Russian brand of Futurism had little to do with the Italian movement of this name and Marinetti, who went to Russia early in 1914, attacked the Russians for their distortion of his conceptions.

It would take us beyond the confines of this issue, which is devoted to aspects of the silver age in Russian art, to discuss the linguistic advances of Khlebnikov or do more than merely allude to the contribution of Malevich and Tatlin. Their real chance came during the heady, if relatively short, period after the Bolshevik Revolution, when the innocent felt that art could flourish. Nowadays their work has numerous admirers, but it is none too easy to decide whether such enthusiasm is due rather more to their association in the eyes of many Westerners with a 'romantic' and 'heroic' political phase than to any intrinsic quality. Constructivism was best suited, however, to the stage and to mass celebrations, and, limited though it is, underneath its mechanistic appearance it has an idealistic form that reminds us, again, of the strong utopian and messianic currents that coursed through Russian veins. But the only creator who really, and then for a short phase, evoked this new idealism was the poet Alexander Blok, whose poem, *The Twelve*, has a lyricism and artistic quality by no means easy to discern in Constructivism.

The history of Russian art is complex and intriguing during the period discussed in this issue, and especially in the years just before the Revolution; evidently much research is required before the situation can be seen as clearly as it deserves. The topic gains in interest because of the connexions between art and literature, ideology, politics and the stage. A gentle word of caution should perhaps be dropped, for the artistic quality of some of the stars may not be quite as distinguished as enthusiasts believe. Part of the fascination of the art of this period lies in the way it illumines the mystery of the psychology of a country such as Russia in which Western and Asiatic currents intermingle. The mystery of Russia remains enduring and Maurice Baring, who had succumbed to its spell, quoted in his memoirs Gogol's words: 'What is the inscrutable power which lies hidden in you? Why does your aching melancholy song echo forever in my ears? Russia, what do you want of me? What is there between you and me?'

This power lies in many directions: the sense of the implacability of fate; the role of evil which makes *The Possessed* a tract for our times; the healing power of Nature and her terror, too; the emotionalism and the suffering; and a belief in the future. Russian life has an immense relevance for our period, from which the golden glow of an earlier civilization is finally fading. To read

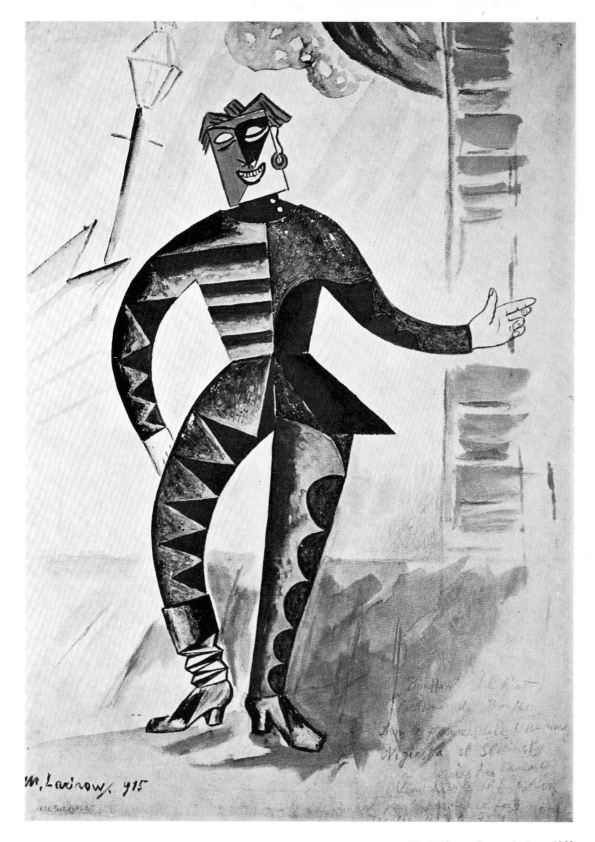

32. *Le Bouffon* by Mikhail Larionov (1881–1964), 1915. Costume design for the ballet *Chout*. Pen and gouache, 67·9 × 47·6 cm. Victoria and Albert Museum

Russian history or literature is salutary if unnerving.

The room was cold; the window had to be shut. It was dark. And the words of that unfashionable writer Rozanov, who died in poverty after the Revolution, came to mind: 'No man is worthy of praise. Every man is worthy of compassion'.

SELECT BIBLIOGRAPHY

Juliette Adam, *Impressions Françaises en Italie*, 1912; Maurice Baring, *What I Saw in Russia*, 1907; ibid, *An Outline of Russian Literature*, 1915 (revised edition, 1944); ibid, *The Puppet Show of Memory*, 1922; Alexandre Benois, 'Russia' in *The History of Modern Painting* by Richard Muther, 1893, III: James E. Billington, *The Icon and the Axe*, 1966; John E. Bowlt, 'Russian Symbolism and The Blue Rose Movement', in the *Slavonic and Far Eastern Review*, LI, April, 1973, pp. 161–81; ibid, 'Synthesism and Symbolism: The Russian *World of Art* Movement' in *Literature and the Plastic Arts 1888–1930*, ed. I. Higgins, Scottish Academic Press, 1973; C. M. Bowra, *The Heritage of Symbolism*, 1943; Mary Chamot, *Natalie Gontcharova*, 1972; Waldemar George, *Larionov*, 1966; Camilla Gray, *The Russian Experiment in Art 1863–1922*, 1962 (new edition, 1971); Jelena Hahl-Koch, *Marianne Werefkin und der russische Symbolismus*, 1967; G. H. Hamilton, *Art and Architecture in Russia*, 1954; George Katkov, *Russia 1917, The February Revolution*, 1967; Valentine Marcadé, *Le Renouveau de l'Art Pictural Russe*, 1971; Maurice Paléologue, *An Ambassador's Memoirs 1914–1919*, 1923–25 (new English edition with introduction by L. B. Schapiro, 1973); Hugh Seton-Watson, *The Russian Empire 1801–1917*, 1967; *The Life and Letters of Anton Tchekov*, ed. S. S. Koteliansky and Philip Tomlinson, 1925; Ruth Kedzie Wood, *The Tourist's Russia*, 1913; *Russia Enters the Twentieth Century*, ed. George Katkov, Erwin Oberländer, Nicolaus Popper and Georg von Rauch (German edition, 1970, English edition, 1971, paperback, 1973); 'Art in Revolution', Arts Council, 1971; 'Russischer Realismus', Kunsthalle, Baden-Baden, 1972–73; Baedeker's and Nagel's guides to Russia.

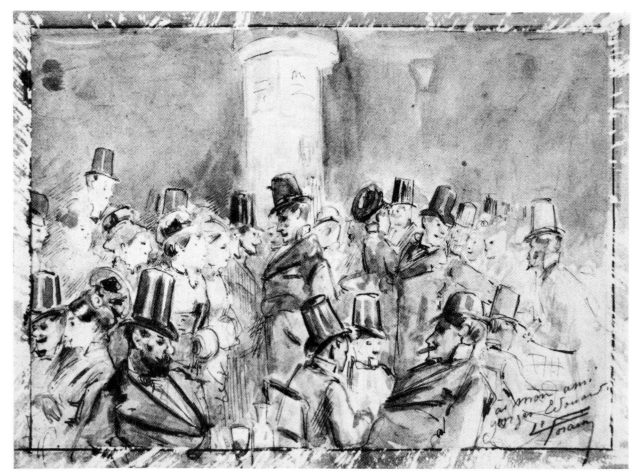

1. *Le Boulevard* by Jean-Louis Forain (1852–1931), 1880. Pen and wash, 17·6 × 25·5 cm. Gift of Léon Suzor, 1952

All the works illustrated, except for Figure 7, belong to the Musée Carnavalet, Paris.

'A Rose's Place among our Memories'

These pages are dedicated to Jean Adhémar
as a token of a long friendship.

The changes that have occurred in our period are so considerable that assumptions that recently seemed valid are now seen to be no longer so. One was that an educated person would have spent some time in Paris in his youth and would have gained familiarity with French culture. The lead had been given by Matthew Arnold, the first, but not the last, English admirer of Sainte-Beuve and Sarah Bernhardt. Not all interest in French writing or theatre was of the highbrow variety: the novels of Paul de Kock and Eugène Sue won staunch admirers on our side of the Channel and a yellow paperback was more or less synonymous with something *risqué*.

Paris was rightly considered the centre of the art world, a point probably first made in print by Thackeray. Indeed the French capital soon became the scene of those great international exhibitions that aroused such acute interest and brought many tourists to Paris. Moreover, English art students (among hundreds from other lands) flocked there either to attend the state schools, such as the Ecole des Beaux-Arts, or the private ones, chief of which was Julian's. Some idea of the way they lived in Paris may be gathered from Shirley Fox's *An Art Student's Reminiscences of Paris in the Eighties* (1909) with its amusing tit-bits about Gérôme and Helleu, William Stott and La Thangue.

A French flavour marked much advanced English

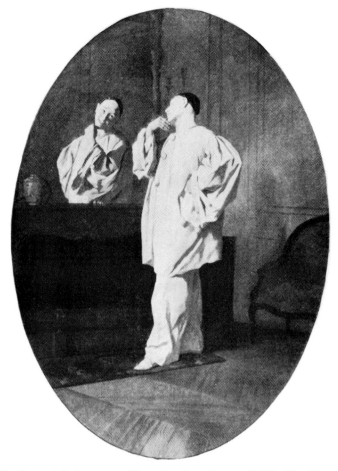

2. *La Dame aux camélias dans une loge de théâtre en 1845—Portrait of Alphonsine Plessis called Marie Duplessis* attributed to Camille-Joseph-Etienne Roqueplan (1800–33). Water-colour, 24 × 18·2 cm. Inscribed on the reverse: *Collinet flutiste, Esther: Levasseur, droite Paganini.* Acquired 1882

3. *Gaspard Dubureau en Pierrot* by Jean Pezous (1815–85). Oil on canvas, 1·54 × 1·14 m. Bequest of Monsieur Waag, 1969

painting from the 1880s onwards: the work of Sickert or Steer is an instance of this fruitful relationship. Later Roderic O'Conor and Matthew Smith were among those working in Paris between the two Wars, and too generous a love of Bohemia is reflected in Nina Hamnet's memoirs, *Laughing Torso*.

British writers did not feel the same urge to cross to Paris; George Moore went there to study art and only on realizing that he was no painter did he take up his pen. Nevertheless, a Francophile character marked much English writing from the 1890s onwards: naturalism and symbolism had their devotees. The love of French literature received a stimulus from the Bloomsbury writers and their satellites, some of whose errors of fact and judgment are pin-pointed by Christophe Campos in an entertaining study. During the 1920s and '30s a number of aspiring writers found their way to Berlin—the 'cosy bar' was a magnet!—but most remained faithful to the world of the *Nouvelle Revue Française*, which had admirable proselytizers in Cyril Connolly and Raymond Mortimer. Connolly's *The Unquiet Grave* suggests the *état d'âme* of a young man of the years prior to 1939, the last phase of Europe's grand patrician culture.

This has changed, just as Paris has changed. The Paris of romance, with its leafy chestnuts, *vespasiennes*, small bars and family restaurants, with the smell of Gauloises and the sight of men in berets and the village life of the quarter, are, if they have not quite vanished, less noticeable than they were, and expeditions are required to find them. As for the aroma of cooking that floats in the air temptingly round noon, this is now more or less submerged by petrol fumes. Yet not all is lost: food still plays an immense role in French life. Hurrah!

The way of getting to Paris has altered, too. Today it is generally in a plane, usually full of stern-looking bureaucrats clutching brief-cases and eager to make life more complicated for us all. In the old days the journey by sea and train could be tiresome, but there was a whiff of adventure as well as of ozone: whom might one pick up? The Golden Arrow sported a luncheon of quality. Who will ever forget the *hors d'œuvre* tray, the half bottles of wine and the dumb-waiter with liqueurs, or, for that matter, the elderly gent. with his bit of fluff off to gay Paree for a dirty weekend, or the Oxford don travelling with his sister and later encountered at Le Sphinx, or was it Chabanais? Alas, the Flèche d'Or, to give it the French title, is as dead as the Brighton Belle and those other crack trains with their air of Edwardian luxury. The departure from Paris

4. *Ernest Coquelin dit Coquelin Cadet (in the role of Scapin),* 1891. Bronze bust, height 52 cm. Gift of MM. Jean and G. Coquelin, 1909

5. *Marguerite Bellanger, actress and mistress of Napoleon III* by Albert-Ernest Carrier de Belleuse called Carrier-Belleuse (1824–87). Terracotta bust, height 72·5 cm. Acquired 1947

was always such fun, with the train puffing smoke in a way reminiscent of Monet's paintings of the Gare Saint Lazare.

The good old days had their disadvantages, but, whatever may be said about them, the rich local colour of many cities was undeniable. Paris had an immensely picturesque quality, one that captivated Shotter Boys and Bonington. Lovers of Paris, who cherish John Russell's book on the city, will have read with cold rage the recent changes that have been devastatingly attacked by Louis Chevalier in his remarkable *L'Assassinat de Paris,* which was brilliantly reviewed by Richard Cobb in the *Times Literary Supplement* under the poignant heading 'the city that lost its heart'. The process of modernization has its monstrous monument in the Tour Montparnasse, a grim reminder of the evil wrecked by the technocrats. What a shame the duel is no longer in vogue! If it were, the modern equivalents of the Three Musketeers could take on the ruthless city planners and bureaucrats as they dispose of history in such a heartless way.

This desecration has happened so rapidly that the visitor arrives in some anxiety that a favourite spot may

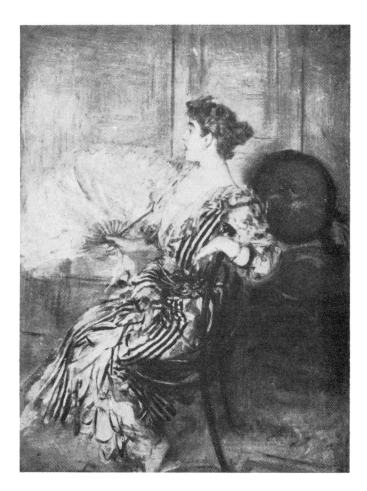

6. *Madame Torri, dancer at the Opera* by Giovanni Boldini (1842–1931) *c.* 1900. Panel, 34·7 × 26·6 cm. Acquired 1934

7. *Arthur Symons.* From Roger Lhombreaud, *Arthur Symons*, 1963. Symons first went to Paris in 1889 at the age of twenty-four and soon became fascinated by the Symbolists

8. *Portrait of Edmond de Goncourt* by Eugène Carrière (1849–1906), *c.* 1892. Oil on canvas, 55 × 45 cm. Gift of Madame Couvreux-Rouchi, 1950

have been ruined during his absence. Yet pleasures remain. One is to stroll along the Seine and look at views depicted by Corot, Lépine, the Impressionists, Bonnard or Marquet. Paris has inspired many artists; and now that Monsieur Chirac is anxious to make an impact on the artistic life of the capital, he might arrange a show devoted to painters and Paris.

Another enjoyable experience is to dwell on the associative character of particular districts—Stendhal, Sutton Sharpe and the rue de Richelieu, Balzac and the rue Raynouard, Proust and the rue Hamelin and George Moore and Montmartre.

The Irish writer penned some of the most tender descriptions of Paris ever written by a foreigner; his was the gift of being able to evoke the feel of the place. His love of Paris and his debt to French literature have been frequently studied. Although he often got his dates muddled and added a dash of blarney to his narrative, the *Confessions of a Young Man* (1888) is an enjoyable book and was influential in its day. Moore admired Gautier, Baudelaire and Balzac. The novels of the last-mentioned,

9. *Paul Verlaine*, French School, *c.* 1880. Oil on canvas, 23·7 × 18·5 cm. Acquired 1956

10. *Grisettes et Ouvriers* by Constantin Guys (1805–92). Pen, sepia and colour, 22·9 × 11·7 cm. Gift of Pontremoli, 1898

11. Opposite: *Au Joyeux Moulin Rouge*. The Moulin Rouge was often visited by Arthur Symons

12. Opposite: *Cirque d'Eté—Champs Elysées*. The circus played a large part in French artistic life

13. Opposite: *Folies-Bergère—Perroquets*. Many English dancers performed at this famous establishment

14. Opposite: *Cirque d'Hiver—La Vie Parisienne*. This poster is a reminder that the duel was a frequent occurrence in French life

10

he wrote, were 'the rock' upon which he built his church and 'his great and valid talent saved me from destruction, saved me from the shoaling waters of new aestheticism and the faint sickly surf of the Symbolists'. He and Henry James were in fact the earliest foreign writers to explore Balzac in depth.

A love of Balzac was one of the most sympathetic traits about the Baron de Charlus, who used to re-read his favourite author in the little train that took the guests of Madame Verdurin to their destination: Proust, one critic said, is written in the margins of Balzac. What a pleasure to think that the great if sardonic poet of the metropolis afforded solace to poor broken Oscar Wilde during his last days in the Hôtel d'Alsace! Vincent O'Sullivan records Wilde as saying: 'When I was a boy my two favourite characters were Lucien de Rubempré and Julien Sorel. Lucien hanged himself, Julien died on the scaffold, and I died in prison'.

A liking for Balzac is the start of a life long romance. Episodes in his books that may seem improbable become much less so when we learn more about life; then the full sweep of the *comédie humaine* sweeps over us: so does the richness of an imagination that created a city where the inhabitants were just as tormented by the struggle for power, money and sex as we are.

Balzac's vision of the world is as relevant today as in his time and many of the modern dramas that fascinate us have a Balzacian touch; his characters are universal. Balzac did not so much create types as individuals: they breathe and move. A course in Balzac should be compulsory for aspiring politicians who would soon learn about the intrigues that face them, and as they watch the antics of their colleagues, or look at themselves in the mirror, they would do well to reflect on Corentin's words in *Les Chouans*: 'Men are worth no more than I esteem them at, almost nothing'. Balzac reserved his special contempt for the liberals, and, though himself a Legitimist, he had a soft spot for the Republicans. He would have had much to say about the way in which the arts have become a ladder (alas, no snakes!) for those scrambling to enter the House of Lords. Not that Balzac's views on politics are necessarily commendable; he was a novelist, not a political pundit.

Balzac is often at his best with that world of pleasure which met for '*soupers fins*', a company made up of journalists, men about town, cocottes and adventuresses. The excellent food and wine, the flow of wit and the

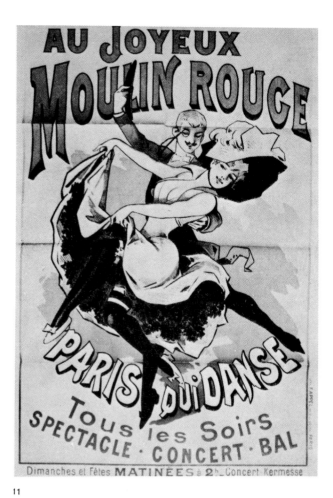

11

13

12

14

aftermath can easily be imagined. Yet it was a dangerous set; the women would strip a man to his last centime. Even to read about one of Balzac's most vivid creations, Valérie Marneffe, sends a shiver down the spine. The brilliant scene in which pretending to have been converted by Madame Crevel she takes in the wretched Crevel, that bourgeois with ideas above his station, is as vivid as a drawing by Daumier. Madame Marneffe is not confined to the pages of Balzac: she can be met with in real life and, despite her cruel fascination, is best given a wide berth. Balzac also explores the more macabre aspects of passion in *La Fille aux Yeux d'Or* and *Une Passion dans le Désert*, and Vautrin, one of the most dominating figures in his books, is homosexual.

One English writer who enthused about Balzac was Arthur Symons. 'That Balzac is the greatest, the most profound thinker in French literature after Blaise Pascal is certain', he wrote. Balzac was just the author for a young man excited by the new and astonishing world offered by Paris. Symons was fascinated by the abnormal character of some of Balzac's writings, relating them to the works of Toulouse-Lautrec, and for all his talent, he was apt to go out of his way to dwell on perversity, though he himself was a mild creature.

Symons first crossed to Paris in 1889 with Havelock Ellis and, as the latter recounted, he had 'never left the roof of his father, a Puritanic Wesleyan minister'. Ellis introduced his young companion to wine and cigarettes, but they kept away from women. When Symons returned to Paris the following year, again with Ellis, they put up at the Hôtel Corneille in the place de l'Odéon, which has been described by Balzac in his story *Z. Marcas*.

Symons and Ellis were soon in touch with interesting circles, visiting the salons of the American painter Dyer and Madame Darmesteter (Mary Robinson), who before her marriage was Vernon Lee's little friend and who became a polished introducer of French literature to the English. More unusual was the way the two young enthusiasts got acquainted with leaders of the *avant-garde*, such as Rodin, Mallarmé, Huysmans, Odilon Redon, Verlaine and Remy de Gourmont. Symons was the right man in the right place; his cult of 'sensations and impressions' enabled him to appreciate, more deeply than other Englishmen of the time, the finer points of modern French art and literature.

His visits to Paris supplied material that lasted him for years. He dug himself into the Paris literary scene: Remy de Gourmont reviewed his poems in the *Mercure de France*; in turn he wrote about a French translation of De Quincey's *Confessions of an English Opium-Eater* and in March 1891 he published an essay on Redon in *La Revue Indépendante*. His poems, some of which were inspired by Degas and Paris night life, show his devotion to French culture, even if at times his passion for the Symbolists and concern with 'sin' seem a shade overdone. Anthony Powell had a point when noting that Symons lacked a sense of humour. Something too deliberate marks his conscious belief in decadence; he makes the reader aware that he is ever struggling against his nonconformist background. However, there is no denying that there was a strong element of diabolism and that the macabre existed in French culture during the epoch of the Romantic

agony, as Mario Praz very rightly called it.

Symons became especially friendly with Verlaine and would often visit him in hospital. He was instrumental in bringing him to London in 1893 and left a valuable account of the visit which was first published by Roger Lhombreaud in his excellent book on Symons (1963). Verlaine told Symons that 'all his misfortunes' came from a woman he had picked up after leaving the Alhambra some twenty years previously. Through Symons, Verlaine met a number of young writers of the Rhymers' set, including Herbert Horne, later celebrated as the author of a *magnum opus* on Botticelli.

The essays on French writers, which Symons brought together as *The Symbolist Movement in Literature* (1899), revealed his understanding of this type of literature: he had the intuition to spot the talent of Jules Laforgue (as did George Moore) and of Mallarmé, although Verlaine was ever his hero. His interpretation has the freshness that comes from personal discovery rather than from the performance of an academic task, and his essays exerted considerable influence on T. S. Eliot and Edith Sitwell, as both acknowledged.

Symons's literary judgments are often pertinent; moreover, they show the way in which a poet such as Verlaine was appreciated at the time. He was prepared to criticize the later work, but maintained that in his finest poems Verlaine had the ability to capture the '*nuance*'. He wrote:

To fix the last fine shade, the quintessence of things; to fix it fleetingly; to be a disembodied voice, and yet the voice of a human soul: that is the idea of Decadence, and it is what Paul Verlaine has achieved.

Symons greatly admired the Brothers Goncourt. He knew Edmond de Goncourt and gave a vivid account of a visit to the old writer at Auteuil in May 1892, describing him surrounded by his Japanese objects, turning over the pages of his albums with their Japanese prints, and delighting in his eighteenth-century French drawings. Unlike most modern critics Symons considered that the work of the two brothers 'is perhaps, in its intention and its consequences, the most revolutionary of the century'. For him it was their nervous sensibility and the 'diseased sharpness of over-excited nerves' that contributed to their way of writing, observing:

But it is this morbid intensity in seeing and seizing things that has helped to form that marvellous style—'a style perhaps too ambitious of impossibilities', as they admit—a style which inherits some of its colour from Gautier, some of its fine outline from Flaubert, but which has brought light and shade into the colour, which has softened outline in the magic of atmosphere.

In his view they were writers after the 'fine shades', and this preoccupation related them to Verlaine.

Oscar Wilde wrote to Symons in 1890 that he looked forward to talking about French art with him: it was, he said, 'the one art now in Europe that is worth discussing—Verlaine's art especially'. Regrettably the two men never exchanged much correspondence, for they would have had a great deal of interest to communicate: both knew Paris night life, though their tastes differed. Symons was typical of his generation in finding that Paris was a city that permitted him to feel free and to indulge his fancies. Paris deliberately catered for just that frame of mind.

15. *Autour du Piano* by Henri Fantin-Latour (1836–1904), 1885. Pen, 17 × 24·2 cm. Gift of Adolphe Jullien, 1910. The sitters represented are A. J. Boisseau, Camille Benoit, E. Chabrier, A.- Lascoux, Vincent d'Indy, Edouard Maître and Amédée Pigeon

Besides going to such places as the Café d'Harcourt or the Café François I, where he would meet his artistic and literary friends, he got to know Aristide Bruant, writing about his establishment, Yvette Guilbert, Mélinite (Jane Avril) of the Jardin de Paris and Nini-Patte-en-l'Air. In later years some of his writings about these themes and people were published in *Colour Studies in Paris* (1918), which has amusing illustrations, a poem dedicated to him by Verlaine and a signed photograph by Bruant. He built up a name as an expert not only on French literature but on life; he was reputed as an amorist with a taste for tarts and ballet dancers, even daring to say so in his poem 'Stella Maris'.

Symons became a well-known figure in London literary life, at one time sharing rooms in Fountain Court, Temple with W. B. Yeats, who wrote about him sympathetically in his autobiography. Symons travelled much and wherever he went looked, read and listened. One of his most rewarding experiences came when Count Lützow arranged for him to visit Dux, the grand castle of Count Walstein, where Casanova had spent his last days.

Symons was in clover on discovering a *cache* of exciting material—masses of letters, rough drafts and the fourth and fifth chapters of the twelfth book of Casanova's memoirs. Later he translated them for the Casanova Society's edition of the memoirs, published in 1922.

Fate struck poor Symons in 1908. While in Bologna he went off his head and was treated with much inhumanity. After his wife had brought him back to England he was confined to a private asylum, but later he was released and, though given only eighteen months to live, survived until 1945. He was never quite the same after his release as he had been before his unhappy experiences, but books and articles of varying degrees of quality, translations from Baudelaire and poems flowed from his pen. In 1929 he brought out *From Toulouse-Lautrec to Rodin*, which, although a shade dated, is one of his most enduring volumes.

Of all his writings on artistic topics, in fact, the essay on Lautrec is the most sustained; it is enriched by memories of the artist whom he met for the first time in 1890. He considered him extraordinary and sinister, writing:

16. *Sarah Bernhardt* by Louise Abbéma (1858–1927), 1875. Black chalk on paper with brown and grey pastel, 15 × 11 cm. Acquired 1884

17. *Gabrielle-Charlotte Réju called Réjane* by Madeleine Lemaire (1845–1928), *c.* 1885–89. Water-colour, 52 × 25·5 cm. Gift of Jacques Porel, son of the sitter, 1935

He walked, his huge head lowered, the upper part of his body which was in perfect proportion leaning heavily on his stick; he stopped—owing to the difficulty he had in walking—stared this way and that way; his black eyes shone furiously, eyes that amused themselves enormously; he began to speak in his deep biting voice and always in some unimaginable fashion—jests or jokes or bitter sarcasms, or single phrases, in which each word told; simple and brutal, mocking, serious and sardonic.

Nowadays the diabolical side of Lautrec's art, which captivated Symons, is not stressed; what then seemed to the critic astonishing and weird is now taken for granted, and if Lautrec's pictures of brothels and night spots are compared with photographs of the places they represent or the entertainers depicted, the romantic transposition that has occurred becomes clear.

Degas, Moreau, Manet and Rodin form the subjects of other pieces in this book and indicate both the breadth of Symons's artistic sympathy and his power of observation. The essay on Rodin shows that the sculptor liked him; he gave him four drawings and favoured him with his observations about, among other matters, the writing of Mallarmé, 'full of foreshortening', and the painting of Moreau. This artist, said the sculptor, '*était froid au fond*'. Rodin also spoke to Symons of his own art, telling him that his secret lay in 'exaggeration'. For Symons,

Rodin was the artist of 'ecstasy', and though this has now worn off a little, his judgement has much to commend it.

Symons was quickly carried away; he had only to mention the boulevards to be reminded of writers and artists, such as Balzac and Flaubert or Gavarni, Daumier and Guys; 'the boulevards' live on, he said, 'in their works', and he was right. Guys is pre-eminently the poet of Paris; constantly inspired by the daily scene, he turned out 'copy', usually of a delightful nature, on the world of the *boulevardier*. His delicate water-colours—those of a Parisian Utamaro—evoke the pleasures of the Second Empire, a period which had far more to recommend it than Leftish historians often choose to allow; he found attractive models in the horsemen riding in the Bois and the carriages with their elegant occupants. He was ever responsive to women, 'ladies of the night' especially; his delicate brush has the power of suggesting the *frou-frou* of crinolines and stockings and of making a later generation regret the advent of jeans and the retreat of the skirt. Or, he takes us to low haunts and shows us whores who have reached the end of the line. No wonder that Baudelaire considered him the poet of modernity!

With his delight in Parisian entertainment Symons belonged to a long line of Englishmen, and typically

214

when the banker Sir John Dean Paul went there in 1802 he entitled his souvenirs of the occasion as being the journal of a party of pleasure. Symons would have appreciated his predecessor's interest in the young women that could be seen at Frascati's and would have noted that, according to Paul, they could prove dangerous.

French art was not Symons's only subject. This all-round cultural journalist, writing about music, theatre, ballet and travel, championed a belief in the equal value of the arts. The time is now to hand when a selection of his writings should be made: it could make a charming and instructive volume; it would confirm the status of a man who had the good nature and taste to assist James Joyce.

Over the years the entertainment world in Paris had become astonishingly varied, including at the start such places as the Amphithéâtre Anglois. The stage was long dominated by Frédérick Lemaître, a marvellous actor with a gift for repartee. When one luckless author complained that he was trampling on his prose, the actor riposted: '*On dit que ça porte bonheur*'. Lemaître appears in the magical film *Les Enfants du Paradis*, in which Jeanne Moreau won every heart and Jean-Louis Barrault excelled himself in the role of the mime. This character was based on Debureau, to whom Jules Janin devoted a book. The Gaité, the Gymnase, the Renaissance and many other theatres were brilliant centres of the Thespian art: dramatists, players, critics—a scintillating group—aroused intense enthusiasm among French and foreigners alike.

Symons got to know Antoine and saw Sarah Bernhardt, the brothers Coquelin, and Réjane. Réjane particularly charmed him, and he wrote about her performing in a variety of plays, including Sardou's *Madame Sans-Gêne* and Becque's *La Parisienne*, in which she must have been splendid. Symons brings this notable *artiste* to life:

Throughout she speaks with that somewhat discontented grumbling tone which she can make so expressive; she empties her speech with little side shrugs of one shoulder, her sinister right eye speaks a whole subtle language of its own. The only moments throughout the play when I found anything to criticize are the few moments of pathos, when she becomes Sarah at second hand.

And he compares her appearance in another play to a drawing by Forain.

It is usually tantalizing to think of past stars and their triumphs; their magic soon vanishes. One English writer with the knack of bringing an actress alive was Maurice Baring, novelist, essayist, journalist and one-time diplomat. He has his devotees: his books on Russian life and literature are admirable; his novels, *C* or *Cat's Cradle* exude the perfume of a vanished cosmopolitan society; his anthology *Have You Anything to Declare?* is a perfect bedside book. Yet one volume rarely mentioned is the small study of Sarah Bernhardt, published in 1933. Like everything else Baring wrote, it has a deceptive simplicity; part of the pleasure it affords arises from its style and elegant punctuation. No doubt Edward Marsh, most gifted of 'cannibals' had a hand.

Baring's book is a model of its kind. In a sense he makes bricks with straw: recollections of past performances, seasoned with occasional anecdotes; and yet the result is a sketch, as vivid as a Sargent, of this majestically passionate actress. He avoids reference to her private life; she was devoted to her son, who liked spending

18. *Yvette Guilbert* by Leonetto Cappiello (1875–1942), 1899. Painted plaster statuette height 34 cm. Gift of L. Cappiello, 1931

money, as the present writer's father, who knew them both, well remembered. And in one sense, the heroine of Baring's book was an extension into real life of Henry James's character Miriam Rooth in *The Tragic Muse*.

Baring's volume may well make the reader long to attend some of the plays in which Sarah Bernhardt won such success, and to experience again the marvels of the French classical drama. Oh, to see *Phèdre* anew! It makes the Londoner realize how much was owed to Peter Daubeny, who brought French companies, among others, to London. Racine is not to every Englishman's taste, yet one recent admirer, Lord Chandos, patriot, wit and *homme cultivé*, knew much of *Phèdre* by heart.

'The most enduring monuments, the most astounding miracles of beauty achieved by the art and craft of man, are but as flotsam drifting for a little upon the stream of time . . .' are the words used by Baring to conclude his book on the incomparable Sarah. And for the aesthete the endeavour to salvage such flotsam is an absorbing task; and one of the pleasures offered by the Musée Carnavalet, a museum which Baring himself cherished, is that it provides a means of experiencing '*le temps retrouvé*' and of musing over the artistic achievements and the variegated experiences that are associated with Paris.

215

The Sharp Eye of Edith Wharton

The connexions between novelists and the Fine Arts in the nineteenth century were extensive. Stendhal and Balzac, the Goncourts and Zola, Bourget and Proust, Henry James and George Moore are among those who wrote art criticism and brought artists into their fiction. The use of an artist in this way provided a writer with a device for advancing his own views about art or of representing a character who was able to move from one social group to another or stand out as a defender, often rather a gruff one, of artistic integrity. Novelists, too, made their points about a personality or his background by suggesting analogies with pictures.

Such allusions would have been appreciated by the public, for art and artists (who were often associated with Bohemianism) played a larger part in public life and discussion than they do now. The nineteenth century was the great age of passionate battles over aesthetic principles, of vast international exhibitions and of widely attended Salons and a time when the secession of artists from conservative artistic bodies aroused vivid and often acrimonious debate. The papers and journals, more numerous and extensive than in our pinched era, devoted considerable space to comment on the arts. Varied material, in fact, was available to feed the novelist's imagination.

If many novelists wrote about painting and even sculpture—that of Rodin for instance—few discussed architecture, although Mérimée, Hugo and Proust did so; even fewer commented on the decorative arts and practically none on the art of the garden. Edith Wharton in this respect was a notable exception. Indeed, her position as a pioneer and a taste-maker is not always recognized.

She lived in a golden age for the collector with modest means and loved going round the antique dealers. Lady Sybil Cutting remembered spending a morning with her in Florence, visiting Salvadori's, where 'bright and rapacious as a Robin', Mrs. Wharton pounced on this or that piece and haggled over the price with the dealer, leaving the details of the affair to be concluded by her husband, Teddy.

Mrs. Wharton's novels and stories show her brilliance in summing up a situation. She perceived the motives that make men and women commit follies and she had a shrewd eye for nuances of behaviour. She made up her mind rapidly, saw things and places quickly and was impatient. Once she had taken in a building or a work of art she rarely cared to repeat the experience; she rather

1. *Edith Wharton* (1862–1937). This famous American novelist also wrote about interior decoration, architecture and gardens. From Louis Auchincloss, *Edith Wharton. A Woman in Her Time* (Michael Joseph), 1972

shocked Gaillard Lapsley by refusing to get out of the car to look at the Bayeux Tapestry; she knew it already.

Professor R. W. B. Lewis in his recent biography of Mrs. Wharton is somewhat surprised that she should have developed such a taste for buildings and the decorative arts, but she came from a New York patrician family and so enjoyed the opportunity of seeing interiors which—as her novels reveal—were by no means without fine pieces and, even if the architecture of her city had little to commend it, Albany and New England were rich in exquisite

examples of neo-Classicism. Moreover, she had the run of her father's library, reading Mrs. Jameson, Kugler and Ruskin and looking at hand books of architecture and art.

As a young girl she had the chance of getting to know much of Europe, where her family had retreated as a consequence of the inflation that raged in the United States after the Civil War. Mrs. Wharton made good use of her opportunities.

After her marriage, she kept up with her reading, despite the demands of fashionable life, and discovered the books of J. A. Symonds, Vernon Lee and James Fergusson, whose *History of Architecture* had a considerable influence on her. Friends such as Egerton Winthrop and Walter Berry shared her interests and the former, a well-off and cultivated dilettante, accompanied the Whartons on some of their early cultural expeditions in Europe.

Shortly after her marriage, Mrs. Wharton discovered a period that delighted her—eighteenth-century Italy, one treated of in her first novel, *The Valley of Decision* (1902). This occurred in Paris where she was sitting for her portrait to Julian Story, a friend of her husband. She was restless and desperately bored for she realized that the picture was going to be a failure, but, as she recalled, 'my eye lit on an arm-chair, the most artless simple and graceful arm-chair I had ever seen.' It was eighteenth-century Venetian. She acquired pieces from this epoch which were noted by Paul Bourget when visiting her house in Newport, Rhode Island. This French writer was gathering material for a series of articles on the United States for a French newspaper, and he and Mrs. Wharton became close friends, and his books and stories were not without influence on her own.

Interior decoration fascinated Mrs. Wharton to such an extent that she collaborated with Ogden Codman, Jr., a Bostonian architect, in bringing out *The Decoration of Houses* in 1898. Presumably Codman provided the practical information, while she helped with the historical background and undertook the job of writing the text. Walter Berry, her Svengali some would claim, took a hand in the drafting—a factual theme was just the thing for a cultivated and highly literate young lawyer. In any event, the result is a polished and charming volume which reveals a close knowledge of many houses in England, France and Italy such as Easton Neston, Vaux-le-Vicomte and the Villa Valmarana and of architects such as Juvara and Vanvitelli who then aroused scant enthusiasm.

The book could have been all twaddle and purple prose, but it is nothing of the sort. Mrs. Wharton—already a professional—had done her home work; she consulted the sources and her knowledge of French, German and Italian meant that she could read the texts as well as looking at the plates.

The aim of the book, which was the first of its kind for about half a century, was functional; it was designed as a guide for the wealthy American who, in those spacious days, was able to build town and country houses on a noble scale. An anonymous reviewer in the *Architect and Building News* (22 January, 1898), while making a few minor criticisms of the book, sagely observed:

When the rich man demands good architecture his neighbors will get it too. The vulgarity of current decoration has its source in

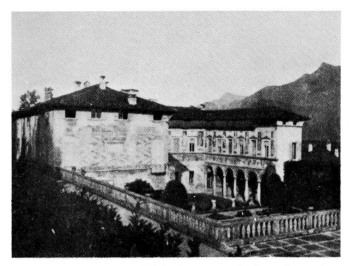

2. *Villa Cicogna, Bisuschio.* Edith Wharton was the first writer to devote a book to Italian villas and gardens which was published in 1904

3. *Bath-room in the Pitti Palace, Florence decorated by Cacialli.* An illustration from *The Decoration of Houses* which Edith Wharton published with Ogden Codman, Jr. in 1898

the indifference of the wealthy to architectural fitness. Every good moulding, every careful detail, exacted by those who can afford to indulge their taste, will in time find its way to the carpenter-built cottage. Once the right precedent is established, it costs less to follow than to oppose it.

Mrs. Wharton and Codman argued that 'Proportion is the good breeding of architecture' and that rooms should be harmonious. The authors provided details about how this could be secured, drawing their precepts from a wide range of comparative material, especially French interiors, but, no doubt as a reflection of Mrs. Wharton's taste, space

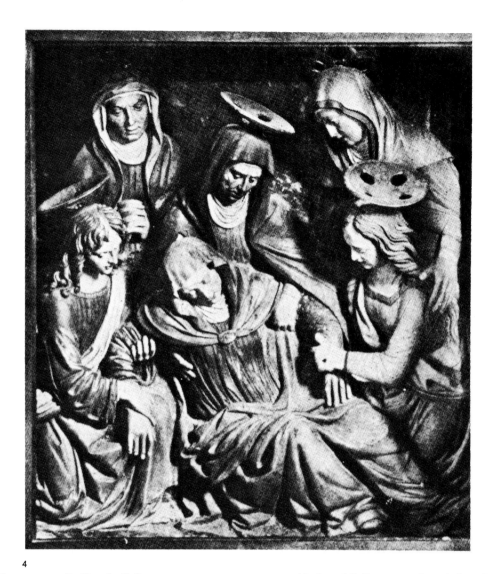

4

was found for references to Italian buildings.

One unusual feature of the volume was the space devoted to the problem of decorating the schoolroom and nursery. The proposals made by Mrs. Wharton and her collaborator were advanced for the time and should find a mention in any history of pedagogy. There should be no place in the school room they claimed, for 'the mildewed Landseer prints of foaming, dying animals, the sheep-faced Madonnas and Apostles in bituminous draperies, commemorating a paternal visit to Rome in the days when people bought copies of the "Old Masters" '. The novel suggestion was made that reproductions of sculpture and drawings that would illustrate either historical or botanical points or of works likely to appeal to children should be hung in rotation in the schoolroom. Bronzino, Van Dyck, Drouais, Velázquez, Murillo and Della Robbia are some of the artists they mentioned. In addition, there could be displayed reproductions of fragments of the Parthenon frieze, busts of great men and of animals from the Assyrian lions down to those of Canova and Barye. The authors maintained: 'the development of any artistic

taste, if the child's general training is of the right sort indirectly broadens the whole view of life'.

Codman is now a shadowy figure. However, Professor Lewes records that he helped Mrs. Wharton over her first house, Land's End in 1893, but that when she consulted him over building The Mount, which was modelled on Wren's Belton House in Lincolnshire, they fell out over the estimate. They seem to have made it up and were certainly on terms again by 1903.

During the 1900s Codman built up a good practice in New York and Newport, mainly as an interior decorator. The interiors of Morse House, Newport and the Victor Sorchen House on Madison Avenue, New York (illustrated in the *Architectural Record*, July 1905) are polite versions of Louis XVI. The anonymous commentator on his work in this periodical considered it to be too dainty and without virility; it lacked 'the liveliness which Mr. Stanford White and others have succeeded in imparting to their successful apartments'. Later Codman married a wealthy woman; either just before or after the First World War he is known to have designed the Villa

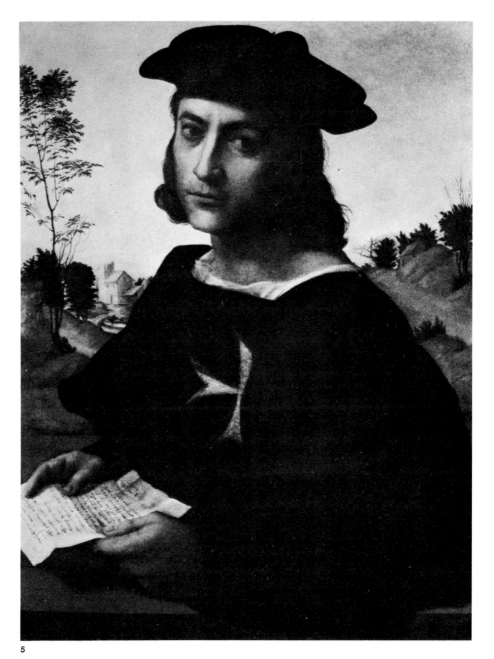

4. Opposite: *Lo Spasimo or The Swoon of the Virgin* by Giovanni della Robbia (1469–1525), *c.* 1514. Terracotta. Edith Wharton was the first to suggest in *Italian Backgrounds* (1905) that some of the figures in a chapel near the Church of San Vivaldo (Montefiore), were not by Giovanni Gonnelli, as supposed, but by Giovanni della Robbia. Her opinion was endorsed by Allan Marquand

5. *Portrait of a Knight of Rhodes* by Franciabiagio (*c.* 1482/3–1525), 1514. Panel, 60 × 45 cm. National Gallery, London. One of Edith Wharton's favourite Italian paintings, as she revealed in *A Backward Glance* (1934)

5

Leopolda at Cap Ferrat, which is now occupied by Colonel Paul. Professor Lewes tells us that, when Mrs. Wharton suffered a stroke in 1937—the year of her death—she was taken to Codman's château de Grégy, south of Paris.

Love of Italy was an article of faith for many Americans of Mrs. Wharton's generation and Berenson, Loeser, Henry Cannon and Ralph Curtis were only some of those who made their homes there. Readers of *The Golden Bowl* hardly need reminding of how Transatlantic wealth helped to *rédorer le blazon* of many an impecunious Italian nobleman. Italy inspired books and essays by Hawthorne, Howells and James. Mrs. Wharton was of this company and she made a major contribution to the study of Italian culture with her notable book, *Italian Villas and their Gardens* which came out in 1904 and was the result of a commission from the *Century* to write articles to accompany a series of pictures by Maxfield Parrish, who is now enjoying something of a vogue. The magazine expected a series of pieces of a type then only too common, rich in romantic local colour, but little else. She produced something quite different; a cogent and original account of a then little-known subject.

Her subject suited her admirably. She was fortunate in being a friend of Vernon Lee, who furnished her with much information about Tuscan villas, and her own social position gained her the entrée. She and Teddy engaged in many expeditions in their hunt for out-of-the-way places. Only once did they go by car; this was when the American Ambassador in Rome, George Meyer, drove them out to the Villa Caprarola. Many of their other journeys were undertaken by horse and carriage. They had to put up with long waits at stations. Once when they were at Pavia station they opened their tea-basket for Mrs. Wharton to boil water but the train came in; she and Teddy had to fight their way on board with cups in their hands.

Mrs. Wharton would have shone as an historian if she had not become a novelist. The volume on villas and gardens is distinguished by its happy blend of elegant style and precise scholarship. She had mastered the literature on the subject and she provided the reader with lists of architects and landscape-gardeners. Her book was a pioneering one, for the only previous specific modern

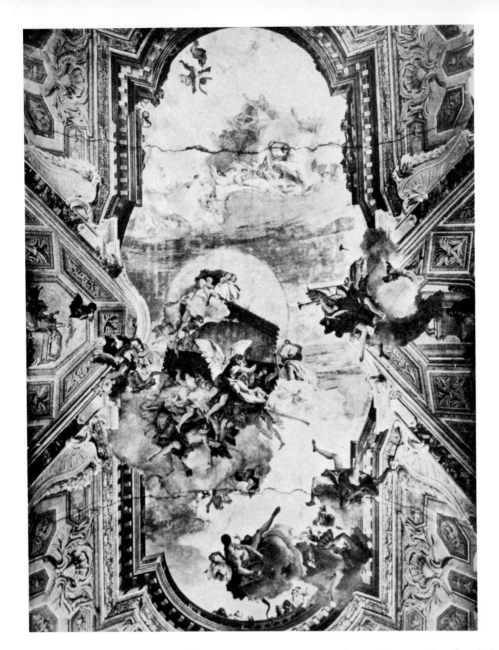

6. *Miracle of the Holy House of Loreto* by Giovanni Battista Tiepolo (1699–1770). Edith Wharton considered this ceiling decoration (now destroyed) in the Scalzi, Venice as 'an epitome of eighteenth-century Venetian art'

publication to deal with Italian gardens was that on the Renaissance garden, published by W. C. Tuckermann in 1884. However, she had the advantage of reading Jacob Burckhardt and Cornelius Gurlitt, to whom handsome acknowledgement is paid.

Mrs. Wharton made her points sharply; she wasted no time. For instance, she grasped the individuality of the garden in Italy as compared with its counterparts in other countries. 'The Italian garden,' she wrote, 'does not exist for its flowers; its flowers exist for it; they are a late and infrequent adjunct to its beauties, a parenthetical grace counting only as one more touch in the general effect of enchantment.' She realized that in Italy the architect understood that the garden had to be blended with the landscape and related to the architectural lines of the house it adjoined and to the requirements of the inmates of the house.

The text is by no means exclusively analytical and is relieved by evocative passages. One especially attractive one is about the theatre of the Villa de' Gori in Siena. She had her favourites, such as the Villa I Collazzi near Florence, the Botanical Gardens at Padua, the Villa Cicogna (Fig. 2) and the Villa Strà, that jewel on the River Brenta. She knew how to sum up the contribution of a man or a period with concision and clarity. 'It was,' are

her words, 'in their guidance of rushing water that the Roman garden-architects of the seventeenth century showed their poetical feeling and endless versatility...'

There was nothing narrow-minded about her attitude. She made the excellent point that the quarrel between those who cared only for 'the artificial natural' and those who favoured nothing but the 'frankly conventional' was a false one: 'both these manners are manners, the one as artificial as the other and each to be judged, not by any ethical standards of "sincerity", but on its own aesthetic merits'. She was alert to modern views and observed that Italian architecture after Palladio and Vignola was only recently recognized and that this was largely owing to the efforts of Gurlitt.

Since her day much more information has been discovered about villas and gardens in Italy—the books of Georgina Masson and Sir Harold Acton are proof of this —but her volume may still be read with profit and enjoyment, as Sir Harold acknowledged in his recent study of Florentine villas.

Books about Italy were so plentiful in the 1900s that it was difficult for a writer to find anything new to say. Edith Wharton managed to find something in *Italian Backgrounds*, which was composed of sketches she had started to write in 1894, but it came out only in 1905, the

7. *Monument of the Cardinals of Amboise in Rouen Cathedral.* An illustration from Edith Wharton's entertaining *A Motor-Flight through France* (1908), a record of her trip with Henry James

year of the publication of *The House of Mirth*. It included essays about Milan, Parma, where she delighted in the Farnese theatre, the Sanctuaries of the Alps, a theme which also attracted Samuel Butler, and Venice.

Her liking for the unusual gave her the most 'delicate pleasure' in attempting to circumvent the compiler of guide-books and in finding something new. She succeeded in doing so when she and her husband found their way to San Vivaldo in Tuscany. Her aim was to see a group of terracotta figures attributed to an obscure seventeenth-century artist, Giovanni Gonnelli, the blind modeller of Gambassi. She expected to find works similar to those of the Via Crucis, but on seeing them she was sure at any rate that some, notably *Lo Spasimo* (Fig. 4), were earlier and by a member of the Della Robbia family. Her hunch was correct as far as two were concerned, and though Berenson scoffed at her idea, *Lo Spasimo* and the *Pietà* have been attributed by Marquand to Giovanni della Robbia.

Knowledge of Italian painting was common among well educated women of her day and she was no exception. One of her favourite pictures was Franciabiagio's *Knight of Rhodes* in the National Gallery, London (Fig. 5); unlike Bourget, she does not seem to have written about Floren-tine or Sienese gold-ground paintings, but she shared his delight in Luini. Her writings contain references to,

among others, Bellini, Carpaccio, Botticelli, Botticini, Foppa, Gaudenzio Ferrari, Piero di Cosimo, Signorelli and Romanino.

Her taste was always individual. Characteristically she found her way to the ruined frescoes by Agostino Carracci in the Ducal villa (Palazzo del Giardino) at Parma of which she said:

This apartment shows the skill of the Carracci as decorators of high, cool, ceremonious rooms, designed to house the midsummer idleness of a court still under the yoke of Spanish etiquette, and living in a climate where the linear vivacities of Tiepolo might have been conducive to apoplexy.

Her appreciation of the Baroque, which had already emerged in her book on Italian villas, was also shown in *Italian Backgrounds* in which she suggested that it was only necessary to imagine what Rome would look like without the monuments of this period to realize the splendour of its contribution. Her plea was for objectivity: art should be interpreted as are the seasons, each with their own particularity; then the critic will 'begin to understand and to sympathize with the different modes in which man has sought to formulate his gropings after beauty'.

Tiepolo was a favourite and she admired the frescoes in the Scalzi (Fig. 6) and the Gesuati. This artist, she wrote, was a painter with a 'love of ethereal distances,

and of cloudless hues melting into thin air', one who could 'suspend his fluttering groups in great pellucid reaches of the sky'. Many years later she introduced the Scalzi in her novel *The Glimpses of the Moon* (1920). *The Marriage of Anthony and Cleopatra* in the Palazzo Labia was another favourite. Not surprisingly, she made Lily Bart in *The House of Mirth* consider appearing as Cleopatra from this picture in *tableaux vivants* but in the end this tragic girl decided to go as a Reynolds, thereby revealing her physical charms to the New York boulevardiers gathered in a fashionable drawing-room.

Mrs. Wharton appreciated Canaletto and Guardi (for her the first real Impressionist) and she had a tender spot for Longhi, as befitted a student of the comedy of manners. 'One feels', she said about his pictures, 'that he did not "arrange" his scenes, any more than Goldoni constructed his comedies. Both were content to reflect, in the mirror of a quietly humorous observation, the every-day incidents of the piazza, the convent and the palace.'

'The motor car has restored the romance of travel' were the words with which she opened *A Motor-Flight through France* (1908), an account of a memorable trip she made with Henry James. It is an enchanting book, touched with irony and humour, and both text and illustrations recall a France that existed until only the other day and that has now fallen a victim to the developer. Most of the book is devoted to her impressions of architecture and though she was well aware that she could not describe them in a professional manner, she believed that a place ought to be found for appreciative interpretation; *Gefühl ist Alles*. She proved her case, for her book is alive with original judgements as when she wrote about 'the great mad broken dream of Beauvais choir—the cathedral without a nave—the Kubla Khan of architecture'. She continued:

It seems in truth like some climax of mystic vision, miraculously caught in visible form, and arrested, broken off, by the intrusion of the Person from Porlock—in this case, no doubt, the panic-stricken. mason, crying out to the entranced creator: 'We simply can't keep it up!' And because it literally couldn't be kept up—as one or two alarming collapses soon attested—it had to check there its great wave of stone, hold itself forever back from breaking into the long ridge of the nave and flying crests of buttress, spire and finial.

Books of this type can easily fall flat; but hers is a glass of a champagne that retains its fizz. She performed a virtuoso turn in her account of the Gothic tomb of the Cardinals in the Cathedral at Rouen (Fig. 7):

A magnificent monument—and to my mind the finest thing about it is the Cardinal Uncle's nose. The whole man is fine in his sober dignity, humbly conscious of the altar toward which he faces, arrogantly aware of the purple on his shoulders; and the nose is the epitome of the man. We live in the day of little noses: that once stately feature, intrinsically feudal and aristocratic in character—the *maschio naso* extolled of Dante—has shrunk to democratic insignificance, like many another fine expressions of individualism. And so one must look to the old painters and sculptors to see what a nose was meant to be—the prow of a face; the evidence of its owner's standing, of his relation to the world, and his inheritance from the past. Even in the profile of the Cardinal Nephew, kneeling a little way behind his uncle, the gallant feature is seen to have suffered a slight diminution: its spring, still bold, is less commanding; it seems, as it were, to have thrust itself against a less yielding element. And so the deterioration has gone on from generation to generation, till the nose has worn itself blunt against the increasing resistances of a

democratic atmosphere, and stunted, atrophied and amorphous, serves only, now, to let us know when we have the influenza.

One of her most sustained and entertaining set-pieces was her description of George Sand's attractive house at Nohant.

When one recalls the throng of motley characters who streamed in and out of that quiet house—the illegitimate children of both sides, living in harmony with one another and with the child of wedlock, the too-intimate servants, the peasant playmates, the drunken companions—when one turns to the Hogarthian pictures of midnight carouses presided over by the uproarious Hippolyte and the sombrely tippling Dudevant, while their wives sat disgusted, but apparently tolerant, above stairs, one feels one's self in the sinister gloom of Wildfell Hall rather than in the light temperate air of a French province.

A Motor-Flight through France is rich in quotable extracts so that it is hard to stop citing them. She saw much, as was only to be expected in view of her energy; she enjoyed the food at Dijon, who does not? As with many of her generation her eyes had been opened by the great exhibition of French Primitives organized by Henri Bouchot in Paris in 1904, and she described pictures by some of the earlier French masters that she found on her tour. She was at her most entertaining when writing about La Tour's pastels in the Museum at Saint Quentin, observing that the 'vivid countenances' may be considered as those of 'émigrés yearning to be back across the border'. She felt that it was reasonable to fancy that 'the unmistakable likeness between all his sitters to be the result of the strong centralising pressure which left the French face no choice between Parisianism and barbarism'.

A taste for Islamic art and architecture was a feature of Parisian taste in the years just before the 1914 War. Mrs. Wharton, who had made Paris her permanent residence, was one of those who were captivated by the exoticism of mosques and Persian manuscripts. She had undertaken a journey to Algeria with Lapsley and another friend on the eve of the War, and in 1917, when she had shown her devotion to France by working tirelessly for the Allied cause, she visited Morocco. She was shown every courtesy by the French authorities and understandably became an admirer of Marshal Lyautey.

It says much for Mrs. Wharton's energy and flair that, although staying in Morocco for only a month, she used her experiences to write a volume about the country, nearly 300 pages long, which came out in 1920. It stresses her attention to detail and her customary diligence with the sources. She read up the proper authorities: for instance, the books by Gaston Migeon and H. Saladin about architecture and the decorative arts in Morocco.

Her life-long interest in decoration made her especially receptive to the aesthetics of Islamic art and her nose for novelty permitted her to make discoveries. She was the first to write about the Saadian mausoleum, hitherto out of bounds to infidels. She noted that the marble columns supporting the roof were apparently unique in Moroccan architecture: 'they lend themselves to a new roof plan which relates the building rather to the tradition of Venice or Byzantine by way of Kairouan and Cordova'. She considered the details of its ornament 'of the most intricate refinement; it seems as if the last graces of the expiring Merinid art had been gathered up in this rare

8. *Apartment of the Grand Vizier's favourite, Palace of the Bahia, Marrakesh.* Edith Wharton was lodged in this apartment during her visit to Morocco in 1917 of which she gave an account in her book of 1920

blossom'. She had the unusual experience of being lodged in the former apartment of the Grand Vizier's favourite in the Palace of the Bahia, Marrakesh (Fig. 8).

Mrs. Wharton long mixed in artistic circles. In New York she knew not only Codman and Winthrop but Edward Robinson, a friend of C. E. Norton, of Harvard, and Director of The Metropolitan Museum. Professor Lewes lists four letters from Sargent to Mrs. Wharton but does not tell us what they say; it would be easy to imagine that they had something in common. They would have met at Mrs. Charles Hunter's house, Hill Hall, Epping, where other guests often included Rodin and Money, Tonks and Sickert. Mrs. Wharton recalls meeting Max Beerbolm and Sir Claude Phillips at Bourdon House, in Mayfair, then occupied by Lady Essex (née Adèle Grant of New York). She was a friend of Sir Ian and Lady Hamilton, who was a patron of the Omega Workshops and generous to many artists.

Jacques-Emile Blanche gave her the freedom of his superb collection, with its paintings by Corot, Boudin, Degas, Manet and Renoir and its early Chinese bronzes. She particularly recalled Manet's *Young Woman with a glove* and an early Gainsborough landscape; she was also an admirer of Blanche's portraits. However, she seems to have met few artists in Paris, although, when visiting Victor Bérard, Director of the Ecole des Hautes Etudes, who lived near the Observatoire, she encountered Lucien Simon, Charles Cottet and René Ménard.

In her subtle volume of memoirs, *A Backward Glance* (1934), Edith Wharton glossed over the problems that beset her—the breakdown of her marriage for instance—but gave a delicious account of her circle in Paris. This largely centred on the comtesse de Fitz-James, who owned pictures by David and Ingres, the D'Haussonvilles and Alexandre de Laborde, an expert on miniatures. Other friends were Madame de Béarn and Raymond Koechlin,

keen collectors of beautiful objects; the latter was an authority on medieval ivories and Japanese prints. In fact, many of her set were keen on architecture, early sculpture and the decorative arts—among them Louis Gillet, Eric Maclagan, later Director of the Victoria and Albert Museum, and Louis Metman, of the Musée des Arts Décoratifs. She was also a friend of Kingsley Porter, whose notable book, *Romanesque Sculpture of the Pilgrimage Roads*, as well as Georgiana King's *The Way of St. James*, fired her with an ambition to see Santiago de Compostela. She ranked it 'not far behind Rome in the mysterious power of drawing back the traveller who has once seen it.'

Mrs. Wharton was a close friend of Berenson and took a broad interest in the arts, but she was not a collector in any real sense; the upkeep of her beautiful eighteenth-century home, the Pavillon Colombe, at Saint-Brice-sous-Fôret and her château at Hyères, as well as her charities, took most of her income. However, she owned a Cézanne of the *L'Allée du Jas de Bouffan* (Fig. 12), which was a present from Walter Berry, and Lord Clark remembers the two marvellous flower-pieces by Odilon Redon that had been found for her by Metman.

One nineteenth-century painter who captured her fancy was Turner and in *Italian Backgrounds* a laudatory paragraph is devoted to his *View at Orvieto* (Fig. 11), which she considered as a vindication of his art—'that true impressionism which consists not in the unimaginative noting of actual "bits", but in the reconstruction of a scene as it has flowed into the mould of memory, the merging of fragmentary facts into a homogeneous impression'.

Edith Wharton did more than write about artistic matters in her non-fictional works; she drew upon her knowledge of art and artists in her books. Edmund Wilson, who in 1941 called for 'Justice to Edith Wharton'—

9

9. *Fifth Avenue in 1895, looking east and south from the first Plaza Hotel.* To the right is 'Marble Row', a group of houses built by Edith Wharton's cousin Mary Mason Jones, who appeared in the novel *The Age of Innocence* (1920) as Mrs. Mingott. From Louis Auchincloss, *Edith Wharton. A Woman in Her Time*, 1972

10. Opposite: *Landscape with Sheep*, by Eugène Joseph Verboeckhoven (1799–1881), 1867. Oil on canvas, 71·12 × 60·96 cm. Courtesy of Sotheby's. In *The Age of Innocence* (1920). Newland Archer's wife, May, was given a picture of this subject by her father for Christmas

the title of an essay in *The Wound and the Bow*—observed with customary acumen that in her novels she adopted 'the practice of inventorying the contents of her characters' homes'.

This trait was best displayed in *The Age of Innocence* (1920), one of her most brilliantly observed novels, in which the theme, briefly put, is the challenge made, or rather almost made, by Newland Archer, a well-born New Yorker, to Society by contemplating abandoning his wife to run off with a member of his clan, Ellen Olenska. She had left her Polish husband, Count Olenska, and pressure was placed on her not to obtain a divorce.

The theme permitted Edith Wharton to display her talents as a reader of the heart and to sound a note of frustration and waste that marks many of her books. It is a historical novel, for the action begins in the 1870s, when she was a girl. She prided herself on her photographic memory and this is revealed in the meticulous fashion in which her characters are placed in settings appropriate to either their station in Society or their intellectual and artistic tastes.

Typical of her method, that of a naturalistic novelist in the French tradition, was her indication of the background of her characters by describing the food they ate. She was keen on the pleasures of the table, recalling in her autobiography the dishes that had been served at her parents' home which were prepared by two Negresses, Mary Johnson and Susan Minneman, 'brilliantly tur-

banned' and emerging from a Snyders-like background. When in *The Age of Innocence* Archer dines with Mr. Letterblair, the senior partner of the old-established firm of lawyers where he worked, she provides a description both of the dining-room, 'a dark shabby room hung with yellowing prints of *The Death of Chatham* and *The Coronation of Napoleon*, and the meal. Decanters of Haut Brion and port (the gift of a client) stood on the sideboard between fluted Sheraton knife-cases. The two men consumed a 'velvety oyster soup', shad and cucumbers, young broiled turkeys with corn fritters, a canvasback with currant jelly and celery mayonnaise. Mr. Letterblair tucked into his meal, for he was already a victim of the light luncheon—a sandwich and a cup of tea. Mrs. Wharton in her little book on France made a point of praising the way in which the French took time to eat and enjoy a proper repast. She tartly observes in her autobiography that James served poor food, but that he did justice to the excellent fare served by their mutual friend Howard Sturgis.

The character of a specific set is lovingly, and yet ironically, revealed in the account in *The Age of Innocence* of the dinner given by Van der Luydens, patrician leaders of old New York Society, for their English relation, the Duke of St. Austrey. He appeared in evening clothes that were so shabby and baggy and had 'such an air of their being homespun that with his stooping way of sitting, and the vast beard spreading over the front he hardly gave

the appearance of being in dinner attire'. The Van der Luyden's treasures were on display: the Du Lac Sèvres, the Trevenna George III plate, the Van der Luyden's Lowestoft (West India Company) and the Dagonet Crown Derby.

Characters were identified with paintings in this book —a method also used by Proust, whom Edith Wharton read with pleasure—so that at this dinner Mrs. Van der Luyden looked more than ever like a Cabanel and Mrs. Archer (Newland's mother) in her grandmother's seed pearls and emeralds reminded her son of an Isabey miniature. On another occasion, when Countess Olenska entered the room 'with her long robe of red velvet bordered about the chin and down the front with glossy black fur' Archer called to mind a Carolus-Duran he had seen in the Paris Salon.

Mrs. Wharton knew how to fit pictures and furniture to the people who owned them. In this novel the new rich financier Julius Beaufort, who was modelled on August Belmont, is described as being a collector of Bouguereau and Meissonier, whose paintings, in fact, were to be found in the collections of men such as Belmont, A. T. Stewart, John Jacob and William Astor and William H. Vanderbilt. Beaufort is made to scoff at the local School. On the other hand, Mrs. Van der Luyden was painted by Huntingdon (i.e. Daniel Huntingdon, 1816–1906) in the 1850s, and this portrait, which faced that of her ancestress Lady Angelica du Lac, was considered to be 'as fine as a Cabanel'. Countess Olenska's sophistication is emphasized by the way in which she gave a special touch to her rented house by introducing her 'bits of wreckage'. There were, Archer noted, 'some small slender tables of dark wood, a delicate little Greek bronze on the chimney-piece, and a stretch of red damask on the discoloured wall-paper behind a couple of Italian-looking pictures in old frames'. Archer was conversant with Ruskin and Vernon Lee, J. A. Symonds and P. G. Hamerton and had read 'a wonderful new volume called *The Renaissance* by Walter Pater'; he talked 'easily of Botticelli', and spoke of Fra Angelico with 'a faint condescension', but Ellen's pictures 'bewildered him'. They were like nothing he was 'accustomed to look at (and therefore able to see) when he travelled in Italy' Mrs. Wharton did not identify these mysterious works, but the red damask suggests that they were gold-ground pictures of a type soon to be praised by Berenson and favoured by such American collectors as Philip Lehman.

Archer's discovery of Ellen's taste provided a further bond between them. When they met at their secret rendezvous at the Metropolitan Museum, they avoided the popular Wolfe collection 'whose anecdotic canvases filled one of the main galleries [in this] queer wilderness of cast-iron and encaustic tiles'. They made their way to a room, where the Cesnola antiquities 'mouldered in unvisited loneliness'.

Archer's parents-in-law have the typical taste of their milieu; Mr. Welland gives his daughter May (Archer's wife) a 'small highly varnished Verboeckhoven *Study of Sheep* for Christmas'. Moreover, in the Wellands' home hung 'a small painting representing two Cardinals carousing, in an octagonal ebony frame set with medallions of onyx'. It was hardly surprising that Archer felt

10

a fundamental lack of sympathy with his wife.

Changes in interior decoration are used to symbolize a new era. After the First World War the widowed Archer is shown in his library, which has been 'done over' by his son Dallas with English mezzotints, Chippendale cabinets, 'bits of chosen blue-and-white and pleasantly shaded lamps'. However, Archer had declined to surrender his old 'Eastlake' writing-table.

In *The Custom of the Country* (1913) Mrs. Wharton provides an amusing and telling description of the 'Looey suites' in the Hotel Stentorian, New York, which in the case of that occupied by the Spraggs was 'hung with salmon-pink damask and adorned with oval portraits of Marie Antoinette and the Princess Lamballe'. A portrait-painter Popple, who moves in the best circles, is used as an epitome of the vulgarity that was breaking through. He was the only man in the tight little Dagonet circle who made a demonstration of being a gentleman. Mrs. Farford, the sister of the ill-fated Roger Marvell, declared about the egregious painter that 'he must be the only gentleman I know; at least he's the only man who has ever told me he was a gentleman—and Mr. Popple never fails to mention it'. How wonderfully Mrs. Wharton depicts Peter Van Degen, the florid would-be lover of the gold-digger Undine Spragg! He can easily be imagined at Chez Mouquin, so evocatively painted by William Glackens.

Mrs. Wharton lived at a time when works of art of great importance were leaving Europe for the United States and in *The Custom of the County* she used the forced sale of the famous Saint-Désert tapestries (designed by Boucher), as a symbol of the transfer of power from a dying aristocracy to a new and brutal plutocracy. They were the pride and joy of the marquis de Chelles, who had been foolish enough to marry Undine Spragg, whose new husband, Elmer Moffatt, acquired them.

11. *View at Orvieto* by Joseph Mallord William Turner (1775–1851), 1828. Oil on canvas, 91×122 cm. Tate Gallery. A glowing account of this picture appears in *Italian Backgrounds*

12. *L'Allée du Jas de Bouffan* by Paul Cézanne (1839–1906), 1867–69. Oil on canvas, 36 × 44 cm. Tate Gallery. Presented to Edith Wharton by her close friend Walter Berry

Despite his lack of scruple and his brashness, Moffatt was not without redeeming features—a genuine sympathy for his lonely little stepson Paul Marvell and a true love of art. On the table in his hotel room could be found a Greek marble, a lapis bowl in a Renaissance enamel mount and a case of Phoenician glass that was 'like a bit of rainbow caught in cobwebs'. Moffatt paid a record price for a Van Dyck and was keen on Ingres; he waived his claim to a Velázquez which the Louvre wanted—a gesture that earned him the Légion d'Honneur.

In these novels, Edith Wharton's approach was akin to that of a genre painter, but in another book, *The Reef* (1912), her touch was that of an Impressionist. This was one of her finest novels, in which James and Charles du Bos discerned the quality of Racine, one of her favourite authors. This may be erring on the fulsome side but its tone substantiates her love of the Grand Siècle. The opening scenes at a Channel port and the ensuing ones in Paris are brushed in with great freedom; the description of the bedroom in the Hôtel Terminus, where Darrow and Sophy Viner have their brief encounter, is reminiscent of a Sickert or an early Bonnard.

Analogies with painting were used by Mrs. Wharton to give accent to scenes in this book. She described how 'Among the flowers and old large pale panelled room, Madame de Chantelle had the inanimate elegance of a figure introduced into a still life to give it scale'. When Darrow looked at Sophy's body through her thin summer dress, it 'recalled the faint curves of a terra cotta statuette, some young image of grace hardly more than sketched in clay'. But when meeting her again, he felt that her 'sidelong grace' had the look of a painted picture. When he went for a walk with his intended bride, Anna Leath (she has the gentleness of a portrait by Aman-Jean or Walter Gay) they went 'through a bit of sober French woodland, flat as a faded tapestry, but with gleams of live emerald lingering here and there among its browns and ochres'.

In *The Glimpses of the Moon* (1922), a novel about an impecunious young married couple living by their wits, Suzy Lanning revealed her true and genuine self when her husband found her standing deeply moved by Mantegna's *Crucifixion* in the Louvre while he was in the mood for Correggio and Fragonard. Her description of Lanning shows that Mrs. Wharton realized that the young aesthete of the years just before the First World War was no longer a devotee of the early Italians; Lanning was an archaeologist and the author of a slender volume of sonnets and a book on 'Chinese influence in Greek Art'. Suzy when visiting him at his bachelor quarters expected to find him 'in a bare room adorned by a single Chinese bronze of flawless shape, or by some precious fragment of Asiatic pottery'. His apartment, however, contained nothing of the sort. In the same novel a German princess shows her modernity by parading her love of Russian music, Gauguin and Matisse, while a Professor Darchivio, who was preparing to give an after dinner talk, chose as his theme the difference between the Sassanian and Byzantine motives in Carolingian art.

Her skill in depicting backgrounds did not desert Mrs. Wharton in later years, and the not very satisfactory novel, *Twilight Sleep* (1927), catches the mood of the new 'modern' interior of the young Wyants' house, with its description of an 'early Kakemono of a bearded sage, on walls of pale buff silk,' and 'three money irises isolated in a white Sung vase in the desert of an otherwise empty table'.

Artists appear in many of her stories—'The Verdict', 'The Pot Boiler' and 'The Temperate Zone'. The young Lucius Harney who jilts Charity Royall in Mrs. Wharton's *Summer* (1917), is an architect engaged on a 'study of the eighteenth-century houses in less familiar districts of New England'. This story, one of her most brilliant, contains some of her finest landscape scenes, which show that her memory retained images of a part of the United States which she had not seen for many years. Her descriptions of the Mountain and the bitter-sweet mood in *Summer* or the observation of a poor farming community in *Ethan Frome* (1911) remind us that she was a compatriot not only of the opulent and cosmopolitan Sargent but of the uncompromising Winslow Homer. Edith Wharton enjoyed the good things of life—the arts and conversation, landscape and love—but, just as much as Lily Bart, she was aware that, though the Furies might sometimes sleep, 'they were there, always there in the dark corners. . . .'

The Singularity of Gino Severini

In 1946 the Harvill Press published an intriguing booklet entitled *The Artist and Society,* which treated of just the sort of topic that captured the imagination in an era of post-war reconstruction when fundamental ideas of this sort were being enthusiastically debated. It was written by Gino Severini in Italy during 1943-46 and was admirably translated from the Italian by Bernard Wall. Today, when Western civilization, plagued by anarchy, inflation and violence, is so plainly undergoing a phase of intense crisis and when the optimist has a hard job to hold to his faith, Severini's essays well repay reading. They are perceptive, positive and relevant to our time, for he stoutly championed Christian beliefs and civilized values.

It was in keeping with his character that this was so, for Severini had undergone troubles and hardships, had lost faith and then regained it and gone his own independent way. This small volume—the only one of his books available in English—is a reminder that his extensive and versatile career as a painter was complemented almost from the start, and increasingly from 1916, by that of a writer. He published a theoretical treatise, *Du Cubisme au Classicisme,* essays on Manet and Matisse and many other topics, as well as two volumes of autobiography. Although some of his essays were issued in book form in 1936 (new edition 1942) as *Ragionamenti sulle arti figurative* many slumber in the files of reviews, and it would be a pious act on the part of an Italian publisher if he were to embark on a collected edition of Severini's invariably stimulating writings.

Severini, who was born in Cortona in 1883, was known in Great Britain before 1914. His work was included in the two exhibitions of Futurist painting staged in London at the Sackville Gallery and the Doré Gallery in 1912 and 1914 and he held a one-man show in April 1913 at the Marlborough Gallery in Duke Street (no connexion with the present firm). He crossed over to London from Paris for the occasion and met Roger Fry, who was interested in his work, Clive Bell, Epstein, Wadsworth and C. R. W. Nevinson. The last-named, later to become the only British Futurist, developed into a close friend and showed him the sights, but Severini confessed that he never had time to visit the National Gallery.

Severini's painting found English admirers and, at the second Futurist exhibition, earned praise from no less a figure than Sickert. This painter confessed he would like to own *Travelling Impressions* (the now lost *Souvenirs de Voyage*) and, with a typical *jeu d'esprit,* called it an amusing and ingenious composition. 'Cruikshank', he went on, 'did something of the same sort in his big temperance picture that was the delight of my schooldays when it hung in the Kensington Museum.'

The association of Cruikshank with Severini might seem an odd one. Yet, although the Italian artist is nowadays chiefly esteemed for his Futurist painting (to the unjustified detriment of his later work), it must be remembered that this ardent theorist and intellectual had a decided sense of fun which emerges in his memoirs and his pictures of Punchinello. The strain of melancholy observed in some of his work after 1920 was by no means incompatible with a liking for the Commedia dell' Arte.

Severini had intense intellectual energy. He was largely self-taught, for his schooldays were cut short owing to his expulsion on account of a prank. When he went to Rome in 1899 to study painting, he was fortunate to fall in with some of the most lively artists of his generation, such as Balla and Boccioni. They introduced him to a new world of ideas. Boccioni made him read Marx, Bakunin, Engels and Labriola. Other friends told him about the Russian novelists and he was particularly excited by Dostoevsky's *The Brothers Karamazov,* which 'with its interminable self-analysis furnished material for no less interminable discussions of general ideas, among them, naturally enough, that of the existence of God. Just as did Alexy Fedorovitch and the brothers Alyoscha, we talked about socialism, anarchy and utopian social reforms'. The young men of his generation, he noted, were dominated by the materialistic philosophy.

Paris was the magnet for the budding artist in the 1900s, especially as little of consequence was then taking place in Italy, or elsewhere, for that matter. Severini arrived in Paris on a cold and wet Sunday morning in October 1906. He had the knack of making friends and, besides meeting his compatriot Modigliani, who took him to Le Lapin Agile in Montmartre, he got to know various French artists and writers, including Max Jacob. He was especially lucky in coming across that great man of the theatre, Lugné-Poë, who ran the Théâtre de l'Oeuvre, one of the most creative centres in Paris, where Ibsen and other dramatists were performed and where the Nabis collaborated in designing sets. Through Lugné-Poë he encountered Félix Fénéon, the former secretary of the *Revue Blanche,* then working at the well-known gallery Bernheim-Jeune, where the first Futurist exhibition was held in 1912. This original and perceptive judge of painting had special allure for Severini: he had been a friend of Seurat. Neo-Impressionism had appealed to Severini's friend

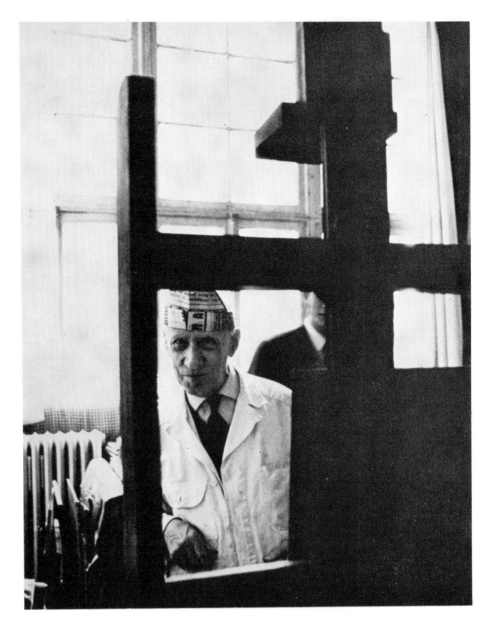

1. *Gino Severini,* 1961. The artist is shown in his studio in the Rue Schœlcher, Paris, with his grandson Sandro Franchina. Photograph by M. Glaviano

All the works illustrating this editorial are by Gino Severini (1883–1966).

Balla, and Severini had come to Paris with the specific desire to study Seurat, as he points out in his memoirs *La vita di un pittore*.

During his early days in Paris, Severini deepened his knowledge of this influential movement and painted townscapes in the divisionist technique. Miss Marianne W. Martin in her excellent book on Futurism (1968) has pointed out that one of Severini's earliest Futurist pictures, *Le Boulevard* (Fig. 2), of 1910, grew out of his neo-Impressionist phase and that in it he extended the two-dimensionalism implicit in this style.

Severini was one of the signatories of the Futurist manifesto on painting published in 1910. The impulse for this movement came from F. T. Marinetti, an extrovert live wire who had the requisite flair and drive to activate a new style and of whom R. W. Flint pithily declared in his recent *Marinetti Selected Writings* (Martin Secker & Warburg, £5):

In his role as 'the caffeine of Europe', Marinetti was a dramatic break in the smooth evolution of Italian elegaic pessimism from Leopardi to Pascoli, Carducci, Gozzano, and D'Annunzio. A monster sprung, apparently, from D'Annunzio's loins who nevertheless kept his distance from the Divine Gabriele, a man who during his best years seemed to have no inner life at all, certainly not by the reigning standards of polite letters, the first wholesale Italian enthusiast for American promotional techniques, the first important Italian disciple of Whitman and yawper of the barbaric yawp, Marinetti became one of the great intuitive sleep-walking impresarios of Europe.

The Futurist exhibition held earlier this year at the Royal Academy (which was previously on view in Newcastle-upon-Tyne and Edinburgh) showed that, although various points in common linked men such as Bocca, Boccioni, Carrà, Russolo, Severini and Soffici, each had an individual style. The first Futurist manifesto of 1909 called for a sweeping away of the past and for the glorification of the machine, but little of this may be observed in Severini's frolicsome paintings. Yet his affinity with the Futurist love of the machine is shown by his efforts to become an aviator.

In one respect Severini's pictures correspond to the Futurist manifesto. This laid down that 'we will sing of great crowds excited by work, by pleasure, and by riot'. It was the second of these stimuli that appealed to him. Like many a Parisian, he amused himself of an evening by looking in at such cabarets as Le Moulin de la Galette and the Bal Tabarin, or smart restaurants such as the Monico. In other words, he became a painter of 'Gay

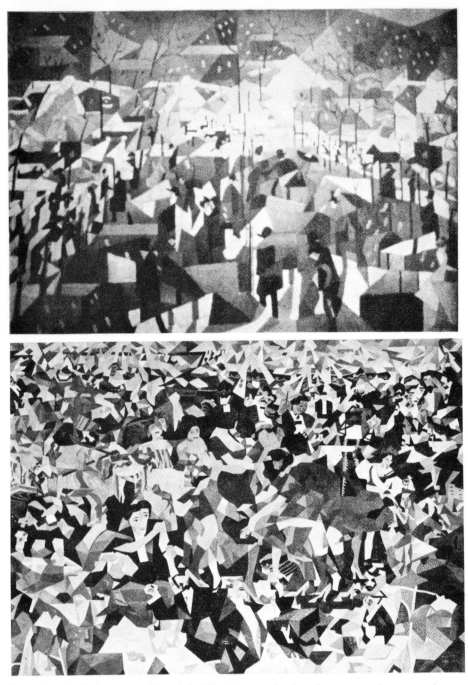

2. *Le Boulevard,* 1910. Oil on canvas, 65 × 92 cm. Collection Mr. and Mrs. Eric Estorick, London. In Severini's one-man exhibition at the Marlborough Gallery, London, 1913

3. *La Danse du Pan-Pan au Monico.* Oil on canvas, 2·8 × 4 m. Musée National d'Art Moderne, Paris. The second version of the celebrated picture (1909–11) last heard of in Germany in 1926 and painted in 1959/60

4. Opposite: *Hiéroglyphe dynamique du Bal Tabarin,* 1912. Oil on canvas, with sequins, 1·75 × 1·56 m. The Museum of Modern Art, New York

5. Opposite: *Self-portrait.* Oil on canvas, 55 × 45 cm. Musée National d'Art Moderne, Paris. The second version (1960) of the picture of 1912 in the Sprovieri Collection and now considered lost

6. Opposite: *Portrait de Madame S.,* 1912. Oil on canvas, 92 × 65 cm. Art Gallery of Ontario Gift of Sam and Ayala Zacks. 1970. The sitter was the wife of R. R. Meyer-See, formerly manager to Martin Henry Colnagi, then joint-founder and director of the Sackville Gallery and subsequently owner of the Marlborough Gallery, London

Paree' and of the agreeable night-life that made the city so tempting at the time, continuing the tradition of depicting *la vie noctambule* which had found a gifted exponent in Toulouse-Lautrec. Yet, whereas this painter fastened on quirks of physiognomy as well as on visual effects, Severini went in solely for the impression made by the scintillating movement of dancers or a crowd of diners. Edwardian exuberance gives vigour to *La Danse du Pan-Pan au Monico* (Fig. 3), which Apollinaire considered the finest Futurist picture of the time. Amusingly, and perhaps characteristically, sequins were added to his charming *Hiéroglyphe dynamique du Bal Tabarin* (Fig. 4).

Severini once recalled that Raoul Dufy had called this picture a *'peinture unanimiste'*. At this date, however, Severini was unaware of the exact significance of the term and, as he observed in the *Mercure de France,* 'my research into movement was almost unconscious'. 'Later', he went on, 'I found in this new point of contact between literature and painting only a confirmation and a certainty.' All the same, as Miss Martin points out in her book, the Futurist leader, Marinetti, was in touch with the Unanimist circle at the Abbaye de Créteil, and she

also remarks on the connexion between *Le Boulevard* and the ideas of Jules Romains.

One of the Severini's most amusing early Futurist pictures, now only known from reproduction, is *Souvenirs de Voyage* of 1909-10 (the painting admired by Sickert), which has as its subject the ideas conjured up by a journey from Italy to Paris. Miss Martin rightly notes that, although this picture bears certain relations to Russolo's *Ricordi di una notte,* Severini's 'cool, intellectual temperament was apparently foreign to the expressionist approach required for such stream-of-consciousness musings. . . .' Nevertheless, this painting heralds the sort of work he was to undertake in the 1920s when nostalgia for the classical past induced him to introduce evocative symbols into his pictures.

Many years after the event Severini recorded how when in Florence in 1911 he studied Bergson's ideas on intuitive philosophy in the Italian translation by Papini, and, like many of his generation, he was profoundly affected by the elegant speculation of this philosopher. He said:

I found in this book the justification of many of my

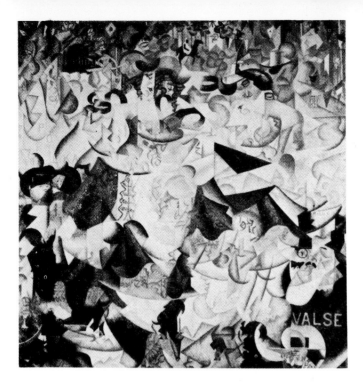

researches. After referring to Bergson's dictum 'to perceive is nothing more than an opportunity to remember', he explained:

> The perception of an object in space is the result of the recollection which is retained of the object itself in its various aspects and in its various symbols; . . . one gesture, one essential feature may, by suddenly throwing light upon our intuition, succeed in presenting to our vision the total reality.

The search for 'the total reality' fascinated him over the years and led him to adopt many and varied forms of artistic expression and to investigate the possibilities of non-representational art.

Severini was fascinated by the problem of suggesting simultaneous movement, so that his pictures of dancers or of Paris street scenes have a cinematic character. As a true Futurist he went in for analogical compositions—the *analogie reali* and the *analogie apparenti*. He made clear, for instance, that when he saw the sea it could produce, as a real analogy, a dancer and, as an apparent one, 'a vision of a great vase of flowers'. His liking for this form

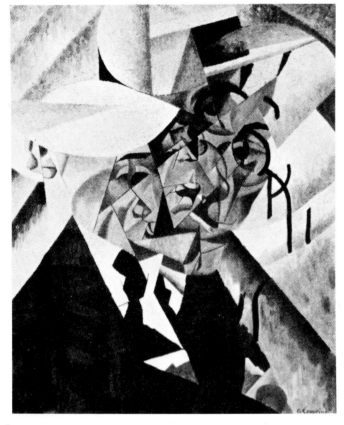

5

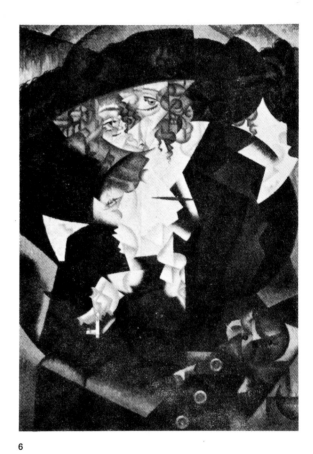

6

aspirations, as such, for example, of penetrating reality with all the sympathy of my being, a sympathy which, according to Bergson, allows a full and complete communication with the absolute, despite its being in a fugitive manner.

The Bergsonian ideas were up to date, because of the confusion of atheism with science, with intellectualism and a purely Kantian concept, Bergson finally opposed a new aspiration towards an absolute which should find an accord with science and, at the same time, afford a renewal of great spiritual ideas.

Dabbling in philosophical and aesthetic speculation was always one of Severini's hobbies. It has to be borne in mind when the nature of his art is studied. Miss Martin appositely quotes his remarks from the preface to the Marlborough Gallery exhibition as an indication of his

of mood-painting affords a link with his later compositions of the 1920s where the nostalgic atmosphere is so apparent. It was hardly surprising that he was something of a symbolist during the immediate pre-war period, for he was closely related to the circle round Paul Fort, *'Prince des poètes',* which met at the Closerie de Lilas in Montparnasse. Fort's daughter, Jeanne, became Severini's wife in 1913.

Considerable discussion has taken place concerning the relation between Cubism and Futurism. Cubism had a determining influence on the nature of the Italian movement and Severini was affected by its principles, but it has also been claimed by G. di San Lazzaro that his sparkling

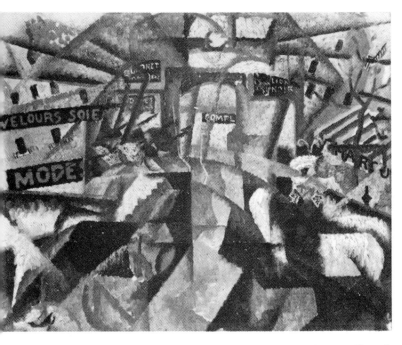

7. *L'Autobus,* 1912. Oil on canvas, 57 × 73 cm. Collection Dr. Riccardo Jucker, Milan. Exhibited Marlborough Gallery, London, 1913. Presented by the artist to Pierre Courthion

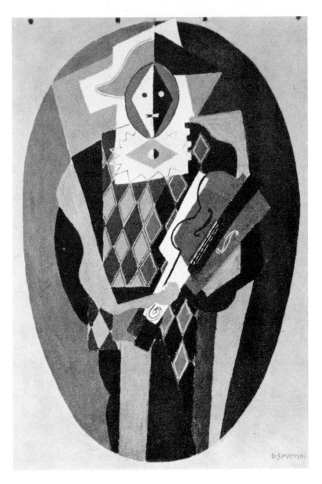

9. *Arlequin avec guitare,* 1918. Tempera, 38 × 27 cm. Collection C. Bilotti, New York

8. *Train de Blessés,* 1915. Oil on canvas, 117 × 90 cm. Stedlijk Museum, Amsterdam. Exhibited in 'Exposition Futuriste d'Art Plastique de la Guerre', Galerie Boutet de Montvel, Paris, 1918

10. *Quaker Oats,* 1917. Oil on canvas, 60 × 50 cm. Collection Mr. and Mrs. Eric Estorick, London. Presented by the artist to Dr. Raymond Geiger

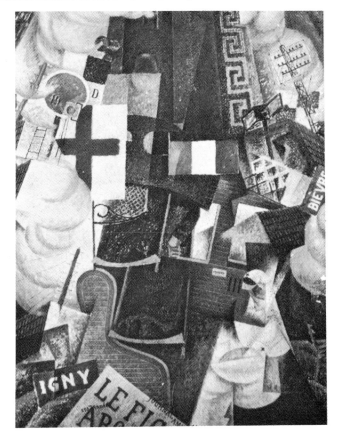

11. *Harlequin, Scapino and Punchinello,* 1921/22. Fresco. Castello Montegufoni, nr. Florence. Commissioned by Osbert and Sacheverell Sitwell

12. *Punchinello,* 1923. Oil on canvas, 65×45 cm. Gemeente Museum, The Hague. According to the artist's notes, the sitter was called Antonio and came from Sardinia

colours were instrumental in introducing a gayer note into Cubism.

A year before the outbreak of the first World War, Severini was afflicted by tuberculosis and a number of English friends, with Nevinson in the lead, raised money to pay him a small allowance. He spent some time in Italy in 1913-14 and later, during the war, he left Paris for a stay in Barcelona. The war inspired some of his most remarkable compositions, such as *Armoured Car* (Collection Richard S. Zeisler, New York) and *Train de blessés* (Fig. 8), both of which were shown at Alfred Stieglitz's Photo-Secession Gallery, New York, in 1917. (A full account of this show is given by Joan M. Lukach, *Burlington Magazine,* April 1971.)

About one of his war-time pictures, *La Guerre,* his aim, he said, was to express the idea of war 'by a plastic ensemble composed of realities—cannon, factory, flag, mobilization order, aeroplane and anchor. According to our conception of *"réalisme idéiste",* no more or less naturalistic description of the battlefield or of carnage could give us the synthesis of the idea, war, as well as these objects of which they were the living symbol'.

This passage comes from the first of his two contributions on aesthetic problems to the influential *Mercure de France.* They are full of good stuff, as when he compared the achievement of contemporary painting—Futurism and Cubism—to the poetry of Mallarmé (a point later

232

13. *Virgin and Child with Saints,* 1934. Fresco and tempera. Notre-Dame du Valentin, Lausanne. The Virgin is based on the Théotokos in the Duomo at Torcello

made by D. H. Kahnweiler in respect of the latter movement) and revealed his growing view that the depiction of movement was not obligatory for a modern artist. There was no need, he said, to abstain from painting bodies which remained still. 'For universal movement could as well reside in a chair as in a trotting horse.' For him the significant artist was the one who sought to render 'the life of all the world'. He even saw a relationship between 'our modern art', with its trend to universality, and the religious art of the Catholic primitives. He went on:

Like them, we express ourselves by synthetic forms inspired by our spiritual or intellectual life rather than by the reality of vision. We differ from them on this major point: the universality of the Catholic painters was the consequence of a religious mysticism and a deism that have almost completely disappeared. Our universality derives from a direct sense of life which we possess through science and scientific philosophy.

In the theories elaborated in the second of his articles Severini showed that he was drawing closer to a classical view of Cubism. It was one in which all was staked on the role of science: 'none of us should neglect the notions which science puts at our disposal so as to intensify our sense of the real'. Significantly he added: 'This sympathy for science also existed at the epoch of Paolo Uccello,

Andrea del Castagno, Domenico Veneziano, Luca Signorelli, Leonardo etc., who were realist painters in the largest sense of the word, as we are'.

Mr. Christopher Green in his instructive book—catalogue of the Léger exhibition held at the Tate Gallery (1970/71) observes that Severini's 'conversion was evangelically total' and that by 1916 this new style, which he terms 'an alliance between Cubist pictorial method and classical aesthetics' was firmly established in his painting. This trend may be seen in *Quaker Oats* (Fig. 10) of 1917. Severini was now in close touch with Juan Gris, Amédée Ozenfant and Diego Rivera. Whereas previously he had cultivated movement, now he cultivated order—*le rappel à l'ordre* called for by Jean Cocteau. This belief led him to paint refined still lifes in which guitars, fruit and bottles are harmoniously displayed as symbols of stability.

It was characteristic of Severini's innate elegance that this should have been so, for, although some of his Cubist pictures strike an austere note, he was not the man to prevent gaiety from creeping into his pictures. It was an augury of the future; later he revealed his skill as a decorator, in the best sense of the word.

233

14. *Still life, c.* 1935. Mosaic. Museo Braschi, Rome. Executed by Salviati, of Venice

15. *Still life, c.* 1935. Oil on canvas, 90 × 72 cm. Collection Antonella Bensi, Milan

16. Opposite: *Set for Deliciae Populi,* 1943. This was performed at the Teatro delle Arti, Rome

During this period he obviously gave much thought to the problems of painting, even taking a plunge into naturalism, as in the tender *Maternité,* now in the Accademia at Cortona. This arresting painting, dating from 1916, bears a relationship to Derain's *Deux Sœurs,* of 1913, in the Royal Museum, Copenhagen. Severini's picture is a poignant reminder that in 1916 his son, Tonio, died.

In the same year Juan Gris brought the Paris dealer Léonce Rosenberg to his studio and the second volume of Severini's memoirs *'Tempo de L'Effort Moderne'. La vita di un pittore* (ed. P. Pacini, 1968), contains fascinating details about his experiences with this dealer and Parisian art life of the time. Rosenberg kept a tight control over artists who were under contract to him; thus Severini was unable to undertake any ballet designs for Diaghilev, who admired his painting and bought one of his pictures.

Looking back at the years just before the end of the war and the early '20s, it is striking to observe the way in which painters, dealers (Léonce Rosenberg, for instance) and, more understandably, critics were eager to put pen to paper in defence of their pet theories. There was time to write and there were places in which such theorizings could be published. Ozenfant and Jeannerat were among the foremost theorists, as may be seen from their book *Après Le Cubisme,* and they founded in 1920 their own review, *L'Esprit Nouveau* (November 1920), to which Severini contributed a stimulating essay on Cézanne.

This Editorial is obviously not the place to give any account of the critical battles that then took place and of the different and complicated theories which were advanced. In any case, now that the battle is over, they make for rather heavy-going. Severini was keen to show his mettle in such conflicts and, after the two articles in the *Mercure de France* to which reference has been made, he published his celebrated *Du Cubisme au Classicisme*

16

(1921). A recent edition of this book, complete with extensive critical apparatus, has been issued by Piero Pacini, a leading expert on the artist. He not only places the book in the intellectual climate of the time, but prints various letters by Severini which are germane to the subject.

This book has to be seen in the light of the discussions that then raged about the significance of the Golden triangle and the theory of proportions, which also exercised Ozenfant and Jeannerat. Severini's thesis, put in a few words, was that painting was in disorder owing to the absence of really serious technical means. For this reason art needed to be based on a reassessment of the contributions of the masters of the early Renaissance and to be linked up with the tradition of Pythagoras and Plato, the Doric Order rather than the Ionic. In order to deepen his knowledge of such matters, Severini plunged into a study of mathematics and early theories on proportion, notably Dürer's, and argued that art should have a strong scientific basis. 'Beauty', he wrote, 'is not discovered by surprise, but little by little and almost in spite of itself.' He ended by declaring:

If I have succeeded in demonstrating how, for an artist, as for anyone who thinks, there is an identity between *Truth* and *Beauty,* between the *individual* and the *universe,* and if I have demonstrated the *necessity* to achieve artistically the expression of this identity, of leaning solidly on *science,* I will have achieved, within the limits of the possible, the aims which I set myself in publishing these notes.

His book caused something of a rumpus and was severely criticized by Ozenfant and Jeannerat. This was the start of a break between the three men, and the beginning of Severini's moving into quite different directions. He himself later confessed that he wrote it out of irritation with his dealer Léonce Rosenberg and most of the men who showed at his gallery, L'Effort Moderne. Whatever may now be thought of Severini's treatise, it shows that he had an independent mind and wrote deeply and coherently about artistic problems.

During the early '20s Severini may have been immersed in intellectual questions, even receiving lessons in mathematics, but these preoccupations did not prevent him from producing some of his most appealing pictures, with themes inspired by the Commedia dell' Arte. The Italian Comedy has offered different things to different men; those fascinated by its vigour and humour include Claude Gillot and Watteau, Giambattista and Domenico Tiepolo and, nearer our own time, Picasso, Braque and Gris, who were especially intrigued by the figure of Harlequin.

This delectable subject-matter received wider currency when, in 1920, Diaghilev staged the ballet *Pulcinella,* with music by Stravinsky and sets by Picasso—sets that are among the most attractive works by this master of stage design. Severini, who painted a Cubist Harlequin (Fig. 9) in 1918, had the opportunity to create one of the most attractive mural decorations of our time on the theme of the Italian Comedy.

He received the commission under amusing circumstances. Osbert and Sacheverell Sitwell, both lovers of stage craft and of the Italian Comedy, had tried to persuade their father, Sir George Sitwell, to commission Picasso to paint decorations for the salotto of their castle,

17. *View from a balcony, c.* 1930. Gouache on board, 34·2×50·8 cm. Beaverbrook Art Gallery, Frederickton, New Brunswick

18. *The Lute, c.* 1942. Oil on canvas, 129× 88·9 cm. Courtesy of the Acquavella Galleries, New York

Montegufoni, close to Florence. This had fallen through over the question of price. They then proposed Severini and their father, who misunderstood them, thought they said Mancini; when he heard that Sargent approved of the artist (i.e. Mancini) he gave his consent.

The brothers had bought a Harlequin by Severini at Léonce Rosenberg's and in his fascinating memoirs, *'Tempo de L'Effort Moderne'. La vita di un pittore* the artist provides details of the negotiations and the contract. Severini, his wife and their daughter Gina arrived at Montegufoni, where they were entertained to a concert by the local band headed by the parish priest and a speech by Sir George Sitwell which Sacheverell Sitwell rendered into French for the painter's benefit. It was then translated into Italian by Severini for the performers. Some years later Léonide Massine suggested that Severini should design the sets for a ballet which would have for its theme the Commedia dell' Arte and be presented by comte

Etienne de Beaumont. It would include not only figures from the Commedia, but Sir George Sitwell, his two sons, Masti, the guardian at Montegufoni, and such types as 'Luxury', 'Pride' and 'Anger'. Massine had in mind to call the ballet *Coucourroucou,* and it would have been inspired by the *Balli di Sfessania* designed by Jacques Callot. Signora Severini remembers that Pizzetti was to write the music. However, as Severini's father died at the time, he was unable to undertake the work.

Severini's frescoes are splendidly fresh and amusing; the main one shows Harlequin, Scapino and Punchinello dancing with gusto (Fig. 11), as if they were taking part in *Façade*. They place Severini in a tradition that has a long Italian ancestry and his work may be compared with the decorations for the Villa Valmarana.

Obviously, Picasso's example must have counted for something in the choice of theme, but Severini himself always treasured the memory of the itinerant company,

19. *Christ and St. Peter,* 1951. Mosaic. St. Pierre, Fribourg

including a Neapolitan Punchinello, which he had seen as a boy in his native Cortona. It is the sort of experience that may still be undergone, although Punch and Judy have replaced the live actors; such an experience we enjoyed last autumn on a Sunday morning in Bergamo. Besides the Montegufoni decorations, Severini painted other easel paintings of Punchinello, such as the amusing picture on our cover, the family of Punchinello and the Neapolitan *Punchinello* (Fig. 12). In such pictures he bought out not so much the pathos of the itinerant clown as his position as a character whose knavish tricks and shrewdness made him a symbol of independence. Severini maintained that by painting this figure he gave a human dimension to his art.

The decorations for Montegufoni were not the only works undertaken by Severini for the Sitwells at this time. In 1920 he did the end papers and a decorated spine for Edith Sitwell's miscellany, *Wheels, Fifth Cycle,* and, two years later, he was responsible for the frontispiece for the second edition of *Façade.* In 1923 he executed the two decorations for Sacheverell Sitwell's poem, *Dr. Donne and Gargantua, Canto the Second.*

The year 1923 witnessed a major change in Severini's life. He returned to the Catholic Church, going through a religious marriage ceremony with his wife; their previous one had been a civil affair. He also become a close friend of Jacques Maritain, whose Thomist philosophy greatly appealed to him. Maritain wrote a small book about him in 1930.

Severini, who continually widened his intellectual horizons, was one of the group that gathered round the review *Esprit,* which was founded by Emmanuel Mounier in 1932. Its aim was to take a stand against the commercial and political exploitation of spiritual values and creative work and to put forward a programme based on a reconciliation of classes. Its adherents were mainly adherents of Thomism and believed in its distinction between the individual and the person. Other writers and artists who adhered to the movement included Chagall, Gargallo and Pierre Courthion, who devoted a study to Severini.

Severini was able to give effect to his religious sentiments in the decorations he painted for churches at Semsales, La Roche, Tavannes, Fribourg and Lausanne (Fig. 13) between 1924 and 1934. Although this side of his work is none too well known, he was one of the most imaginative and capable religious artists of our age. His opportunity to work on such a large scale and devote himself to such a long period was largely due to the patronage of Monsignor Besson, Bishop of Fribourg, Lausanne and Geneva.

Much of Severini's time during the '20s was devoted to working in fresco and mosaic. He took naturally to the latter technique, for some of the characteristics of Futurist painting lead on to it. However, he did other work too, such as his fascinating 'surrealistic' still-life compositions, which maintained, in a non-Futurist style, the theory of *analogie apparenti,* and the emphasis was often placed in these on echoes from an antique past. Thus, comic antique masks and architectural fragments, as well as bowls of fruit and birds, were introduced into such attractively decorative compositions as Figure 14: the effect is one of epicurean delight. His ability to use such motifs for decorative purposes was excellently shown in the set of five pictures, with ruins and Harlequins, which he painted for the Paris apartment of Léonce Rosenberg in 1929.

Severini revealed his connexion with tradition in such works and, now that more is known than used to be the case about the tradition of Italian still life painting, his works may be associated with those painted in the seventeenth and eighteenth centuries. Two still lifes representing a duck and a fish (1931) and fishes (1931) bring to mind the sort of picture painted by the Neapolitan Recco, while his musical still life harks back to those of the Bergamask painters, Baschenis and Bettera. Severini pointed out in *Critica d'Arte* that this return to painting the object did not signify that he considered the essential character of art to be naturalistic representation of reality; he believed that, unless the 'form' expressed in his work contained a metaphysical and transcendental spirit, and was in fact, poetic, the presence of art was denied. He went on to claim that art should assume a hermetic character. 'I believe', he said, 'that today it is vital to make painting once more difficult and accessible to a few; difficult by reason of adherence to the craft of painting, rare on account of quality and elevated by its spiritual content.'

237

20

20. *Lumière et mouvement.* Oil on canvas, 65×45.5 cm. Courtesy Galerie Motte, Geneva

21. *Nature Morte,* 1948. Oil on canvas, 46×61 cm. Collection May, New York

21

Besides his church decorations and easel paintings, Severini undertook other types of works during the '20s and '30s. For instance, he designed the backcloth for *Façade* when this ballet, with words by Edith Sitwell, music by William Walton and choreography by Frederick Ashton, was performed at the international musical festival at Siena in 1929 and again at the Salle Pleyel in Paris in 1933. Other tasks included illustrations for Paul Fort's *L'amour, enfant de bohême* (1930) and Paul Valéry's *Le Cimetière Marin* (1930). The same year saw the publication in London by Frederick Etchells and Hugh Macdonald of the Haslewood Press of an album of sixteen gouaches by Severini with the title of *Fleurs et Masques.* This volume presents some of his most delightful artistic virtues and Osbert Sitwell in a review (*Observer,* 7 December, 1930), after pointing out that it was difficult to sum up accurately their curious nostalgia, went on:

> But with his eloquent economy and lovely deliberation he removes us to the strange southern land of vines, of fallen columns and stone heads peering from the soil, against a golden background of broken aqueducts, mandolines, masks and flowers, which is at once new and familiar, being that remote, though seemingly so near and fabulous, land in which at times all modern artists, poets, and musicians must endeavour to escape: unless, indeed, they are determined to stand by the village petrol pump and the thousand desolations of technical invention.

During the late '30s Severini continued to paint still lifes and did a number of portraits and pictures of sad-looking youths. Much of his time was taken up with decorative work. Anyone who cares to find his way around the vast and stark Palazzo del Giustizia in Milan will find relief in coming across the five upright mosaics which he did in 1936 for the ambulatory of the Tribunale Legale; these form a pleasing contrast to the Forain-like scenes that greet the visitor. He did other work in the

22. *Danseuse.* Oil on canvas, 73×46 cm. Collection Panichi, New York

same year for the Post Office at Alessandria, near Turin, and in 1937 he executed mosaics and frescoes for the University of Padua.

Severini was especially drawn to mosaic, and the still life in Roman style (Fig. 14) made after his design by the famous Venetian firm of Salviati looks almost like its ancient prototype. In an interesting essay of 1952 on mosaic and mural art Severini observed that the reason which explains the great interest afforded by ancient

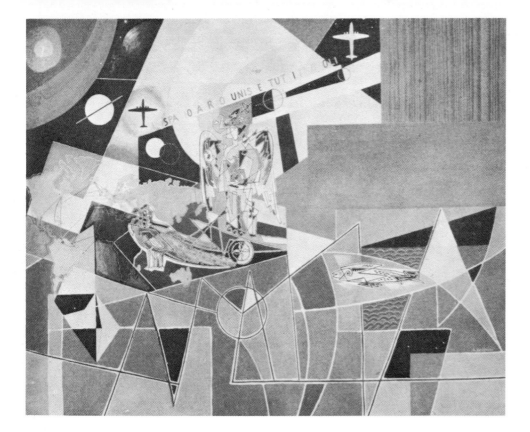

23. *Sketch for the decoration of K.L.M. offices, Via Bissolati, Rome,* 1954. Oil on canvas, 58×74 cm. Private collection, Rome

mosaics lies in 'the perfect union between art and craft'. He pointed out that when he first came across the Ravenna mosaics, he saw an analogy between them and the 'modern' art inaugurated by the Impressionists. He went on:

Thus, certain deformations found in Matisse, for example, evoke the figures in missals of the Merovingian or Carolingian time; certain figure paintings by Cézanne and Van Gogh recall the portrait of Maximilian and other Ravenna mosaics and later, Cubism and Futurism recall, both in intentions and means, the Byzantine epoch. . . . Impressionism, to which Cézanne gave a form constitutes a new vision of the world, which is not without some relationship, at least on a strictly pictorial plane, with the mosaicists of the fourth, fifth and sixth centuries.

Severini's ideas on this subject, as on many others, would repay detailed study, but it is worth emphasizing that he did not consider mosaic to be an old-fashioned medium. He saw it as one with an intense suggestive power. Noting that the Surrealist influence was discernible in many contemporary painters, he observed that these counted much on the suggestive power of forms. He went on:

The majority, ignorant of the art and technique of mosaics, do not realize how much power is gained by the material employed by the mosaicist and up to what point there can emerge from it this almost magical charm to which aspire the admirers and disciples of Rimbaud.

The mosaicist who understands his métier succeeds almost effortlessly in achieving a transposition of reality, and even the anecdote, so to say, becomes the poetical expression of a reality more dreamt about than seen.

Although always interested in the problems of stage design, Severini only had a chance of showing his skill with such work from 1938 when he did the sets and costumes for O. Vecchi's *Anfiparnasio*, A. F. Grandi's *La Strega* (1938) and Lorenzo de' Medici's *Aridosia* (1939). In 1940 he was responsible for the sets and costumes for productions of Stravinsky's *Pulcinella* and Busoni's *Arlecchino* at the Fenice Theatre, Venice. He also did

designs for Pergolesi's *Flaminia* (1942) and Goldoni's *La Casa Nova* (1943). How gracefully he accomplished such tasks is shown by the set for *Deliciae Populi* illustrated here (Fig. 16), which was performed at the Teatro delle Arti, Rome, in 1943.

Severini was now in his late fifties, but no diminution in his artistic and intellectual energy was apparent and from about 1940 his paintings revealed a new departure. It showed considerable vigour, which, as Signora Gina Severini Franchina has suggested, was probably due to the delight he took in Stravinsky's music, and in this year, it will be remembered, he had undertaken his designs for *Pulcinella*. During the war years, which he spent in Italy, he painted numerous fluent and appealing still lifes, harlequins and even nudes.

Severini's later works are none too well known. In the years immediately after the War, he returned to Paris, where abstraction was a dominant force; its influence may be seen in his pictures, not that he abandoned contact with the human figure. In the 1950s he used a technique reminiscent of his Futurist paintings and his colour became gay, rich and amusing. He did a remarkable series of dancers which were inspired by the fact that his youngest daughter, Romana, danced classical ballet. His aim was to suggest a synthesis between music, movement and colour, and the results possess extraordinary vitality as may be seen from Figure 24.

In the post-war years decoration continued to engage him. His work of this type included the mosaics *Via Crucis* (1946) and *S. Marco* (1961) for Cortona, frescoes for the Capuchin church at Sion, Switzerland (1947) and a mosaic for St. Pierre, Fribourg (1951, Fig. 19). He did secular decorations too, for the K.L.M. (Fig. 23) and Alitalia offices in Rome and Paris respectively (1953–54) among others.

Severini's ability to design a large and complex composition is admirably demonstrated in the huge mural

decorations (72 m. long) he painted on the theme of agriculture for the Palazzo dei Congressi on the outskirts of Rome. This fascinating work, which runs across the entrance hall, combines naturalistic figures—workers engaged in viticulture—with more abstract designs that show a relationship with Kandinsky and Larionov and emphasize how his Futurist and Cubist experience permitted him to organize space in an efficient and ordered manner. The colours are vivacious and varied. The decoration indicates that he may be placed in the great Italian decorative tradition.

During the later years he continued to comment on the contemporary scene with insight and brilliance. His grasp is shown in *The Artist and Society*. Although his prediction in this that the epoch of bourgeois domination 'is drawing to a close (if not already over)' has fortunately proved premature, his view that the Revolution 'is pressing to overturn the existing scale of values and create a new order' has validity. What he claimed was that this new situation did not 'justify a refusal to recognize the value of art, even when this is not the product of the individualistic and bourgeois world'. In his essay on the position of art in Russia (in this volume) he emphasized that

. . . art, as such, cannot be enslaved and lowered in order to become the instrument of propaganda or of immediate social action, or the immediate reflection of a social edifice under construction. If this happens to it, it ceases to exist as art and is no longer an element of culture and civilization; moreover it is of small utility to the regime that makes such mediocre use of it, and in the end it reveals the errors of such a regime.

He wisely went on to argue that the artist should not be indifferent to the tragic events of his time and that 'Independence is not indifference. The independence of the intellectual, whether artist, writer, scientist or philosopher should testify to the freedom of the intelligence faced with contingent and changing things'.

After emphasizing that modern life is not in accordance with human measurement, for it is dehumanized by commercialization and industrialization, he came out with a proud affirmation of a belief in humanity and truth. He sharply criticized Existentialism and proclaimed that he saw no reason to cast himself head first into 'an abyss of nothingness. The martyrs of which I have spoken, the kindness and spirituality to be found scattered throughout the world, the honesty and disinterestedness of many fine and admirable souls—all these things make the despair of self-annihilation and the leap into the abyss seem unjustified indeed'.

His concluding words are inspiring:

And indeed the poet loves things and life and loves the Truth, which illuminates them because in them he seeks for Truth. It is by means of love that the poet or any other man issues from his solitude into communion with the world. It is through love and through Truth that the world can be regenerated.

It is not necessary to be as devout as Severini to sympathize with his affirmation of faith and to succumb to the fascination of an artist who remains one of the most interesting and complex of his time. In many ways the intellectual evolution of Severini, who died in 1966, mirrors the spiritual drama of our age. He grew close to the abyss, peered into it and then drew back.

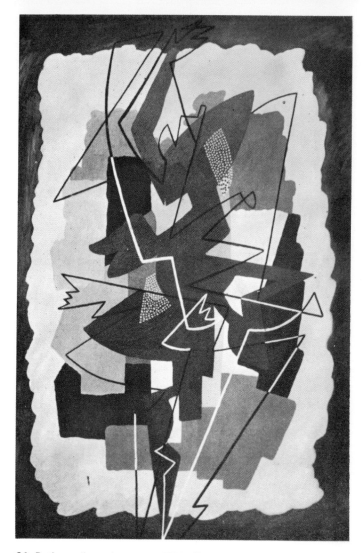

24. *Rythme d'une danseuse,* 1959. Oil on canvas, 92 × 65 cm. Private collection, Rome. Exhibited Salon de Mai, Paris, 1959

25. *Composition,* 1965. Oil on canvas. Private collection, Arezzo

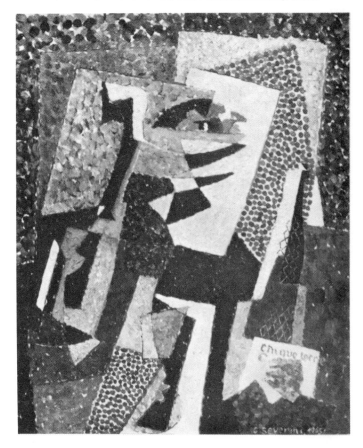